BREAKING THE MOLD

The Legacy of the Noah L. and Muriel S. Butkin
Collection of Nineteenth-Century French Art

Gabriel P. Weisberg

With contributions by Kirsten Appleyard,
Heather Lemonedes, Sarah J. Sik, and Janet L. Whitmore;
research assistance by Yvonne Weisberg

Snite Museum of Art, University of Notre Dame

This publication was made possible by generous gifts from
Mr. and Mrs. Thomas J. Lee '59 and Mr. Ralph M. Hass.

ISBN 978-0-9753984-3-2

Distributed by the University of Washington Press

Published in association with an exhibition of the same title,
September 2–December 2, 2012, Snite Museum of Art

Library of Congress Cataloging-in-Publication Data

Snite Museum of Art.

Breaking the mold : the legacy of the Noah L. and Muriel S. Butkin
collection of nineteenth-century French art / Gabriel P. Weisberg ; with
contributions by Kirsten Appleyard, Heather Lemonedes, Sarah J. Sik,
and Janet L. Whitmore ; research assistance by Yvonne Weisberg.

 pages cm

Published in association with an exhibition of the same title, September
2/December 2, 2012, Snite Museum of Art.

Includes bibliographical references.

1. Painting, French—19th century—Exhibitions. 2. Butkin, Noah L.,
1918-1980—Art collections—Exhibitions. 3. Butkin, Muriel—Art
collections—Exhibitions. 4. Painting—Private collections—Indiana—South
Bend—Exhibitions. 5. Snite Museum of Art—Exhibitions. I. Weisberg,
Gabriel P. II. Title.

ND547.S59 2012

759.409'03407477289--dc23

 2012020473

Contents

Acknowledgments

The *Breaking the Mold* exhibition and publication represent a major milestone for the Snite Museum of Art, University of Notre Dame. Not only has this project allowed us to develop and share important scholarship for the Noah L. and Muriel S. Butkin Collection of Nineteenth-Century French Art, it also provides a welcome and overdue opportunity to recognize the Butkins' impressive generosity to both the Snite Museum of Art and the Cleveland Museum of Art. Both institutions benefited greatly from the Butkins' prescient, mold-breaking taste for nineteenth-century French art, and from their keen eyes, careful recordkeeping, and generous spirits.

The Snite Museum's Butkin collection contains more than two hundred artworks and is one of the true strengths of the Museum. Featuring nineteenth-century French oil sketches, it includes many riches that can be mined for what the paintings reveal not only about the French Academy, but also about extant finished paintings based upon these studies. The revelations in this catalogue emanate from the creative and arduous efforts of "team Weisberg," led by art historians Gabriel and Yvonne Weisberg and greatly assisted by art historians Janet Whitmore, Sarah Sik, and Heather Lemonedes. All contributed important essays to this publication.

I have known of the Weisbergs by reputation for many years. My former director and mentor E. Frank Sanguinetti held them in very high regard. Therefore, I was delighted when the Weisbergs immediately and enthusiastically accepted my invitation to organize this exhibition and publication. I learned that they had been close friends and advisors of the Butkins, and that they were eager to solidify Muriel's and Noah's legacies as major benefactors and to underscore the Butkins' groundbreaking interest in nineteenth-century French art. Thus motivated, the Weisbergs attacked the project with extraordinary passion, visiting the Butkin collection at the Snite Museum of Art, traveling with me to the Cleveland Museum of Art, and most

importantly, consulting numerous archives and specialists during a summer passed in France. It has truly been a joy to work with the Weisbergs. Their love for nineteenth-century French art is infectious and is industriously applied through encyclopedic knowledge of the Academy, incisive and unflagging research, keen connoisseurship, and finely honed writing.

The Weisbergs and I wish to thank individuals associated with the Cleveland Museum of Art who have been gracious and generous colleagues: Director, Collections Management Mary E. Suzor; Curator of Drawings Heather Lemonedes; and emerita curator Diane De Grazia. We are especially grateful for the fourteen artworks the Cleveland Museum of Art made available for the *Breaking the Mold* exhibition.

The Butkins' personal assistant, Rita Wisney, generously shared biographical information as well as historical photographs.

This publication also allowed us to document the crucial work of Director Emeritus Dean Porter and Emeritus Curator of Western Art Stephen Spiro in encouraging the Butkins to share important artworks with the Snite Museum. While Porter and Spiro regularly visited the Butkins in Cleveland, we believe Muriel only once visited the Snite Museum and, even more extraordinary, Noah never had an opportunity to see the Museum. Former graduate intern Kirsten Appleyard interviewed Spiro and utilized text provided by Porter to prepare her fine *Partnering in Beauty* essay describing the Butkins' relationship with the Snite Museum of Art.

Curator of European Art Cheryl Snay very thoughtfully designed the exhibition and the museum's exhibition team oversaw the installation: Associate Director Ann Knoll, Exhibition Designer John Phegley, and Exhibition Coordinator Ramiro Rodriguez. Notre Dame faculty member and award-winning graphic designer Robert Sedlack has once again designed an elegant exhibition catalogue. It benefited greatly from the talents of editor Sarah Tremblay and former Photographer and Digital Archivist Eric Nisly. Additional images were provided by Art Resource; the Cleveland Museum of Art; the Musée des Beaux-Arts, Dijon; the University of Iowa Museum of Art; Suzanne Nagy; and Yvonne M. L. Weisberg. Kirsten Appleyard collected provenance information for Butkin artworks from private galleries and auction houses. Special thanks to Curator of European Art Cheryl Snay, who greatly assisted the physical examination of artworks, both for scholarly purposes and to determine conservation needs. Conservator Monica Radecki skillfully treated a small number of paintings to enhance the viewer's experience.

Pat Soden, former director of the University of Washington Press, eagerly and ably orchestrated the Press's distribution agreement.

Mr. Ralph M. Hass and Snite Museum Advisory Council members Mr. and Mrs. Thomas J. Lee '59 made this publication possible through generous gifts.

It is a joy to release this exhibition and publication from the finely hewn mold that has been crafted by "team Weisberg." While Butkin paintings have been exhibited at the Snite Museum of Art for over thirty years, I am deeply grateful to this group of scholars for so intelligently placing them within their historical context, for highlighting their importance to Notre Dame and Cleveland, and for so completely securing the legacy of Noah and Muriel Butkin.

Charles R. Loving
Director and Curator, George Rickey Sculpture Archive

A Tale of Two Collections

Gabriel P. Weisberg

Although the names of Noah and Muriel Butkin are associated with many artworks at the Snite Museum of Art, University of Notre Dame, and at the Cleveland Museum of Art (CMA), the Butkins have remained largely unknown, their legacy unheralded amid the myriad objects in the possession of these museums. While the Butkins by nature were unassuming people, what they have given to these two institutions should be better understood, especially since the objects they collected are linked to new ways of examining the art of the nineteenth century in Europe. The Butkins were in advance of the now well-established tendency of moving away from traditional categories of collecting, such as Romanticism or Impressionism, by concentrating on painters who had been forgotten or whose work had not been adequately assessed by curators or art historians. The fact that their collection has been divided between two homes is unusual: it speaks to the generosity of the Butkins and their willingness to make their objects available to different audiences in the two very different institutions. Numerous paintings given by the Butkins are on view at the Cleveland Museum of Art, while light-sensitive drawings from Muriel's sizable collection of works on paper are shown periodically. At the smaller Snite Museum, the works are more readily accessible and visible. The two groups of objects were collected at the same time, often through interactions with the same people—curators, art historians, directors—and through the Butkins' singular passion for the nineteenth century. The story of how this unique collection was formulated, and how it was assembled, deserves to be known.

My wife, Yvonne, and I were close friends with the Butkins when we lived and worked in Cleveland, where I served as curator of art history and education at the CMA until early 1981. We saw the Butkins on a regular basis, and Noah would frequently call me several times a day, until he passed away in 1980, to discuss future art purchases. We were richly rewarded through our contacts with the couple, learning much about areas of the nineteenth century that were still foreign to us. We also recognized that these unpretentious people (figs. 1 and 2) came to the world of collecting as a means of combining an intense interest in art with

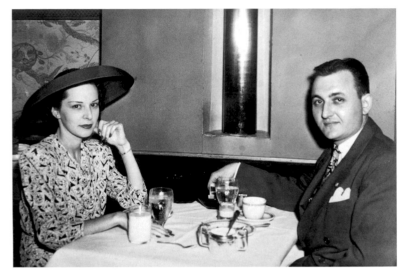

Fig. 1. Muriel and Noah Butkin in a restaurant.
Courtesy of The Cleveland Museum of Art Archives.

a desire to broaden their personal contacts. The Butkins' acute involvement with their collection, and their genuine interest in learning about the art they amassed, attracted curators, dealers, art historians, and museum directors. The couple hoped that others would develop a similar passion for the artworks—whether drawings or large-scale paintings, by well-known or obscure artists.

Noah Butkin was a hard-driving businessman, whose fervent interest in painting was paired with a down-to-earth wit; as time progressed, he showed that he was a fast learner, with an innate eye for art that allowed him to become more independent than most collectors working with museum curators. He eventually made decisions based on his own reactions to a work of art. Muriel was the opposite. Demure, shy, introspective, and retiring, she nevertheless maintained a determination that matched Noah's when it came to collecting. But where Noah was passionate about paintings, Muriel's love was drawings.[1] Both valued working with professional people, whether it was the authoritative Sherman E. Lee, then director of the CMA; the (at that time) still-learning Stephen B. Spiro, a valued curator at the Snite Museum of Art; or me. Both of them loved art,

and acquiring it became their life. The Butkins aspired to build collections that would have lasting value, comprised of objects that would be seen, studied, and used by future generations. They selected their works carefully, as proven by the fact that only a few pieces were deaccessioned from their holdings after they acquired them.[2]

The Butkins' singular achievement is illuminated by examining the range of objects that they gave to Notre Dame and to Cleveland within the context of the growth of nineteenth-century studies over the past forty years. When they began collecting, many areas of nineteenth-century art were uncharted territory.[3] Only the great names—Ingres, Delacroix, Manet, Degas, Monet—reigned supreme. Other artists were not part of the discourse yet; their works had been written out of history because of the taste for the evolution and pursuit of modernism, a movement in which many of them did not participate. While the Butkins were not alone in opening up broader approaches to nineteenth-century art (developing an appreciation for academic painting, for example, or for lesser-known Realists), they were inventive in what they collected. They focused on artists whose work they felt deserved stronger attention, not only because it had been neglected but also because it was of high quality.[4] The latter consideration often became the touchstone of their pursuit of art objects.

How the Butkin Collection Came About: The People and the Art

Although I had been at the Cleveland Museum of Art for several years, my first contact with the Butkins came in 1976 at the suggestion of museum director Sherman E. Lee, who believed that we had interests in common. At the time, I was completing my book on the Realist painter François Bonvin, a monograph that was eventually published in 1979.[5] But the road toward publication was a difficult one, since the book needed financial support in order to secure the best possible photographs for reproduction. Such costs were obviously prohibitive for a junior curator, and Sherman Lee believed that Noah Butkin could help

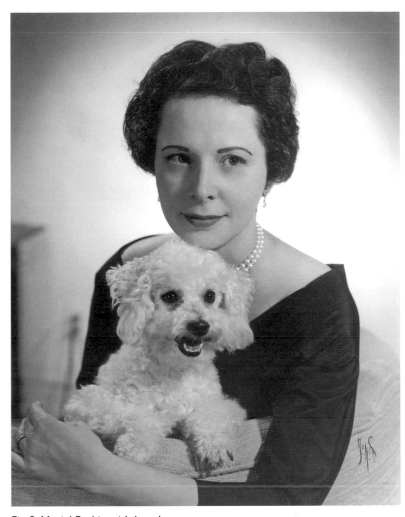

Fig. 2. Muriel Butkin with her dog.
Courtesy of The Cleveland Museum of Art Archives.

through his private foundation, which provided small grants to worthwhile projects.

My initial meeting with Noah and Muriel was at a local Cleveland restaurant, where Noah took an immediate interest in the Bonvin book. He had been exposed to Bonvin's paintings in Sherman Lee's personal collection, which included a still life of asparagus by the artist that hung in Lee's dining room—a location often visited by Noah, since he was to become a member of the CMA Board of Trustees. Sherman Lee also had a genuine interest

in Bonvin and other Realists, and he hoped to see a major international exhibition on these artists presented at the Cleveland Museum of Art. With the support of the Bonvin book came Noah's interest, along with Muriel's, in purchasing artworks by this artist—works that were, at the time, regularly available on the art market in galleries and auction sales. All circumstances converged, and Bonvin became a point of contact, eventually leading to the publication of the book and the acquisition of several Bonvin paintings and drawings for the CMA (cat. nos. 10, 12, 13) and the Snite Museum (cat. no. 11).

As the relationship with the Butkins deepened, Noah and Muriel became strongly committed to finding other Realist works of art for themselves, for the Cleveland Museum of Art, and for *The Realist Tradition: French Painting and Drawing, 1830–1900*, an exhibition held at the Cleveland Museum (and other venues) beginning in the fall of 1980.[6] Noah's determination to add Realist paintings to his collection led him to work with a number of international dealers, including André Watteau, who had a gallery on rue la Boétie in Paris.[7] Watteau would send transparencies of potential works for sale to Butkin, which Noah would then show to Sherman Lee and me. In this way, a number of key paintings were acquired: a landscape by Célestin Nanteuil, a boatyard by Jean-Charles Cazin, and Jules Bastien-Lepage's *Portrait of Madame Samary of the Odéon* (cat. no. 3).

Noah's desire to build a representative nineteenth-century collection took another turn of events when he saw a transparency of *Les brigands romains*, by Charles Gleyre (fig. 3). This supposedly lost painting by the Swiss artist strongly appealed to Butkin; Sherman Lee also valued the work highly, and Noah became resolved to secure it. However, the French state has the right of approval before any artwork judged to be of interest to French culture leaves the country. Even though Butkin had paid for the work, the Gleyre painting could not leave France until an arrangement was made between the French museums and the collector stating that the painting would hang in Cleveland until the deaths of both Noah and Muriel; then, it would be returned

to France to hang permanently in a French national collection.[8] It was only recently, after Muriel's death in 2009, that the painting was sent back to France. This episode chronicles Noah's determination to see an important work come to Cleveland. He was not going to be stopped, even by the French government.

Noah Butkin's ability to get art dealers to help him develop his collection is well established in the records of objects he and Muriel left to the Snite and Cleveland museums. Martin Reymert and Robert Kashey, of the Shepherd Gallery in New York City, would often come to Cleveland with paintings or drawings they had found in Europe, especially Paris. They wanted the Butkins to have first choice of the objects. On these occasions, or "vernissages," as Muriel called them, we would meet over lunch or in Noah's office, where all of us were able to look at the pieces. A good number of works were obtained in this manner; some are noted in this publication (cat. nos. 21, 49, 71).

In addition to relying on the Shepherd Gallery for paintings or drawings, Noah and Muriel wanted to deal directly with European sources. In the fall of 1977, when I was in Europe with Yvonne working on the *Realist Tradition* exhibition, we met with the Butkins in Paris. Noah was still looking for works by Bonvin, as was Muriel; several were added to their collection, and some eventually entered the Snite and Cleveland museums after this trip. While in Paris, we visited several dealers together, including the Galerie Jacques Fischer–Chantal Kiener on rue de Verneuil, where we found a major painting by Gustave Colin (cat. no. 23). Both Noah and I liked the work of this painter, who had an active career—primarily as a landscapist and genre painter in the southwestern part of France (his paintings included depictions of bullfights)—and who exhibited with the Impressionists. Sherman Lee, however, was less enamored with Colin's oil; it hung in my office, behind my desk, until I left the CMA and it entered the Snite Museum's collection.

As the years passed, Noah discovered other works on his own, often in major auctions at Sotheby's or Christie's. Developing an interest in the work of Jules Bastien-Lepage—he had already

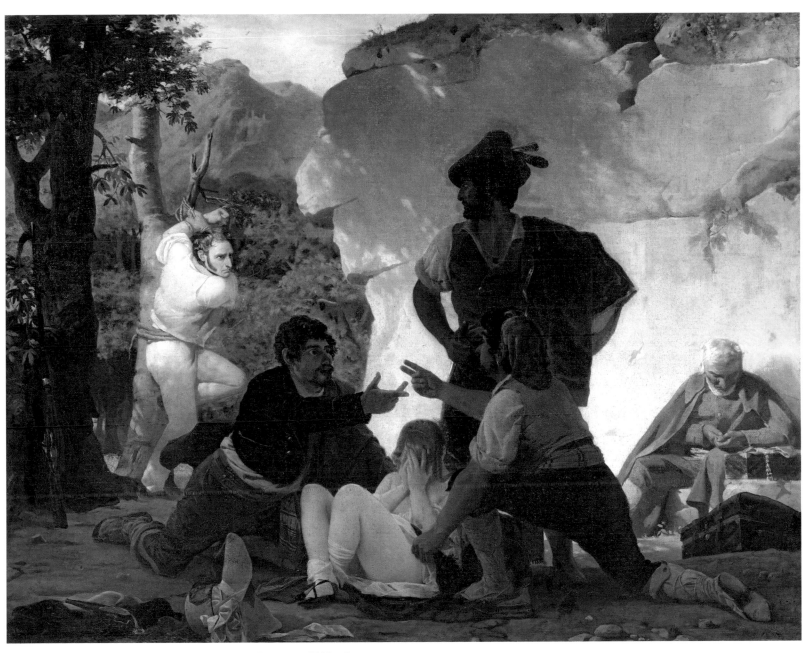

Fig. 3. Charles Gleyre (Swiss, 1806–1874), *Les brigands romains*, 1831, oil on canvas, 39.37 x 49.61 inches (100 x 126 cm), Musée du Louvre, Paris, RF 1977-7. Photo: Gerard Blot. Réunion des Musées Nationaux/Art Resource, NY

purchased the *Portrait of Madame Samary*—Noah was very excited by the opportunity to bid on Bastien-Lepage's *Portrait of Albert Wolff* (cat. no. 4), which came up for sale in 1979.[9] After securing this portrait, Noah recognized that he had rescued Wolff from the art historical oblivion caused by his opposition to the Impressionist movement, which the critic scathingly expressed in newspaper reviews published in the daily Parisian press. Noah was always attracted to oppositional figures, and the Albert Wolff portrait suited his penchant for polemical controversy. The fact that the painting was also very small, much like an early Netherlandish miniature, also endeared it to Noah; he saw that technical skill and psychological depth were not limited to large-scale paintings. He proudly hung the piece in the living room of his house in Shaker Heights, Ohio.

The Nature of the Butkin Collection

Noah and Muriel Butkin were dedicated to collecting art in areas not widely appreciated during the 1970s. Many of the artists they sought out were linked to the Realist movement, a group that would receive extensive scrutiny in the *Realist Tradition* exhibition of 1980–81. While Noah collected the paintings of Antoine Vollon (cat. nos. 77–79), Muriel assembled unusual landscape drawings by this artist. One example shows a broad panorama of a particular environment at Versailles (cat. no. 80), composed in black and white chalk with a certain freedom that we associate with Romanticism and, later, Impressionism. Numerous other works by François Bonvin and Théodule Ribot (cat. nos. 63–67), another Realist, were added to the collection, as Noah, under the inspiration of Sherman Lee, identified pieces that emphasized the simple activities of daily life in the nineteenth century. Some exemplified the interest in religious experience that was central to Ribot, Henri Gervex, and other artists of the era (cat. nos. 45, 67). Religious training, the life of novitiates, and the experience of first communion were recorded by the Realists in paintings that documented actual locations where such scenes took place. For example, Gervex painted an oil study of one of the communicants inside the Église de la Sainte-Trinité (Church of the Holy Trinity) in Paris (cat. no. 45); this served as preparation for his finished version of the first communion.

Preparatory studies became another fascination for Noah Butkin, as they provided important visual evidence of how artists were trained and how they composed their scenes in the nineteenth century. While Yvonne and I were in Paris in 1977, after Noah and Muriel had returned home, we located a sketch by Isidore Pils for *The Death of a Sister of Charity* at André Watteau's gallery (cat. no. 58). Noah appreciated its significance as a preparatory study for a much larger, more complex composition, and he purchased it and gave it to the Snite Museum.[10] Other sketches were eventually secured, including some by Hippolyte-Jean Flandrin (cat. nos. 35–38), one of the leading academic painters of the July Monarchy. Reminders of the academic tradition, they documented how artists developed and modified (or did not) their compositions while working on large paintings with numerous figures. Painters often used such preliminary sketches and oil studies to carefully understand how a finished work would look in the space of a small chapel. Noah's dedication in bringing these studies together reveals that he was interested in the broadest spectrum of nineteenth-century creativity.

Completely forgotten painters, such as Eugène Poidevin (called Lepoittevin; cat. no. 52), Édouard Pingret (cat. no. 60), and Victor Lecomte (cat. no. 50), provided an opportunity to expand the collection further into totally uncharted waters. Recent research has shown that Lepoittevin contributed to the still-life revival movement that spread rapidly from the 1850s onward, encompassing Bonvin and Ribot, among many others.[11] The decision to buy the Pingret was motivated primarily by the uniqueness of the scene, but recent research has identified that the image portrays a historical subject linked to the kings of France. Shown at the 1824 Salon, Pingret's composition depicts Diane de Poitiers receiving a letter from Francis I; she reads the message in front of an open window, while the courier who brought the document sits in front of her.[12] This reconstruction of an event

and personalities from the past shows how painters were inspired by historical references.

But of all the Butkins' purchases, among the most unusual was a work by Lecomte that Noah would give to the Snite Museum (cat. no. 50). With this painting, he was captivated by one of the most prevalent themes of nineteenth-century art: an interest in light and how different methods of illumination revealed an interior.[13] This concern had been a key component of seventeenth-century painting, and two centuries later, many artists were equally obsessed by light sources—especially the new gas lamps that were replacing candles for indoor lighting. Lecomte, who died in 1920, became a specialist in this category, producing many Salon paintings with the subject of *sous la lampe*. Thus, the Snite Museum composition is an important example of an artist dedicated to a dominant theme. The painting demonstrates that Noah was moving into another collecting area that few were thinking about at the time, by selecting a painting in the Realist mode that was tied to a widespread experimentation with lighting effects.

Noah was also attracted to the work of Jean-Léon Gérôme. Along with a few other collectors, he was in the vanguard of the interest in an artist who most scholars still viewed as an impediment to the history of Impressionism. Outside of the important 1986 monograph on Gérôme by Gerald Ackerman, it was not until 2010–11 (in a major exhibition at the Getty Museum in Los Angeles, the Musée d'Orsay in Paris, and the Museo Thyssen-Bornemisza in Madrid, and in the accompanying catalogue) that Gérôme was introduced to the general public.[14] When Noah was expanding the boundaries of his collection, appreciation of Gérôme was limited; the painter had not yet become a major historical figure whose position in art museums was firmly established. Securing four studies by Gérôme was, therefore, a gamble. Now in the Snite Museum collection (cat. nos. 40, 42–44), the pieces attest to Noah's desire to chronicle how an academically trained painter worked.

With the work of Jehan-Georges Vibert, Butkin took an even greater chance. Vibert was known for his innumerable paintings of religious types (priests and cardinals), most produced on a small scale to meet the demands of an insatiable nineteenth-century market for satire and anecdotal subject matter. But Butkin was not interested in these rather commonplace and repetitious themes. He was attracted by other aspects of Vibert's oeuvre: paintings of artists in their studios or of people mesmerized by the fury of the water along the coast of France. He purchased three Viberts, two of which remain with the Butkin collection in Cleveland and Notre Dame (cat. nos. 75–76); the other, a painting of an artist and model in his studio, has disappeared, most likely deaccessioned from the Butkins' holdings.[15]

Cleveland's Vibert painting shows a model dressed in historical costume, posing in a studio illuminated by two arc lamps, while the male artists in training paint him. The intensity of the lighting is equaled by the seriousness of their study. This work, like the one by Lecomte, was related to the increasing concern with finding new ways to depict artificial illumination; it also demonstrated that night classes were held in various studios. The Snite Museum's Vibert oil, showing figures along the rocky outcropping at Etretat, is the most original in the artist's output. The painting likely developed from a journey that the artist and his friends took to this tourist site on the Normandy coast. It conveys a rich sense of romantic drama, melodrama even, as the waves beat against the rocks, frightening some members of the group. As a narrative painting based upon real-life experience, it has no peer within Vibert's oeuvre; he most likely kept the work with him until his death, since it contained references and memories of personal significance. With these Viberts and the works by Gérôme, Noah Butkin's collection was bringing together paintings in areas outside the traditional scope of Realism—specifically, genre scenes that told stories about the lives of the artists and about nineteenth-century forms of entertainment.

This trend in Noah's acquisitions dovetailed nicely with the organization of *The Realist Tradition*, then being formulated at the

Cleveland Museum of Art. A large part of the Butkins' collecting in the latter 1970s was tied to this exhibition; Noah purchased several works that were included in the show. Organized thematically—essential for funding through the National Endowment for the Humanities—the exhibition examined the social themes addressed by French Realist and Naturalist artists from the late 1830s until 1900. While there were some well-established names on the checklist (Courbet, Caillebotte, Degas), the exhibition broadened the range of Realism to encompass the varied ways the term was used by art critics of the nineteenth century. Both painting and drawing were examined; in fact, one of the show's overarching goals was the liberation of drawing from its reputation as merely a preparation for paintings.

A smaller, secondary exhibition held simultaneously was dedicated to the drawings and watercolors of Léon Bonvin (half-brother of François), expanding the importance of the Realist vision in exquisite pieces that few had even known existed.[16] From Léon Bonvin's early work—often dark and dour scenes of the interior of his own inn—to his study of plants and flowers in the fields near his home and as still lifes on spare tables, there was no denying that this artist was an original figure, whose suicide provided an aura of tragedy to his works. Here again, the Butkins were at the forefront of the attention given to this artist, purchasing examples for their own collection (cat. nos. 14–15).

Noah Butkin contributed a number of pieces to *The Realist Tradition*, including Jean-Charles Cazin's *Boatyard* (fig. 4) and François Bonvin's *Portrait of Louison Köhler* (cat. no. 12). The latter painting, exhibited at the 1874 Paris Salon, is a key work in Bonvin's reexamination of Dutch seventeenth-century prototypes to visualize themes that had personal meaning for the artist.[17] Another painting that Noah loaned to the show was a work by Alphonse Legros that eventually entered the Snite Museum (cat. no. 51). The exhibition cast light on this little-known artist. Legros's position in the Realist movement was documented; friendships with several better-known painters helped establish his role as a significant artist.

The Realist Tradition built upon Noah's fascination with Bonvin, Ribot, and Vollon, among other artists. And Noah's collecting continually enlarged the discoveries made in the process of organizing the exhibition. Each side was richly served by looking at artists who had long been forgotten by the canon of art history. In this examination, the exhibition proved unsettling to many with a one-track vision of what Realism contained: Courbet and, after him, the Impressionists. The show demonstrated that there were academic Realists, such as Isidore Pils (cat. nos. 58–59), and others who, like Jules Breton (cat. no. 16), combined Realism with the tradition of the Renaissance. There was considerable sadness when the exhibition opened in Cleveland, as Noah Butkin had died from a massive heart attack six months before. The personal opportunity to see displayed the new areas of nineteenth-century art that he had worked so hard to bring to light was denied him at the end.

The Achievement: The Collection Now

The Cleveland Museum of Art received a number of paintings after Noah's death. Following Muriel's death in 2009, Cleveland received additional paintings as well as Muriel's collection of drawings, and paintings that had been on long-term loan at the Snite Museum of Art were bequeathed to Notre Dame's collection. Many of the works donated to the CMA are large paintings. The pieces that entered the Snite Museum are often on a smaller, more intimate scale—including many of the preliminary oil sketches (cat. nos. 35–38, 43, 58), which the Butkins hoped could be shown together in a gallery dedicated to the creative ways in which artists worked.

Muriel and Noah believed that sharing their collection between two institutions would allow more of the paintings to be exhibited, seen, studied, and researched by visitors, faculty members, and students. While some of the objects they collected are religious in nature, this was not the reason they gave them to the Snite Museum. The achievement of the collection (whether considered together or singly) is that it exposes viewers to

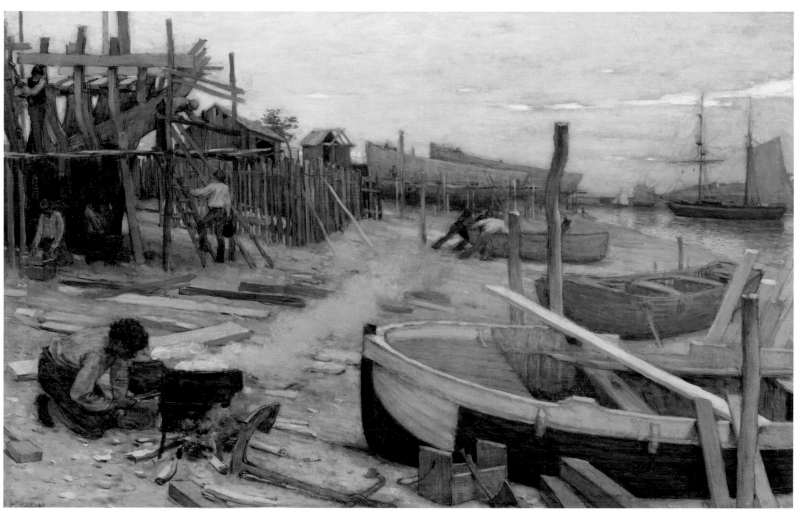

Fig. 4. Jean-Charles Cazin (1841–1901), *The Boatyard (Le chantier)*, ca. 1875, oil on canvas, 30.55 x 48.31 inches (77.60 x 122.70 cm), The Cleveland Museum of Art, Gift of Mr. and Mrs. Noah L. Butkin, 1977.123.

many under-appreciated artists who played a significant role in the development of nineteenth-century art in France. While the Butkins did not fully know how the nineteenth-century art-historical canon was being expanded, the contribution that their diverse holdings made to this growth cannot be underestimated. They formed their collection out of a passionate commitment to gather objects that were unfamiliar; in the process, they brought together paintings and drawings that helped shatter the stranglehold that the evolution of modernism had held on the collecting of nineteenth-century art. Their bravery in forging new directions has created a legacy that influences what others collect today.

One other aspect of the Butkins' generosity at Notre Dame needs to be noted. Along with the objects they donated, Noah and Muriel provided a small acquisitions fund to be used in securing new paintings for the museum. Under the guidance of Stephen Spiro, the Snite Museum obtained, among other pieces, an unfinished portrait by Jules Bastien-Lepage of Constant Coquelin (cat. no. 2), an actor at the Comédie-Française and a leading supporter of academic painting. This piece reveals another side of Bastien-Lepage's oeuvre: his commitment to portraiture. The lifelike quality of the painting—Coquelin appears ready to speak—is a feature also found in the Madame Samary portrait in Cleveland. It was a hallmark of Bastien-Lepage's grounding in a type of verisimilitude suggested by photography, a medium that he became increasingly interested in before he died. The fund has also recently been used to assist the purchase of Théodule Ribot's *Portrait of Léon Charly* (cat. no. 65), a poet and associate of the painter. The selection of this luminous painting reemphasizes that painters admired by the Butkins are still considered for acquisition by the museum staff. In using this fund to build upon the original Butkin donation, the Snite Museum maintains the collectors' legacy into the future. It is a fitting continuation of what the Butkins hoped to accomplish, and they would certainly applaud the museum's sustained dedication to little-known artists of the nineteenth century.

The Noah L. and Muriel S. Butkin Collection of Nineteenth-Century French Art has proved to be one of the most transformative gifts ever made to the Snite Museum of Art, significantly enriching its collection and contributing to its visibility as an institution. The story of how this generous donation came about is a remarkable one, resulting from friendships established between the Butkins and several key players at the museum, most notably Stephen B. Spiro. The former John D. Reilly Curator of Western Arts at the Snite Museum, Spiro dedicated thirty-two years to developing the museum's European collection. According to Charles R. Loving, the current director of the Snite Museum, "[Spiro's] finely-honed acquisition skills... combined with his impeccable taste... enabled him to ferret out important, beautiful, and affordable works of art." In addition to this expertise, Spiro possesses a "thoughtful and sensitive nature which has endeared him to so many."[1]

When Robert Kashey and Martin Reymert of the Shepherd Gallery in New York were deciding to whom they should direct the Butkins, two of their most enthusiastic nineteenth-century French art collectors, it was not surprising that they arrived at Spiro as the natural choice. Muriel collected eighteenth- and nineteenth-century European drawings, while Noah tended toward nineteenth-century French paintings, with a preference for oil sketches; both were areas in which Spiro specialized. While Spiro in his modesty would deny such a claim, his combination of professional *savoir-faire* and personable demeanor is what, in large part, was responsible for the lasting partnership between the Butkins and the Snite Museum. According to Dean A. Porter, the museum director from 1974 to 1999, "having a passionate and knowledgeable curator with the sensitivity for quality art was critical when the Butkins decided to be beneficiaries of the Notre Dame Art Gallery and then the Snite Museum of Art. I have always subscribed to the belief that 'people give to people.'"[2]

Because of Spiro's close relationship with the Butkins, the organizers of *Breaking the Mold* asked him to share his insights about their interaction with the Snite Museum. The result was a gracious outpouring of information. Spiro enthusiastically recounted details regarding his introduction to the Butkins, the logistics of their collecting, their particular taste in art, and their pattern of giving to the Snite Museum. Perhaps most intriguing were his memories of the Butkins themselves, which paint a portrait not only of two remarkable collectors and donors but also of benevolent spirits and genuine friends.

Finding a Niche

It began in the fall of 1976. Spiro made his usual appointment to visit the Shepherd Gallery, a frequent haunt where he scouted potential material for the Snite Museum's collection. Upon arriving at the gallery, he was surprised to discover that the Butkins were already present. The gallery proprietors, Kashey and Reymert, introduced them, and Spiro launched into a friendly discussion with Noah, an informal meeting that lasted about forty minutes.

When Spiro returned to Notre Dame, a letter from Noah was waiting for him, inviting him to Cleveland. Short and to the point, the dispatch contained one sentence in particular that held profound implications for the future of the Snite Museum: "I think I have some important projects that I can discuss with you." As Spiro suspected and later confirmed, the Shepherd Gallery meeting that had initially seemed a happy coincidence had, in fact, been shrewdly arranged by Kashey, Reymert, and Butkin.

As Spiro and the Butkins became fast friends, details regarding the Butkins', particularly Noah's, collecting history came to light.[3] A Cleveland chemical engineer and metals executive, Noah began his collecting career by acquiring seventeenth-century Dutch and Flemish paintings, including fine works by such masters as David Teniers the Elder, Jan van Goyen, and Allart van Everdingen.[4] It did not take long, however, before he became aware that he was buying in a field with a highly established

market, where many of the major masters and important works were already in museums or other private collections. As a result, the finest pieces were quite scarce and, when available, extremely expensive. Noah also knew that these early works often had complex conservation problems.

By about 1975, therefore, Noah had turned his attention toward some of the less familiar areas of nineteenth-century French painting, especially Realist oil sketches. According to Spiro, the Realism of the nineteenth century appealed to Butkin in much the same way as had seventeenth-century Dutch and Flemish art: "Enthusiasm and curiosity were integral to Noah Butkin's experience of art. His instinctive taste allowed him to appreciate in nineteenth-century French art a tradition of Realism that derived from the seventeenth-century old masters he had first admired."[5] In addition to these works having fewer conservation problems, Noah found that he could procure higher quality pieces for lower prices than he had previously paid.[6] A handful of major institutions, such as the Metropolitan Museum of Art in New York, the Cleveland Museum of Art, and the Chicago Art Institute, were beginning to reconsider their nineteenth-century collections by reexamining some of the prominent Salon and academic artists of the period that they had formerly deaccessioned.[7] But very few private collectors at the time were interested in searching out nineteenth-century French oil sketches. Noah thus enjoyed both the general availability of works and the opportunity to be in competition with major institutions.

Spiro also notes how Noah's changing collecting interests coincided with the planning of a major exhibition at the Cleveland Museum of Art entitled *The Realist Tradition: French Painting and Drawing, 1830–1900*. Organized by Gabriel P. Weisberg, then head of the Cleveland Museum's education department and a friend of the Butkins, this internationally important project spurred Noah to purchase a number of works that could be included in the show. Indeed, Noah often expanded his collection based on a desire to contribute to museum exhibitions.

Selecting the Objects

Despite his many professional and cultural engagements, Noah Butkin always found time to attend to his collecting interests.[8] He and Muriel bought regularly from dealers and galleries, mostly in New York and Paris. Spiro notes, in addition, how runners from auctions would often go straight to Noah with available paintings (instead of going to a gallery first), knowing that he could write a check immediately if he liked a work. Moreover, Noah and Muriel traveled to Europe themselves once or twice a year. Two galleries that were pioneers in developing the market for nineteenth-century French art, the Shepherd Gallery in New York and Galerie Jacques Fischer–Chantal Kiener in Paris, were especially important for the Butkins, and many of the works in their collection have one or the other in their provenance. The Shepherd Gallery, in particular, was integral to the expansion of the Butkin collection. According to Spiro, Noah was often in contact with Kashey and Reymert regarding a work they knew was on the market. Reymert would routinely tour France and England in search of new paintings and drawings, returning to the United States and granting Noah and Muriel a chance to sift through his acquisitions and make selections. On rare occasions, Noah would even purchase a painting that Kashey and Reymert recommended without having seen it, so great was his trust in their opinion. Overall, the Butkins' enthusiasm for art, along with their business acumen and an ability to make swift and wise decisions, led to the rapid growth of their collection.

In deciding precisely which works to purchase, the Butkins often followed their gut instincts. There is no denying their awareness of artists' names and their relative importance; these were without a doubt frequently in the back of their minds. However, Noah and Muriel responded first and foremost to the paintings themselves. As Spiro relates, Noah had an intuitive sense for a work's aesthetic quality and essential human content: "Mr. Butkin had a great eye.... When you stood in front of a painting with him, he would immediately talk about how he loved the color

and brushwork, and how the composition and narrative were interesting to him."[9] Although perhaps he never spoke in the proper terms of connoisseurship, it was evident that Noah was a true connoisseur.

Muriel had a similar "open-mindedness and receptivity" when it came to deciding which works to procure. Carter Foster has noted that "she is a collector who has acquired with her eyes rather than her ears."[10] For the Butkins, quality, rather than reputation, was the most important criterion of purchase. They collected everything from self-portraits and portraits of an artist's family members to still lifes by landscape painters, as well as fresh and spontaneous preliminary sketches for larger compositions. In fact, of the more than one hundred and seventy paintings in the Butkin collection, a large percentage represents the early efforts of artists working on important commissions, many for projects in Paris. Spiro recounts: "[The Butkins] loved showing works to me and Sherman Lee [then director of the Cleveland Museum of Art] that were not necessarily by an important artist, but which were of such a high quality that they caused Lee to exclaim 'Now you're real collectors!'"[11] Even when they did purchase works by well-recognized masters, the Butkins were very selective. "For example, rather than a conventional landscape by Cazin, [Noah] chose an unusual work going back to the painter's debut that depicts a shipyard near Boulogne-sur-mer. By Trouillebert, instead of the pale imitation of Corot that the artist made his specialty, Butkin bought a striking painting showing some laborers in the act of constructing a viaduct."[12] The Butkins thus demonstrated a marked originality in their collecting habits, building their beautiful holdings with their eyes, rather than following what was popularly accepted.

An Invaluable Gift

According to Muriel, "A collector does not truly own his or her treasures but is their temporary custodian."[13] From the time she and her husband first began collecting, it was their ultimate desire to share the art publicly. This is not to say that they did not enjoy

their purchases; Noah installed his collection at his office and at home, while Muriel kept her drawings on some walls of their house and in boxes in her library study. Porter recalls this proud display: "As we toured their beautiful home, it was obvious that they lived, not accessorized, with their collections. Every work of art, whether it is a French oil sketch or terracotta, or English silver, was special."[14] Much of the Butkins' art, however, went to surrounding institutions. Indeed, by the time Spiro met Noah, the donor had already placed his sizable collection of seventeenth-century Dutch and Flemish paintings on loan to a college in Cleveland, and had gifted several of his most important works to the Cleveland Museum of Art.

It is not surprising, therefore, that almost immediately after their introduction Butkin began discussing with Spiro the possibility of donating pieces from his nineteenth-century French collection to the University of Notre Dame. When asked about Noah's decision, Spiro explained that collectors such as the Butkins often chose to give works to the Snite Museum because they wanted the art to be on immediate display; when pieces are bequeathed to larger institutions such as the Art Institute of Chicago or the Metropolitan Museum of Art, they are frequently relegated to storage rooms for want of gallery space. In the words of Porter, "Given to any other institution, many [of the Butkins' paintings] might have been subjected to the darkness of museum vaults. At Notre Dame, they would be on permanent view."[15]

While this fact undoubtedly contributed to the Butkins' donation to the Snite Museum, their generosity was further fueled by their relationship with Spiro, which in turn was sparked by their mutual interest in many of the lesser-known but talented artists of the nineteenth century. According to Spiro, he and Noah Butkin got along enormously well, both professionally and personally. Porter describes this rapport: "The Spiros, Judy and Stephen, and the Butkins, Muriel and Noah, almost immediately became very close friends. In fact, the Butkins seemingly 'adopted' the Spiros, as their relationship quickly developed more along the lines of family than one of museum/benefactor."[16] Noah would

often request that Stephen and Judy visit him at his home; the two men saw each other every two or three weeks, and they spoke on the phone almost every other day. At the end of each visit that Spiro made to Cleveland, Butkin would reserve some time to go through his collection and point out certain works. "If you want this for the museum, then you can take it with you right now," he would say. As a result, trip after trip, Spiro found himself returning to Notre Dame with six to twelve works of art in hand—wonderful Dutch paintings, drawings, English silver, sculptures, and of course, French oil sketches. Spiro comments, "I was always so surprised and grateful for his very casual generosity. He never made a big fuss over these gifts, and he always seemed so delighted that I was so pleased."[17]

Noah continued this pattern of giving throughout his lifetime—and even beyond. Sadly, before he ever had the opportunity to visit Notre Dame, he suffered a heart attack on February 10, 1980. He died a day later, but not before he and Muriel confirmed plans to make Notre Dame the beneficiary of his oil sketch collection. Moreover, the Butkins set up an acquisition fund for the museum, thereby enabling Spiro to continue purchasing sculptures and oil sketches that would complement or fill gaps in the collection. Other than specifying that Spiro not spend the money on drawings (as that was Muriel's domain), Noah gave no directions for how the funds should be used. So far, two dozen acquisitions have been made possible by the Butkins' generosity.

The reflection of two remarkable individuals' tastes—and the result of a passionate quest lasting barely ten years—the Butkin collection has proved an invaluable addition to the Snite Museum. Before Noah and Muriel's donation, the Snite Museum had only a handful of interesting nineteenth-century paintings to hang in its large new gallery; their gift allowed the period to be shown in much greater range and with more exciting examples. By the time the Butkin collection was installed, four out of every five paintings exhibited in the nineteenth-century gallery bore the Butkin name. In an article outlining the history of the museum, Porter describes the Butkins' donation in the following terms:

"No single gift would contribute more significantly to Notre Dame's international reputation."[18] He elsewhere comments, "The Butkins put Notre Dame's Museum on the map."[19]

Surrounded by the major encyclopedic collections of the Art Institute of Chicago, the Detroit Institute of Arts, the Cleveland Museum of Art, and the Indianapolis Museum of Art, the Snite Museum nevertheless has been able to set itself apart as a rich "niche" resource because of the Butkin collection. Suzanne Folds McCullagh, curator of early prints and drawings at the Art Institute, has remarked, "If one wants to learn about pre-Impressionist French art of the nineteenth century, a pilgrimage to South Bend is mandatory... and the truth is that the Snite has greater strength in some areas than our legendary collection. It is to be commended, envied, visited and treasured, nurtured, shown, and published."[20] Similarly, Sylvain Bellenger, then head of the paintings department at the Cleveland Museum of Art, observed in 2000 that "the Butkin gifts contribute greatly to the Snite's originality. One of the most important areas to continue—and expand—is the acquisition of [nineteenth-century French] sketches. This focus is not only savvy... but it is something that, to my knowledge, is not done systematically by any other museum in the world."[21]

That is to say, the Butkin collection and endowment allow the Snite Museum to make original contributions to the interpretation of European art history. Chosen with skill and care, each work in Noah's holdings—whether a self-portrait, landscape, or still life—provides instructive information about the multifaceted nineteenth century, both historically and aesthetically. In the words of Loving, the museum's current director: "Containing important exemplars of nineteenth-century French academic paintings—many of which are studies for finished paintings found in European museums and churches—the collection has much to reveal about the training and working methods of its artists, nineteenth-century French criticism and patronage, and this pivotal, transitional period in French art that led to Impressionism."[22]

It is thus safe to say that the Butkins and their collection have immeasurably enriched the Snite Museum as an institution. For Spiro, his time at Notre Dame will always, in part, be defined by his friendship with Noah Butkin—their frequent visits, their animated discussions, their common pursuits. These two men made a formidable duo, dedicating their lives to beauty and learning, and to the sharing of these experiences with others. While this partnership was tragically and prematurely laid to rest, its legacy endures—in the energy of Meissonier, the elegance of Court, and the wonder they inspire.

1 Charles R. Loving, "From the Director," *The Snite Museum of Art: Calendar of Events, September 2008–January 2009* (Notre Dame, IN: Snite Museum of Art, 2008), 3.

2 Dean A. Porter, "Noah and Muriel Butkin, Shaker Heights" (unpublished article, 2010), 4.

3 Much of the art that the Butkins donated to the Snite reflects Noah's particular taste, as Muriel had her own collection of French drawings that was donated to the Cleveland Museum of Art.

4 Some of the most important of these old master paintings now belong to the permanent collections of the Snite and Cleveland museums. Stephen Spiro, "Noah L. Butkin, 1918–1980," *The Snite Museum of Art / University of Notre Dame: Newsletter/Calendar 1980* (Notre Dame, IN: Snite Museum of Art, 1980).

5 Ibid.

6 Noah also occasionally bought Impressionist paintings (by Eugène Boudin, Gustave Caillebotte, and others) when they became available at a reasonable price. According to Spiro, Noah was arranging to purchase a group of four or five Impressionist paintings shortly before his death.

7 At that point, the nineteenth-century collections of these institutions largely consisted of the major names of Neoclassicism, Romanticism, Realism, and Impressionism.

8 Besides being the founder and president of Alloys and Chemicals Corporation, Noah was a devoted supporter of the Cleveland Orchestra, the Western Reserve Historical Society, and the Northern Ohio Metropolitan Opera Association. The visual arts, however, were his special interest. Spiro, "Noah L. Butkin, 1918–1980."

9 Stephen Spiro, interview by Charles R. Loving and author, South Bend, IN, December 3, 2010.

10 Carter E. Foster, "The Butkin Taste: Collecting French Drawings in Cleveland," in Carter E. Foster, Sylvain Bellenger, and Patrick Shaw Cable, *French Master Drawings from the Collection of Muriel Butkin* (Cleveland: The Cleveland Museum of Art, 2001), 8.

11 Spiro, interview by Loving and author.

12 Louise d'Argencourt and Roger Diederen, *European Paintings of the 19th Century*, vol. 1, *Aligny–Gros* (Cleveland: The Cleveland Museum of Art, 1999), xix.

13 Muriel S. Butkin, January 2001, quoted in Foster, Bellenger, and Cable, *French Master Drawings*, iv.

14 Porter, "Noah and Muriel Butkin," 4.

15 Ibid., 5.

16 Ibid., 1.

17 Spiro, interview by Loving and author.

18 Dean Porter, "A History of Notre Dame's Art Collection," *Notre Dame Magazine*, Spring 2006, http://magazine.nd.edu/news/10143-a-history-of-notre-dame-s-art-collection (accessed February 25, 2011).

19 Porter, "Noah and Muriel Butkin," 5.

20 Suzanne Folds McCullagh, personal correspondence to Charles R. Loving, July 1, 2000, quoted in e-mail from Loving to author, February 7, 2011.

21 Sylvain Bellenger, personal correspondence to Charles R. Loving, October 11, 2000, quoted in e-mail from Loving to author, February 7, 2011.

22 Loving, e-mail to author, February 7, 2011.

Catalogue Entries

Heather Lemonedes, Sarah J. Sik,
Gabriel P. Weisberg, and Janet L. Whitmore

Théodore Caruelle d'Aligny, 1798–1871

Landscape in Italy, perhaps mid-1830s
oil on canvas
25.50 x 19.63 inches (64.80 x 49.80 cm)
Signed lower left: monogram *CA*
Snite Museum of Art
Gift of Mr. and Mrs. Noah L. Butkin
2009.045.074

1

Provenance
Jan Milner, London; Sotheby Parke-Bernet, July 20, 1977, cat. no. 142; Shepherd Gallery, New York, 1977; Mr. and Mrs. Noah L. Butkin, 1977; placed on loan with the Snite Museum of Art, University of Notre Dame, 1980; converted to a gift of the estate of Muriel Butkin, 2009.

Exhibitions
Exposition rétrospective des artistes lyonnais, peintres & sculpteurs, 1904, Palais Municipal des Expositions (Quai de Bondy), Lyon.

Puvis de Chavannes et la peinture lyonnaise au XIXe siècle, 1937, Musée des Beaux-Arts, Lyon.

The Lure of Rome: Some Northern Artists in Italy in the Nineteenth Century, 1979, Hazlitt, Gooden, and Fox, Fine Art Dealers, London.

Théodore Caruelle d'Aligny (1798–1871) et ses Compagnons, 1979, Musée des Beaux-Arts, Lyon.

Paysagistes Lyonnais, 1800–1900, 1984, Musée des Beaux-Arts, Lyon.

Romanticism & the School of Nature: Nineteenth-Century Drawings and Paintings from the Karen B. Cohen Collection, 2000, Metropolitan Museum of Art, New York.

Paysages d'Italie-les peintres du plein air (1780–1830), 2001, Galleries Nationales du Grand Palais.

L'École de Barbizon: Peindre en plein air avant l'impressionisme, 2002, Musée des Beaux-Arts, Lyon.

Selected Bibliography

Aubrun, Marie-Madeleine. *Théodore Caruelle d'Aligny: 1798–1871; Catalogue raisonné de l'oeuvre peint, dessiné, gravé.* Paris: M.-M. Aubrun, 1988.

———. *Théodore Caruelle d'Aligny (1798–1871) et ses Compagnons.* Orléans: Musée des Beaux-Arts, 1979.

Harrison, Colin. "L'École de Barbizon. Lyon" *Burlington Magazine* 144, no. 1196 (November 2002): 704–5.

Ives, Colta Feller. *Romanticism & the School of Nature: Nineteenth-Century Drawings and Paintings from the Karen B. Cohen Collection.* New Haven, CT: Yale University Press, 2000.

L'École de Barbizon: Peindre en plein air avant l'impressionisme. Paris: Réunion des musées nationaux, 2002.

Storck, Adrien. *Exposition rétrospective des artistes lyonnais, peintres & sculpteurs.* Lyons: Palais Municipal des Expositions (Quai de Bondy), 1904.

1 Ca
Ga
Pei
20

2 Se
Co

3 Se
de

4 Se
of
as
u
cl

5 S
o

Jules Bastien-Lepage, 1848–1884

Portrait of the Actor Constant Coquelin l'Aîné (1841–1909),
ca. 1881–82
oil on canvas
13.25 x 11.38 inches (33.70 x 28.90 cm)
Inscribed on stretcher in brown ink: *Portrait de Constant Coquelin l'Aîné / par Bastien-Lepage / Acheté par moi à la vente après décès de / Bastien-Lepage / …May*
Snite Museum of Art
Purchased with funds provided by the Butkin Foundation
1981.105

Provenance

Galerie Georges Petit, Paris, sale Jules Bastien-Lepage, May 11–12, 1885, cat. no. 26, *Portrait de M.X. (Londres)*; purchased by M. May, 32 Boulevard Haussmann; Shepherd Gallery, New York, 1981; purchased by the Snite Museum of Art with funds provided by the Butkin Foundation, 1981.

Exhibitions

French and Other European Drawings, Paintings, and Sculpture of the Nineteenth Century, 1981–82, Shepherd Gallery, New York, cat. no. 13 (illus.).

Exposition des oeuvres de Jules Bastien-Lepage, March–April 1885, École Nationale Supérieure des Beaux-Arts, Paris, cat. no. 154, *Portrait de M. Coquelin aîné (Londres)*.

Selected Bibliography

Exposition des oeuvres de Jules Bastien-Lepage. Introduction by Louis de Fourcaud. Paris: Imp. réunies, 1885, p. 58, cat. no. 154.

Tableaux, études, esquisses, aquarelles et dessins laissés dans son atelier par feu Bastien-Lepage. Vente à Paris Galerie Georges Petit. Paris: Imprimerie de l'Art, 1885, cat. no. 26.

Much of Jules Bastien-Lepage's art was inspired by the provincial life of his native village of Damvilliers, in the Meuse region of France. But beyond the Naturalist works, genre paintings, and occasional landscapes that he painted and exhibited at the Salons, the artist had a singular affinity for portraiture. He was especially dedicated to portrayals of theatrical performers in France and England—a country that he visited several times during his short career. His sitters included the famed actress Sarah Bernhardt, Madame Samary of the Comédie-Française, and Henry Irving, a leading actor in England. In all of these portraits, Bastien-Lepage conveyed the character and liveliness of his subjects, who seem ready to speak or to engage with an audience. Although purchased through the Butkin Foundation by the Snite Museum of Art rather than by the Butkins in their lifetime, this portrait of the actor Constant Coquelin Aîné directly corresponds to the Butkins' taste for another portrait by Bastien-Lepage that they donated to the collection of the Cleveland Museum of Art (see cat. no. 3).

Bastien-Lepage's friendship with Coquelin and his brother, who was also a performer, is attested to in several ways: the brothers collected some of his works and exhibited them in their homes, and they were close associates of other painters in Bastien-Lepage's orbit, such as P. A. J. Dagnan-Bouveret (1852–1929), Emile Friant (1863–1932), and Jules-Alexis Muenier (1863/69–1942). Photographs of the actors exist in the Muenier photo archives, confirming the warmth of the ties between this circle of colleagues. Deeply affected by Bastien-Lepage's early and unfortunate death, the brothers attended his funeral in 1884.

This particular painting was already known as *Portrait of Coquelin aîné* when it was listed in Bastien-Lepage's estate sale, held in May 1885.[1] The piece was also included in the large 1885 retrospective of Bastien-Lepage's work at the École Nationale Supérieure des Beaux-Arts in Paris. Although its title was that time listed as *Portrait of M.X.*, the size of the painting exhibited matches the size of the Snite painting, further documenting the fact that this piece was publicly visible during the 1880s.[2]

2

26

Paul Eudel, a colleague and writer on the artist, noted that the portrait "was begun in London during a stay of the Comédie Française, then the painter or the artist having had to leave, the portrait remained as is with only the head finished."[3] The unfinished quality actually heightens the study's sense of spontaneity. By focusing attention on Coquelin's facial expression and leaving the remainder of the work in the state of a sketch, Bastien-Lepage emphasizes the performer's energy and enthusiasm. As an example of his portraiture of the early 1880s (it can be dated to either late 1881 or 1882), the painting reveals the artist's remarkable ability to convey the lifelike presence of his sitters. —GPW

1 *Tableaux, études, esquisses, aquarelles et dessins laissés dans son atelier par feu Bastien-Lepage*, Vente à Paris Galerie Georges Petit (Paris: Imprimerie de l'Art, 1885), cat. no. 26.

2 *Exposition des oeuvres de Jules Bastien-Lepage*, introduction by Louis de Fourcaud (Paris: Imp. réunies, 1885), 58, cat. no. 154.

3 Paul Eudel, *L'Hôtel Drouot et la curiosité en 1884—1885*, with a preface by Philippe Burty (Paris: G. Charpentier, 1886), 396 (this author's translation).

Jules Bastien-Lepage, 1848–1884

Portrait of Madame Samary of the Odéon, ca. 1881
oil on canvas
21.13 x 18.25 inches (53.67 x 46.36 cm)
Inscribed upper left: *A ma bonne Madame Samary /*
BASTIEN-LEPAGE
Cleveland Museum of Art
Bequest of Muriel Butkin
2010.25

3

Provenance
Galerie André Watteau, Paris; Mr. and Mrs.
Noah L. Butkin; bequest of Muriel Butkin to
the Cleveland Museum of Art, 2010.

Exhibitions
*The Realist Tradition: French Painting and
Drawing, 1830–1900*, 1980–81, The Cleveland
Museum of Art, cat. no. 225.

Selected Bibliography
*The Realist Tradition: French Painting and
Drawing, 1830–1900*. Cleveland: The Cleveland
Museum of Art and Indiana University Press,
1980, pp. 253–54, cat. no. 225.

When Bastien-Lepage completed this painting of the famed actress Marie Samary, he had already established himself as a leading portraitist who was attracting a large following among theatrical performers of the Third Republic (1870–1940). He was commissioned to complete several canvases of Sarah Bernhardt, an actress with whom he became very close, and he established ties with other actors and celebrities who attended the salon gatherings of Edmund Adam in Paris. It was here that the painter socialized with politicians (including Léon Gambetta), authors, and other artists, becoming a member of the social elite of the era.

Bastien-Lepage's portraits document how he mingled with this select group. His friendship with Bernhardt led to the exhibition of a painting of her at the 1879 Paris Salon. Other portrayals of stage performers include one of the English actor Henry Irving (National Portrait Gallery, London) and another of the Catalan dancer Rosita Mauri (Musée Jules Chéret, Nice). Writers of the era recalled evenings spent dining with Bastien-Lepage, Marie Samary, and her sister Jeanne—both of whom were deeply involved with the Comédie-Française, along with the Coquelin brothers (see cat. no. 2). A colleague of the art critic Albert Wolff, Bastien-Lepage was not only warmly written about by the critic in his newspaper reviews, he also completed a small portrait of Wolff seated in his study (cat. no. 4). With these portraits, Bastien-Lepage moved away from the dour peasant scenes of displaced vagabonds, wood gatherers, and street peddlers that he often exhibited at the public Salons, focusing instead on a more glamorous facet of contemporary life.

Bastien-Lepage shared Edgar Degas's (1834–1917) sense of engagement with his sitters. In the *Portrait of Madame Samary*, the painter shows the actress as if she is about to speak. The tilt of Marie's head and her upward glance toward the viewer suggest a momentary candor that is similar to some of the best effects found in Impressionist portraits of the era. The sitter's placement within an intimate setting is in keeping with Bastien-Lepage's desire to document where his models lived and moved. His treatment of the figure, along with the spontaneity of his paint application, demonstrates that the Naturalist aesthetic he advocated in his Salon paintings was also applicable to portrait compositions. This modern approach broke away from the rigid conventional attitudes toward portraiture. —*GPW*

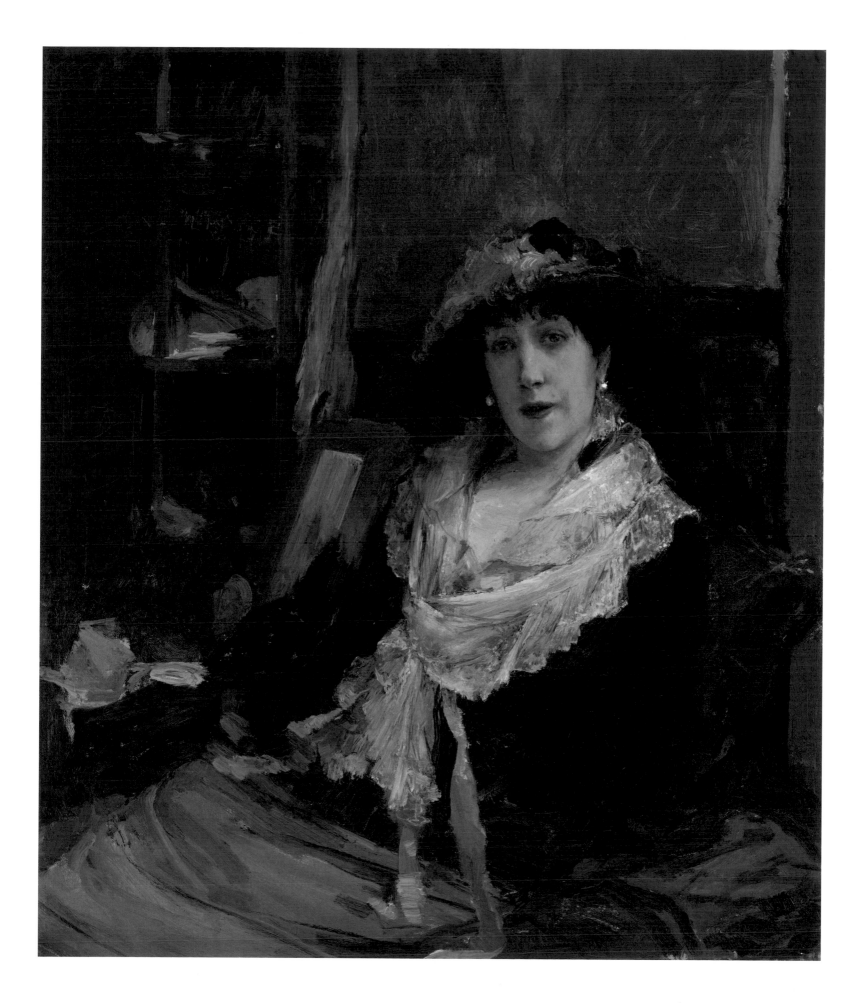

Jules Bastien-Lepage, 1848–1884
Portrait of Albert Wolff
oil on panel
12.56 x 10.63 inches (31.90 x 27 cm)
The Cleveland Museum of Art
Bequest of Muriel S. Butkin
2010.22

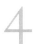

Provenance
Sotheby's, London, *European Painting*, May 9, 1979, cat. no. 327; Mr. and Mrs. Noah L. Butkin; bequest of Muriel S. Butkin to the Cleveland Museum of Art, 2010.

Exhibitions
Paris Salon, 1881, cat. no. 98.

Exposition des oeuvres de Jules Bastien-Lepage, March–April 1885, École Nationale Supérieure des Beaux-Arts, Paris, cat. no. 135.

Selected Bibliography
Rewald, John. *The History of Impressionism.* New York: The Museum of Modern Art, 1961, p. 397 (illus. but not discussed).

A productive art critic who wrote for the influential newspaper *Le Figaro,* Albert Wolff was much read, much feared, and little liked, especially by those whose artwork reflected the most progressive avant-garde tendencies of the era. He was a staunch opponent of Impressionism, and his sharp tongue and acid writings could make or ruin reputations overnight. Commenting on the Impressionist show of 1876, held at the prestigious Galerie Durand-Ruel, Wolff stated in *Le Figaro*:

> After the Opera fire, here is a new disaster overwhelming the district. At Durand-Ruel's there has just opened an exhibition of so-called painting.... [A] group of unfortunate creatures stricken with the mania of ambition have met there to exhibit their works.... Those self-styled artists give themselves the title of non-compromisers, impressionists; they take up canvas, paint, and brush, throw on a few tones haphazardly and sign the whole thing... it is a frightening spectacle of human vanity gone astray to the point of madness.[1]

Certain members of the radical group, including Édouard Manet's brother Eugène, had to be restrained from provoking Wolff to a duel because of his offensive statements.[2]

This is not to say that Albert Wolff was opposed to all aspects of modern painting. He fancied himself a connoisseur of art, collecting drawings, paintings, prints, and sculptures, which he kept in his private study—as visualized by Bastien-Lepage in his small painting of the critic. Wolff's taste was similar to that advocated by the Coquelin brothers (see cat. no. 2), who appreciated the more modern painters within the academic establishment, such as P. A. J. Dagnan-Bouveret and Emile Friant. He was an eager supporter of artists who painted and drew within the academic tradition while also depicting modern themes. Bastien-Lepage was among those whose work Wolff praised in his newspaper reviews, which championed the paintings the artist exhibited at the annual Salons in Paris.

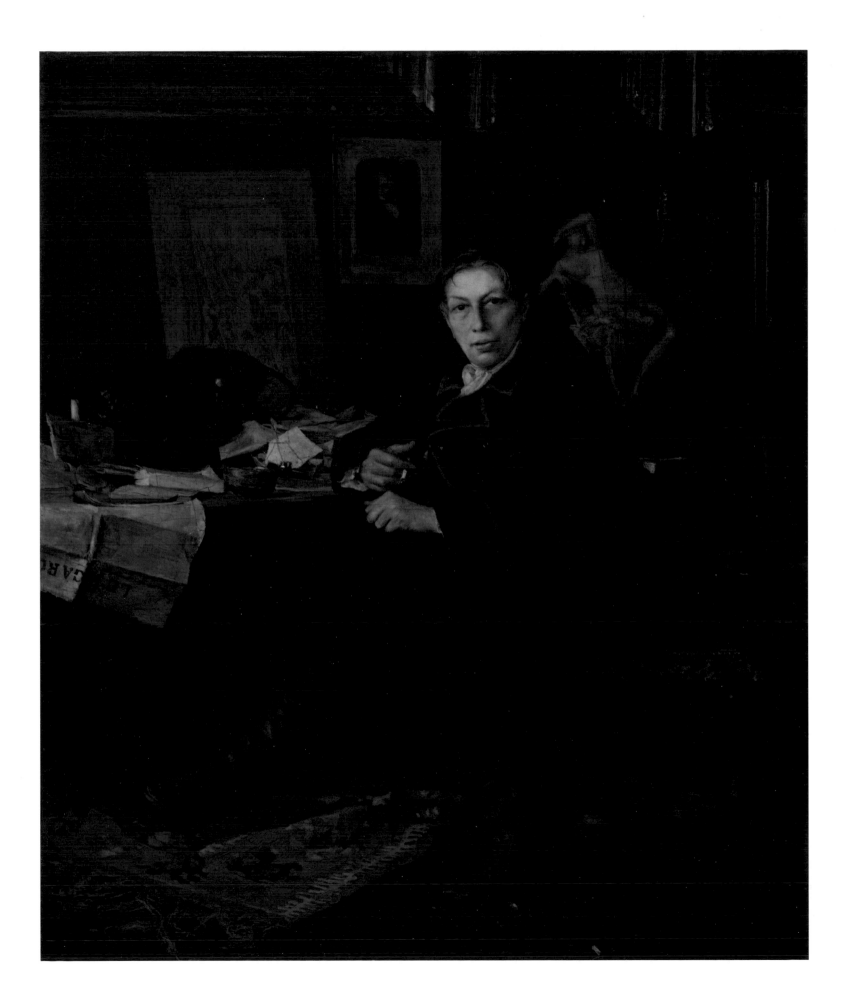

Wolff saw Bastien-Lepage as an able continuator of the traditions of Jean-François Millet (1814–1875) and Gustave Courbet (1819–1877), especially in his sincere renditions of peasants from the Meuse region of France. Wolff did much to place Bastien-Lepage directly in the forefront of the Naturalist movement, which advocated concern and sympathy for the struggles of the rural worker. He helped to publicize the painter's work widely, eventually allowing him to be seen, after his early death in 1884, as the primary progenitor of a large-scale international Naturalist movement that spread to painters in several European countries.[3]

A year after Bastien-Lepage's death, Albert Wolff penned, in the pages of *Le Figaro*, one of his most moving essays on the work of this young artist, whom he deeply admired. "The modern school of naturalism has not seen a representative as complete as he was; he was a master of science and his sincerity was tested before nature."[4] Continuing his review, Wolff commented that Bastien-Lepage was a great portraitist whose creativity pushed him to depict his sitters with such compelling immediacy that the viewer was continually attracted "to the surprising truth of his faces."[5] Nowhere are these qualities better revealed than in Bastien-Lepage's portrait of Albert Wolff himself.

When the Wolff portrait was exhibited at the 1881 Paris Salon, it did not go unnoticed. One critic, writing for the English periodical *The Academy*, noted, "The figure of M. Wolff himself is studied, as M. Lepage studies every human type which really interests him. We are made conscious of the little bit of pose, of the slight pretence [*sic*] of the dress—the red leather high boots, brown coat, and full blue trousers—through which is suggested a something of deformity in the proportions of the body, to which the immense length of the jaw and the depression of the head respond."[6] These perceptive comments capture how Bastien-Lepage portrayed his sitters truthfully, without idealizing them

in any way. The reviewer continued by remarking that although "we are conscious of these things, we are above all impressed by the lightning vivacity of the self-assurance which animates their piercing look. It is, perhaps, not quite a kindly rendering of M. Albert Wolff and his peculiarities.... But it may rank as one of [Bastien-Lepage's] best portraits of men."[7]

With this small, intimate portrait, Bastien-Lepage reexamined the tradition of miniature painting begun by earlier Netherlandish masters and continued by French painters such as Ernest Meissonier (1815–1891), creating a work that is highly suggestive of Netherlandish hidden symbolism and meticulous realism. By showing Wolff in his working room, amid his possessions and the artwork he collected, he documented that the much-reviled critic was a man of erudition and taste—a man whose personal inclinations were often based on the traditions of the past, rather than leading him toward sponsorship of modern, radical innovation. —*GPW*

1 Albert Wolff, exhibition review in *Le Figaro*, April 3, 1876, as quoted in John Rewald, *The History of Impressionism* (New York: The Museum of Modern Art, 1961), 368–69.

2 Ibid., 370.

3 For further aspects of this phenomenon, see Gabriel P. Weisberg, *Illusions of Reality: Naturalist Painting, Photography, Theatre and Cinema, 1875–1918* (Brussels: Mercatorfonds, 2010).

4 Albert Wolff, "Bastien-Lepage," *Le Figaro*, March 17, 1885.

5 Ibid.

6 E. F. S. Pattison, "The Salon of 1881," *The Academy* 19, no. 473 (May 28, 1881): 399.

7 Ibid.

Émile Bernard, 1868–1941

Street Scene: Two Women Seated Selling Bread, ca. 1895
black ink and wash on brown wove paper
10.38 x 13 inches (26.40 x 33 cm)
Signed lower left in black ink: *Emile Bernard*
Snite Museum of Art
Gift of Mr. and Mrs. Noah L. Butkin
2009.045.012

5

Provenance

Shepherd Gallery, New York; Mr. and Mrs.
Noah L. Butkin, 1978; placed on loan with
the Snite Museum of Art, University of Notre
Dame, 1979; converted to a gift of the estate of
Muriel Butkin, 2009.

In 1884, Émile Bernard enrolled in the Paris atelier of Fernand Cormon (cat. nos. 24–26), where he became a close colleague of Louis Anquetin (1861–1932) and Henri de Toulouse-Lautrec (1864–1901). Bernard's commitment to experimentation and his engagement with Impressionism and Pointillism—a painting technique then practiced by Georges Seurat (1859–1891)—led to disagreements with Cormon; he was expelled from the studio in 1886. In 1887, working closely with Anquetin, Bernard developed a style known as Cloisonnism. Inspired by Japanese decorative enamel works in which each section is separated by metallic "cloisons," they created flat, decorative paintings that used black borders around each form.

In 1888, Bernard was in Pont-Aven, Brittany, with Paul Gauguin (1848–1903), working in the Cloisonnist manner. Together, they built on this decorative approach to prepare the foundation for Symbolist painting. At the Exposition Universelle in Paris in 1889, Bernard exhibited Cloisonnist paintings inspired by the countryside in Brittany, reinforcing his ties with Gauguin. He used primitive forms in his compositions, especially those drawn from artworks of the past, translating them into the highly personal, naïve style that characterized his paintings and prints at the end of the 1880s and beyond.

During the 1890s, Bernard spent ten years in Cairo, Egypt, where he produced a series of street scenes involving bread sellers. In these drawings—often executed with color washes, as in this example—Bernard developed a rather weighted approach to his figures, who appear rooted to the earth. The scenes provide one example of an artist responding to the exotic culture and milieu of "the Orient."[1] —*GPW*

1 The author is indebted to Fred Leeman for assistance in cataloguing this drawing, which will be included in Leeman's catalogue raisonné on Bernard (in process). For further insight into this series of drawings, see *Aquarelles Orientales d'Émile Bernard, 1893–1904* (Saint-Germain-en-Laye: Musée Départemental du Prieuré, 1983), cat. nos. 48–53.

Étienne-Prosper Berne-Bellecour, 1838–1910

Japonaise, ca. 1878
watercolor on card
14.50 x 10.25 inches (36.80 x 26 cm)
Signed lower left: *E Berne-Bellecour*
Snite Museum of Art
Gift of Mr. and Mrs. Noah L. Butkin
2009.045.014

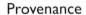

6

Provenance

The Norton Galleries; Sotheby Parke-Bernet
sale no. 3788, October 3, 1975, cat. no. 214;
Mr. and Mrs. Noah L. Butkin, 1975; placed on
loan with the Snite Museum of Art, University
of Notre Dame, 1979; converted to a gift of the
estate of Muriel Butkin, 2009.

Recognized as one of the premier battle-scene painters following the Franco-Prussian War of 1870–71, Étienne-Prosper Berne-Bellecour maintained an active agenda producing military paintings, until his death in 1910. His importance rested on the numerous awards he received at the Paris Salon exhibitions: a medal in 1869, first-class medals in 1870 and 1872, and a third-class medal in 1878. His paintings were applauded, and he received the Légion d'honneur for his work. But there was another dimension to his creativity.

Although his brother-in-law Jehan-Georges Vibert (see cat. nos. 75–76) had urged him to give up anecdotal genre painting and take up military imagery, Berne-Bellecour did not surrender this tendency easily. At the 1878 Exposition Universelle in Paris, he exhibited four watercolors that reiterated his commitment to other themes. Among these works was a watercolor titled *Japonaise*, most likely the Snite Museum piece, which was shown alongside *Cocher russe, Le bouquet, and Un amoureux*.[1] This watercolor reflects one of the ways that artists of the era were reacting to the taste for all things Japanese, by producing representations of Western women wearing Japanese kimonos and posing either inside a room or in nature. Paintings and drawings in this manner were extremely popular; they proliferated throughout the Third Republic, contributing to what has been called Japanomania.[2]

When *Japonaise* was shown publicly in 1878, it was already in a private collection; a certain M. Allain was listed as the proprietor in the official catalogue. The image gives rise to the suggestion that Berne-Bellecour may have produced other Japanese-inspired watercolors, as well as paintings with Orientalist themes such as *An Arab Smoking*, a watercolor sold at Sotheby's in 1972. How many works in this vein he completed is unknown, but clearly he cannot be viewed simply as a painter of military scenes. —*GPW*

1 See *Catalogue officiel: Exposition universelle de 1878 à Paris*, vol. 1, *Groupe 1: Oeuvres d'art, classes 1 à 5* (Paris: Imprimerie nationale, 1878), 69, cat. nos. 883–86.

2 Gabriel P. Weisberg, et al., *The Orient Expressed: Japan's Influence on Western Art, 1854–1918* (Jackson, MS: The Mississippi Museum of Art and The University of Washington Press, 2011).

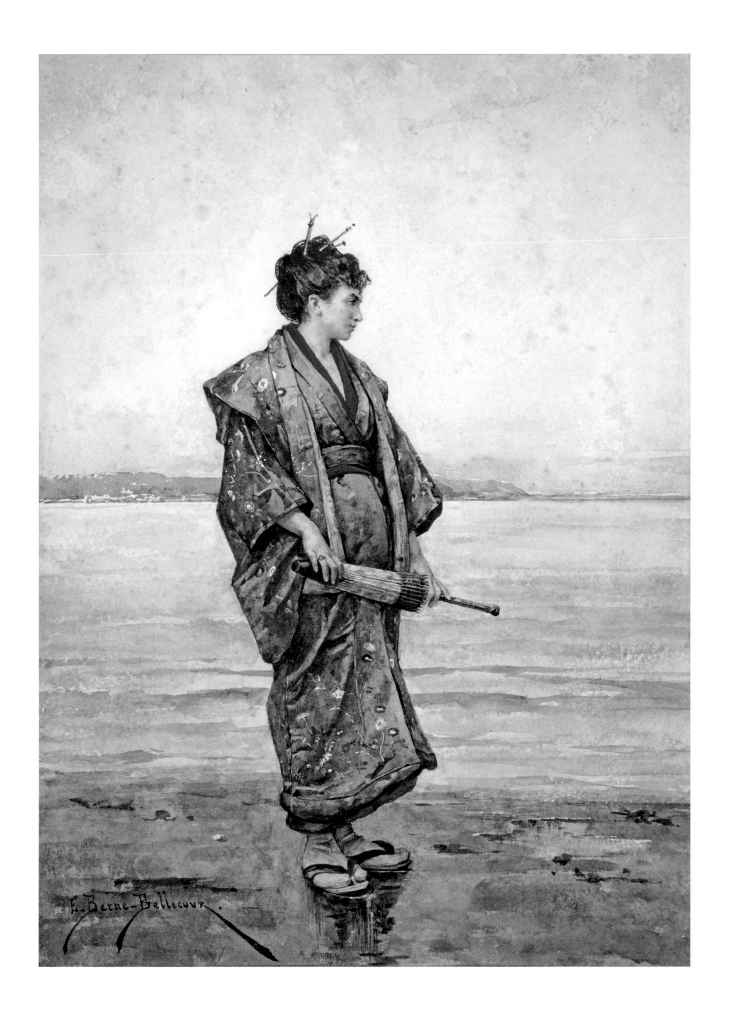

Albert Besnard, 1849–1934
The Hunters
black ink and wash on cream card
13.88 x 9.88 inches (35.20 x 25.10 cm)
Signed lower right in ink: *ABesnard*
Inscribed on verso: *0.23* (in ink), *189* (in graphite), *3[?]41* (in ink)
Snite Museum of Art
Gift of Mr. and Mrs. Noah L. Butkin
2009.045.008

7

Provenance

Sotheby Parke-Bernet, *European Drawing and Watercolors*, April 20, 1978, cat. no. 402; Shepherd Gallery, New York, 1978; Mr. and Mrs. Noah L. Butkin, 1978; placed on loan with the Snite Museum of Art, University of Notre Dame, 1978; converted to a gift of the estate of Muriel Butkin, 2009.

As one of the most prolific and honored painters of the Third Republic, Albert Besnard received numerous commissions for murals in Paris (for example, at the École de Pharmacie) and in regional churches, such as the one at Berck-sur-Mer.[1] He gained a wide following that led to requests for portraits for some of the most influential families in France, including *Madame Henry Lerolle and Her Daughter Yvonne* (1880, The Cleveland Museum of Art) and *Madame Roger Jourdain* (1886, Musée d'Orsay, Paris).[2] Besnard was elected to the Institut de France in 1913, and succeeded Carolus-Duran as the director of the French Academy in Rome. By 1922, he was director of the École des Beaux-Arts in Paris; in 1924, he became a member of the Académie Française.

Besnard was often asked to illustrate the most cherished novels and stories of the era. These three figures and a dog in a boat seem to be involved in a hunt, although the specifics of when and where it is taking place remain unidentified.[3] —*GPW*

1 See Gabriel P. Weisberg, "Albert Besnard at Berck-sur-Mer: Decorative Art Nouveau Painting in Public Buildings," *Apollo* 151, no. 459 (May 2000): 52–58.

2 Gabriel P. Weisberg, "Madame Henry Lerolle and Daughter Yvonne," *The Bulletin of the Cleveland Museum of Art* 64, no. 10 (December 1977): 326–43.

3 Discussions with Mme. Chantal Beauvalot, who is completing the catalogue raisonné on Besnard, yielded no specific information on this work.

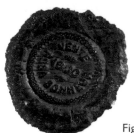

Rosa Bonheur, 1822–1899

The Mud Hole
oil on canvas
10.88 x 16.88 inches (27.60 x 42.90 cm)
Signed lower right: *Rosa Bonheur*
Inscribed on verso in wax stamp: *Rosa Bonheur vente 1900* (fig. 1)
Snite Museum of Art
Gift of Mr. and Mrs. Noah L. Butkin
2009.045.053

8

Provenance
Sotheby's, London, sale 2921, October 18, 1978, cat. no. 334; Shepherd Gallery, New York, 1978; Mr. and Mrs. Noah L. Butkin, 1978; placed on loan with the Snite Museum of Art, University of Notre Dame, 1979; converted to a gift of the estate of Muriel Butkin, 2009.

Exhibitions
Millet and His Barbizon Contemporaries, 1985, Keio Department Store Gallery, Tokyo, and other locations in Japan, cat. no. 35.

Illuminations: Images of Landscape in France, 1855–1885, March 1–April 29, 1989, The Heckscher Museum of Art, Huntington, New York; May 13–July 29, 1990, The Walters Art Museum, Baltimore, Maryland; September 9–November 4, 1990, The Dixon Gallery and Gardens, Memphis, Tennessee, cat. no. 6.

Rosa Bonheur's artistic inclinations were nurtured from an early age by her parents: Raymond Bonheur, a drawing instructor and little-known painter, and Sophie Bonheur née Marquis, a music teacher.[1] When her family migrated to Paris in 1829, Rosa was unable to attend the École des Beaux-Arts, as the school did not begin admitting female pupils until 1897.[2] Instead, she pursued her passion for painting in the galleries of the Louvre, where she copied from the masters and educated herself in the tradition of European *animaliers*. At the age of nineteen, Bonheur began to exhibit paintings at the annual Parisian salons, but it was not until her late twenties that her work received wide acclaim. Her reputation was solidified with the exhibition of the monumental canvas *The Horse Fair* (The Metropolitan Museum of Art, New York) at the Salon of 1853. Highly praised in France, this painting brought Bonheur to international attention following its tour to America, England, and Belgium.

While Bonheur is best known as an *animalier*, the art historian François Crastre, one of her earliest biographers, reports that she approached landscapes with the same ardor and sensitivity that she expressed for the animal kingdom.[3] The small-scale canvas *The Mud Hole* demonstrates an all-consuming examination of rural terrain. It was likely drawn from the environs of her home, the Château de By, located near Barbizon—known for its famous school of landscape painters. With just a sliver of sky showing at the top of the composition, the view of barren, unworked earth is seen from a bird's-eye perspective. The only signs of life appear in the sparse clumps of grass in the foreground and the few trees that dot the horizon line. While the viewer's focus is drawn overwhelmingly downward to the muddy earth, the water at the center of the composition reflects the overcast blue sky, mirroring the celestial in this small terrestrial body. The French critic Theodore Bentzon (the pen name of Marie-Thérèse Blanc) commented specifically on the enigmatic power of such small studies, remarking: "Notwithstanding the beauty of [Bonheur's] finished paintings, what we should most covet in her very complete work would, perhaps, be her original sketches. She has never consented to give up a single one of these, in spite of the most tempting offers, keeping them as material for further work."[4]

The damp, desolate landscape of *The Mud Hole* is redolent of the conditions that had driven Bonheur and her long-term partner, the artist Nathalie Micas (1824–1889), to seek respite in the warmer climate of Nice to treat the failing health to which Micas finally succumbed in the summer of 1889. Since this undated composition—absent animal life and nearly devoid of vegetal life—is not known to correspond to any larger, finished painting,

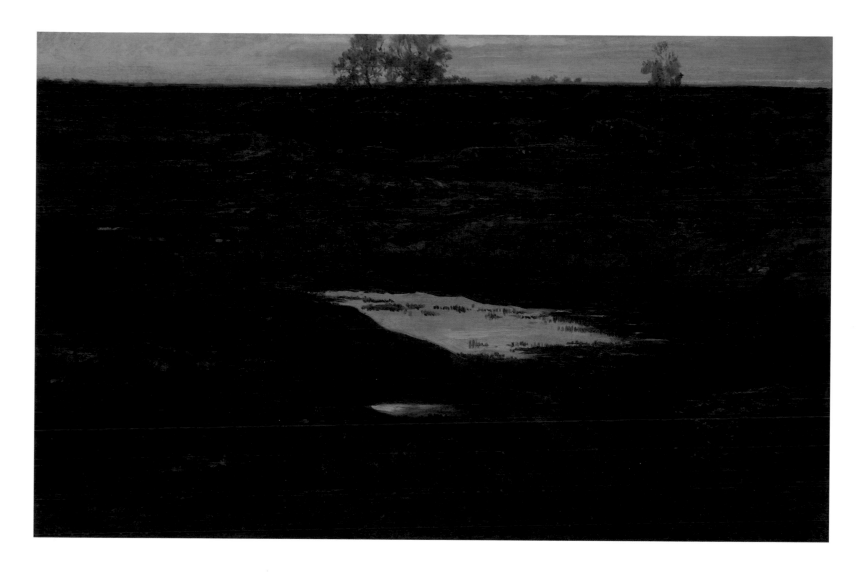

it is tempting to see in Bonheur's sketch a deep melancholy, perhaps related to her companion's passing. She had known Micas since the age of eight and wrote of her death, "This loss broke my heart. It was a long time before I could find in my work any relief from my bitter pain."[5]

In the fall of 1898, Bonheur met the American painter Anna Klumpke (1856–1942), with whom she would live for the remainder of her life. As Bonheur's heir, Klumpke retained access to the artists' records, which in 1908 she combined with her own recollections to publish the pseudo-autobiographical account *Rosa Bonheur: Sa vie, son oeuvre*. Klumpke was sensitive to the hardships posed to the artist by the overcast weather and damp conditions recorded in *The Mud Hole*, remarking, "Even with electricity, the short, sunless days of winter make it difficult to paint. One can't go out into the fields and forest because of the rain, mud, and fog. In these cold weeks of winter, so hard on old people, one gladly dreams about lands where the sun is less greedy with its rays."[6] —SJS

1 Theodore Stanton, ed., *Reminiscences of Rosa Bonheur* (New York: D. Appleton, 1910), 2–3. For the most current scholarship on Rosa Bonheur, see Francis Ribemont, *Rosa Bonheur: 1822–1899* (Bordeaux: Musée des Beaux-Arts de Bordeaux, 1997) and Gabriel P. Weisberg, *Rosa Bonheur. All Nature's Children* (New York: Dahesh Museum, 1998).

2 Tamar Garb, *Sisters of the Brush: Women's Artistic Culture in Late Nineteenth-Century Paris* (New Haven, CT: Yale University Press), 102–3.

3 François Crastre, *Rosa Bonheur*, trans. Frederic Taber Cooper (New York: Frederick A. Stokes, 1913), 63.

4 Theodore Bentzon, "Rosa Bonheur," trans. Bellina Phillips, *The Outlook* 62, no. 1 (May 6, 1899): 45.

5 Crastre, *Rosa Bonheur*, 73. For the circumstances of Bonheur and Micas's introduction as children, see p. 18.

6 Anna Klumpke, *Rosa Bonheur: The Artist's [Auto]biography*, trans. Gretchen van Slyke (Ann Arbor: University of Michigan Press, 2001), 227.

Rosa Bonheur, 1822–1899

Studies of a Fawn
oil on paper, mounted on canvas
14.25 x 19.13 inches (36.20 x 48.60 cm)
Signed lower right: *Rosa Bonheur*
Inscribed on verso stretcher: wax stamp (fig. 1)
Snite Museum of Art
Gift of Mr. and Mrs. Noah L. Butkin
2009.045.075

9

Provenance
Galerie Georges Petit, Paris, May 30–June 20,
1900, cat. no. 376; Shepherd Gallery, New
York, 1977; Mr. and Mrs. Noah L. Butkin,
1977; placed on loan with the Snite Museum
of Art, University of Notre Dame, 1980;
converted to a gift of the estate of Muriel
Butkin, 2009.

Fig. 1. Wax stamp on verso of canvas.

In 1860, at the age of thirty-eight, Bonheur retired to the
outskirts of Paris and settled with her companion and collaborator
Nathalie Micas at the Château de By, where she resided and
painted for the remainder of her life. While a working artist
in Paris, Bonheur had supplemented her academic knowledge
of the history of animal painting with frequent visits to farms,
urban slaughterhouses, and livestock markets, and she had kept
an impressive menagerie at her Parisian studio. Situated on the
edge of the Fontainebleau Forest, however, the Château de By was
ideally located for Bonheur to spend many hours observing the
appearance and behavior of animals in the wild. It also allowed
her to expand her fold of pet animals, which included mustangs
from America, ponies from Iceland, monkeys, gazelles, parakeets,
and a yak, in addition to more common barnyard and forest
animals such as sheep, cows, horses, and deer.[1]

Bonheur's many paintings of deer began to appear shortly after
her move to the château, most notably with the exhibition of *A
Family of Deer Crossing the Summit of the Long Rocks in the Forest
of Fontainebleau* (John and Mable Ringling Museum of Art,
Sarasota, Florida) and *Deer in Repose* (Detroit Art Institute) at
the Exposition Universelle of 1867. *Studies of a Fawn*, executed
in oil paints on paper, likely dates from this latter period of
Bonheur's career. It comprises five sketches of a fawn's head
and two posterior studies of a fawn at rest—varying angles that
suggest experimentation with the placement of figures for a larger
composition. The only full-length study incorporates a long-cast
shadow signifying high noon, as the animal reclines during the
heat of a summer day. Several of the sketches are set against a
nondescript green background to simulate the play of the deer's
coloring with the greenery of a forest. However, Bonheur's
careful observation of the angle of the fawn's head, the subtle turn
of its ears, and the play of its eyes indicate that she was primarily
concerned with capturing differing psychological states, ranging
from quiet repose to alert awareness of the artist's presence.
The contemporary art critic Léon Roger-Milès commented
specifically on the attention Bonheur paid to the interior qualities
of animal life, writing, "Through the infinite study that she

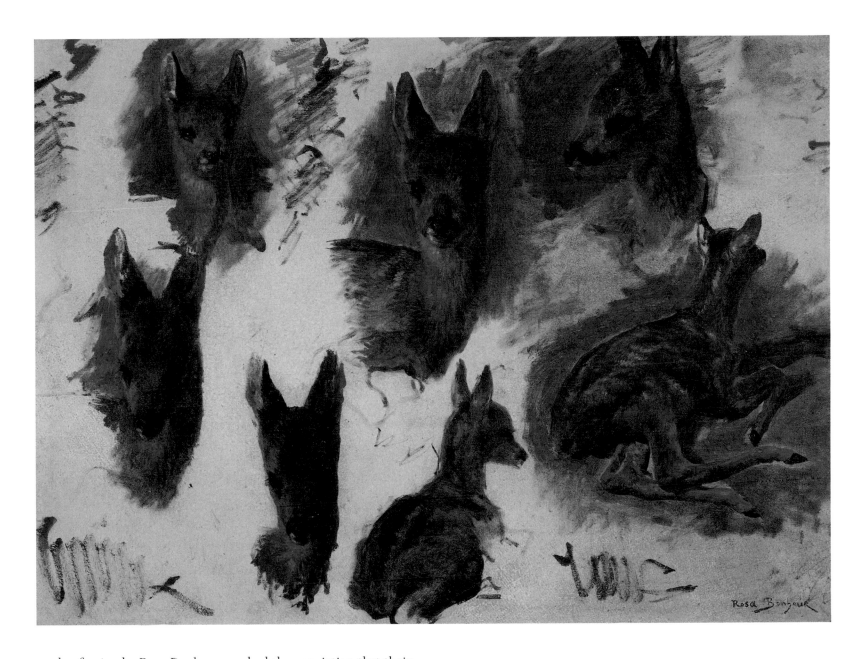

made of animals, Rosa Bonheur reached the conviction that their
expression must be the interpretation of a soul, and since she
understood the types and the species that her brush reproduced,
she was able, through an instinct of extraordinary precision,
to endow them, one and all, with precisely the glance and the
psychic intensity that belongs to them."[2] —*SJS*

1 For a more complete inventory, see François Crastre, *Rosa Bonheur*, trans. Frederic
 Taber Cooper (New York: Frederick A. Stokes, 1913), 54.

2 Cited in ibid., 72. For an extended discussion of Bonheur's attitude toward the
 spiritual and psychological aspects of animals, see Léon Roger-Milès, *Rosa Bonheur:
 Sa vie—son oeuvre* (Paris: Société d'édition artistique, 1900), 79–109.

François Bonvin, 1817–1887
Attributes of Music, 1863
oil on canvas
24.63 x 45.69 inches (62.56 x 116.05 cm)
Signed and dated upper right: *F Bonvin, 1863*
Cleveland Museum of Art
Bequest of Noah L. Butkin
1980.233

10

Provenance

Hôtel Drouot, Paris, sale March 19, 1976, cat. no. 42; Brame et Lorenceau, Paris; Mrs. Walter Feilchenfeldt, Zurich; Noah L. Butkin; bequest of Noah L. Butkin to the Cleveland Museum of Art, 1980.

Exhibitions

Chardin and the Still-Life Tradition in France, 1979, The Cleveland Museum of Art, cat. no. 10.

Selected Bibliography

Weisberg, Gabriel P. *Bonvin*. Paris: Geoffroy-Dechaume, 1979, pp. 73–74, 76 (illus.).

———. "Charles Jacque and Rustic Life." *Arts Magazine* 56, no. 4 (December 1981): 93, fig. 9.

———. "The Traditional Realism of François Bonvin." *The Bulletin of the Cleveland Museum of Art* 65, no. 9 (November 1978): 280–98.

Weisberg, Gabriel P., with William S. Talbot. *Chardin and the Still-Life Tradition in France.* Cleveland: The Cleveland Museum of Art, 1979, pp. 66–67, 89, cat. no. 10.

No subject interested the Realist painter François Bonvin more than still lifes. Associated with a number of collectors who were interested in restoring appreciation for earlier still-life painters, Bonvin reworked many of the themes of Jean-Siméon Chardin (1699–1779), including kitchen scenes. He consequently became one of the pioneering figures in the Chardin revival, bringing the still-life genre back to a position of genuine importance, beginning in the 1850s.[1] As Bonvin's career evolved, and as his opportunities to study Chardin paintings in private collections increased, his own works were greeted with considerable support. Critics saw in him a reincarnation of the eighteenth-century master, most notably in the way he studied simple objects and infused his paintings with light and atmosphere. Equally important was Bonvin's ability to reimagine Chardin's arrangements of objects for a totally new audience.

As early as 1855, Bonvin became less interested in painting items associated with the preparation of food and began to work with objects that had deeper associations. In *Still Life with Musical Instruments* (1855, Musée du Vieux Château, Montluçon), he focused on a longstanding visual tradition. Chardin and many others had made symbolic paintings depicting attributes of the arts and music; these often functioned as large-scale room decorations, and included a diverse selection of instruments and related objects of the artist's choosing. Sometimes, as is the case in Bonvin's *Attributes of Music*, music books or sheet music were incorporated, generally positioned at eye level on a shallow ledge or tabletop, so that the viewer could engage with them.

In 1863, Bonvin created three paintings involving allegories of the arts: *Attributes of Music*, *Attributes of Sculpture*, and *Attributes of Painting*. The latter two works are now housed in the Musée du Louvre, but the three pieces might originally have been part of a single room interior.[2] The stately organization of forms in *Attributes of Music* is different from the way Bonvin positioned simpler objects in many of his other still-life compositions, perhaps because this painting was created for an entirely different

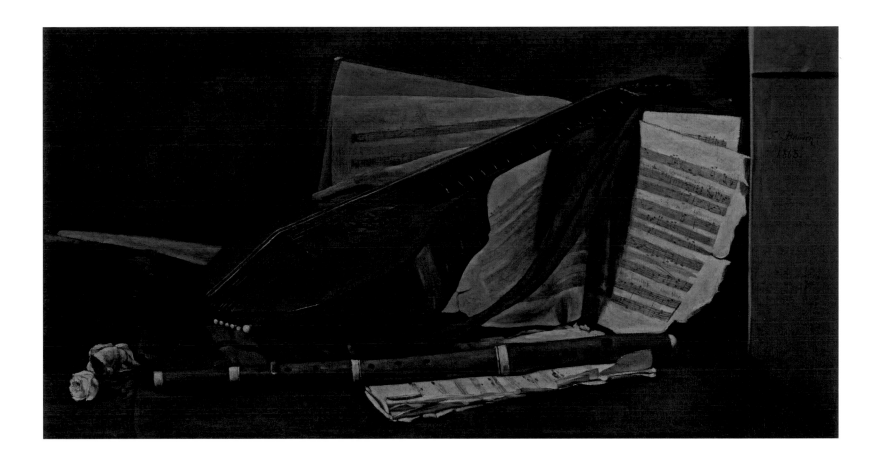

purpose. The artist selected just two instruments: a cittern and a flute. These help to frame the musical page that is open to the viewer. The musical notation suggests a keyboard accompaniment with an Italian text, perhaps for a solo voice rather than for the instruments depicted. The word *amor* appears in the text and a rose lies on the table, suggesting that this painting is also an allegory of love: both love of music and love of Bonvin's young second wife, Céline Prunaire, herself a musician.

Although Bonvin continued to paint much smaller versions of *Attributes of Music* into the 1880s, his involvement with the theme was most successful in the Cleveland Museum's composition. Here, the Realist painter demonstrated that with the careful placement of forms, he could recall and validate the paintings of Chardin, claiming his rightful place as the "new Chardin." Additionally, the selection of objects and their integration in the painting reveal a personal meaning that would have been recognizable to collectors at the time. —*GPW*

1 Gabriel P. Weisberg, "Themes of Nineteenth Century Still Life," in *Chardin and the Still-Life Tradition in France* (Cleveland: The Cleveland Museum of Art, 1979), 48–80.

2 Gabriel P. Weisberg, "The Traditional Realism of François Bonvin," *The Bulletin of the Cleveland Museum of Art* 65, no. 9 (November 1978): 282, 293–94, and fig. 2. While art historian Louise d'Argencourt partially accepts the hypothesis of the three paintings being part of a commission, she notes that no documentation exists to support it.

François Bonvin, 1817–1887
Nude Figure (Male Académie), 1858
pen and ink and gray wash
10 x 5.88 inches (25.40 x 14.90 cm)
Signed and dated lower right: *f. Bonvin, 1858*
Inscribed on mat: *A mon cher et bon ami E. Bocourt f. Bonvin 1864*
Snite Museum of Art
Gift of Mr. and Mrs. Noah L. Butkin
2009.045.024

11

Provenance
Shepherd Gallery, New York; Mr. and Mrs. Noah L. Butkin; placed on loan with the Snite Museum of Art, University of Notre Dame, 1982; converted to a gift of the estate of Muriel Butkin, 2009.

Selected Bibliography
Weisberg, Gabriel P. *Bonvin.* Paris: Geoffroy-Dechaume, 1979, p. 269, cat. no. 260.

Academies, or anatomical drawings of nude models, are exceptionally rare in Bonvin's work. He was more interested in using working-class models from the streets of Paris, whom he posed in his studio in their commonplace garments. This study of a nude male figure standing in a dimly lit interior space reveals the Realist artist's penchant for direct analysis. He carefully renders the model's anatomy without any attempt to follow a classical canon of proportions or to hide the male genitals. In this, Bonvin is following the direction established by his friend Gustave Courbet, who in his paintings of nude women was not afraid to emphasize a model's fleshiness, bulky weight, and female attributes. Bonvin's study also conveys a sense of pensiveness; the figure's downturned head implies that he is preoccupied with his inner thoughts, even while he poses for the artist.

During the late 1850s, when this piece was drawn, Bonvin's importance as a member of the Realist tradition was exceptionally well established. Collectors appreciated both his still-life compositions and his innumerable charcoal and chalk drawings of the working class.[1] And in 1859, just one year after the completion of this academy, Bonvin held an exhibition in his Paris studio of art by young painters whose work had not fared well with the traditional Salon jury.[2] Among the artists featured were Théodule Ribot (cat. nos. 63–67), Antoine Vollon (cat. nos. 77–80), James McNeill Whistler (1834–1903), and Henri Fantin-Latour (1836–1904), painters who were then working in a manner similar to Bonvin's and who helped establish Realism as the modern artistic movement in vogue. Bonvin's academy—which reflects the tradition of training from the nude model practiced at the École des Beaux-Arts and at private ateliers, yet in a starker, less stylized manner—was most likely seen and studied by other Realist artists, contributing to their direct manner of recording and visualizing the human figure. His commitment to younger artists of the era reveals that Bonvin relished the opportunity to engage with friends and colleagues and to see that their works, along with his own, were increasingly recognized by a larger public. —*GPW*

1 A number of these drawings are reproduced in Gabriel P. Weisberg, *Bonvin* (Paris: Geoffroy-Dechaume, 1979), cat. nos. 259, 261, 262, 263.

2 For a discussion of this exhibition, see Colleen Denney, "Exhibitions in Artists' Studios: François Bonvin's 1859 Salon des Refusés," *Gazette des Beaux-arts* 122, no. 1496 (September 1993): 97–108.

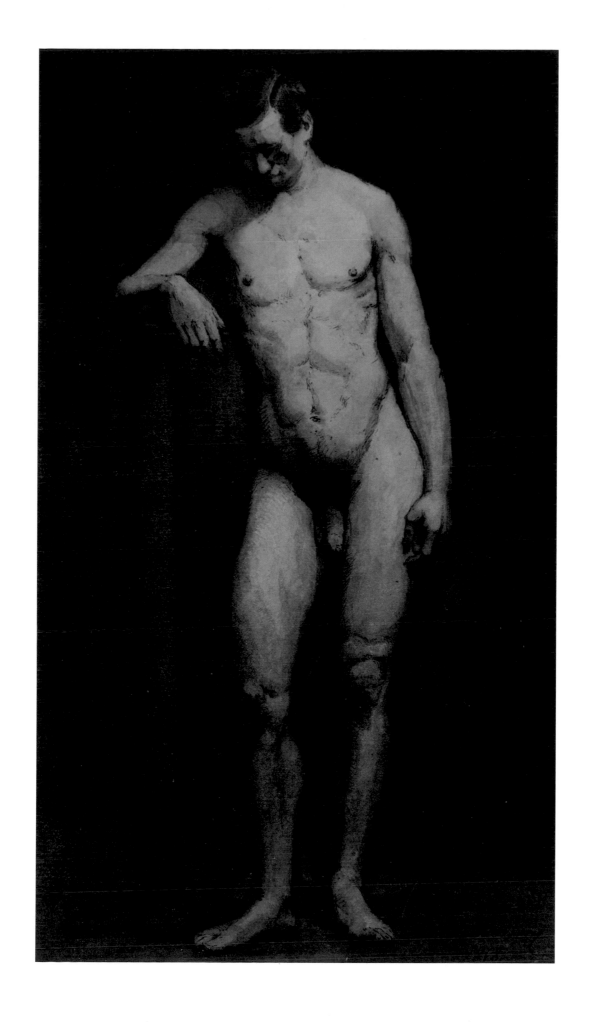

François Bonvin, 1817–1887

Portrait of Louison Köhler (Young Woman with a Mandolin),
before 1874
oil on canvas
21.63 x 18.13 inches (54.94 x 46.10 cm)
Signed lower left: *F. Bonvin*
The Cleveland Museum of Art
Gift of Mr. and Mrs. Noah L. Butkin
1977.124

12

Provenance

Paris sale, Hôtel Drouot, December 19, 1973,
cat. no. 213, *La musicienne*, signed lower left;
Vachet Collection, Paris; Robert Caby, Paris;
Mr. and Mrs. Noah L. Butkin; gift of Mr. and
Mrs. Noah L. Butkin to the Cleveland Museum
of Art, 1977.

Exhibitions

Paris Salon, 1874, cat. no. 218, *Portrait of Mlle.
L. De K.*

*The Realist Tradition: French Painting and
Drawing, 1830–1900*, 1980–81, The Cleveland
Museum of Art, cat. no. 217.

Selected Bibliography

Weisberg, Gabriel P. *Bonvin*. Paris: Geoffroy-
Dechaume, 1979, pp. 110 (illus. in color), 127.

———. *The Realist Tradition: French
Painting and Drawing, 1830–1900*. Cleveland:
The Cleveland Museum of Art and Indiana
University Press, 1980, pp. 246–47, cat. no.
217.

———. "The Traditional Realism of François
Bonvin." *The Bulletin of the Cleveland Museum
of Art* 65, no. 9 (November 1978): 280–98.

This portrait of Bonvin's companion Louison Köhler reveals his dedication to the masters of previous generations, especially seventeenth-century Dutch painters, as well as his adoption of the Realist tradition's straightforward, candid style. Exhibited at the Paris Salon of 1874, without identifying the sitter, the painting utilizes the same format that Bonvin had used in the early 1850s for *A Young Woman Playing a Mandolin* (L. H. Van Baaren Collection, Utrecht). His model plays an instrument while reading pages of music resting on a stand before her, recalling the concert performances painted in the seventeenth century by Gerard Ter Borch (1617–1681), Gabriel Metsu (1629–1667), and Jan Vermeer (1632–1675). Although Bonvin's subject evokes past traditions, he relates this theme to late nineteenth-century France by portraying his model in contemporary clothing.[1]

The motif of the young musician also had a more personal meaning for Bonvin: his tempestuous second wife, Céline Prunaire, was a musical performer. However, when Bonvin completed this painting in 1874, he was living not with Céline but with the less excitable Louison Köhler. Bonvin and Köhler remained together for eighteen years, and she nursed the painter through innumerable bouts of illness during the 1880s. The 1874 painting is a happy resolution of the musician theme, marking the last time that Bonvin used it in his work.

Louison's mouth is open, as if she were singing a song, indicating that a concert is in progress. The pieces of delicate pastry in the foreground and the wine glass with a spoon in it suggest the sensual pleasure of food and wine. This symbolism is heightened by the framed picture on the rear wall, where a provocative nude adds an overtone of erotic sensuality. By including a painting within a painting, Bonvin reveals his awareness of how younger painters such as Edgar Degas (1834–1917) and James Tissot (1836–1902) were adding layers of meaning to their portrait compositions with this type of reference.[2]

Bonvin's portrayal has the aura of an official Salon portrait. This must have amused the artist, since the depiction of his intimate companion hung at the Salon among more formal portrait

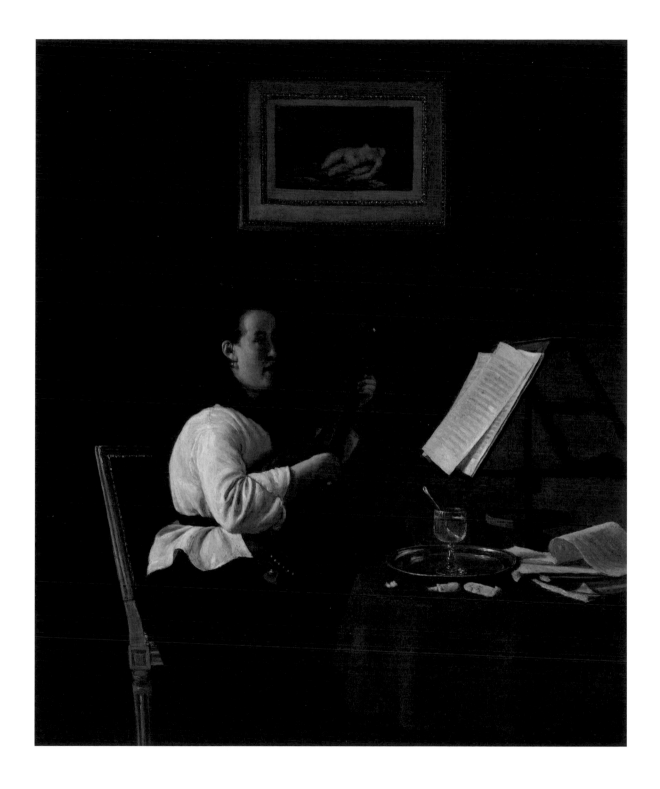

compositions by academic painters. The painting expresses his desire that others respect Louison and her role in his life; he shows her in her best finery, wearing pearl earrings and a black Spanish-style veil draped over her hair and shoulder. By referencing both historical prototypes and subtle allusions to his relationship with Louison, Bonvin has achieved an uncommon type of representation: a painting that speaks to his own life, while reflecting his reverence for artists from the past. —*GPW*

1 Gabriel P. Weisberg, *The Realist Tradition: French Painting and Drawing, 1830– 1900* (Cleveland: The Cleveland Museum of Art and Indiana University Press, 1980), 246–47, cat. no. 217.

2 Gabriel P. Weisberg, "The Traditional Realism of François Bonvin," *The Bulletin of the Cleveland Museum of Art* 65, no. 9 (November 1978): 280–98.

François Bonvin, 1817–1887
Woman at the Spinet, 1860
fabricated chalk with touches of brown and red chalk and
stumping on tan laid paper
16.50 x 12 inches (42 x 30.50 cm)
Signed and dated lower left in black chalk: *F. Bonvin 1860*
Watermark: Venus standing on a sphere with *VDL* in lower
half of sheet; countermark *Van Der Ley* in top half of sheet
The Cleveland Museum of Art
Bequest of Muriel Butkin
2010.166

13

Provenance
P. and D. Colnaghi and Co., Ltd., London;
Williams and Son, London, December
1975; Mr. and Mrs. Noah L. Butkin, Shaker
Heights, Ohio; bequest of Muriel Butkin to the
Cleveland Museum of Art, 2009.

Exhibitions
French Drawings: Post-Neo-Classicism, spring
1975, Colnaghi, London, cat. no. 25 (illus.),
Lady at the Piano.

Selected Bibliography
Weisberg, Gabriel P. *Bonvin*. Paris: Geoffroy-
Dechaume, 1979, cat. no. 264.

A woman at a piano was a recurrent theme in the oeuvre of
François Bonvin. A sketch entitled *The Piano* exhibited at the
Salon of 1849—only the third in which the artist was included—
was an early manifestation of his interest in the subject. Eleven
years later, Bonvin returned to the theme in two highly worked
chalk drawings, each depicting a woman at a spinet. James
McNeill Whistler's canvas *At the Piano* may have inspired Bonvin
to look at the subject anew. In the spring of 1859, Whistler's
painting was included in an impromptu Salon des Refusés held
in Bonvin's atelier, alongside canvases by Théodule Ribot,
Henri Fantin-Latour, and Alphonse Legros.[1] The exhibition was
small—eight works are thought to have comprised the show[2]—
and Whistler's painting would have likely made a significant
impression on Bonvin.

The motif of a comfortable, middle-class woman at a piano
diverges from Bonvin's Realist interest in depicting honest labor.
Cooks, servants, and workmen appear much more frequently in
his work of the 1850s and '60s. And yet, the subject of a woman
at the piano was one that he addressed with particular care in
the two drawings he made in 1860, the year after his Salon des
Refusés. The dramatic contrasts of *Woman at the Spinet*, in the
collection of the Cleveland Museum of Art, are meticulously
worked, the rich black of the chalk offset by highlights in the
figure's face, the lace at her throat and wrists, the keyboard,
and the music. Hints of pink enliven her hands and a carnation
on the floor. Far more than a mere study, the drawing is signed
and dated, with every detail resolved. A second drawing of the
same subject, known as *The Spinet*, is now in the collection of
the Rijksmuseum, Amsterdam. In 1862, Bonvin worked the
Amsterdam composition into an oil painting, now in the Burrell
Collection, Scotland.[3] Whereas the figure in the Cleveland
drawing is depicted in profile, wearing a black dress whose
severity is mitigated only by the white lace cuffs, bodice, and
kerchief, the same figure is seen in the Amsterdam sheet from
behind, wearing a pale dress and once again playing the same
instrument. Both the Amsterdam drawing and the related

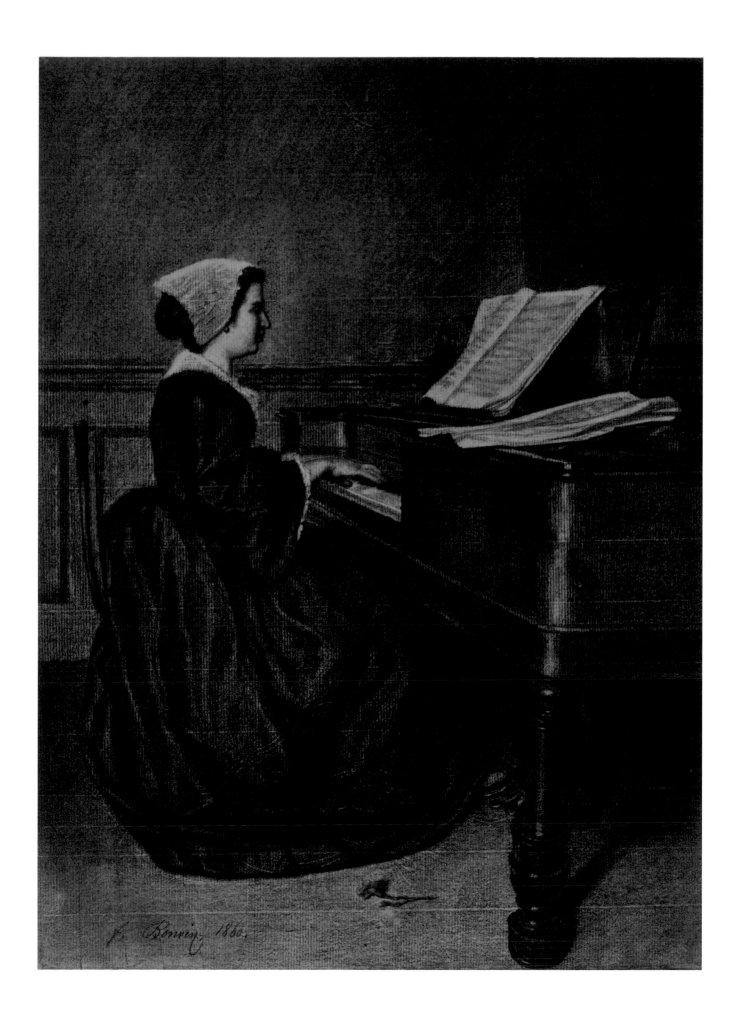

Léon Bonvin, 1834–1866

Kitchen Interior, 1856
ink and watercolor
9 x 5.75 inches (22.86 x 14.61 cm)
Signed and dated lower left: *L Bonvin 1856*
Snite Museum of Art
Gift of Mr. and Mrs. Noah L. Butkin
2009.045.011

14

Provenance
Paul Prouté, Paris; Shepherd Gallery, New York, 1977; Mr. and Mrs. Noah L. Butkin, 1977; placed on loan with the Snite Museum of Art, University of Notre Dame, 1979; converted to a gift of the estate of Muriel Butkin, 2009.

Exhibitions
The Drawings and Watercolors of Léon Bonvin, November 12, 1980–January 18, 1981, The Cleveland Museum of Art; February 15–March 27, 1981, the Walters Art Gallery, Baltimore, Maryland.

Selected Bibliography
Weisberg, Gabriel P., and William R. Johnston. *The Drawings and Watercolors of Léon Bonvin.* Cleveland: The Cleveland Museum of Art in cooperation with Indiana University Press, 1980, cat. no. 5.

Raised in humble circumstances and responsible for helping to run his family's tavern, Léon Bonvin had little time to study art, except under the guidance of his half-brother, the Realist painter François Bonvin. Yet his innate talent as a draftsman and watercolorist is immediately evident in his images. He first worked in charcoal and pen and ink, creating studies of his father and black-and-white views of the desolate environment around his family home in Vaugirard, on the outskirts of Paris. He focused on scenes that he knew well: the interior and yard of his house, the building where he worked, and the road just outside. These early sketches allowed Léon to gradually train himself as an artist, with some encouragement from his half-brother. Finding opportunities to draw conflicted with his work at the inn, forcing him to rise in the early morning hours, when no one was around, to create his studies.

Whether Léon Bonvin had the opportunity to see works created by other members of the Realist group, outside of François's images, remains undocumented. If he did, he must have been impressed by their fascination with solitary, quiet interiors that mirrored his own interests. Théodule Ribot completed at least one wash-and-pencil drawing of a kitchen interior that in some ways reflects Léon's attention to the architecture of a room. And Antoine Vollon completed a view of a kitchen interior in the early 1860s, close to the time when Bonvin was working on this composition.[1] All of these works share a similar viewpoint, a concentration on humble, simple objects, and a sense of desolation.

What is most apparent in Bonvin's study is his detailed rendering of every object in the room. The candlesticks across the top of the mantle are individually observed. The wood stacked against the rear wall is ready to be burned in the stove at the left. The ceramic containers on the stove and the metallic pots and pans hanging from the wall above are carefully outlined. Bonvin has brought a meticulous sense of observation to his description of this empty kitchen, the space where he worked every day preparing meals for customers. The hint of color, and the way light subtly bathes the corner of the room, provides a suggestion of the superb colorist that Bonvin would become within a few short years. As a preview of the direction his work would take, this watercolor has few peers among his early compositions. —*GPW*

1 See Gabriel P. Weisberg, *The Realist Tradition: French Painting and Drawing, 1830–1900* (Cleveland: The Cleveland Museum of Art and Indiana University Press, 1980), cat. no. 112.

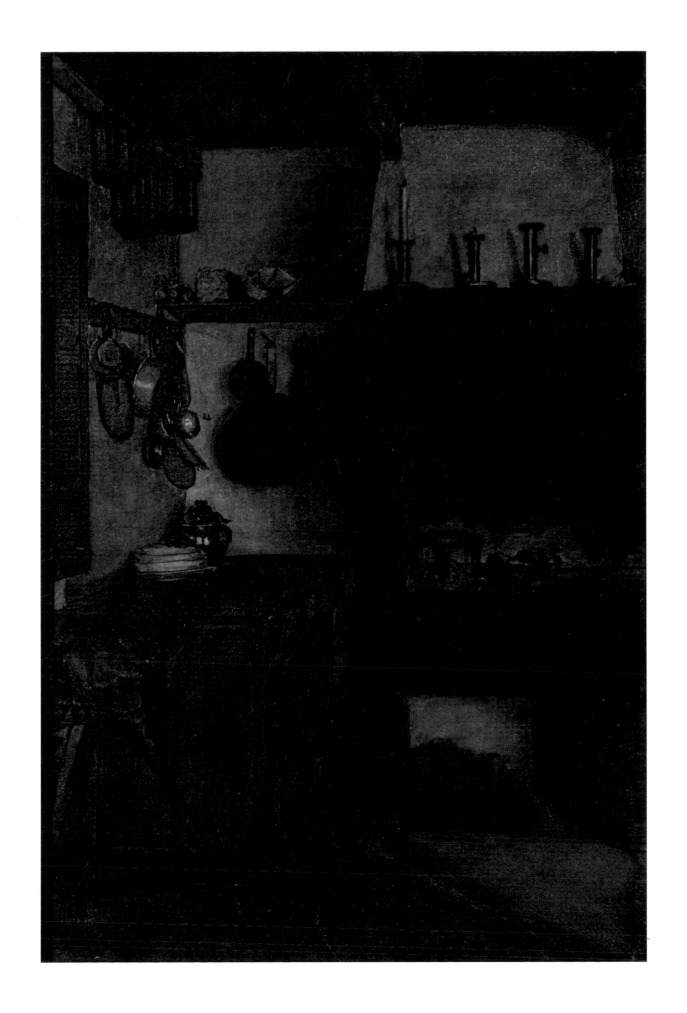

Léon Bonvin, 1834–1866

Still Life with Wildflowers, 1864
watercolor with touches of gouache on cream wove paper
7.24 x 9.53 inches (18.40 x 24.20 cm)
Signed and dated lower left in black ink: *Léon Bonvin. 1864*
Cleveland Museum of Art
Bequest of Noah L. Butkin
1980.235

15

Provenance
Galerie Jacques Fischer–Chantal Kiener, Paris, 1977; Mr. and Mrs. Noah L. Butkin, Shaker Heights, Ohio; bequest of Noah L. Butkin to the Cleveland Museum of Art, 1980.

Exhibitions
The Drawings and Watercolors of Léon Bonvin, November 12, 1980–January 18, 1981, The Cleveland Museum of Art; February 15–March 27, 1981, the Walters Art Gallery, Baltimore, Maryland, cat. no. 16 (illus. p. 41).

The Lessons of the Academy, February 8–May 29, 1983, The Cleveland Museum of Art.

French Drawings from the Collection, December 13, 1994–March 12, 1995, The Cleveland Museum of Art.

Selected Bibliography
Weisberg, Gabriel P., and William R. Johnston. *The Drawings and Watercolors of Léon Bonvin.* Cleveland: The Cleveland Museum of Art in cooperation with Indiana University Press, 1980, p. 43, cat. no. 16 (illus. p. 41).

"Year in Review for 1980." *The Bulletin of the Cleveland Museum of Art* 68 (June 1981): 215, cat. no. 178.

The subjects that dominated Léon Bonvin's art in the 1850s—charcoal studies of family members, views of the family inn isolated in a bleak landscape, and quiet corners of domestic interiors—were followed by landscapes and still lifes in watercolor in the 1860s. Drawing from nature appears to have been Bonvin's chief pleasure and an opportunity for escape from domestic responsibilities and financial worries. His mature watercolors frequently record early morning or evening rambles through his garden and the countryside. Meticulous studies of grasses, wildflowers, or delicate shrubs often occupy the foreground of landscapes in which atmospheric renderings of distant fields recede into the distance. Similarly detailed botanical studies can be found in Bonvin's still lifes. Although some of his still lifes were elaborate tabletop arrangements of fruit, vegetables, wine, ceramic ware, and cutlery, at times the artist focused simply on a handful of flowers, souvenirs of walks in the fields. *Still Life with Wildflowers* demonstrates his keen powers of observation and his introspective, melancholy temperament.

Here, a spray of red blossoms with dark green foliage is unceremoniously arranged in a small blue and white bowl, set upon an otherwise empty wooden shelf or tabletop. Humble flowers from his backyard garden or the fields were what interested Bonvin. When asked whether he would paint camellias or other hot house flowers, he responded, "Do not ask me to do these; my heart is not in them."[1] In keeping with the doctrine of the Realists, François Bonvin apparently encouraged Léon, his younger brother, to draw and paint from life and to "do everything directly from nature."[2] The wildflowers depicted here may be English wallflowers, native to southern Europe and known in France as *giroflées* (literally, "clove-scented").[3] Frequently found in cottage gardens, wallflowers bloom in spring and are admired for their crimson, velvety blossoms. Critic and collector Philippe Burty likened Bonvin's penchant for the wild and the uncultivated to Jean-François Millet's devotion to peasant life.[4] Bonvin's meditative affection for the quiet corners of the landscape in which he lived was not unlike the attachment Barbizon School artists felt for the Fontainebleau Forest; thistles, cowslips, and wild pansies of the fields embodied the majesty of nature for him, just as the oak trees of Fontainebleau did for Théodore Rousseau (1812–1867).

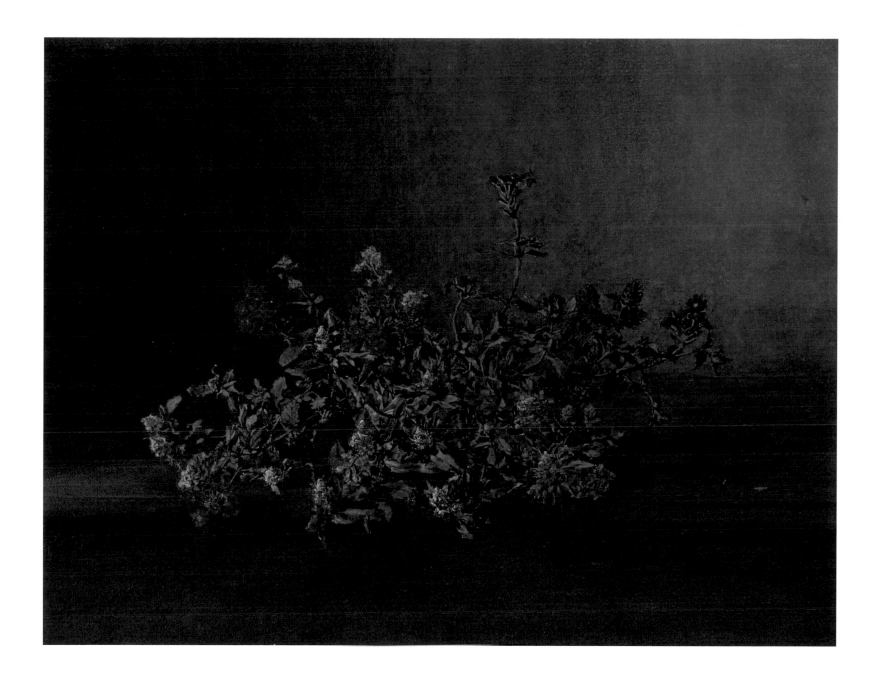

According to Burty, Bonvin often painted at night, by the light of a lamp enclosed in a box that was designed to cast a strong beam on a still life arranged on a table. *Still Life with Wildflowers* may have been painted with such a device. The composition is dark, with delicate red blossoms the only shades of warmth amid the somber gray and brown tonalities. In 1866, two years after painting this work, and prompted by financial despair and a crisis of confidence in the salability of his drawings, Bonvin committed suicide at the age of thirty-two. Knowing the artist's unhappy end, this still life, a delicate marvel of observation and expression, takes on the character of an elegy. —*HL*

1 Quoted in Philippe Burty, "Léon Bonvin," *Harpers New Monthly Magazine* 72, no. 427 (December 1885): 46.

2 Ibid., 38.

3 My thanks to Ann McCulloh, Curator of Plant Collections at the Cleveland Botanical Garden, for suggesting this identification.

4 Burty, "Léon Bonvin," 46.

Jules Breton, 1827–1906

The Gleaner, 1877
black chalk and graphite
11.50 x 7.75 inches (29.21 x 19.69 cm)
Signed and dated lower right: *J. Breton / '77*
Snite Museum of Art
Gift of Mr. and Mrs. Noah L. Butkin
2009.045.010

16

Provenance
Shepherd Gallery, New York; Mr. and Mrs. Noah L. Butkin, 1979; placed on loan with the Snite Museum of Art, University of Notre Dame, 1979; converted to a gift of the estate of Muriel Butkin, 2009.

Exhibitions
Jules Breton and the French Rural Tradition, 1982, The Joslyn Art Museum, Omaha, Nebraska, cat. no. 75.

Selected Bibliography
Sturges, Hollister, et al. *Jules Breton and the French Rural Tradition*. Omaha, NE: The Joslyn Art Museum, 1982, pp. 112–13.

Originally catalogued as either a study for or a copy after Jules Breton's sole entry for the 1877 Paris Salon, this drawing is now seen within a larger context.[1] It is clearly related to the 1877 Salon painting, *The Gleaner* (Musée des Beaux-Arts, Arras), especially in the pose of the central figure. However, that painting also includes haystacks and figures at the right that are not fully realized in the drawing. The emergence of another painting, sold at Sotheby's in New York in April 2004, enlarges the discussion surrounding the sketch.[2] In that canvas, the gleaner is again closely linked in pose and dress to the Snite drawing, but the haystacks at the right are shown without figures. Thus, the Sotheby painting correlates more directly to the drawing, suggesting that it could have been an intermediary canvas done in preparation for the much larger Salon composition. In any case, the Snite drawing is a key example of a theme that Breton continually reworked throughout his career.

Beginning with his 1854 Salon painting *The Gleaners* (National Gallery of Ireland, Dublin), Breton focused on a custom he had been familiar with since childhood. Raised in the small village of Courrières in northern France, he was aware of the traditions of field labor and the importance of gleaning—that is, gathering grain left by reapers—for poor families. Breton centered much of his early work on such peasant scenes. As he acquired an international reputation, he moved away from a straight realistic depiction and absorbed the traditions of the Renaissance. His iconic figures became larger than life, assuming symbolic significance; his gleaners support their burden on their backs like caryatid forms from ancient Greece. By combining Realism with the classical tradition, Breton elevated gleaning to a mythical status equal to ancient Greek or Italian Renaissance sculpture. The Snite drawing exemplifies how the artist reworked themes, figures, and types throughout his career, and how his drawings could either stand on their own or be seen as preparatory work for paintings. —*GPW*

1 Hollister Sturges et al., *Jules Breton and the French Rural Tradition* (Omaha, NE: The Joslyn Art Museum, 1982), 113.

2 Sotheby's, New York, *19th Century European Painting*, April 23, 2004.

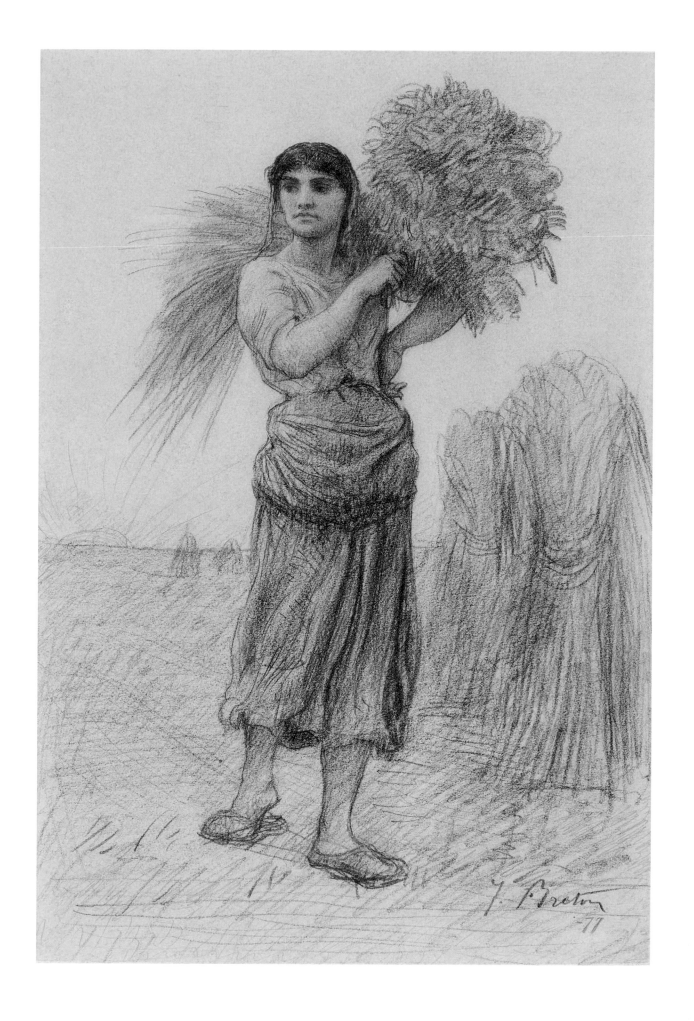

Gustave Brion, 1824–1877

Oil Study for an Unknown Painting, ca. 1867

oil on panel

7.13 x 12 inches (18.11 x 30.48 cm)

Inscribed on verso: label with title in French; *vente Borie (?) 23 fevrier 1881*

Snite Museum of Art

Gift of Mr. and Mrs. Noah L. Butkin

2009.045.101

17

Provenance

Sale Victor Borie, Paris, February 1881, cat. no. 125; Jan D. Milner; Mr and Mrs. Noah L. Butkin, 1979; placed on loan with the Snite Museum of Art, University of Notre Dame, 1980; converted to a gift of the estate of Muriel Butkin, 2009.

As a representative of the Alsatian school of painters that flourished during the Second Empire (1852–1870), Gustave Brion turned increasingly to documenting the life and traditions of his native region, near the city of Strasbourg. Early in his career, he completed paintings containing social messages influenced by events in Paris and other locales. But by the close of the 1850s, Brion was less interested in recording social struggles; instead, his canvases revealed an intense interest in the folklore, local history, and individuals of his home territory. He illustrated episodes from peasant life and legend during an era when Alsace was part of France, before it was annexed by Germany after the Franco-Prussian War. Familiar with traditional costumes and local events, he invested his Salon paintings with the same degree of exactitude and detail as history paintings of Greece and Rome. He also made a series of remarkable studies for Victor Hugo's romantic novel *Les Misérables*, works that elevated his reputation.

It has been suggested that this oil sketch is a study for Brion's painting *Vosges Peasants Fleeing before the Invasion* (1867, Kemper Art Museum, Washington University in St. Louis), although it might instead be traced to the creative evolution of either *The Pilgrims of Sainte Odile* (1863) or the *Return of Pilgrims* (location unknown).[1] An academically trained artist, Brion prepared drawings and sketches for each of his large-scale Salon paintings. These often reveal an interest in spontaneity, as in this example, that was not fully maintained in the more meticulous finished paintings that were publicly exhibited. If this is a study for the *Invasion*, then the peasants are hiding in a makeshift tent in very cold weather, trying to maintain their spirits with the meager meal that is placed in the foreground. The military figures carrying lances at the right and in the background reinforce the association with the *Invasion*, which depicts an 1814 Prussian incursion. —*GPW*

1 In the preparation of this entry, the author sought the expertise of Markus Pilgrim, who completed a mammoth study on Gustave Brion. See Markus Pilgrim, *Gustave Brion (1824–1877): Mémoire de Maîtrise d'Histoire de l'Art* (Paris: Université de Nanterre, 1992), cat. nos. 84, 99, 159, 240. The painting at the Snite Museum is unknown to Mr. Pilgrim, who could not add any further information beyond what he cited in his study.

Alexandre Cabanel, 1823–1889

A Graveyard Scene
oil on canvas
11.50 x 18.13 inches (29.21 x 46.05 cm)
Signed lower right in red: *Alex Cabanel*
Snite Museum of Art
Gift of Mr. and Mrs. Noah L. Butkin
2009.045.105

18

Provenance
Vicomte Georges Martin du Nord, Paris;
Shepherd Gallery, New York, 1975; Mr. and
Mrs. Noah L. Butkin, 1975; placed on loan with
the Snite Museum of Art, University of Notre
Dame, 1980; converted to a gift of the estate of
Muriel Butkin, 2009.

Selected Bibliography
Hilaire, Michel, and Sylvain Amic. *Alexandre
Cabanel, 1823–1889: La tradition du beau.*
Paris: Somogy éditions d'art, 2010.

By the 1860s, Alexandre Cabanel was well established as one of France's leading academic painters. The scope of his work included history painting, portraiture, and *grands décors* for numerous public spaces in Paris—not a surprising development for the precocious artist from Montpellier. Cabanel's art studies began at age eleven, when he was admitted to the local art school, and continued in Paris after his acceptance at the École des Beaux-Arts a scant five years later.

The oil sketch titled *A Graveyard Scene* reflects Cabanel's training at the École des Beaux-Arts, but also his lifelong fascination with the performing arts. Although the exact source for the theme of the painting is uncertain, it is clearly part of a larger literary narrative that the artist was considering as a full-size easel painting. Like all students at the École, Cabanel was expected to master the study of Western literature, ranging from the traditions of ancient Greece and Rome to medieval church writings and the classical French canon of the sixteenth, seventeenth, and eighteenth centuries. The scope of this education provided students with a rich resource for selecting appropriate subjects for their artwork.[1] The challenge was learning how to transform the written text into visual imagery that would offer viewers an insight into humanity or a moral lesson.

A Graveyard Scene may be connected to an opera by composer Etienne-Nicolas Méhul, whose works were a mainstay for the Opéra Comique in the 1790s. His 1794 lyric opera *Mélidore et Phrosine* was based on a narrative poem by Pierre-Joseph-Justin Bernard, a librettist who specialized in tactfully erotic verse during the pre-Revolutionary decades. Méhul's adaptation of Bernard's story of star-crossed lovers resulted in one of the earliest French lyric operas that could be described as Romantic in character, thus signaling the shift from the classicism of Franz Joseph Haydn and Wolfgang Amadeus Mozart to the emotive Romanticism of Ludwig van Beethoven.[2] Cabanel's love of music, and opera in particular, is confirmed by his close friendships with composer Victor Félix Massé, during his years at the Villa

Medici in Rome, and later with the Swedish soprano Christina Nilsson, who modeled for his paintings of Pandora, Ophelia, and Marguerite.

Equally important, the subject of Mélidore and Phrosine was popularized in an etching created by Pierre-Paul Prud'hon (1758–1823) for a new edition of Bernard's poem, published by François Ambroise Didot in 1797. In Prud'hon's dramatic rendition (fig. 1), the figure of Mélidore, disguised as a monk, clasps the recently drowned but still voluptuous Phrosine in his arms beneath the light of the full moon. The rich interplay of light and shadow in the etching underscores the emotional intensity of the poem, and establishes the story as one of erotic tragedy. Perhaps even more than the Méhul opera, Prud'hon's etching resonated with the emerging Romantic generation of artists.[3]

Cabanel's painting evokes much of the same erotic drama—although the figure of Phrosine is now lying on the ground partially clothed, while Mélidore cradles her dead body. In the background, the full moon rises amid ominous clouds in a threatening sky. However, the figure of a gravedigger in the background of Cabanel's sketch does not appear in either the opera or the narrative poem, thus leaving the question of the literary source without a definitive answer.

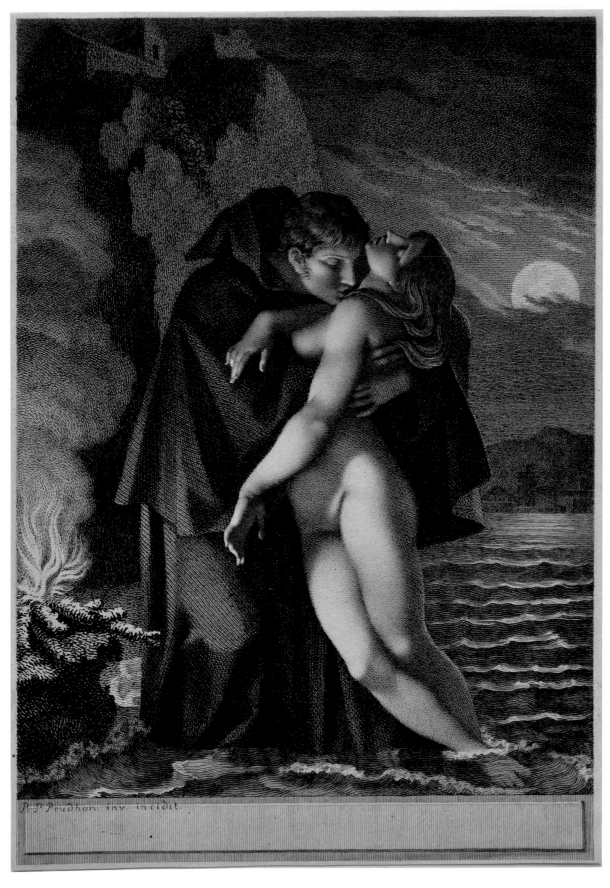

Fig. 1. Pierre-Paul Prud'hon, *Amours de Phrosine et Melidore* (1797), 8.375 x 5.75 inches (21.3 x 14.6 cm), etching and engraving, The University of Iowa Museum of Art, Edwin B. Green Art Acquisition Endowment, 1998.322

Regardless of the textual source, the oil sketch demonstrates Cabanel's predilection for loosely executed Romanticism in his preliminary studies. Further, the overt eroticism of the image, as well as the coded suggestion of illicit sexuality among monastic orders (however false it might be if the "monk" is indeed Mélidore in disguise), suggests that Cabanel was fascinated by human transgressions as much as his more openly bohemian colleagues. Although he does not seem to have turned this image into a finished painting, the theme of repressed sexuality later emerged very clearly in his images of Venus, for which he is best known today. —*JLW*

1 See "Vers le Prix de Rome," in Michel Hilaire and Sylvain Amic, *Alexandre Cabanel, 1823–1889: La tradition du beau* (Paris: Somogy éditions d'art, 2010), 70–85. Cabanel's early work reflects the dominance of his literary education at the École in paintings such as *Le festin d'Esther (The Feast of Esther)* (Musée Fabre, Montpellier) or *La mort de Priam (Death of Priam)* (Musée Fabre, Montpellier), both from 1841.

2 Edward J. Dent, *The Rise of Romantic Opera* (Cambridge: Cambridge University Press, 1976), 71. Bernard's poem was also the basis for a popular melodrama by playwright René Charles Guilbert de Pixérécourt (1773–1844), who was associated with the Théâtre de la Gaîté in Paris.

3 The power of Prud'hon's etching is evident in a much later painting by Edouard Joseph Dantan (1848–1897), who copied the earlier work in his own *Phrosine et Mélidore* in 1878 (Musée des Beaux-Arts, Bordeaux).

Émile Auguste Carolus-Duran, 1838–1917

Lovers Embracing at the Edge of the Forest at Sunset, 1877
oil on canvas
21.88 x 18.13 inches (55.58 x 46.05 cm)
Signed and dated lower left: *Carolus-Duran 77*
Snite Museum of Art
Gift of Mr. and Mrs. Noah L. Butkin
2009.045.073

19

Provenance
Shepherd Gallery, New York; Mr. and Mrs.
Noah L. Butkin, 1975; placed on loan with
the Snite Museum of Art, University of Notre
Dame, 1980; converted to a gift of the estate of
Muriel Butkin, 2009.

Selected Bibliography
Carolus Duran, 1837–1917. Paris: Réunion des
musées nationaux, 2003.

Gaudichon, Bruno, ed. *Des amitiés modernes
de Rodin à Matisse: Carolus-Duran et la Société
nationale des beaux-arts, 1890–1905*. Paris:
Somogy éditions d'art, 2003.

Born in the northern border city of Lille, Carolus-Duran arrived in Paris in 1853 to study at the Académie Suisse at a moment when the art world was full of burgeoning contradictions: Realist painters were challenging conventional academic approaches to subject matter; photography was in its infancy as a technology but was increasingly influential on painting; and the credibility of the powerful annual Salon exhibition was being questioned openly by young artists. In this maelstrom of activity, the sixteen-year-old Carolus-Duran obtained his basic lessons in painting and then left Paris for extended stays in Spain and Rome. It was not until 1868, at age thirty-one, that he made his debut at the Salon with *Evening Prayer* (location unknown), a painting that he sent to the Paris exhibition from Rome. The following year, he returned to Paris with his young wife, the artist Pauline Croizette, and began his career as a portrait painter, perhaps in part because of the need to support his growing family.

Lovers Embracing at the Edge of the Forest at Sunset is an anomaly in Carolus-Duran's work, which consists primarily of portraits and occasional genre scenes. The stylistic character of the painting is closely related to the tradition of Romantic landscape painting in the use of intense color, broad brushstrokes, and the emotionally charged subject of a lover's tryst. In spirit, it echoes the wild landscapes of the Italian painter Salvator Rosa (1615–1673), whose compositions were often structured in a similar pattern and whose work would have been familiar to Carolus-Duran from his long stay in Italy during the 1850s and '60s.

When Carolus-Duran moved back to Paris from Rome in 1869, he found himself in an art world that was increasingly attentive to the Realism of Gustave Courbet (1819–1877) and Édouard Manet (1832–1883). Even before his return to the French capital, however, his work showed the influence of Courbet in paintings such as *The Convalescent* (1860, Musée d'Orsay, Paris), which is loosely based on Courbet's earlier work of the same title. Likewise, Carolus-Duran's portrait of himself and his new wife, *The Kiss* (1868, Palais des Beaux-Arts, Lille), is very much in keeping with the early romanticized work of Courbet from the 1840s.

In analyzing *Lovers Embracing at the Edge of the Forest at Sunset*, it is impossible not to consider *The Kiss* as a source for this later oil sketch. The entwined lovers near the forest, although admittedly very sketchy, nonetheless have the same hair colors

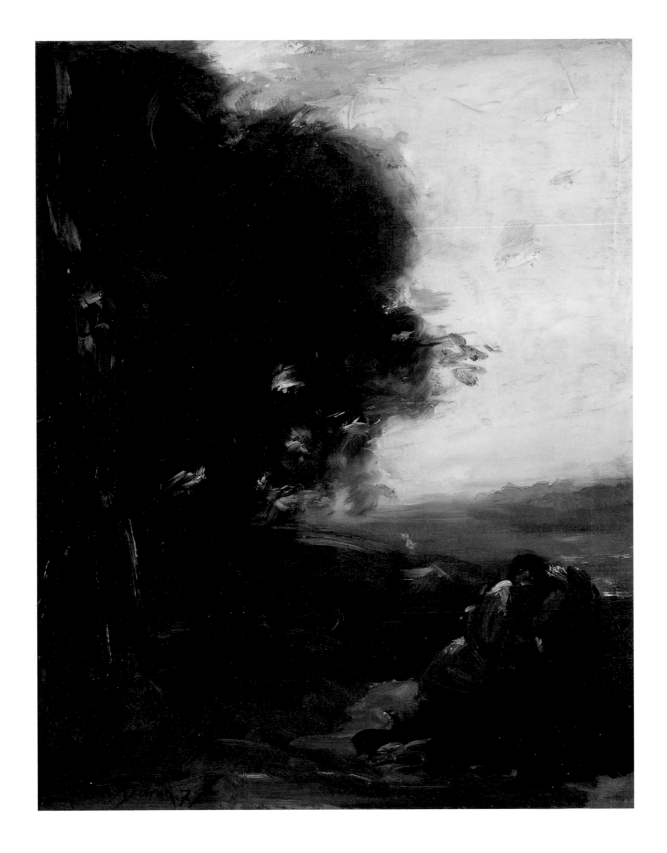

and head shapes as Carolus-Duran and Pauline Croizette in the painting celebrating their marriage from a decade earlier. Given the date of 1877, it is also likely that Carolus Duran was aware of the Impressionists' use of unmixed colors; he seems to have utilized that technique in this sketch with a stark juxtaposition of yellow and blue on the horizon. Most tempting, however, is the possibility that this intensely human and atypical painting might have been—in part, at least—a remembrance of Courbet, who died that same year. —*JLW*

Émile Auguste Carolus-Duran, 1838–1917
Portrait of the Artist's Son, Pierre, at Age Nine, 1885
oil on canvas
21.25 x 17.38 inches (54 x 44.10 cm)
Signed and dated upper right: *Carolus-Duran / 3 7bre 85*
Inscribed upper left: *Pierre, VIIII ans.*
Snite Museum of Art
Gift of Mr. and Mrs. Noah L. Butkin
2009.045.072

20

Provenance

Shepherd Gallery, New York; Mr. and Mrs. Noah Butkin, 1976; placed on loan with the Snite Museum of Art, University of Notre Dame, 1980; converted to a gift of the estate of Muriel Butkin, 2009.

Selected Bibliography

Carolus Duran, 1837–1917. Paris: Réunion des musées nationaux, 2003.

Galerie Brame et Lorenceau. *Carolus-Duran*. Paris: Brame et Lorenceau, 2003.

Gaudichon, Bruno, ed. *Des amitiés modernes de Rodin à Matisse: Carolus-Duran et la Société nationale des beaux-arts*, 1890–1905. Paris: Somogy éditions d'art, 2003.

Hirschl and Adler Galleries. *A Selection of Nineteenth and Twentieth Century Works*. New York: Hirschl and Adler Galleries, 1990.

Pillement, Georges. "Les Pré-Impressionistes." Zoug, Switzerland: Les clefs du temps, 1974.

As a portrait painter in an age when photographers were offering increasing competition for the middle-class market, Carolus-Duran built his career by catering primarily to wealthy society women. His clients ranged from Nadezhda Polovtseva, wife of the Russian secretary of state (1876, State Hermitage Museum, St. Petersburg), to the American Emily Warren Roebling (1896, Brooklyn Museum, New York), as well as numerous members of the French upper classes. In general, these portraits were idealized images of sitters clad in luxurious fabrics and positioned in richly decorated settings.

The more intimate *Portrait of the Artist's Son, Pierre, at Age Nine* in the Snite Museum's collection offers a glimpse of Carolus-Duran as a family man. Like so many of his colleagues, he often relied on his wife as a model, as in the critically acclaimed Salon painting *The Lady with the Glove* (1869, Musée d'Orsay, Paris). By the mid-1880s, his young son, Pierre, seems to have followed in his mother's footsteps as a sitter. In contrast to Carolus-Duran's contemporary Claude Monet (1840–1926), whose son Jean modeled only in the sense that he played quietly while his father painted him, Pierre seems to have posed formally—in Renaissance profile views and in costume.

The 1885 portrait shows Pierre in strict profile against a burgundy background, dressed carefully in a black suit with a white sailor collar and red undershirt. What is most captivating, however, is his earnest and serious expression as he maintains the immobility of his pose. The inscription in the upper left indicates that Pierre is nine years old in this image. Another small oil sketch (private collection) shows Pierre in an identical pose but with slightly different clothing; the black cap and suit remain the same, but the white sailor collar is replaced with a loose white bow-tied scarf around his neck. The handling of the paint in that work is much more fluid and sketchy. More curiously, this second painting is titled *Portrait du Prince Orsini* and carries an inscription in the upper left that reads "Michel VII ans" (Michael at age seven), although it is clearly the artist's son.[1]

Yet another image of Pierre, *Portrait de Pierre Carolus-Duran*, is part of the collection of the Musée des Beaux-Arts, Nice, this one a full-length frontal view of the boy dressed in the same black suit, white sailor collar, and red undershirt as in the Snite Museum painting.[2] However, Pierre no longer wears a hat, but instead holds a riding crop and hat in his hands; in addition, he sports black knee-high riding boots. The inscription at the top center of this painting reads "Pierre Carolus-Duran, huit ans" (Pierre Carolus-Duran at age eight). It is signed "Carolus-Duran"

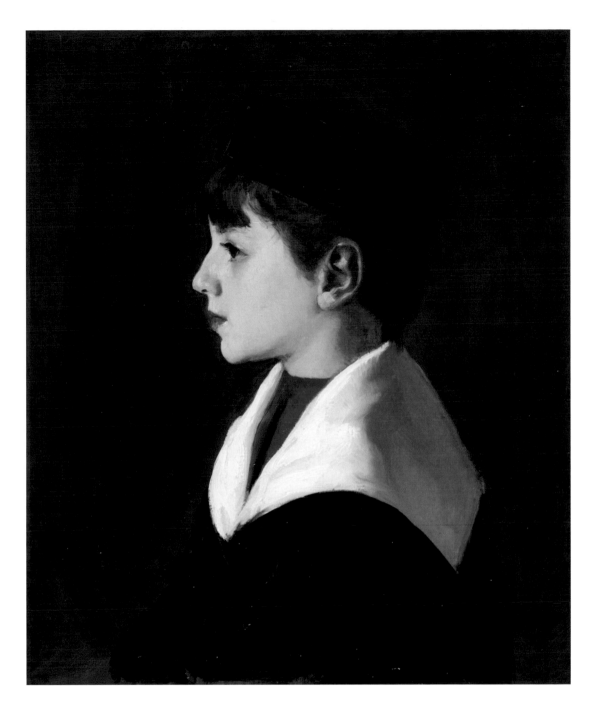

in the lower left corner. The Musée des Beaux-Arts, Nice, dates the portrait to 1884.

Side by side, these three portraits of Pierre Carolus-Duran suggest that he was a remarkable model for a young child. Although the dating of the paintings is not entirely clear, the ages indicated in the inscriptions seem to be consistent with Pierre's facial development, moving from the "seven-year-old" portrait of a sweet and still babyish boy, to the earnest full-length image of an eight-year-old looking soberly at his father, and finally to the Snite Museum portrait at age nine, in which Pierre poses with the maturity of an experienced model. All three paintings, however, suggest that modeling was a routine part of the relationship between father and son. —*JLW*

1 For a reproduction of *Portrait du Prince Orsini*, see the catalogue for an exhibition at Galerie Brame et Lorenceau, February 28–April 26, 2003, *Carolus-Duran* (Paris: Brame et Lorenceau, 2003), 39. The painting is an oil on canvas measuring 21.13 x 17.75 inches (53.67 x 45.09 cm). The meaning of the title referring to Prince Orsini remains uncertain, although one possible interpretation is that "Prince Orsini" may have been a fictional or historical figure that Carolus-Duran modeled on his young son.

2 See the website of the Musée des Beaux-Arts, Nice, for a reproduction of *Portrait de Pierre Carolus-Duran* (1884), at http://www.musee-beaux-arts-nice.org/francais/collections/duran.html. The painting is an oil on canvas measuring 61.42 x 36.22 inches (156 x 92 cm), inventory number 2464.

François Chifflart, 1825–1901
Soldier Being Mauled by a Lion
oil on panel
13 x 9.88 inches (33 x 25.10 cm)
Signed lower left: *F Chifflart*
Snite Muscum of Art
Gift of Mr. and Mrs. Noah L. Butkin
2009.045.116

21

Provenance
Galerie Jacques Fischer–Chantal Kiener, Paris; Shepherd Gallery, New York; Mr. and Mrs. Noah L. Butkin, 1975; placed on loan with the Snite Museum of Art, University of Notre Dame, 1981; converted to a gift of the estate of Muriel Butkin, 2009.

Exhibitions
François Chifflart au Musée d'Orsay: Graveur et illustrateur, 1993–94, Musée d'Orsay, Paris, and Musée Sandelin, Saint-Omer.

Selected Bibliography
Chabert, P. G., ed. *François-Nicolas Chifflart, 1825–1901*. Saint-Omer: Musée Hôtel Sandelin, 1972.

Dagen, Philippe. "François Chifflart au Musée d'Orsay: Grand graveur et esprit libre." *Le Monde*, February 4, 1994.

Le Men, Segolène. "Chronique des arts." *Gazette des beaux-arts*, ser. 6, 123 (May–June 1994): 9–10.

Michaux, Lisa Dickinson, with Gabriel P. Weisberg. *Expanding the Boundaries: Selected Drawings from the Yvonne and Gabriel P. Weisberg Collection.* Minneapolis: Minneapolis Institute of Arts, 2008.

Sueur, Valérie. *François Chifflart: Graveur et illustrateur.* Paris: Réunion des musées nationaux, 1993.

François Chifflart's career began auspiciously with admittance to the École des Beaux-Arts in 1844, as a student of Léon Cogniet (1794–1880), and a Salon debut the following year. Five years later, he placed third in the Prix de Rome competition, and in 1851, he won the prestigious prize with his painting of *Pericles at His Son's Deathbed* (1851, École Nationale Supérieure des Beaux-Arts, Paris). During his next five years of study at the Villa Medici in Rome, however, the young painter seems to have struggled to meet the requirements of his academic program as well as the wishes of his patrons.

Back in Paris by 1857, he continued to exhibit whenever possible, but it was his drawings of scenes from *Faust* that attracted the attention of both Charles Baudelaire and Théophile Gautier at the 1859 Salon.[1] Baudelaire's praise, in particular, was indicative of why Chifflart's sensibility was incongruent with that of the École des Beaux-Arts: "Everyone justly rebukes M. Chifflart's two drawings (*Faust au combat* and *Faust au sabbat*) for their excess of darkness and gloom…. But their *style* is truly fine and imposing. What a dream of chaos!… I count it to M. Chifflart's greatest credit that he has treated these poetic subjects heroically and dramatically, and that he has thrust far from him all the accepted trappings of melancholy."[2] The artist's essentially Romantic temperament was further showcased that same year in an album published by Alfred Cadart (Chifflart's brother-in-law) entitled *Oeuvres de M. Chifflart: Grand prix de Rome.*[3]

The publication of this album was to have significant consequences for Chifflart's future; it demonstrated that he could make his living creating etchings and illustrations, and it also introduced him to the novelist Victor Hugo, who had received a copy of the album. Hugo's Romantic approach to literature resonated with Chifflart, resulting in not only a lifelong friendship but also an artistic collaboration between writer and illustrator. Chifflart was responsible for the illustrated versions of *Notre Dame de Paris* and *L'Histoire d'un crime.*[4] In addition, he contributed illustrations to several of Hugo's poetry collections.[5]

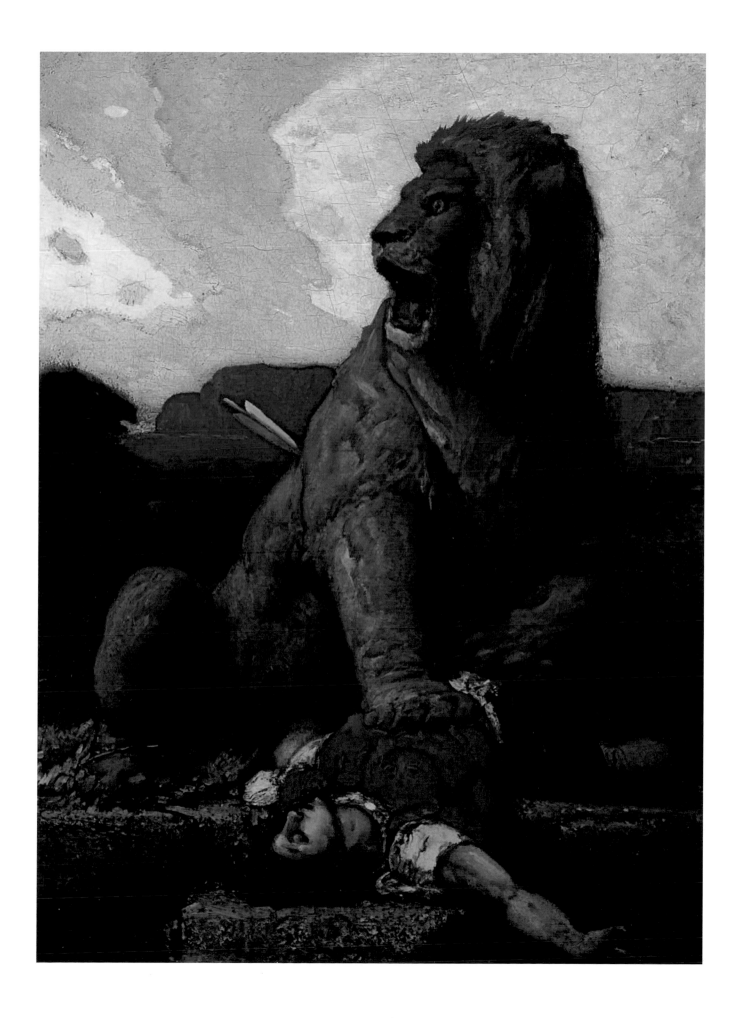

The Snite Museum painting may well have been a study for an etching in one of Hugo's late poetry collections. At the end of his life, Hugo published a series of eighteen poems written primarily for his grandchildren, Georges and Jeanne Hugo, who he was raising after the death of his son and daughter-in-law in 1871.[6] One of the poems in this collection, "Un lion avait pris un enfant," tells the tale of a lion who captured a young prince and took him back to his lair. Naturally, the prince's father is distraught at his loss and terrified that there will be no proper heir to his throne. In the midst of the furor, a knight arrives and volunteers to slay the lion.

> By came a knight
> That road, who halted, asking, "What's the fright?"
> They told him, and he spurred straight for the site!
> The beast was seen to smile ere joined they fight,
> The man and monster, in most desperate duel,
> Like warring giants, angry, huge, and cruel.
> Stout though the knight, the lion stronger was,
> And tore that brave breast under its cuirass,
> Scrunching that hero, till he sprawled, alas!
> Beneath his shield, all blood and mud and mess.[7]

Hugo's image of the slain knight, with the lion's paw on his chest, seems to correspond directly with Chifflart's painting. In addition, the arrow piercing the lion's back is consistent with the next stanza of the poem, in which "A whole battalion, sent by that sad king / With force of arms his little prince to bring, / Together with the lion's bleeding hide."[8] The sketchy quality of the background and sky also suggest that this oil painting may have been intended as the mock-up for a literary illustration. Although an illustrated version of *L'Art d'être grand-père* was never published, it seems likely that Hugo and Chifflart may have been considering a new edition in the last years of the poet's life.
—JLW

1 Charles Baudelaire, *Art in Paris, 1845–1862: Salons and Other Exhibitions*, trans. Jonathan Mayne (London: Phaidon, 1965), 183–84.

2 Ibid., 184. The two drawings referenced in Baudelaire's commentary are today known only through lithographic copies by Alfred Bahuet (1862–1910) in the Victoria and Albert Museum, London. See the Victoria and Albert Museum website at http://collections.vam.ac.uk.

3 *Oeuvres de M. Chifflart: Grand prix de Rome* (Paris: Alfred Cadart, 1859).

4 See Victor Hugo, *Notre Dame de Paris* (Paris: J. E. Hugues, 1876–77) and *L'Histoire d'un crime: Déposition d'un témoin* (Paris: C. Lévy, 1877).

5 See Victor Hugo, *Les travailleurs de la mer* (Paris: Hetzel and A. Lacroix, 1869), and *Châtiments: Seule édition complète, revue par l'auteur* (Paris: J. Hetzel, 1872).

6 *L'Art d'être grand-père* was originally published in 1877. For an English translation of the poem, see "The Epic of the Lion," in *Selections Chiefly Lyrical from the Poetical Works of Victor Hugo* (London: G. Bell, 1911), 278–89.

7 Ibid., 278–79.

8 Ibid., 279.

Attributed to Georges-Jules-Victor Clairin, 1843–1919

Turbaned Arab Wearing a Djellabah

oil on canvas

25 x 14 inches (63.50 x 35.56 cm)

Signed lower right: *DC* (added later)

Snite Museum of Art

Gift of Mr. and Mrs. Noah L. Butkin

2009.045.108

22

Provenance

Schweitzer Gallery, New York; Mr. and Mrs. Noah L. Butkin; placed on loan with the Snite Museum of Art, University of Notre Dame, 1980; converted to a gift of the estate of Muriel Butkin, 2009.

Born in Paris and trained at the École des Beaux-Arts under François-Edouard Picot (1786–1868) and Isidore Pils (cat. nos. 58–59), Georges Clairin made his Salon debut in 1866 with *Episode of a Conscript of 1813* (location unknown). Two years later, in 1868, Clairin and his friend Henri Regnault (1843–1871) traveled to Spain. There, he discovered an affinity for Moorish architecture and the Orientalist paintings of Mariano Fortuny y Marsal (1838–1874).[1] The two young painters continued their journey to Tangier, Morocco, where they hoped to live while painting the exotic North African and Arab culture surrounding them. With the outbreak of the Franco-Prussian War in 1870, however, both were required to return to Paris to join the military. Clairin went back to Morocco at the close of the war and spent the next eighteen months in Tangier, Fez, and Tétouan.[2]

Turbaned Arab Wearing a Djellabah reflects the artist's lifelong interest in North African themes and figures. Although many of Clairin's paintings from this period incorporate the frenzied staged battles known as "fantasias" and exotic harem scenes, the solitary figure in this canvas is more somber. The turbaned Arab, wearing a black *djellabah* over his white robe, pauses on a stony street as if he has seen or heard something unusual. The architectural setting behind him provides a sharp contrast between the dark recessed space to the left and the brightly lit wall on the right. What is most enigmatic, however, is the reddish light that flows around this elderly man, casting red shadows on his white robe, his face and beard, and the stones behind him. There is no overt explanation of the situation, nor is it necessarily intended to function as a narrative image; rather, it evokes a moment of troubled awareness, and perhaps sorrow, at whatever the figure is witnessing.

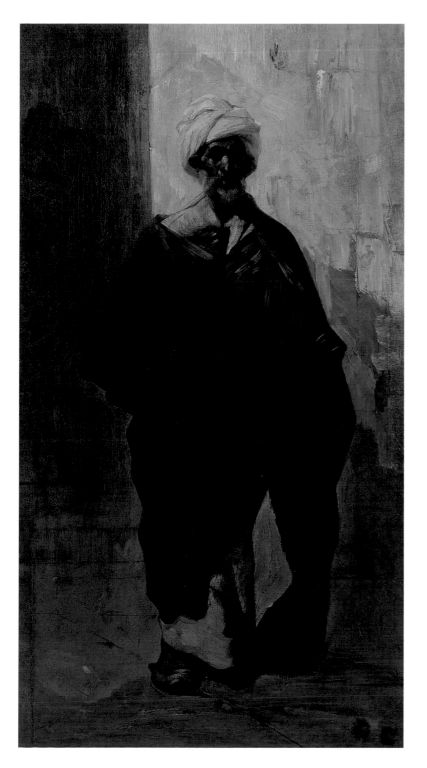

Orientalist imagery continued to be an important element in Clairin's work long after he left Morocco in 1873. Whether *Turbaned Arab Wearing a Djellabah* dates from his first sojourn in Tangier or from a later period is unknown. The mysterious environment and sorrowful mood evoked by the elderly Arab bathed in reddish light hints at a Symbolist fascination not only with exotic locales but with disquieting emotions, as well.

In later years, Clairin's work would be both more decorative and more theatrical. He was commissioned to decorate the Salon du Glacier at the Paris Opera with a cycle illustrating the twelve months of the year, and he frequently composed Orientalist genre scenes filled with multiple figures in action or seductive harems. Clairin's most famous client, however, was the actress Sarah Bernhardt, whom he painted in nearly every role she played. These works tend to be less evocative and more theatrical than *Turbaned Arab Wearing a Djellabah*. —JLW

1 The influence of Moorish architecture can be clearly seen in *Entering the Harem* (ca.1870, Walters Art Museum, Baltimore), which features the interlocking vaulting typical of the Hall of the Two Sisters at the Alhambra palace complex in Granada, Spain. This type of "stage" would reappear in Clairin's work for many decades.

2 Henri Regnault was killed during the Battle of Buzenval, just outside of Paris, and died on January 19, 1871.

Gustave Colin, 1828–1910

View of the Harbor at Saint-Jean-de-Luz, 1872
oil on canvas
31.75 x 46.50 inches (80.65 x 118.11 cm)
Signed and dated lower right: *Gustave Colin 1872*
Snite Museum of Art
Gift of Mr. and Mrs. Noah L. Butkin
2009.045.056

23

Provenance
Galerie Jacques Fischer–Chantal Kiener, Paris;
Mr. and Mrs. Noah L. Butkin, 1977; placed on
loan with the Snite Museum of Art, University
of Notre Dame, 1980; converted to a gift of the
estate of Muriel Butkin, 2009.

Gustave Colin was a frequent exhibitor at mainstream venues such
as the Paris Salon, the Salon of the Société Nationale des Beaux-
Arts, and the Exposition Universelle. He also exhibited in the
famed Salon des Refusés in 1863, and later participated in the first
Impressionist exhibition in 1874. In addition, he showed works at
provincial exhibitions organized by the Société des Amis des Arts
in Arras and Lille.[1] The provincial art societies that emerged in the
mid-nineteenth century provided regional painters with venues
where they could exhibit and, hopefully, attract the attention of
collectors.[2] There can be little doubt that the Arras-born Colin
found a sympathetic audience for his work; Count Armand Doria,
one of the leading collectors of Realist and Romantic painting in
the nineteenth century, became his principal patron.[3]

Colin's landscapes of the 1870s depict a variety of scenes drawn
from the south of France. He recorded views of the tree-lined
streets of Ciboure, in Pyrénées-Atlantiques, under the powerful
heat of a summer's day, as well as panoramas of the seaport of
Saint-Jean-de-Luz that capture the intensity of the region's light
and color. He became a regular inhabitant of this coastal town,
and is buried in a small cemetery overlooking the city.[4]

Colin was an early devotee of the dazzling light and vivid color
of the French Mediterranean coast, prefiguring the widespread
interest in the region by later nineteenth- and early twentieth-
century artists. Nowhere is his fascination with this richness of
color, light, and texture more evident than in his landscapes of
Saint-Jean-de-Luz. *View of the Harbor at Saint-Jean-de-Luz*—a
breathtaking bird's-eye perspective of the water and a boat set
against bleached-out buildings—is a masterly rendition of a
brilliant summer day. While we cannot be sure of the artist's
exact location when he painted the vista, it is clearly a view of
Saint-Jean-de-Luz harbor, perhaps seen from Sainte-Barbe.

Colin's representation of sunlight placed him in the vanguard of
the more progressive nineteenth-century landscapists. Although
this canvas cannot be linked with certainty to the paintings he
showed with the Impressionists in 1874, it is similar to what the
other Impressionists were exhibiting. The date on the canvas
appears to be 1872, but the last number could also be read as a 9,
making it difficult to precisely situate the painting in the artist's
oeuvre. During this period, Colin produced many similar scenes
of this locale, where he lived for many years.[5] —*GPW*

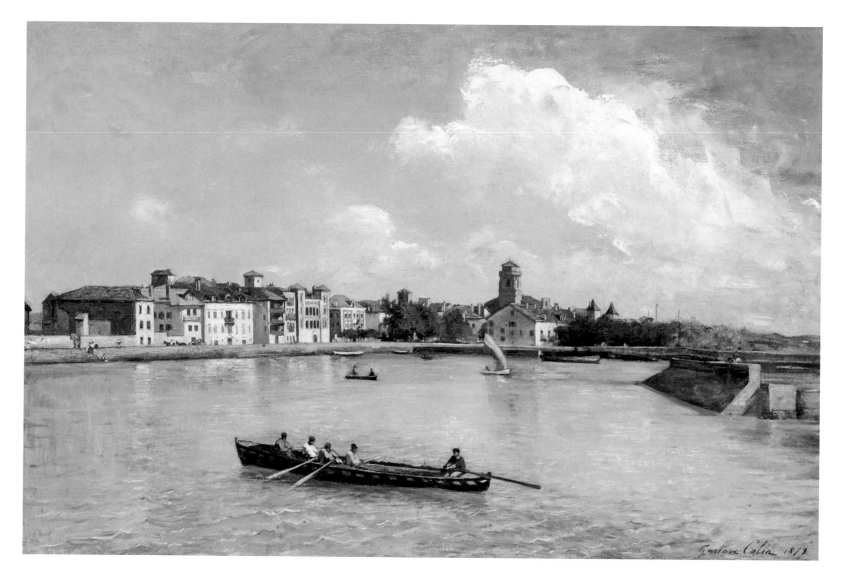

1 For further reference to Colin's participation in these shows, see Gaston-Louis Marchal and Patrick Wintrebert, *Arras et l'art au XIXe siècle* (Arras: Commission départementale d'histoire et d'archéologie du Pas-de-Calais, 1987), 60. See also Hervé Oursel, "Gustave Colin," in *Gustave Colin, 1828–1910* (Arras: Musée d'Arras, 1967), 9–14. On Colin and the Impressionists, see *The New Painting: Impressionism, 1874–1886* (San Francisco: The Fine Arts Museums of San Francisco, 1986), 120.

2 See Oursel, "Gustave Colin," 9–14.

3 Ibid., 14.

4 In the late 1970s, I visited this site and attempted, unsuccessfully, to locate descendants of the artist.

5 A painting identified as the *Baie de Saint-Jean-de-Luz*, dated on the reverse "1877," was exhibited at Hazlitt Gallery in London in the 1960s. See *Gustave Colin, 1828–1910: First London Exhibition, November–December 1969* (London: Hazlitt, 1969).

Fernand Cormon (pseudonym of Fernand-Anne Piestre),
1845–1924
The Head of Cain, ca. 1878–80
oil on canvas, with graphite
10.75 x 8.38 inches (27.31 x 21.29 cm)
Signed lower left: *F. Cormon*
Inscribed lower left: *à mon ami Le Conteau ton dévoué*
Snite Museum of Art
Gift of Mr. and Mrs. Noah L. Butkin
2009.045.088

24

Provenance
Norton B. Gardner; Mr. and Mrs. Noah L.
Butkin, 1968; placed on loan with the Snite
Museum of Art, University of Notre Dame,
1980; converted to a gift of the estate of Muriel
Butkin, 2009.

Exhibitions
*Salon de 1880—XXXIe exposition internationale
de Gand*, 1880, Gand, Belgium.

Salon de la Société des artistes français, 1880,
Paris.

Exposition Universelle, 1889, Paris.

*Vénus et Caïn: Figures de la préhistoire,
1830–1930*, 2003–04, Musée d'Aquitaine,
Bordeaux, France; Museo Nacional y Centro
de Investigacion, Altamira, Spain; and Musée
National des Beaux-Arts du Québec, Canada.

Selected Bibliography

Compin, Isabelle, and Anne Roquebert.
*Catalogue sommaire illustré des peintures du
Musée du Louvre et du Musée d'Orsay*. Paris:
Réunion des musées nationaux, 1986.

Compin, Isabelle, Geneviève Lacambre, and
Anne Roquebert. *Catalogue sommaire illustré des
peintures / Musée d'Orsay*. Paris: Réunion des
musées nationaux, 1990.

Pontsere, Jacqueline. "Peinture et dessins du
XIXe siècle, Moulins: Musée départemental."
Revue du Louvre 5/6 (1980): 344–48.

*Vénus et Caïn: Figures de la préhistoire, 1830–
1930*. Paris: Réunion des musées nationaux,
2003.

à mon ami Le Couteur
ton dévoué
F. Cormon

Fernand Cormon began his study of art in Brussels with Jean-François Portaëls (1818–1895), a painter best known for his Orientalist scenes from North Africa, but returned home to Paris in 1863 to train with Alexandre Cabanel and Eugène Fromentin (1820–1876). Cormon's modest debut at the Salon in 1868 was followed in 1870 with a medal for *Marriage of the Niebelungen* (1870, Musée des Beaux-Arts, Lisieux). During the 1870s, he explored a range of Orientalist subjects, depicting scenes from Hindu traditions as well as more typical North African genre images.[1] Having begun to establish his reputation as a successful Salon painter, Cormon embarked on a journey to Tunisia, where he could actually see the environment he had been painting for several years.

Returning to Paris in 1877, Cormon focused his attention increasingly on religious and historical images, including his monumental composition *The Flight of Cain* (1880, Musée d'Orsay, Paris).[2] Although the original source for this subject is the book of Genesis (chapter 4), Cormon referenced Victor Hugo's poem "Conscience" as a subtitle for *The Flight of Cain*:

> When with his children clothed in animal skins
> Disheveled, livid, buffeted by the storms
> Cain fled from Jehovah,
> In the fading light, the grim man came
> To the foot of a mountain in a vast plain[3]

In the final painting, he emphasized the wretchedness of Cain's tribe, fleeing from Jehovah in their ragged clothing and fully aware that they were condemned to wander forever.

In preparation for this major painting, Cormon made numerous studies and oil sketches, including *The Head of Cain* now at the Snite Museum. Earlier drawings show the progression of the composition, from the very loose pen and ink study *La fuite du Caïn* (1878, Musée du Louvre, Paris) to the more polished pen and ink drawing *Exodus of Cain's Family* (1878, Museum of Fine

Arts, Boston).[4] In both of these studies, there is a group of two or three figures in front of Cain; in the final painting, these ancillary figures are gone, leaving the isolated old man to lead his family into the wilderness alone.

The Snite Museum's oil and graphite sketch is a more detailed study of Cain's head, possibly the last preparatory drawing for the painting. Not only is it quite finished, but the graphite grid visible in the background suggests that it may have been used to transfer the image of Cain's head to the final canvas. Cormon made minor changes to the hair between the oil sketch and the painting, removing the hair tie seen in the sketch for the final composition. Also of note is the slight shift in Cain's expression, from sorrowful reflection to a more furrowed brow indicative of anxiety and exhaustion, as he leads his family into a future without hope of redemption. —*JLW*

1 Cormon's *Death of Ravana, King of Louka* (1875, Musée des Augustins, Toulouse), based on the Indian epic *Ramayana*, was unusual even within the context of French Orientalist painting. Although critics noted that the subject was obscure, the painting nonetheless received a Prix de Salon medal in 1875.

2 See Isabelle Compin, Geneviève Lacambre, and Anne Roquebert, *Catalogue sommaire illustré des peintures / Musée d'Orsay* (Paris: Réunion des musées nationaux, 1990), or an online image at http://www.musee-orsay.fr/en/collections/index-of-works.

3 "Conscience" was included in a collection of poems, *La légende des siècles*, originally published in 1859. See Victor Hugo, *La légende des siècles. La fin de Satan. Dieu*, edited by Jacques Truchet (Paris: Gallimard, 1950).

4 For online images of these early drawings, see http://arts-graphiques.louvre.fr/ for Etude pour *La fuite de Caïn* and http://www.mfa.org/collections for *Exodus of Cain's Family*.

Fernand Cormon (pseudonym of Fernand-Anne Piestre), 1845–1924

Portrait of a Young Man
oil on canvas
21.13 x 17.50 inches (53.70 x 44.50 cm)
Signed lower left: *Cormon*
Snite Museum of Art
Gift of Mr. and Mrs. Noah L. Butkin
2009.045.089

25

Provenance
Shepherd Gallery, New York; Mr. and Mrs. Noah L. Butkin, 1975; placed on loan with the Snite Museum of Art, University of Notre Dame, 1980; converted to a gift of the estate of Muriel Butkin, 2009.

Selected Bibliography
Ingres and Delacroix through Degas and Puvis de Chavannes: The Figure in French Art, 1800–1870. New York: Shepherd Gallery, 1975.

The sitter in *Portrait of a Young Man* radiates an intensity that dominates this modestly sized painting. His direct, attentive gaze, combined with the sharp contrast between bright and dark hues, creates a sense that this individual was fully present in the moment when his portrait was being painted. There can be no question that this model was someone well known to Cormon, especially since this is clearly not a portrait commissioned by a wealthy patron.

The viability of portraiture in the second quarter of the nineteenth century was under considerable strain due to the dual pressures of photography, which supplanted many portrait painters in the middle-class marketplace, and Impressionism, which challenged the bourgeois conventions of portraiture as being overly formal and academic.[1] As a professor at the École des Beaux-Arts, Cormon was committed to the principles of classically derived art education, and he certainly would have been expected to demonstrate those aesthetic standards in his own work. However, *Portrait of a Young Man* has an immediacy and intimacy that was entirely contemporary in the 1870s and '80s.

The composition is both simple and sophisticated, borrowing Édouard Manet's strategy of placing the figure against an undefined background without a horizon line as a reference point. Even more engaging is the dark silhouette of hair and jacket against the mottled golden background, creating a visual frame for the young man's face. The viewer cannot help but be curious as to his identity and his thoughts.

Although the name of this individual remains unknown, there are possibilities to consider. One is that the sitter was a student of Cormon in the 1880s, when his atelier was full of passionate young artists striving to redefine the art world in contemporary terms. Vincent van Gogh, Eugène Boch, and Henri de Toulouse-Lautrec can be ruled out because they clearly did not look like the sitter, but Henri Rachou, Louis Anquetin, and Charles Laval each shared enough of the sitter's physical characteristics to be considered as possible candidates. It is also entirely possible that the model was a young man who assisted Cormon in keeping the

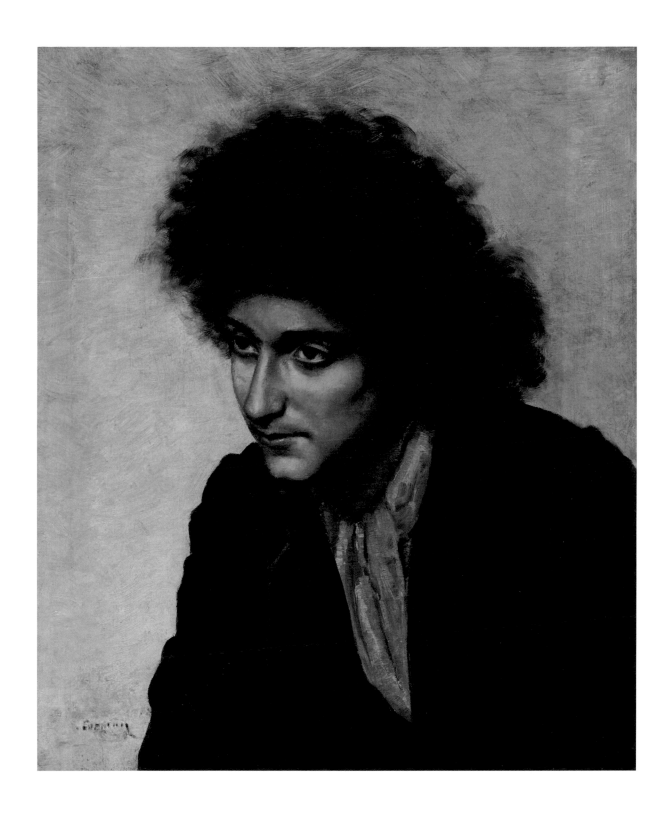

studio clean—no small task when dealing with the paraphernalia of paints, canvases, brushes, and props. He may have been an immigrant from a Mediterranean country, perhaps even one of the French colonies in North Africa. Regardless of who he was, however, his moody demeanor evokes the intensity of the Parisian art world during the early decades of the Third Republic in France. —*JLW*

1 For a further discussion of Impressionism's effect on portraiture, see Colin B. Bailey's essay "Portrait of the Artist as a Portrait Painter," in *Renoir's Portraits: Impressions of an Age* (New Haven, CT: Yale University Press in association with the National Gallery of Canada, Ottawa, 1997), 1–51.

Fernand Cormon (pseudonym of Fernand-Anne Piestre),
1845–1924
Self-Portrait, 1912
graphite on beige wove paper
4.56 x 3.13 inches (11.60 x 8 cm)
Signed and dated lower left in graphite: *F. Cormon / 1912*
The Cleveland Museum of Art
Bequest of Muriel Butkin
2009.131

26

Provenance
P. and D. Colnaghi and Co., Ltd., London;
Shepherd Gallery, New York, 1980; Mr. and
Mrs. Noah L. Butkin, Shaker Heights, Ohio;
bequest of Muriel Butkin to the Cleveland
Museum of Art, 2009.

Exhibitions
*French and Other European Drawings, Paintings,
and Sculpture of the Nineteenth Century*, 1980–
81, Shepherd Gallery, New York, cat. no. 40
(illus.).

A successful history painter, Cormon exhibited regularly at
the Salon from the 1870s until his death, and was appointed a
chevalier of the Légion d'honneur in 1880. Although a trip to
Tunisia in the mid-1870s inspired Orientalist subjects in his early
work, he is best remembered for a series of paintings that traced
the ascent of prehistoric man. Motivated in part by the publication
of Charles Darwin's *On the Origin of Species* in 1859, paintings,
sculptures, engravings, and illustrations featuring prehistoric
motifs became increasingly prolific in late nineteenth-century
Europe.[1] The discovery of Paleolithic paintings in Altamira Cave
in Spain in 1879, followed by a similar discovery in the Cave of
Pair-non-Pair in France in 1881, further fueled interest in the
subject among artists. While classical antiquity was associated
with monuments, ruins, works of art, and literature, prehistoric
archaeology provided only fragments of human existence,
allowing artists greater freedom and innovation. Cormon
dedicated numerous canvases to the march of prehistoric man
toward civilization. In his epic composition *The Flight of Cain*
(1880, Musée d'Orsay, Paris; see cat. no. 24), Cormon attempted
to reconcile the Bible with contemporary theories of evolution,
echoing endeavors during this period to promote ideas of
supernaturally guided evolution.

As his fascination with prehistoric themes increased, Cormon
immersed himself in literature on evolution, reading Darwin
as well as the studies of the French anthropologist Louis-
Laurent-Gabriel de Mortillet, who believed in universal stages
of evolution, and Jean-Albert Gaudry, the French geologist and
paleontologist who studied fossil mammalia. Between 1893
and 1897, Cormon executed a series of ten paintings and many
preparatory studies focusing on the subject of evolution for the
Muséum National d'Histoire Naturelle in Paris. In a quest to
achieve anatomical accuracy and authenticity, Cormon insisted
on working from live models, striving to capture humanity in
its most basic form. His paintings succeeded in giving artistic
expression to the archeological advances of the period.

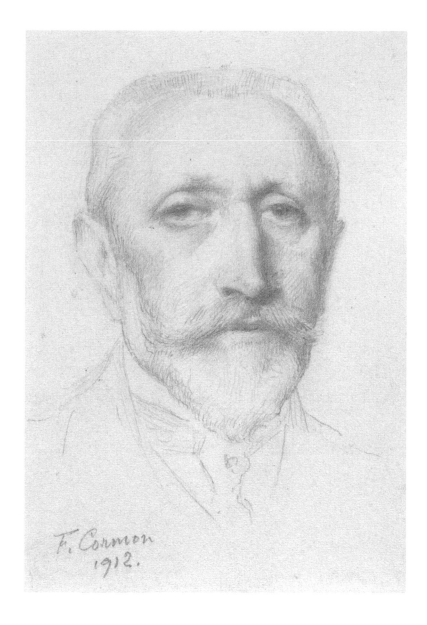

F. Cormon
1912.

Bernard. According to the somewhat fanciful reminiscences of the Scottish artist Archibald Standish Hartrick, Bernard was dismissed from Cormon's studio for his radical, expressive use of color. The eighteen-year-old Bernard painted the drab, brown background behind a model in streaks of vermilion and vert veronese. When Cormon asked the young artist what he was doing, Bernard explained that he saw it that way. His tutor replied that if that was the case, he had better go and see things that way somewhere else.[3]

In this late, modestly sized self-portrait, Cormon described himself as restrained and pensive, his heavily lidded eyes expressive of melancholy or fatigue. The delicate use of graphite suggests a drawing in silverpoint, a technique used during the Renaissance to achieve great linear purity and precision. Because silverpoint cannot be erased, such drawings were testaments of virtuosity. Fifteenth-century Netherlandish artists such as Jan van Eyck (ca. 1395–1441) and Rogier van der Weyden (ca. 1399–1464) particularly favored rendering portrait drawings in silverpoint. Cormon may have been associating himself with great artists of the past in this deceptively modest drawing. —*HL*

1 The emergence of prehistoric humankind as both a scientific discipline and a source of artistic inspiration is explored in *Vénus et Caïn: Figures de la Préhistoire*, 1830–1930 (Paris and Bordeaux: Réunion des musées nationaux and Musée d'Aquitaine), 2003.

2 Cornelia Homburg, *Vincent van Gogh and the Painters of the Petit Boulevard* (Saint Louis and New York: Saint Louis Art Museum in association with Rizzoli International, 2001), 96.

3 A. S. Hartrick, "A Painter's Pilgrimage through Fifty Years" (1939), quoted in Susan Alyson Stein, ed., *Van Gogh: A Retrospective* (New York: Hugh Lauter Levin, 1986), 81.

Cormon is equally well known for his Parisian atelier, in which he taught the fundamentals of drawing. Perhaps to his chagrin, the Atelier Cormon became a meeting place for a group of young artists who in 1884, led by Henri de Toulouse-Lautrec, painted a satirical variant of Puvis de Chavannes's *Sacred Grove* in which the muses' serenity was interrupted by an intrusion of bohemian artists—an apt metaphor for the invasion of the avant-garde into Cormon's academic studio.[2] In 1886, Vincent van Gogh (1853–1890) entered Cormon's atelier with the goal of sharpening his skills in draftsmanship. There, the Dutch artist became acquainted with Toulouse-Lautrec, Louis Anquetin, and Emile

Joseph-Désiré Court, 1797–1865

Triumphal Scene, ca. 1827
oil on canvas
15.25 x 23 inches (38.74 x 58.42 cm)
Signed lower right in red: *Court*
Snite Museum of Art
Gift of Mr. and Mrs. Noah L. Butkin
2009.045.081

27

Provenance

Sotheby Parke-Bernet, New York, *19th Century European Paintings*, May 12, 1978, cat. no. 249; Shepherd Gallery, 1978; Mr. and Mrs. Noah L. Butkin, 1978; placed on loan with the Snite Museum of Art, University of Notre Dame, 1980; converted to a gift of the estate of Muriel Butkin, 2009.

Selected Bibliography

Boime, Albert. "The Quasi-Open Competitions of the Quasi-Legitimate July Monarchy." *Arts Magazine* 59 (April 1985): 94–105.

In the 1820s, Joseph-Désiré Court was considered one of the most promising young painters of the day. He studied under Antoine-Jean Gros (1771–1835) at the École des Beaux-Arts, and won the Prix de Rome in 1821 for his painting *Delilah Delivering Samson to the Philistines*. After several years of study in Rome, he made his Salon debut in 1824, the same year in which Jean-Auguste-Dominique Ingres (1780–1867) submitted the *Vow of Louis XIII* (1824, Cathédrale Notre-Dame-de-l'Assomption de Montauban) to wide critical acclaim. Ingres's return to Paris from Italy, and his willingness to accept students into his studio, encouraged the perception that he was the "leader" of the Neoclassical painters in France at the time. Although this assessment was at least in part a creation of the Paris press, many young artists such as Court looked to Ingres for direction, if not actual instruction.

Court's 1827 submission to the Salon was the *Death of Caesar* (1827, Musée des Beaux-Arts, Arras), a painting for which an oil sketch exists at the Musée Fabre in Montpellier. The composition of this work is similar to Ingres's *Apotheosis of Homer* (1827, Musée du Louvre, Paris), also shown at the 1827 Salon. More significantly, Court employs the classical subject matter so prevalent in the years that Ingres was living and teaching in Paris; his choice of subjects changed dramatically in the 1830s, when he shifted his attention to portraiture and the modern history paintings destined for King Louis Philippe's new Museum of French History at Versailles.[1] Thus, the Snite Museum's classically inspired oil sketch *Triumphal Scene* probably dates from this period in the late 1820s.

Another aspect of Court's *Triumphal Scene* is that it is similar in height to the oil sketch for the *Death of Caesar*, although the format of the Snite Museum study is more rectangular. Again, the composition is reminiscent of Ingres's *Apotheosis of Homer*, but the subject is clearly a Roman leader being crowned with the laurel

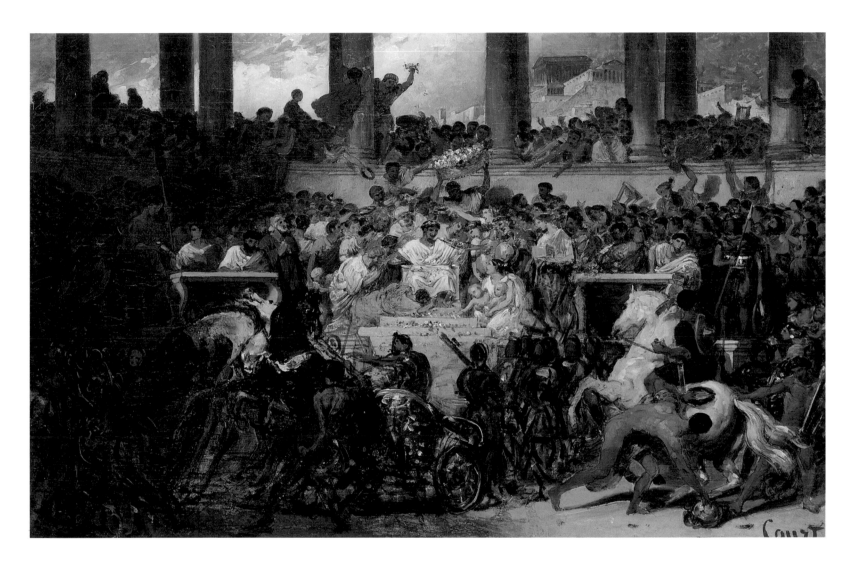

wreath of victory. His white toga and short dark hair are echoed in the study for the *Death of Caesar*, an indication that perhaps these two sketches were intended to be pendant paintings when originally conceived. Certainly, Caesar's moment of triumph and his ultimate assassination would make a logical pairing for exhibition at the Salon.[2] —*JLW*

1 For a discussion of Court's work for the government of the July Monarchy, see Albert Boime, "The Quasi-Open Competitions of the Quasi-Legitimate July Monarchy," *Arts Magazine* 59 (April 1985): 94–105.

2 An intriguing echo of Court's *Triumphal Scene* is evident in *Romans of the Decadence* by Thomas Couture (1815–1879), which was shown at the Salon of 1847. Couture's composition is close enough to Court's to raise the question of whether the younger artist may have seen the original painting.

Adrien Dauzats, 1804–1868

Spanish Landscape (Patibulo de Alicante a Villena), 1846
watercolor on white wove paper
7.81 x 10.69 inches (19.80 x 27.10 cm)
Signed lower left: *A Dauzats 1846*
Inscribed lower right: *Patibulo de Alicante a Villena*
Watermark: *J Whatman / Turkeymill / 1833*
Snite Museum of Art
Gift of Mr. and Mrs. Noah L. Butkin
2009.045.009

28

Provenance

Sotheby's, London, *19th Century European Drawings and Watercolors*, November 23, 1978; Shepherd Gallery, New York, 1978; Mr. and Mrs. Noah L. Butkin, 1978; placed on loan with the Snite Museum of Art, University of Notre Dame, 1978; converted to a gift of the estate of Muriel Butkin, 2009.

Adrien Dauzats was an untiring traveler, visiting France, Spain, Palestine, and Egypt. He accompanied Baron Isidore-Justin-Séverin Taylor on his expeditions, providing illustrations for his picturesque volumes.[1] Trained in the academic tradition, Dauzats was also a frequent exhibitor at the Paris Salons, specializing in interiors of churches and genre subjects. But it was through his illustrations for Baron Taylor's volumes that he gained his widest attention and following.

As a Romantic artist with a penchant for landscape imagery, Dauzats produced countless panoramic views of the scenery he encountered in the Near East, in France, and in Spain—where he probably saw this gallows situated in a flat valley under a leaden, cloudy sky. At the right of the sketch, a small iron cage containing a human skull is suspended on a battered square pier. A reminder of what can happen to sinners, the watercolor is a powerful warning to onlookers. —*GPW*

1 Isidore-Justin-Séverin, Baron Taylor, *Voyages pittoresques et romantiques dans l'ancienne France, 1820–1878* and *Voyage pittoresque en Espagne, en Portugal, et sur la côte d'Afrique, de Tanger à Tétouan, 1826–1862.*

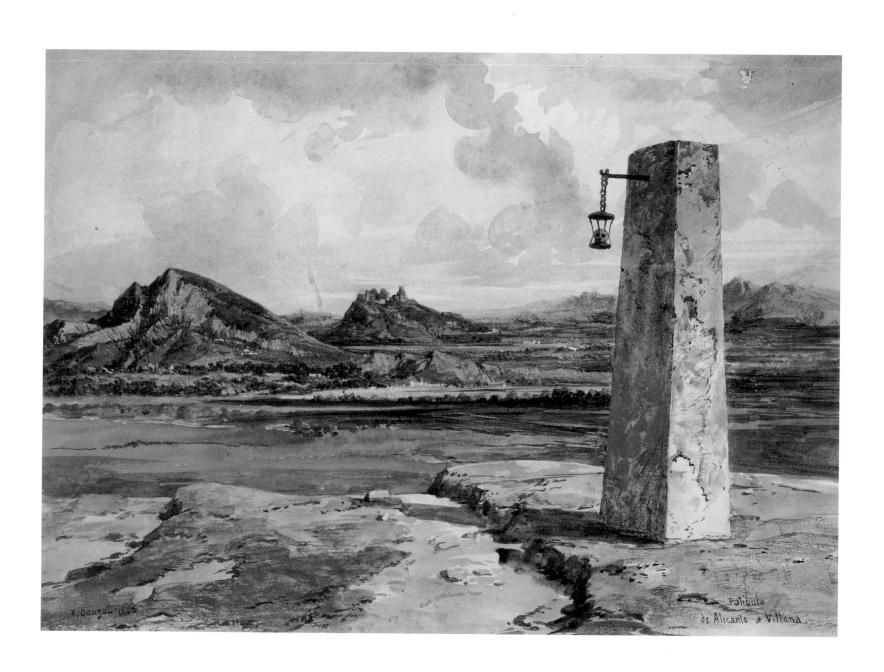

Patíbulo
de Alicante a Villena.

Alfred Dehodencq, 1822–1882

Study for "King Boabdil's Farewell to Granada," 1869
oil on canvas
22.50 x 18.25 inches (57.20 x 46.40 cm)
Inscribed on verso, center stretcher in ink: *Vente DeHodencq
no 88 / 1847*, with red sale stamp at left
Snite Museum of Art
Gift of Mr. and Mrs. Noah L. Butkin
2009.045.109

29

Provenance

Galerie Arnoldi-Livie, Paris; Mr. and Mrs.
Noah L. Butkin, 1976; placed on loan with
the Snite Museum of Art, University of Notre
Dame, 1980; converted to a gift of the estate of
Muriel Butkin, 2009.

Selected Bibliography

Rosenthal, Donald A. *Orientalism: The Near
East in French Painting, 1800–1880.* Rochester,
NY: Memorial Art Gallery of the University of
Rochester, 1982, p. 92, fig. 94.

Selected Works from the Snite Museum of Art.
Notre Dame, IN: Snite Museum of Art,
University of Notre Dame, 1987, p. 192 (illus.).

Regarded as the last significant Romantic painter, Alfred
Dehodencq entered the École des Beaux-Arts in 1839 to work
with Léon Cogniet. By 1844, he was participating in the Paris
Salon, where he exhibited a religious painting, *Saint Cecilia in
Adoration* (location unknown). Dehodencq was wounded in the
arm during the 1848 revolution and left Paris to regain his health
at Barèges, in the Pyrénées. Finding artistic reward in southern
France, he traveled to the city of Pau and then on to Madrid,
where he became increasingly mesmerized by Spanish art, life,
and culture. Aside from a brief trip to Paris in 1855, Dehodencq
remained in Spain and Morocco for fourteen years (he was
the first European artist to actually live in that North African
country; others had only visited). By 1850, he had entered the
studio of the well-established Madrazo family in Madrid where,
with their assistance, he exhibited the *Fight of the Novillos* (1850,
Musée des Beaux-Arts, Pau). In 1863, Dehodencq returned to
Paris, where he continued to exhibit until 1868. He committed
suicide in 1882.

Inspired by the works of Eugène Delacroix (1798–1863), the
master he most admired, Dehodencq moved between Spain and
Morocco in search of imagery that suited his Romantic vision.
Like Delacroix, he responded to the brilliant light and color of
the landscape, as well as to the dynamic and exotic traditions of
the Spanish and North African people. This sketch in the Snite
collection is directly related to one of his finished compositions,
L'Adieu du roi Boabdil à Grenade (fig. 1), which was exhibited
at the Paris Salon of 1869.[1] That Salon, one of the last of the
Second Empire, drew on all the artistic traditions of the century.
Dehodencq clearly wanted to secure his position as a Romantic
painter in the orbit of Delacroix (who had died in 1863). To do so,
he chose a theme that he knew well from his study of Spanish and
Moorish history during his long sojourn in the region.

Boabdil (1460–1527), the last Moorish king of Granada, was
proclaimed leader in 1482. Holding onto Granada for Spain, he
engaged in struggles with his father, the deposed king, and with
his uncle. In 1491, the Spanish rulers Isabella and Ferdinand

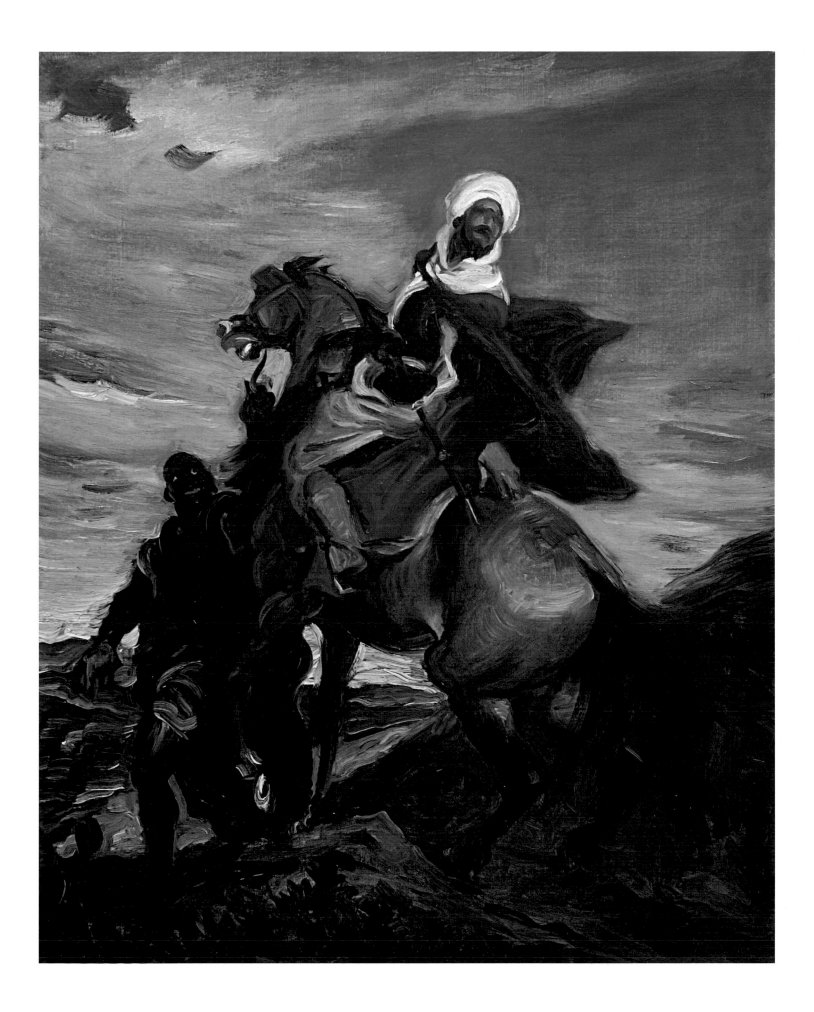

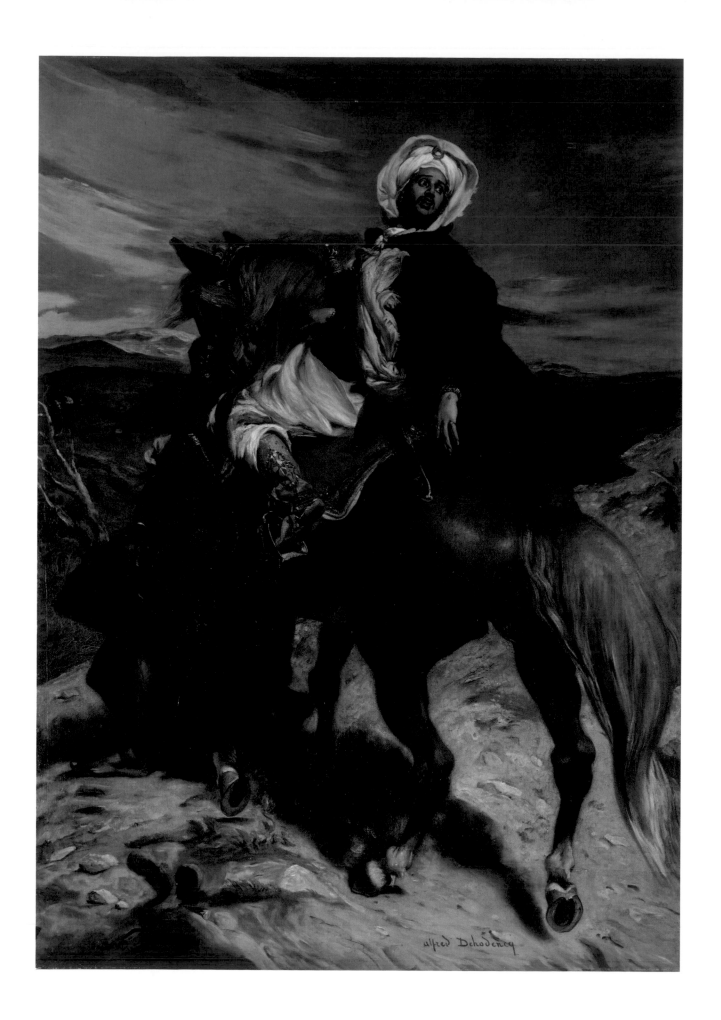

summoned Boabdil to cede Granada to them. Boabdil refused, leading to the siege of the city by the Castilians. By January 1492, Granada had surrendered, thus ending the 785-year presence of Moors in Spain; Boabdil was allowed to hold onto only a small section of Andalusia. Crossing into Africa, he was killed in battle. The location from which he longingly looked back on Granada for the last time, often cited in literature, became known as the "last sigh of the Moor." It is this particular moment that Dehodencq chose to depict in his painting.

Boabdil's anguish is palpable in the way he looks wistfully back at his lost home. The rich coloration of the finished canvas, and the frozen movement of the horse and rider stopped in their tracks, relates the image to any number of Romantic compositions by Delacroix. This early sketch demonstrates Dehodencq's process of developing his composition and color scheme before beginning the much larger Salon version, which was grand in both theme and size.[2] The French government purchased the finished painting in May 1869 for 2500 francs, a large sum of money for any painter to receive at the time.[3] Sent first to the Roubaix Museum, then to Tourcoing, it was eventually brought back from the provinces to become part of the Musée d'Orsay's collection when the museum opened in 1986.

Dehodencq's paintings attracted the attention of the avant-garde artist Édouard Manet, who had himself depicted Spanish themes even before he went to Spain in the mid-1860s. As an example of a grandiose, Spanish inspired-image, *L'Adieu du roi Boabdil à Grenade* can be directly linked to the "cult of Spain" that fascinated Manet and many other painters, including Théodule Ribot, in the closing years of the Second Empire. At the same time, Dehodencq's use of color and treatment of spatial movement reveal that he was the direct heir of Romanticism. —*GPW*

1 See the file on *L'Adieu du roi Boabdil à Grenade*, Salon of 1869, Paris, RF 1986-9, in the Documentation department at the Musée d'Orsay, Paris.

2 The Salon version measures 12.37 x 9.02 feet (3.77 x 2.75 m).

3 See RF 1986-9, Documentation department, Musée d'Orsay, Paris.

Alfred Dehodencq, 1822–1882

Portrait of the Artist's Son Edmond, ca. 1866
oil on canvas
17.25 x 12.25 inches (43.80 x 31.10 cm)
Snite Museum of Art
Gift of Mr. and Mrs. Noah L. Butkin
2009.045.124

30

Provenance
Galerie André Watteau, Paris; Mr. and Mrs. Noah L. Butkin, 1977; placed on loan with the Snite Museum of Art, University of Notre Dame, 1996; converted to a gift of the estate of Muriel Butkin, 2009.

After his arrival in Spain in 1849, Dehodencq married an Andalusian woman from Cádiz. This union, and the birth of his three sons, cemented Dehodencq's ties to Spain. Upon his return to Paris in 1863, following a prolonged stay in Morocco, Dehodencq did a number of group portraits of his family and several studies in oil and pastel of his son Edmond. He also made sketches, often in pastel, of his daughter Marie—who was born in Paris—including one now in the collection of the Stanford University Museum of Art in California.[1] The studies show his children drawing, painting, and reading, revealing that he valued their creative aptitude. In the case of Edmond, at least, Dehodencq hoped that his son would follow in his footsteps and become a professional artist. Several of his children, however, died at a young age, casting a pall over Dehodencq's home life; Marie, his youngest child, died following a bout with meningitis, leaving him distraught. The gifted young Edmond began painting at age six, and exhibited at the Salon from 1873 until his untimely death at age twenty-seven.

The Snite Museum piece portrays Edmond as a young boy, sitting and painting in front of an open paint tray. Dehodencq shows his son's curiosity and innocence as he engages in a tradition already well established in the family. Capturing the intimacy of the moment and a sense of childhood inquisitiveness, the work underscores the hope and enthusiasm that Dehodencq felt in recording his children's evolution toward maturity. The painting also shows the Romantic artist's growing association with Realists such as François Bonvin and Théodule Ribot, who emphasized family life and values in numerous images of children reading, singing, or painting. —*GPW*

1 See Lorenz Eitner, Betsy G. Fryberger, and Carol M. Osborne, *The Drawing Collection* (Stanford, CA: Stanford University Museum of Art, 1993), 218.

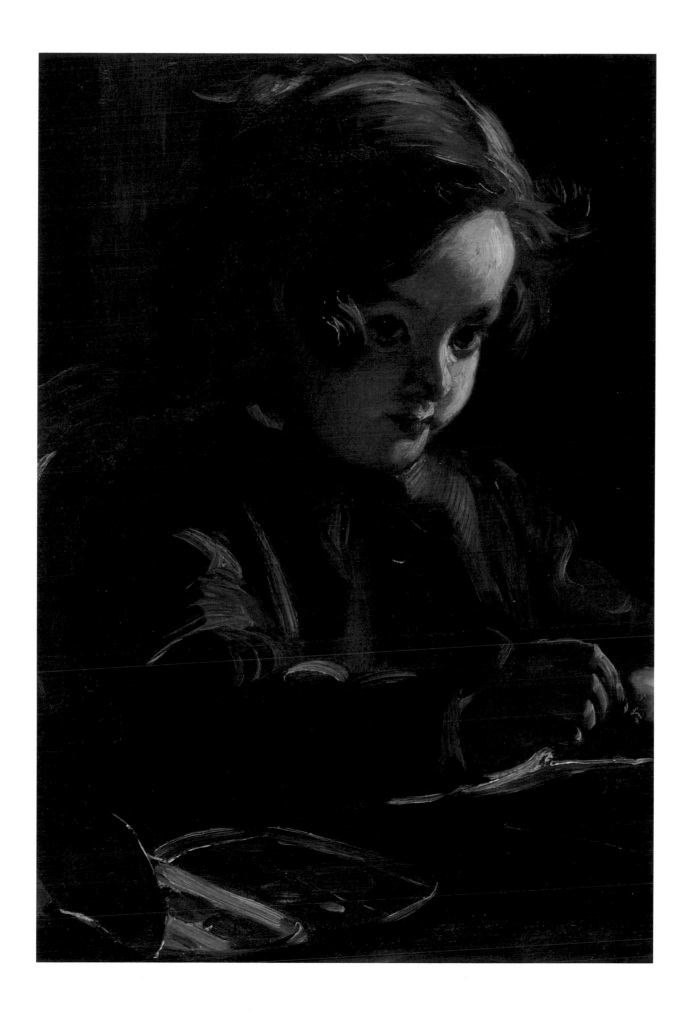

Circle of Eugène Delacroix, 1798–1863

Horatio Defending the Bridge
oil on canvas
26.75 x 37.50 inches (67.95 x 95.25 cm)
Inscribed on verso, upper left of stretcher bar, typed on a white
label: "*Horatio Defending the Bridge* on canvas: 27 x 37""
Inscribed on verso, upper right of stretcher bar, in blue ballpoint
pen on a white sticker: *147/545*
Snite Museum of Art
Gift of Mr. and Mrs. Noah L. Butkin
2009.045.052

31

Provenance
Viollet-le-Duc, France; Roswell D. Sawyer,
New York; Mrs. Jonathan Sawyer, Dover,
New Hampshire; Frank S. Bradley, Dover,
New Hampshire; T. Gilbert Brouillette (art
dealer), New York; posthumous gift, May
22, 1957, to Mead Art Gallery, Amherst,
Massachusetts; Mr. and Mrs. Noah L. Butkin,
1976; placed on loan with the Snite Museum
of Art, University of Notre Dame, 1979;
converted to a gift of the estate of Muriel
Butkin, 2009.

Exhibitions
Lent by Roswell D. Sawyer, ca. 1880, to the
Metropolitan Museum of Art, New York.

National Academy of Design, New York.

Selected Paintings, 1952, Brooks Memorial Art
Gallery, Memphis, Tennessee, cat. no. 11.

Eight Staten Island Collectors, 1955, Staten
Island Museum, New York, cat. no. 18.

Selected Paintings, 1955, Museum of Fine
Arts, Little Rock, Arkansas, cat. no. 15.

Selected Bibliography
Eight Staten Island Collectors. New York:
Staten Island Museum, 1955, cat. no 18.

Selected Paintings. Memphis: Brooks Memorial
Art Gallery, 1952, cat. no. 11.

Selected Paintings. Little Rock, Arkansas:
Museum of Fine Arts, 1955, cat. no. 15.

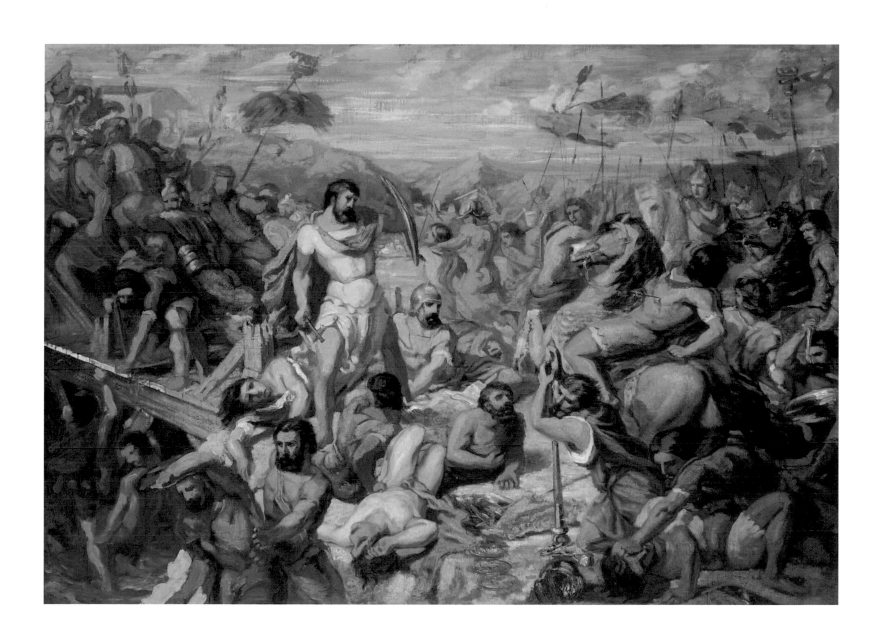

The theme of *Horatio Defending the Bridge* places this oil sketch squarely within the Neoclassical tradition of academic history painting in early nineteenth-century France. Although the artist is unidentified, the choice of an ancient Roman military battle as a subject strongly suggests that he was trained at the École des Beaux-Arts in Paris, and that he studied with one of the followers of Jacques-Louis David (1748–1825). The sculptural modeling of the figures, despite the inevitably unfinished quality of a sketch, is consistent with the École's educational practice of drawing from plaster casts of classical sculptures. It is also typical of the Neoclassical style advocated by David and his associates.

Equally significant is the choice of subject, Horatio's defense of the Roman Republic at the Pons Sublicius in the late sixth century BCE. According to the ancient story, Rome was under threat from the army of Lars Porsena, the Etruscan king of nearby Clusium. Having dispatched one garrison of Roman soldiers, the Clusium army headed toward the Pons Sublicius, the bridge located at a vulnerable bend in the Tiber River. Strategically, a victory at the bridge meant easy access into the city of Rome. However, three Roman officers stood their ground on the bridge, allowing their troops to pass safely within the walls of Rome while battling the invaders single-handedly to a draw. Two of those officers were senior commanders who followed the lead of a junior officer, Publius Horatius, whose fierce defense of the Republic had already been tested in an earlier battle where he lost an eye. Although improbable in its specific details, this tale of courage and heroism was repeated by many credible ancient sources.[1]

Early nineteenth-century French painters were accustomed to referencing ancient Greek and Roman tales in order to make political arguments about the civic affairs of their own time. One celebrated example was David's Neoclassical work *The Oath of the Horatii* (1784, Musée du Louvre, Paris), which appeared to narrate the story of the Horatii family's vow to fight to the death in order to protect the Roman Republic, but which was in fact a rallying cry for the republican forces of France as they contemplated the possibility of revolution.[2] Similarly, Théodore Géricault's *Raft of the Medusa* (1819, Musée du Louvre, Paris) was ostensibly a dramatic tale of rescue at sea, but in reality a condemnation of the corruption and venality of the French government in covering up the craven behavior of aristocratic naval officers. Because both David and Géricault (1791–1824) seem to have been major influences on the painter of *Horatio Defending the Bridge*, it is reasonable to wonder if there was a now lost political meaning to this image.

The more Romantic stylistic elements of this painting are seen in the sense of drama and the unapologetic presentation of dead and dying soldiers. The seminude dead man falling off the Pons Sublicius, for example, is clearly based on a similar figure in Géricault's *Raft of the Medusa*, as is the prominent diagonal composition. Likewise, the rearing horses recall the paintings of both Géricault and Eugène Delacroix, as well as the Baroque imagery of Peter Paul Rubens (1577–1640) in works such as *Henri IV at the Battle of Ivry* (1590, Uffizzi Gallery, Florence). The classical, Baroque, and contemporary sources for a painting like *Horatio Defending the Bridge* are inexorably intertwined. Any artist trained at the École des Beaux-Arts in the early decades of the nineteenth century would have been well versed in the aesthetic, literary, and historical developments of Western art, and if he was lucky enough to study in Rome, his direct knowledge of Italian sources would have been even deeper.
—JLW

1 The primary ancient sources for the story of Publius Horatius are Dionysius of Halicarnassus, *The Roman Antiquities* 5 (Cambridge, MA: Harvard University Press, 1986), 1–39; Gaius Plinius Secundus [Plinius Major], *Natural History*, book 34.11 (London: Loeb Classical Library Series, 1961–71); and Livy, *The History of Rome* 1–2 (London: Dent, 1912).

2 Since students who trained at the École des Beaux-Arts were well schooled in classical literature, the artist of the Snite Museum painting may have intended to connect the figure of Horatio to the Horatii family depicted by Jacques-Louis David.

Sébastien Dulac, 1802–after 1851
The Model Cooking, 1832
oil on canvas
23.50 x 19.25 inches (59.70 x 48.90 cm)
Signed and dated lower right in black oil: *Dulac . 1832*
Snite Museum of Art
Gift of Mr. and Mrs. Noah L. Butkin
2009.045.113

32

Provenance
David Daniels, New York; Shepherd Gallery,
New York; Mr. and Mrs. Noah L. Butkin, 1976;
placed on loan with the Snite Museum of Art,
University of Notre Dame, 1980; converted to
a gift of the estate of Muriel Butkin, 2009.

Exhibitions
Paris Salon, 1833.

*Ingres and Delacroix through Degas and Puvis de
Chavannes: The Figure in French Art*, May 20–
June 28, 1975, Shepherd Gallery, New York.

*The Artist and the Studio in the Eighteenth and
Nineteenth Centuries*, 1978, The Cleveland
Museum of Art.

Raphael et l'art français, November 15, 1983–
February 11, 1984, Galeries Nationales du
Grand Palais, Paris.

Selected Bibliography
Bellier de la Chavignerie, Émile. *Dictionnaire
général des artistes de l'école française.* Paris:
Librarie Renouard, 1838, vol. 1, p. 172.

*Les salons retrouvés: Éclat de la vie artistique
dans la France du Nord, 1815–1848.* Vol. 2,
*Répertoire des artistes ayant exposé dans les
salons du nord de la France (1815–1848).* Lille:
Association des conservateurs des musées du
Nord-Pas-de-Calais, 1993, p. 197 (illus.).

Raphael et l'art français. Paris: Réunion des
musées nationaux, 1984.

*Salon explication des ouvrages de peinture,
sculpture, architecture, gravure, et lithographie.*
Paris, 1833, cat. no. 762.

Zakon, Ronnie L. *The Artist and the Studio
in the Eighteenth and Nineteenth Centuries.*
Cleveland: The Cleveland Museum of Art,
1978, p. 59, cat. no. 29.

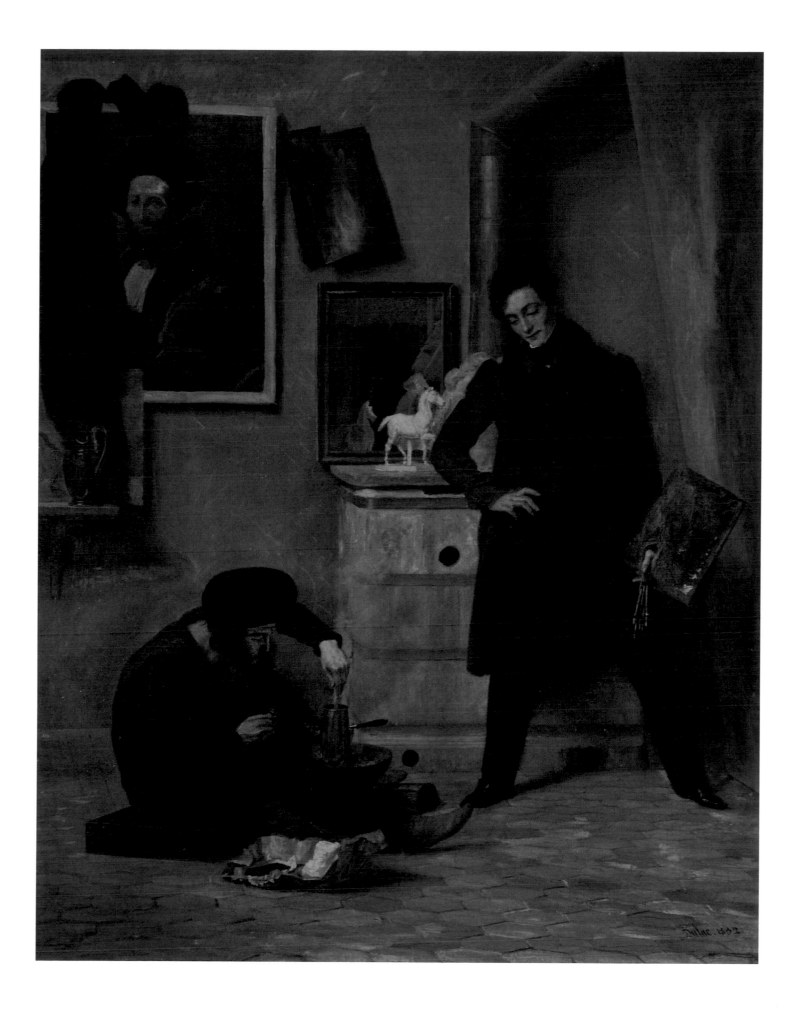

The subject of the artist's studio has a long history, dating at least as far back as the early 1600s. Jacob van Oost's painting *The Artist's Studio* (1666, Groeninge Museum, Bruges) is a typical example of the casual and humorous approach that artists have often employed in portraying their own workspaces. In that image, several small children pretend that they are responsible for the sophisticated drawing on display, while a stray piece of a sculpted big toe juts into the composition from the lower right corner. Other painters have taken a more pragmatic attitude, showing a realistic image of themselves at work; Jan Vermeer's *Artist's Studio* (1665–66, Kunsthistorisches Museum, Vienna) and George Morland's *Artist in His Studio & His Man Gibbs* (ca. 1802, Nottingham City Museums and Galleries) both illustrate the studio space in which the artists worked.

In the nineteenth century, there were an increasing number of depictions of artists' studios, reflecting the changing definition of the artist as a bohemian genius rather than an economically secure, professional creator of culture.[1] Horace Vernet's raucous painting *The Artist's Studio* (1820, private collection) suggests that painters not only work at their easels, but also duel with each other while half-nude models and live horses and dogs stand idly by, waiting to be drawn, painted, or sculpted. Vernet's image is full of entertaining exuberance, but nonetheless conveys one aspect of the spirit of Romanticism during the Restoration period.

Sébastien Dulac's painting *The Model Cooking* is very much a part of this witty tradition of the representation of the studio. Like Van Oost, Dulac takes an amused pose, as the artist (presumably Dulac himself) is forced to interrupt his work on a sizeable canvas while his model takes a break to reheat some hot chocolate. On the wall in the background is a copy of Raphael's *Portrait of Baldassare Castiglione* (1514–15, Musée du Louvre, Paris), a gently ironic comment on the commonplace activity of creating art. Castiglione was the author of the 1528 book *The Courtier*, which described how to become an ideal gentleman.[2] Needless to say, Dulac's attempt at creating a gentlemanly environment has been lost on his "cooking model."

It seems likely that the inclusion of Raphael's portrait also has a more serious meaning for Dulac. He shows himself dressed in the same harmonious but subtle browns, grays, and blacks that Castiglione wears, albeit updated for the 1830s, and he draws a parallel between himself and the portrait in his organization of the composition; both Dulac and Castiglione face left, while the self-absorbed model faces right. The model is totally engrossed in his task, completely unaware of the amused observation by both his employer and the figure in the painting on the wall behind him. Dulac thus associates himself directly with the gentlemanly courtier represented by both Castiglione and his portraitist, Raphael. Finally, it might be noted that a significant portion of Dulac's commissions at this time were portraits, thus establishing another connection between himself and the Italian Renaissance master.

Although little is known of Dulac's biography, his fashionably somber clothing and the presence of a plaster copy of a horse sculpture by Théodore Géricault both intimate that Dulac saw himself as a Romantic artist. His studio is not lavish, but it appears quite comfortable for an artist in the early years of his career. Further, he seems to have been a reasonably successful painter in the early 1830s. He exhibited *The Model Cooking* at the Salon of 1833, along with ten portraits and two other paintings: a religious image titled *L'Ange gardien* and another interior genre scene called *Interieur d'un pensionnat.*[3] —JLW

1 The Compton Verney Gallery, in Warwickshire, England, developed an exhibition exploring the images of artists' studios in 2009. Entitled *The Artist's Studio* (September 26, 2009–December 13, 2009), the exhibition then traveled to the Sainsbury Centre for Visual Arts at the University of East Anglia, Norwich (February 9, 2010–May 23, 2010). For further information, see Giles Waterfield and Anthonia Harrison, *The Artist's Studio* (Norwich, England: Sainsbury Centre for Visual Art, University of East Anglia, 2009).

2 See *Raphael et l'art français* (Paris: Réunion des musées nationaux, 1984), 108.

3 The last record of Dulac's work is his presence at the Salon of 1851, and thus his death date can only be estimated as "after 1851." See *Raphael et l'art français*, 108.

Fig. 1. Théodore Rousseau (1812-1867), *Landscape with a Stream*, chalk on paper, 10.38 x 17 inches (26.47 x 43.18 cm), Snite Museum of Art, 1976.040

Jules Dupré, 1811–1889

Fallen Trees in the Berry Region, 1834
black crayon with highlights of white chalk and watercolor
17.75 x 24.75 inches (45.09 x 62.87 cm)
Signed and dated lower right: *Jules Dupré 1834*
Inscribed lower left in black: *Lugt 421*
Collection stamp at lower left: *A. Beurdeley*
Snite Museum of Art
Gift of Mr. and Mrs. Noah L. Butkin
2009.045.015

33

Provenance

Hôtel Drouot, Paris, sale Dupré atelier, January 30, 1890, cat. no. 134; Hôtel Drouot, Paris, Beurdeley sale, June 3–4, 1920, cat. no. 130; Palais d'Orsay, Paris, sale May 16, 1979, cat. no. 115; Mr. and Mrs. Noah L. Butkin, 1979; placed on loan with the Snite Museum of Art, University of Notre Dame, 1979; converted to a gift of the estate of Muriel Butkin, 2009.

Exhibitions

Exposition du centenaire de l'art français, 1889, Paris, cat. no. 201.

Exposition de l'art français, 1912, Saint Petersburg, cat. no. 253, *Paysage dans le Berry*.

Jules Dupré, 1811–1889: A Loan Exhibition, September 9–October 21, 1979, The Dixon Gallery and Gardens, Memphis, Tennessee.

Selected Bibliography

Aubrun, Marie-Madeleine. *Jules Dupré, 1811–1889: Catalogue raisonné de l'oeuvre peint, dessiné et gravé*. Paris: Léonce Laget, 1974.

Jules Dupré traveled throughout the countryside with his colleague and friend Théodore Rousseau, looking for natural sights that they could sketch on the spot and then develop into paintings. This new approach to painting from nature was characteristic of the Barbizon school, which in the 1830s revived the landscape tradition of the seventeenth-century Dutch masters. As part of this group, Dupré and Rousseau captured vibrant impressions of light, subtle atmospheric conditions, and unusual views of the countryside. At one time they shared a studio, and they often painted side by side outdoors, developing a collaborative approach to creativity that would later be shared by the Impressionists; Claude Monet and Auguste Renoir, for example, likewise painted the same landscapes simultaneously.

Both Dupré and Rousseau worked in the Berry region, in the central part of France, during the 1840s. In this chalk drawing, Dupré records a dramatic scene of a large fallen tree, either cut down by human hands or uprooted by the force of a violent storm. Sensitive to shifting light effects, he recreates the gentle movement of silky clouds across the sky, adding a sense of delicacy to the composition. A work by Rousseau in the Snite Museum collection makes an interesting comparison with Dupré's chalk drawing (fig. 1).[1] Both are set in the Berry region and both use a low horizon line, reinforcing the close working ties between the artists.

The importance of Dupré's drawing is confirmed by the stamp of Alfred Beurdeley in the lower left corner, attesting to the fact that it was once in his collection during the nineteenth century. Beurdeley was a sophisticated and careful connoisseur of drawings and prints, whose collection assured the provenance of a given work. —*GPW*

1 See Michael Schulman, *Théodore Rousseau: Catalogue raisonné de l'oeuvre graphique* (Paris: Editions de l'Amateur, 1997), cat. no. 284, *Pacage et marais dans la Plaine de Soutteraine dans le Berri*. This work is in the Snite Museum's collection but was not a Butkin gift.

François-Xavier Fabre, 1766–1837

Marius and the Gaul, 1796
oil over ink on paper, mounted on canvas
12.13 x 14.63 inches (30.80 x 37.10 cm)
Inscribed on back: *Fait par Fabre en 1796* (Made by Fabre in 1796)
Label on back: *Mario / No 29 - No 8*
Snite Museum of Art
Gift of Mr. and Mrs. Noah L. Butkin
2009.045.062

34

Provenance

P. & D. Colnaghi (Old Master Trading), Ltd., 1978; Mr. and Mrs. Noah L. Butkin, 1978; placed on loan with the Snite Museum of Art, University of Notre Dame, 1980; converted to a gift of the estate of Muriel Butkin, 2009.[1]

Exhibitions

Consulate-Empire-Restauration: Art in Early XIX Century France, April 21–May 28, 1982, Wildenstein, New York.

La Grande Manière: Historical and Religious Painting in France, 1700–1800, 1987–88, Memorial Art Gallery of the University of Rochester, Rochester, New York; Jane Voorhees Zimmerli Art Museum, New Brunswick, New Jersey; High Museum of Art, Atlanta, Georgia.

Selected Bibliography

Autour de David. Lille: Musée des Beaux-Arts de Lille, 1983.

Bordes, Philippe. "François-Xavier Fabre, 'Peintre d'Histoire, I.'" *The Burlington Magazine* 118, no. 863 (February 1975): 91–98.

————. "François-Xavier Fabre, 'Peintre d'Histoire-II.'" *The Burlington Magazine* 118, no. 864 (March 1975): 155–62.

Consulate-Empire-Restauration: Art in Early XIX Century France. New York: Wildenstein, 1982.

Rosenthal, Donald A. *La Grande Manière: Historical and Religious Painting in France, 1700–1800.* Rochester, NY: Memorial Art Gallery of the University of Rochester, 1987, pp. 92–93.

1789: French Art during the Revolution. New York: Colnaghi, 1989, pp. 180–82, cat. no. 20.

Unlike many of his artistic colleagues, François-Xavier Fabre spent most of his career in Italy, which is undoubtedly where he painted the oil sketch *Marius and the Gaul*. Fabre's early education at the Montpellier Art Academy was followed by more sophisticated training in the studio of the Neoclassical painter Jacques-Louis David in Paris, where he won the Prix de Rome in 1787. Once he completed his studies in Rome, Fabre chose to move to Florence in 1793 rather than return to Paris, where the French Revolution posed many challenges for someone with his royalist political views.

The decision seems to have been a happy one, as Fabre quickly found both friends and patrons among Florentine society. His work consisted primarily of portraits—for both local aristocrats and wealthy tourists—and classical landscapes in the tradition of Claude Lorrain (1604–1682) and Nicolas Poussin (1594–1665). The Neoclassicism that he learned in David's studio remained the foundation of Fabre's work, although his religious and historical paintings become less frequent over the years. However, he seems to have begun at least two classical history paintings in 1796. One is *Oedipus and Antigone*, known only through a small sketch in which the grieving Antigone weeps on Oedipus's lap, as he sits stoically against a rocky background.[2] The composition, as well as the dark backdrop and reddish-orange robe, echo elements in the painting *Marius and the Gaul* from the same year. Both works depict classical subjects; both were done as oil sketches on top of ink drawings on paper, which were subsequently mounted on canvas; and both date to 1796, thus highlighting Fabre's continuing interest in developing major classical themes.

In the case of *Marius and the Gaul*, the Snite's small oil sketch can be documented as a preliminary study for a larger painting that was purchased by Lord Holland, an English aristocrat who was part of the international community in Florence. The opportunity to create a classical history painting for a knowledgeable patron was undoubtedly appreciated by Fabre, who would go on to paint additional classical subjects for Lord Holland after completing *Marius and the Gaul*.[3]

The subject of *Marius and the Gaul* is the Roman Republican general Marius, who was forced into an untenable political position by the maneuverings of his rival, Sylla (or Sulla).[4] As a result of these complex machinations, Marius was sentenced to death in 89 BCE. Fabre chose to illustrate the moment in the story when the Roman soldier arrived to execute Marius but was forced to flee the scene without carrying out his task; the intensity and power of Marius's gaze so overwhelmed and shamed him that he was rendered incapable of completing his duty. This episode is part of a tangled and complicated tale full of intrigue, treachery, and misguided attempts to maintain honor, a state of affairs in the ancient Roman Republic that was entirely similar to the situation in revolutionary France.

One of the most curious aspects of Fabre's work is that he chose the same subject as another of David's former pupils, Jean-Germain Drouais (1763–1788), whose large painting *Marius at Minturnae* was completed in 1786. Both Drouais's and Fabre's works are clearly influenced by David's *Oath of the Horatii* (1784, Musée du Louvre, Paris), but the similarity between the two later paintings suggests that Fabre had seen the Drouais painting at the French Academy in Rome, where it was exhibited in 1786. In both cases, the themes of courage in the face of death and choosing to follow one's deepest principles reflect the preoccupations of many Neoclassical artists during this period of political turmoil and strife.

Fabre remained in Florence until 1824, when his mistress, Princess Louise of Stolberg-Gedern, Countess of Albany, died and left him her fortune. At age fifty-six, Fabre returned to his hometown of Montpellier, where he established an art school, continued to paint, and created the collection of artworks that became the foundation of the Musée Fabre, which was inaugurated in 1828. —JLW

1 The provenance of the small oil sketch *Marius and the Gaul* has occasionally been confused with the provenance of the large completed painting of the same subject that was reliably documented as part of Lord Holland's art collection in London from 1796 until World War II. That painting then passed by inheritance to Lady Tessa Agnew (formerly Viscountess Galway). Philippe Bordes documents this information through the Holland House Papers, MS 51637, fols. 54–55, which are now in the British Library Archives (formerly British Museum). He also notes: "Unfortunately, the picture, last seen a few years ago at Melbury [House], Dorset, has been momentarily misplaced." That note was written in 1975, but the painting is still apparently "misplaced." See Philippe Bordes, "François-Xavier Fabre, 'Peintre d'Histoire-II,'" *The Burlington Magazine* 118, no. 864 (March 1975): 156n5.

2 *Oedipus and Antigone* was sold at Drouot Richelieu, salles 5 & 6, in Paris on Friday June 28, 2002, cat. no. 131. It is now in a private collection. This sketch is done in oil on paper, mounted on canvas, as is the Snite's Butkin collection sketch *Marius and the Gaul*.

3 Bordes, "François-Xavier Fabre, 'Peintre d'Histoire-II,'" 155–62. In this article, Bordes details the cordial relationship between Lord Holland and Fabre, noting: "On 10 May 1796, he [Fabre] announced to Lord and Lady Holland, who had returned to London the preceding month, that their painting was finished." Bordes also records that Lord Holland ordered another classical history painting after receiving *Marius and the Gaul*. The subsequent painting was *Theseus and Ariadne at the Entrance to the Labyrinth*, and it was completed in June 1797. Bordes, "François-Xavier Fabre, 'Peintre d'Histoire-II,'" 156.

4 The source for the story of Marius is Plutarch, *Lives of the Noble Grecians and Romans*, ed. Arthur Hugh Clough (Oxford: Benediction Classics, 2010).

Hippolyte-Jean Flandrin, 1809–1864
Studies for the Chapel of Saint John the Evangelist, Church of Saint-Séverin, Paris, 1839–40
Snite Museum of Art
Gift of Mr. and Mrs. Noah L. Butkin

35 *The Calling of Saint John*
oil on canvas, mounted to panel and cardboard
11 x 8.63 inches (27.90 x 21.90 cm)
Signed lower right: *Hte Flandrin*
2009.045.082

36 *The Martyrdom of Saint John*
oil on canvas, mounted to panel and cardboard
11.75 x 8.63 inches (29.80 x 21.90 cm)
Signed lower right: *Hte Flandrin*
2009.045.083

37 *Saint John on Patmos*
oil on canvas, mounted to panel and cardboard
11.75 x 9.13 inches (29.80 x 23.20 cm)
Signed lower left: *Hte Flandrin*
2009.045.084

38 *The Last Supper*
oil on canvas, mounted to panel and cardboard
11 x 9.13 inches (27.90 x 23.20 cm)
Signed lower right: *Hte Flandrin*
2009.045.085

Provenance
Sotheby Parke-Bernet, New York, sale 4161, October 13, 1978, cat. no. 211; Shepherd Gallery, New York, 1978; Mr. and Mrs. Noah L. Butkin, 1978; placed on loan with the Snite Museum of Art, University of Notre Dame, 1980; converted to a gift of the estate of Muriel Butkin, 2009.

Exhibitions
Christian Imagery in French Nineteenth Century Art, 1789–1906, May 20–July 26, 1980, Shepherd Gallery, New York.

Les élèves d'Ingres, October 8, 1999–January 2, 2000, Musée d'Ingres, Montauban, France; January 29–May 8, 2000, Musée des Beaux-Arts et d'Archéologie, Besançon, France.

Selected Bibliography
Delaborde, Henri. *Lettres et pensées d'Hippolyte Flandrin*. Paris: H. Plon, 1865.

Hippolyte, Auguste et Paul Flandrin: Une fraternité picturale du XIXe siècle. Edited by Jacques Foucart. Paris: Réunion des musées nationaux, 1985.

La revue de l'art, ancien et moderne 32 (July–December 1912): 224–25, 229.

Les élèves d'Ingres. Montauban: M. H. Lavallée and G. Vigne, 1999.

Rosenthal, M. "La conservation des peintures dans les églises parisiennes," *Bulletin de l'art français* 4e (1907): 111–12.

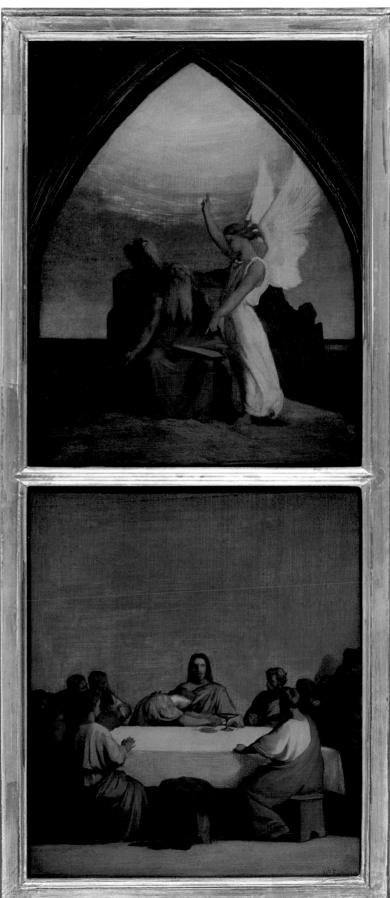

Fig. 1. Church of Saint-Séverin, Paris. Photograph by Suzanne Nagy.

Hippolyte-Jean Flandrin began his career in earnest when he returned to Paris in 1838, after five years of study as a Prix de Rome winner at the Villa Medici in Rome. He had received his basic art education in his hometown of Lyon, and then moved to Paris with his brother, Paul, in 1829 to study with Jean-Auguste-Dominique Ingres at the École des Beaux-Arts. There can be no doubt about the importance of Ingres's influence on the Flandrin brothers, but Hippolyte's years in Rome also acquainted him with the masters of the Italian Renaissance; in particular, the many frescoes at the Vatican provided a continual source of inspiration and reflection. In fact, Flandrin's first foray into a major religious commission was *Saint Claire Healing the Blind* (1837, Cathedral of Nantes), which he sent to the Paris Salon in 1837.

On his return to Paris, Flandrin's first major commission was for a series of murals in the Chapel of Saint John at the Church of Saint-Séverin, in the Latin Quarter (fig. 1).[1] Projects such as this were controlled by the Prefect of the Seine and had consistently been awarded to Prix de Rome winners when they returned from their studies in Italy; Flandrin was therefore the most likely person to receive this particular project. The subjects for the murals, which had already been chosen by the parish clergy in cooperation with the prefecture, were the Calling of Saint John, the Martyrdom of Saint John, the Last Supper, and Saint John on Patmos.[2] Flandrin probably created the four oil paintings in the Snite Museum collection to show the client how the final compositions would appear on the walls of the chapel (cat. nos. 35, 36, 37, 38).

The challenges of painting murals in a Gothic church like Saint-Séverin were significant, especially for a young painter without previous experience in this type of project. The building itself presented the greatest obstacle. Located just a few blocks from the Seine River, the church was often damp and chilly. In addition, the lighting conditions were less than ideal. Most difficult of all was deciding how to successfully create murals on stone walls that were prone to be somewhat moist. Unlike the Renaissance frescoes of Italy, which were painted with tempera pigment on plaster walls in a warm climate, the murals at Saint Séverin would require a medium that could resist the humidity of Paris.

Fortunately for Flandrin, the July Revolution of 1830 had ushered in more liberal social and political policies that resulted in an increased number of opportunities for religious artwork.[3] Beginning in 1831, there was a flurry of commissions for religious paintings and sculptures, including the completion of the Chapel of the Virgin at Saint Thomas Aquinas, beginning in 1831; the Christian decoration of La Madeleine, beginning in 1835; and the redecoration of the Gothic church of Saint-Méry from 1840 to 1843.[4] The most important of these commissions, from Flandrin's perspective, was the burst of activity in painting religious decorations for the new Church of Notre-Dame-de-Lorette. Painters there had experimented with hot wax (encaustic) as a medium for creating a smooth, matte surface on the stone walls. Once it had dried onto the walls, the encaustic provided a smooth, light-colored surface that could be painted with pigmented wax. The hope was that this technique would permit the creation of mural paintings that would survive the inhospitable climate for many centuries. Flandrin also appreciated the matte finish of an encaustic surface, which enabled him to create paintings that would look similar to the frescoes of early Renaissance masters such as Masaccio (1401–1428) and Fra Angelico (ca. 1400–1455).

With assistance from his brother Paul, Flandrin completed the walls of the chapel in two years. On the west wall, closest to the main entrance, are the images of the Martyrdom of Saint John in the lower section and the Calling of Saint John in the upper section (fig. 2); on the east is the Last Supper, surmounted by the

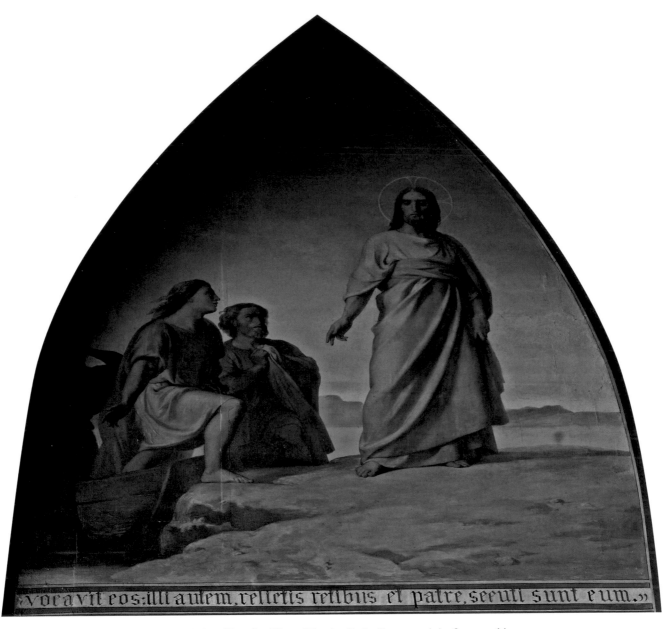

Fig. 2. West wall of the Chapel of Saint John, Church of Saint-Séverin, Paris. Photograph by Suzanne Nagy.

depiction of Saint John on the island of Patmos (fig. 3). All four murals are bordered by a decorative banding that separates the various episodes of the apostle's life into independent paintings. Later muralists at Saint-Séverin would continue to employ this technique, as did other painters at Saint-Méry in 1842 and 1843.

The final murals in the Chapel of Saint John are nearly identical to the Snite Museum's four small oil paintings. If these were indeed the original images presented for approval by the parish and the officials of the prefecture, then Flandrin made very few changes in transferring his compositions to the walls of the chapel. He did,

however, make numerous preparatory drawings that offer insight into his working method as he developed the overall scheme. For example, a small study of the head of Saint John, now in collection of the École Nationale Supérieure des Beaux-Arts, in Paris, demonstrates how carefully Flandrin developed the figures for the murals, paying special attention to the facial expression of Saint John as he stares up at Christ, who beckons to him and his brother, James the Lesser.

Also important in Flandrin's murals at Saint-Séverin is the influence of the Renaissance art that had surrounded him on

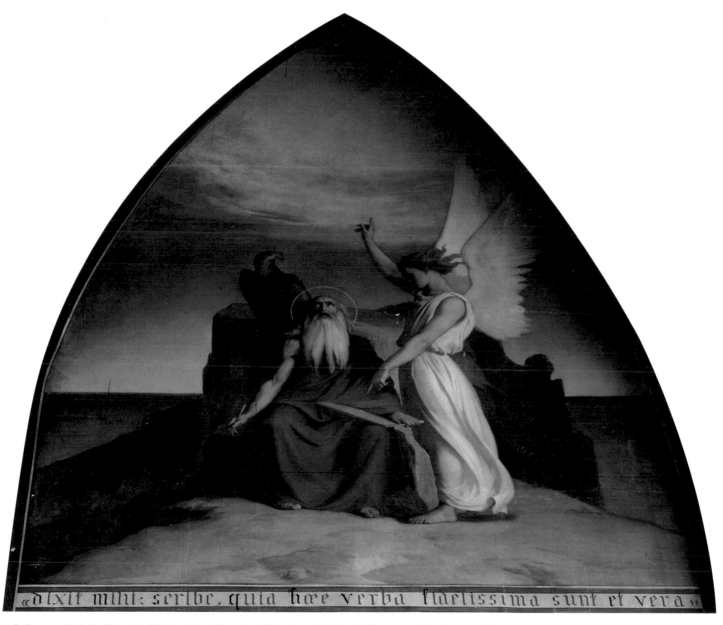

«dixit mihi: scribe, quia hæc verba fidelissima sunt et vera»

Fig. 3. East wall of the Chapel of Saint John, Church of Saint-Séverin, Paris. Photograph by Suzanne Nagy.

a daily basis during his years in Rome. In *The Calling of Saint John*, the lessons of Italian fresco painting are clearly evident (cat. no. 35). Issues of scale and perspective are deftly handled by positioning the figures against a low horizon line and by creating a believable, but simplified landscape in the distance. This allows the viewer to understand the narrative without being distracted or confused by excessive detail that would be incomprehensible when looking at the image some fifteen feet overhead. In fact, Domenico Ghirlandaio's (1449–1494) fresco depicting the *Calling of the First Apostles* (1481) in the Sistine Chapel might well have provided inspiration for Flandrin's figure of Christ in *The*

Calling of Saint John. The positions of the figures are remarkably similar, as are the colors of their clothing, with the exception that Flandrin's oil painting shows Christ with one arm upraised rather than at his side. In the final mural at Saint-Séverin, he revised the composition so that it echoed the pose Ghirlandaio had used in the Sistine Chapel fresco (cf. fig. 2).

The Martyrdom of Saint John (cat. no. 36), located directly beneath *The Calling* in the chapel, is certainly the most dramatic of the four narratives in Flandrin's mural cycle, but even in this context, the artist maintains his classical training. The

composition is balanced and restrained, in spite of the gruesome image of Saint John being boiled in oil. Although the Roman onlookers' gestures indicate that they are disturbed by the event they are witnessing, they nonetheless do not turn away from this attempted execution. The tale ends miraculously, as Saint John survived this attack without harm and instead was banished by the Roman emperor Domitian to the island of Patmos. In the final version of this scene on the wall of the chapel, Flandrin made one key change from the Snite Museum painting: he repositioned the figure of Saint John from a frontal view to a three-quarters view, which allows the visitor to better observe the saint's calm demeanor in the face of death (cat. no. 36).

Across the chapel, on the east wall, are *The Last Supper and Saint John on Patmos*. Naturally, *The Last Supper* (cat. no. 37) owes an aesthetic debt to Leonardo da Vinci's famous version of the subject in the Refectory of Santa Maria delle Grazie, in Milan (1495–98). As in Leonardo's fresco, Flandrin has placed Christ at the center of the table, with the apostles grouped evenly on either side. What is strikingly different here is the extremely sparse setting, with nothing except a table to indicate that this is even a meal. There are no plates or glasses to suggest the Seder celebration, only a loaf of bread and a chalice. On the right side of the painting, and also in the wall mural at Saint-Séverin, the cut-off figure of Judas hurries away from the table, leaving his green cloak behind on an empty stool (cf. fig. 4) The only change that Flandrin made in transferring this image to the wall mural was to move the bread and wine forward on the table, so that they are closer to the viewer. The Musée des Beaux-Arts, Rouen, owns a very loose sketch of this composition, which outlines the basic positioning of the apostles.[5]

Finally, the painting of *Saint John on Patmos* concludes the mural cycle with a mystical image of the elderly saint recording his visions of the future (cat. no. 37). To his right stands a white-clad angel who seems to be directing the revelations that Saint John receives. To his left is an eagle, the symbolic animal traditionally associated with John as an evangelist. Overhead, in the Gothic arch formed by the architecture of the chapel, a brilliant light leads the viewer's eye upward as if to share in the visionary event. This is the only one of the oil paintings that was recreated without revisions in the final mural version. Likewise, the extant preparatory drawings show few changes to the composition, indicating that Flandrin had probably settled on this image quite quickly.[6]

The mural decorations of the Chapel of Saint John were completed in 1841, and Flandrin was almost immediately asked to begin a new fresco commission for the Romanesque church of Saint-Germain-des-Prés, a medieval structure even older than Saint-Séverin. With his career as a religious painter well underway, Flandrin continued to refine his technique for painting murals on the damp walls of Paris's ancient churches. In 1859, he was asked by the prefecture to address the already obvious damage to the Saint-Séverin murals. The east wall, and particularly the lower image of *The Last Supper*, was especially in need of attention (fig. 4). Part of the solution was to create a replica painting on canvas, so that there would be a reference in case the wall mural should need to be redone. Unfortunately, Flandrin died before completing this canvas, and his brother Paul asked that the request be canceled.[7]

Meanwhile, Paul Flandrin took over the restoration effort. He correctly assessed that the phenomenon of "rising damp" was responsible for the damage, and thus developed a strategy for opening the joints between the stones, where mineral salts had disintegrated the encaustic base of the mural. This process worked reasonably well, although Paul Flandrin applied it only to the lower section of the painting and the decorative architectural borders. In 1881, a restorer named Charles Maillot proposed using the same technique on the figures in *The Last Supper*; his recommendation was approved by the prefecture's Commission on Beaux-Arts, with the additional stipulation that he dry out the

wall by creating regularly spaced perforations that would assist in preventing further damage in the future. This time, the results were only marginally successful.

The evolving deterioration of the east wall mural in the Chapel of Saint John is caused by the presence of water and mineral salts (usually potassium nitrate) that the wall absorbs from the underlying soil. This phenomenon, known as capillary action, occurs when porous stone absorbs groundwater that gradually rises through the wall because of simple hydraulic pressure.[8] At Saint-Séverin, the presence of potassium nitrate was again noted in the southern wall of the building in 1902. The professional restoration firm of Brisson Brothers recommended that the plaster in the joints be hollowed out (as Paul Flandrin had done in 1859) and that the wall be dried out and cleaned. For reasons that remain unknown, the plan was not implemented at this time, nor was a 1911 recommendation for installing unglazed earthenware pipes to absorb the mineral salts in the walls.[9]

By 1926, the condition of *The Last Supper* had become desperate, prompting art historian Léon Rosenthal to write: "It is not acceptable that we let this painting, an honored example of nineteenth-century religious art, disappear without trying to save it."[10] If restoration was not possible, he claimed, then the painting should be removed from the wall and preserved.[11] Rosenthal's advocacy seems to have prompted action by the Municipal Commission on Ancient Paris, and in 1928, a new restoration effort began. Under the direction of Alfred Belhomme, the east wall was again dried and cleaned, and the mural was restored. This was the last time that any work was done on Flandrin's early project.

Today, the damage to the east wall is again extremely serious. The paint has disappeared from the joints between the stones, and large chunks of paint are missing from both the clothing of the apostles and the lower left side of the decorative border. Contemporary restoration technology can now address these issues much more successfully than in the past, but funding such efforts remains a daunting challenge. The four small oil paintings in the Snite Museum of Art may soon be the only remaining echo of Flandrin's earliest mural project. —*JLW*

1 The Church of Saint-Séverin is located on the rue des Prêtres-Saint-Séverin, in the medieval maze of streets between the rue Saint-Jacques and the boulevard Saint-Michel.

2 According to Georges Brunel, the relevant archives about this commission are missing from Saint-Séverin's records. If they were to be found, they might contain additional information about the rationale for the choice of Saint John the Evangelist as the subject for the chapel. See Brunel's essay "La Chapelle Saint-Jean à Saint-Séverin (1839–1841)" in *Hippolyte, Auguste et Paul Flandrin: Une fraternité picturale du XIXe siècle*, ed. Jacques Foucart (Paris: Réunion des musées nationaux, 1985), 84.

3 During the French Revolution (1789–99), religious buildings in Paris that had not been destroyed or significantly damaged were transformed into secular structures. The most famous of these renovations was the "rededication" of the Cathedral of Notre Dame as a Temple of Reason. Likewise, the Panthéon, which was originally designed as a church dedicated to the patron saint of Paris, Saint Genevieve, became a temple to the great men of France; and the Church of La Madeleine was initially a monument to the glory of the Napoleonic Army. It was not until the Bourbon Restoration, beginning in 1814 under Louis XVIII, that a major new church emerged on the architectural landscape of the city: the Church of Notre-Dame-de-Lorette, designed by Hippolyte Lebas in 1821–23 and completed in 1836.

4 François Gabriel Guillaume Lépaulle, Henri Lehmann, Théodore Chassériau, and Eugène-Emmanuel Amaury-Duval all decorated chapels in the ambulatory of Saint-Méry during this period of decoration and restoration of the sixteenth-century church. See Brunel, "La Chapelle Saint-Jean," 84.

5 In 1859, Flandrin also created a finished drawing in graphite of *The Last Supper*, which is now at the Snite Museum. Because of the date, it seems likely that the drawing was intended to be the foundation for an edition of engravings or etchings. See Stephen B. Spiro, *Nineteenth-Century French Drawings* (Notre Dame, IN: Snite Museum of Art, University of Notre Dame, 2007), 34. A slightly different version of this graphite drawing, signed and dated 1859 (Musée des Beaux-Arts, Dunkerque), shows an architectural setting that includes a door in the left background and a faint suggestion of wall coverings behind the figure of Christ. Twenty years after the completion of the murals at Saint-Séverin, Flandrin continued to rework this image.

6 There is an early sketch of the figures of the angel and Saint John in the Musée des Beaux-Arts, Rouen, as well as a drawing that is almost identical to the oil painting in the Musée des Beaux-Arts, Dunkerque.

7 The painting was sent to the church in Chevilly-Larue, a southern suburb of Paris, but it is now lost. See Brunel, "La Chapelle Saint-Jean," 86.

8 Electro-osmosis, a process in which electrically charged water molecules assist in creating paths for water to move in the wall, may also be involved in creating the issue. In addition, electromagnetic fields within the earth can exacerbate the problem. Whether or not these are present at Saint-Séverin is unknown, but its proximity to the Seine is one indicator that electromagnetic force may be a factor. For more information on engineering solutions, see the Technical Fact Sheet at AdvancedGeoHumiditySolutions.com. Also see Meghan Hogan, "The Other Side of Ellis Island beyond the Museum: Dozens of Ruins are Slowly Being Stabilized," *Preservation: The Magazine of the National Trust for Historic Preservation*, December 2, 2005, 78–82.

9 The 1911 proposal was based on the technique used at the Church of Saint-Méry where it was reasonably successful in ridding the walls of the built-up mineral salts.

10 Léon Rosenthal was the director of the Musée des Beaux-Arts in Lyon, Flandrin's hometown, as well as a professor of art history at the Lycée Louis le Grand. His original statement to the Municipal Commission on Ancient Paris reads: "Il n'est pas admissible qu'on laisse disparaître, sans tenter de la sauver, une page qui a honoré l'art religieux du XIXe siècle." *Commission municipale du vieux Paris, procès-verbaux, année 119265* (Paris, 1930), 121. Quoted in Brunel, "La Chapelle Saint-Jean," 87. English translation by JLW.

11 Ibid.

Edward Gabé, 1814–1865
The Proletariat Seizing the French Throne, 1848
oil on canvas
31.38 x 38.63 inches (79.70 x 98.10 cm)
Signed lower right: *E Gabé*, with illegible date
beneath the signature
Snite Museum of Art
Gift of Mr. and Mrs. Noah L. Butkin
2009.045.050

39

Provenance
Mr. and Mrs. Noah L. Butkin; placed on loan
with the Snite Museum of Art, University of
Notre Dame, 1979; converted to a gift of the
estate of Muriel Butkin, 2009.

Exhibitions
*Les années romantiques: La peinture française
de 1815 à 1850*, 1996, Musée des Beaux-Arts,
Nantes, and Galeries Nationales du Grand
Palais, Paris.

Selected Bibliography
*Les années romantiques: La peinture française
de 1815 à 1850*. Paris: Société française de
promotion artistique, 1996.

Born in 1814 in Paris, Edward Gabé lived in the midst of political
turmoil throughout his career. As a young artist in the early
1830s, he witnessed the ultra-royalist king Charles X attempt to
eradicate the gains of the first French Revolution (1789–99), only
to be unceremoniously tossed out during the July Revolution of
1830. Eighteen years later, in 1848, Louis Philippe, the "citizen
king" who came to power in 1830, fled into exile in England
in the wake of yet another revolution by the working people of
France.[1] During these decades, Gabé worked as a miniaturist
and a genre painter, occasionally submitting works to the annual
Salon, beginning in 1835.

Most likely, Gabé was trained initially as a miniaturist, a skill that
would have served him well in earning a reasonable living before
the advent of photography. A small watercolor on ivory entitled
An Unknown Girl (1850, Wallace Collection, London) illustrates
his ability to create subtle gradations of color and texture in this
painstaking medium. At some point in his career, perhaps in the
mid-1830s when he first exhibited at the Salon, Gabé enlarged his
format from portrait miniatures to small genre paintings such as
a work currently at the Bowes Museum, *Cows, Sheep, and a Goat
at a Drinking Trough* (Bowes Museum, Barnard Castle, County
Durham, England). This painting demonstrates the same mastery
of texture and atmospheric conditions that is evident in *An
Unknown Girl*, but it also betrays the inexperience of the painter
in depicting fully rounded forms at this time.

As Gabé continued to develop as a genre painter, he focused
primarily on French seascapes and still lifes before traveling
to Italy. The known paintings from Naples all date to 1847,
thus establishing the probable date for his sojourn in Italy.[2] On
returning to Paris in either 1847 or 1848, Gabé again found
himself in a city reeling from political and social unrest. The
revolution began in late February 1848 and continued until the
insurrection of the so-called June Days (June 23–26), when
workers barricaded the streets in protest of the closing of the
National Workshops—a project that would have offered relief
for the severe unemployment problems of the time. It was this
moment of uprising and political outrage that Gabé depicted in
a series of paintings, including *The Proletariat Seizing the French
Throne*.

In this dramatic scene, Gabé portrays the workingmen of Paris in
Louis Philippe's throne room, enjoying the now-deposed king's
liquor, as well as his comfortable furniture. The compositional
awkwardness seen in the artist's early genre paintings is now
entirely overcome, replaced with a sophisticated handling of

space and multiple figures. Like many painters in the 1840s and '50s, Gabé's work shows the influence of Dutch seventeenth-century genre painters such as Jan Steen (1626–1679) and Adriaen Brouwer (1605–1638). However, Gabé has transformed the merrymaking peasants typical of a Brouwer tavern scene into exhausted men who celebrate their hard-won victory with a mixture of sorrow and gladness. The figure in the blue vest at the right, for example, seems wrapped in sadness even at his moment of triumph. On the left side of the painting, another man proudly holds the French tricolor, while pointing to the ermine-trimmed royal robes now on the floor near an overturned chair.

Gabé's series of at least four paintings chronicles both the initial uprising in February and the June Days that followed. In historical order, but not necessarily the order in which they were painted, the events depicted are *Incident of the Revolution of 1848 in Paris,* *in the Court of the Louvre* (Bowes Museum, Barnard Castle, County Durham, England); *The Proletariat Seizing the French Throne* (Snite Museum of Art); *Incident of the Revolution of 1848 in Paris at the Corner of Rue St Jacques* (Bowes Museum, Barnard Castle, County Durham, England); and *The Barricade at Porte St Denis, 1848* (1849, Bowes Museum, Barnard Castle, County Durham, England). All of the paintings are similar in size, although not identical, and all were most likely painted within a year of one another. The client and the intended destination of these works are not known. —*JLW*

1 For a readable and scholarly account of these tumultuous and complex decades, see Alistair Horne, *Seven Ages of Paris* (New York: Vintage Books, 2004), 211–76.

2 The Neapolitan paintings include *Bay of Naples* (1847), *Figures beside the Bay of Naples* (1847), *Neapolitan Scene* (1847), and *Figures on the Waterfront with Bay of Naples and Vesuvius Beyond* (1847). All are in private collections. See E. Bénézit, Dictionary of Artists (Oxford: Oxford University Press, 2006), 3:1203–4.

Jean-Léon Gérôme, 1824–1904

The Artist's Studio (A Sketch), 1886/87
oil on canvas
12.75 x 9.75 inches (32.39 x 24.77 cm)
Signed lower center: *J L GÉRÔME*
Inscribed on verso: *1886 or 1887*
Snite Museum of Art
Gift of Mr. and Mrs. Noah L. Butkin
2009.045.121

Provenance

Ledoux-Lebard Collection, Paris; Shepherd Gallery, New York, 1978; Mr. and Mrs. Noah L. Butkin, 1978; placed on loan with the Snite Museum of Art, University of Notre Dame, 1988; converted to a gift of the estate of Muriel Butkin, 2009.

Selected Bibliography

Ackerman, Gerald M. *The Life and Work of Jean-Léon Gérôme: With a Catalogue Raisonné.* New York: Sotheby's Publications, 1986, p. 260, cat. no. 348c.

As one of the preeminent academic artists of the nineteenth century, the French painter and sculptor Jean-Léon Gérôme devoted his long career to perfecting and perpetuating the European tradition of the beaux arts. A native of the Franche-Comté, he was enrolled in drawing classes at the age of nine and rigorously trained in draftsmanship for five years, before being allowed to advance to oil painting. At sixteen, he was permitted by his father to enter the Parisian atelier of the painter Paul Delaroche (1797–1856), where he began to work extensively from the live model.[1]

Following a brief stint in the studio of the painter Charles Gleyre (1806–1874), Gérôme made his Salon debut in 1847 with *The Cock Fight* (Musée d'Orsay, Paris). In 1852, Gérôme set off on his first trip to what, in nineteenth-century parlance, was deemed "the Orient." Although Gérôme's initial desire was to visit Russia, the Crimean War forced him to reroute to an alternate destination, and consequently (somewhat by historical happenstance), he visited Istanbul, where he began to conceive the Orientalist paintings for which he would become most famous.[2] Shrewdly recognizing a market for subjects drawn from the edges of Western Europe, Gérôme would make many future trips to the Orient, particularly North Africa.

Gérôme began to exhibit the Orientalist canvases inspired by these travels at the Salon of 1859, the same year in which he entered into a lucrative business arrangement with the powerful art dealer Jean-Michel-Adolphe Goupil. With branches in Paris, Brussels, London, Berlin, and New York, the Goupil firm offered an international market for Gérôme's paintings and disseminated his imagery widely through authorized reproductive engravings.[3] Gérôme's first serious ventures into sculpture appear to have resulted from his work with Goupil, who believed there was a market for statuettes of figures derived from his painted compositions. He had already dabbled in three-dimensional modeling as a study aid in the execution of his paintings, and his work in modeling statuettes for Goupil soon led to forays into large-scale salon sculptures.

The sketch *The Artist's Studio* is one of three known studies for a painting Gérôme completed in 1886 entitled *The End of the Sitting* (private collection). In both the finished composition and the study reproduced here, Gérôme focused attention upon a maquette for a statue entitled *Omphale* (location unknown), which he was in the process of modeling in clay for translation into marble by craftsmen. The statue, exhibited at the Salon of 1887, depicted a Lydian queen who served as Hercules' slave master for one year, after he committed a murder in a state of rage. Although a fairly obscure episode from the life of Hercules, the story had been depicted by artists as diverse as Lucas Cranach the Elder (1472–1553), Peter Paul Rubens (1577–1640), and François Boucher (1703–1770). In 1834, it had been revived in literary form by Théophile Gautier in *Omphale: A Rococo Story*, and in 1872, it was interpreted musically by the composer Camille Saint-Saëns in the symphonic poem *Le rouet d'Omphale*. In Gérôme's statuesque rendering of the mythological queen, Omphale assumes the posture of the well-known *Farnese Hercules*, leaning upon the phallic club she has confiscated from the strongman. While the clay maquette is placed atop a turntable for practical reasons, the low vantage point that Gérôme utilizes in the painting—as well as his choice to inscribe his signature on the step that he would use to alight the turntable—enhances the imposing qualities of this powerful female figure, who, in the best known scene from the mythological account, watches over Hercules as he assists her maidservants in the emasculating task of spinning wool.

The scene is set in a corner of the artist's Clichy studio, and the late hour of the day is subtly suggested by long shadows cast by the panes of the windows. Although not seen in the sketch, Gérôme animated the finished composition with the figure of the nude studio model, who provides a final service for the day by wrapping the maquette with wet cloths, while the artist squats at a basin of water to rinse his tools—subtly suggesting his own subservience to the sculpted *Omphale*. In a memorial essay published in 1904, the art historian M. H. Speilmann offered an insightful recollection of an encounter with Gérôme and the model for *Omphale* when he visited the artist's studio in the 1880s:

> The model, whose fine form and features the statue reproduced, was sitting reading while she waited near the stove, a shawl of yellow Chinese silk lightly thrown over her. She rose and walked with sandaled feet towards the statue. "What does Monsieur think of it?" she asked, as she surveyed it with a respect amounting to absolute veneration. "Would monsieur like to see the harmonious, flowing lines?" And as she turned the statue slowly on the pivot she gazed in rapt admiration on the reproduction of her form. "See how beautiful it is!" she exclaimed; "see how it is modeled. I have sat to *le maître* for five years, and I have seen no greater art from him than this. His other work of 'Anacréon et Gladiateur' I do not like so well as this. *Que c'est beau!*" At that moment the master returned. "Ah, you are looking at my 'Omphale'?" he said. "It is my rest from painting, as you know; my relaxation."[4]

A series of five photographs of Gérôme and his model, taken
in 1887 by Louis Bonnard (Bilbiothèque Nationale de France,
Paris), documents the lengthy process of creating the sculpture.[5]
Gérôme's decision to paint a moment from its arduous creation
reflects his desire to encourage respect for the rigors of the
academic process. *The End of the Sitting*, along with the studies
for it, is not only a meditation upon the relationship of painting
to sculpture but also a commentary on studio practice. It
emphasizes the time, discipline, and effort that was dedicated to
a work of art as it developed over a course of days, rather than
impressionistically over the course of minutes or hours. —*SJS*

1 For the most thorough biographical account of Gérôme, see Gerald M. Ackerman,
The Life and Work of Jean-Léon Gérôme: With a Catalogue Raisonné (New York:
Sotheby's Publications, 1986). For the most current scholarship, see Scott Allan
and Mary Morton, eds., *Reconsidering Gérôme* (Los Angeles: J. Paul Getty Museum,
2010).

2 Most notable among the art historians who critiqued these works is Linda Nochlin
in the seminal essay "The Imaginary Orient," *Art in America*, May 1983, 118–21,
187–91.

3 For a discussion of this relationship, see *Gérôme & Goupil: Art and Enterprise* (Paris:
Réunion des musées nationaux; Pittsburgh: The Frick Art and History Center,
2000).

4 M. H. Spielmann, "Jean-Léon Gérôme: 1824–1904; Recollections," *The Magazine
of Art* 2 (1904): 204.

5 Allan and Morton, *Reconsidering Gérôme*, 308–10.

Jean-Léon Gérôme, 1824–1904

Leaving the Oasis, 1880s
oil on wood panel
19.63 x 32 inches (49.86 x 81.28 cm)
Signed lower center right: *J. L. Gérôme*
Cleveland Museum of Art
Gift of Mr. and Mrs. Noah L. Butkin
1977.126

41

Provenance

Sotheby Parke-Bernet, New York, sale April 25, 1968, cat. no. 265 (illus.); Sotheby Parke-Bernet, Los Angeles, sale May 27, 1974, cat. no. 81 (illus.); the Norton Galleries; Mr. and Mrs. Noah L. Butkin; gift of Mr. and Mrs. Noah L. Butkin to the Cleveland Museum of Art, 1977.

Exhibitions

Paris autour de 1882, 1982–83, The Museum of Fine Arts, Gifu, and The Museum of Modern Art, Kamakura, Japan, cat. no. 22 (illus.).

Selected Bibliography

Ackerman, Gerald M. *The Life and Work of Jean-Léon Gérôme: With a Catalogue Raisonné.* New York: Sotheby's Publications, 1986, p. 303, cat. no. 545.

d'Argencourt, Louise, and Roger Diederen. *European Paintings of the 19th Century.* Cleveland: The Cleveland Museum of Art, 1999, pp. 296–97.

The Butkins collected only a handful of paintings that can be classified as Orientalist genre paintings, purchasing them just at the moment when international interest in this type of painting was reviving. Their appreciation of Realist paintings then moved in another direction, leaving this example as one of the few completed paintings by Gérôme that they possessed.[1]

With this work, Gérôme displayed his knowledge of the Near East, which he had visited on several occasions. He often traveled in the company of others who took photographs of the scenes they encountered and commented on the various locations in letters and journals. Returning to Paris, Gérôme completed compositions depicting the sights he had seen, such as caravans or oases in the midst of expansive desert landscapes. The details that he records in this panel capture his experience of "the Orient" and show his sensitivity to the arid environment: the sunlight creates patterns of shadows; the sleek dogs walk at a fast pace, moving quickly out of view; while the camels move with a lumbering gait. Scenes such as this became an important part of Gérôme's repertoire, playing a significant role in fostering the Orientalist aesthetic. They were completed at a time when Westerners were demanding a more accurate transcription of the Near East, moving away from the imaginary Orient that writers and painters had constructed at the height of the Romantic era, earlier in the nineteenth century. —*GPW*

1 The Butkins owned another work by Gérôme, *Shore Birds, North African Birds*, which unfortunately was not given to either the Cleveland Museum of Art or the Snite Museum of Art; its current location remains unknown. For reference to this superb painting, see Gerald M. Ackerman, *The Life and Work of Jean-Léon Gérôme: With a Catalogue Raisonné* (New York: Sotheby's Publications, 1986), cat. no. 540.

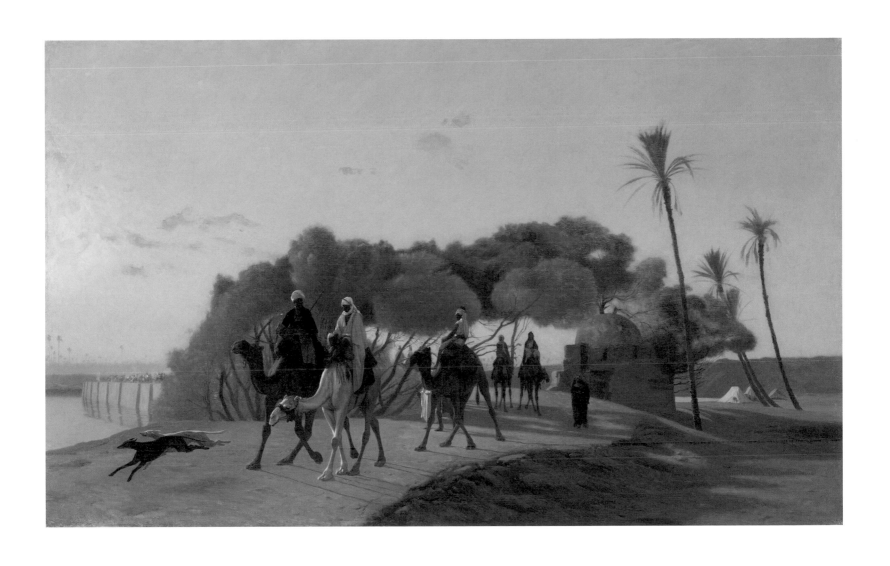

Jean-Léon Gérôme, 1824–1904

Study for "Raphael in the Sistine Chapel"
(*formerly Michelangelo in the Sistine Chapel*)
oil on canvas
7 x 10.38 inches (17.80 x 26.40 cm)
Snite Museum of Art
Gift of Mr. and Mrs. Noah L. Butkin
2009.045.098

42

Provenance

Jacques Fisher–Chantal Kiener, Paris; Mr. and Mrs. Noah L. Butkin, 1978; placed on loan with the Snite Museum of Art, University of Notre Dame, 1980; converted to a gift of the estate of Muriel Butkin, 2009.

Selected Bibliography

Ackerman, Gerald M. *The Life and Work of Jean-Léon Gérôme: With a Catalogue Raisonné*. New York: Sotheby's Publications, 1986, p. 244, cat. no. 279b.

The composition *Raphael in the Sistine Chapel* is something of an anomaly in Gérôme's oeuvre. Although the painter had made a failed bid for the prestigious Prix de Rome as a young man, he never developed a passion for the art of the Italian Renaissance. After Paul Delaroche abruptly closed his atelier in 1843 following the tragic death of a student, Gérôme's father agreed to finance his son's trip to Italy in the company of Delaroche and the young painter Jean Eugène Damery (1823–1853). Delaroche had drawn heavily from Raphael in his famous fresco *The Hemicycle of Fine Arts*, which he executed for the École des Beaux-Arts between 1837 and 1841 with the assistance of several of his students. But Gérôme did not hold the Renaissance master in as high regard, and it is known that he viewed both Michelangelo and Donatello as "excessive in their style." In fact, the painter Pascal-Adolphe-Jean Dagnan-Bouveret (1852–1929), who was later a student of Gérôme, reported that the elder artist confided in him that he had spent the Italian trip largely outdoors, studying picturesque landscapes.[1]

The Snite Museum's oil study corresponds to a moderately sized canvas finished in 1880 and since lost. The scene depicted is drawn from a most likely apocryphal account set forth by Giorgio Vasari in the *Lives of the Most Eminent Painters, Sculptors, and Architects*. In the story, the architect Donato Bramante admitted his young friend Raphael into the Sistine Chapel while Michelangelo was in exile in Florence, following one of his confrontations with Pope Julius II. Although commentators have remarked that this event likely did not take place, and that the effect of Michelangelo's art upon Raphael has not been definitively settled as positive, Vasari attributes Raphael's encounter with the Sistine Chapel as the basis of a figural shift in his works toward the "grandeur and majesty which he always did impart to them from that time forward."[2] The vantage point Gérôme selects in visualizing this imagined epiphanic encounter mimics that of Raphael. Caught in midstep, the young painter gazes up in awe at the ceiling, while the scaffolding creates a visual rhythm of ascent and descent, emphasized by the figure of Bramante descending the staircase. —*SJS*

1 Gerald M. Ackerman, *The Life and Work of Jean-Léon Gérôme: With a Catalogue Raisonné* (New York: Sotheby's Publications, 1986), 23.

2 Giorgio Vasari, *Lives of the Most Eminent Painters, Sculptors, and Architects*, vol. 3, trans. Mrs. Jonathan Foster (London: Henry G. Bohn, 1851), 23.

Jean-Léon Gérôme, 1824–1904

*Study for "Socrates Seeking Alcibiades
in the House of Aspasia,"* ca. 1861
oil over ink, on canvas
8.38 x 13.63 inches (21.30 x 34.60 cm)
Snite Museum of Art
Gift of Mr. and Mrs. Noah L. Butkin
2009.045.067

43

Provenance
Shepherd Gallery, New York, 1973; Mr. and
Mrs. Noah L. Butkin, 1973; placed on loan
with the Snite Museum of Art, University of
Notre Dame, 1980; converted to a gift of the
estate of Muriel Butkin, 2009.

Exhibitions
*French Nineteenth-Century Oil Sketches: David to
Degas*, March 5–April 16, 1978, The William
Hayes Ackland Memorial Art Center, The
University of North Carolina at Chapel Hill,
pp. 80–81, cat. no. 38.

Selected Bibliography
Ackerman, Gerald M. *The Life and Work of
Jean-Léon Gérôme: With a Catalogue Raisonné.*
New York: Sotheby's Publications, 1986,
p. 210, cat. no. 131b2.

One of two known oil sketches for the painting *Socrates Seeking Alcibiades in the House of Aspasia*, this study depicts a moment of dramatic tension, as the aged philosopher fervently clasps the hand of his beloved student, attempting to lead the charismatic and wayward Alcibiades away from a debauched lifestyle. Competing against Socrates' stoicism is the enticing figure of the courtesan Aspasia, who lies in the lap of the virile young Alcibiades. The setting is a sun-drenched pavilion erected in the interior courtyard of the house that Aspasia shared with her paramour— Alcibiades' guardian, the Athenian statesman Pericles. Because she was from Miletus, Aspasia could not wed Pericles, a citizen of Athens, even if he were to divorce his wife. But the pleasure palace the two shared became a center of intellectual and artistic activity, a relationship addressed in 1862 by J. B. Capefigue in the study *Aspasie et le siècle de Pericles*. Even though Aspasia was famed for her wit and taste, Socrates held her intellect in great disdain, a fact that was taken pointedly to task at the end of the nineteenth century by female classical scholars, notably in the poem "Xantippe" published by Amy Levy in 1880.

Although Alcibiades turns his body toward the sensual Aspasia, who rests her bosom in his lap (the seat of sensual pleasure), he turns his head (the locus of rational thought) toward Socrates. Socrates and the servant who approaches the group are clad modestly in full-length robes, despite the heat suggested by the warm color palette, which infuses the atmosphere with the golden light of an intensely sunny day. Alcibiades and his female companions, in contrast, have loosened their robes, one of which is seen draped over a chair in the foreground. Behind Socrates, a nearly nude woman sidles her head toward his shoulder and reaches enticingly to loosen his toga, in an invitation to join their revelry. Socrates, whom an intoxicated Alcibiades described in Plato's *Symposium* as "the only person who ever made me ashamed,"[1] is undistracted by the display. He stands as the sole counterbalance to an elaborate cast of supporting characters, who represent the vast array of sensual pleasures offered by Aspasia's hospitality. Examining the painting's details, we see that Aspasia has orchestrated for Alcibiades an environment that would stimulate all of his senses: his hand rests on the small of his lover's back; the summer air is fragrant with the flowers that wreathe her hair; his vision is met by sensuous skin and luxurious fabrics; his ears are filled with the soft strains of the harp played by another

woman, who rests beside him; his appetite is indulged by the tray of food borne by the servant.

Exhibited at the Salon of 1861, the finished *Socrates Seeking Alcibiades in the House of Aspasia* also harkened back to Gérôme's interests as a young student in the atelier of Charles Gleyre. There, he had associated with a group of fellow students who called themselves the Néo-Grecs. As Gerald Ackerman points out, the appellation the group chose denoted not only the classical subject matter they favored but also their affinities to an undercurrent of homoeroticism that coursed through the Neoclassical period. That tradition had produced the homoerotic canvases of students of Jacques-Louis David who were variously known as the Barbus and les Grecs.[2] Although not overtly asserted, Gérôme's selection of the relationship between Socrates and Alcibiades would have similarly implied homoerotic associations to the educated viewer. Accounts differ as to the nature of Socrates' relationships to his young pupil, but Alcibiades speaks at length in Plato's *Symposium* of his youthful attempts to seduce his teacher; and many references exist in both classical and modern literature to Socrates' sexual ardor for the rash and handsome young man. Read in this light, the composition presents a choice not simply between sensual pleasure and intellectual sobriety, but between two lovers competing for Alcibiades' attention. *SJS*

1 Plato, *The Dialogues of Plato*, vol. 1, trans. Benjamin Jowett (New York: Random House, 1920), 339.

2 Gerald M. Ackerman, *The Life and Work of Jean-Léon Gérôme: With a Catalogue Raisonné* (New York: Sotheby's Publications, 1986), 34.

Jean-Léon Gérôme, 1824–1904

Study for "Le picador," ca. 1866–70
oil on canvas
10 x 8.88 inches (25.40 x 22.50 cm)
Signed lower left: *J L Gérôme*
Inscribed lower left, above signature: *à Mr. Knoedler*
Snite Museum of Art
Gift of Mr. and Mrs. Noah L. Butkin
2009.045.123

Provenance

Knoedler Collection, Sotheby Parke-Bernet,
New York, sale 3711, January 16, 1975, cat. no.
186; the Norton Galleries, 1975; Mr. and Mrs.
Noah L. Butkin, 1975; placed on loan with
the Snite Museum of Art, University of Notre
Dame, 1988; converted to a gift of the estate of
Muriel Butkin, 2009.

Exhibitions

*Cavaliers and Cardinals: Nineteenth-Century
French Anecdotal Paintings*, June 25–August 16,
1992, Taft Museum, Cincinnati; September 19–
November 15, 1992, Corcoran Gallery of Art,
Washington, DC; November 21, 1992–January
17, 1993, Arnot Art Museum, Elmira, New
York, p. 46, cat. no. 8.

Selected Bibliography

Ackerman, Gerald M. *The Life and Work of
Jean-Léon Gérôme: With a Catalogue Raisonné.*
New York: Sotheby's Publications, 1986, pp.
222–23, cat. no. 177b.

Gérôme developed a passion for traveling to exotic locales,
where he executed extensive sketches in preparation for paintings
finished in his studio. However, when he exhibited *Le picador*
(location unknown) at the Salon of 1870, he had neither visited
Spain nor witnessed a bullfight. This discrepancy led Gérôme
scholar Gerald Ackerman to argue that *Le picador*, as well as the
slightly earlier *Bull and Picador* (1867–68, private collection),
were deliberate rebuttals to what he perceived as compositional
shortcomings in the French painter Édouard Manet's Spanish
bullfighting scenes.[1] Ackerman argues that Gérôme in particular
appears to rectify the perspective of the fallen horse and mounted
picador from corresponding elements that had been roughly
sketched in Manet's scenes.[2] The finished version of *Le picador* has
since been lost, however, and we must judge such a comparison to
Manet's work on the basis of this sole preliminary sketch (which
Gérôme either gifted or sold to the American dealer Michael
Knoedler), in combination with engraved reproductions of *Le
picador* published by Adolphe Goupil.

The lifelong distaste Gérôme fostered for Manet's work is well
documented, culminating in his vehement resistance to the
staging of the Manet memorial exhibition at the École des Beaux-
Arts in 1884. According to Fanny Hering, who published a study
of Gérôme in 1892, the artist derided the work of Impressionists
and plein-air painters as frequently "insipid and badly executed:
badly drawn, badly painted, and stupid beyond expression." He
readily claimed that he had had "the honour of having waged war
against these tendencies."[3] Gérôme had long dismissed Manet's
paintings as *cochonneries* (rubbish), and in launching a full-scale
attack against the posthumous exhibition, the academic master
denounced Manet as "the apostle of decadent fashion, the art of
the fragment," arguing that his work set a bad example for the
students at the École who were engaged in rigorous academic
training.[4]

à m. Knoedler
J.L. Gérôme

In the sketch *Le picador*, Gérôme depicts a moment from the first of the three acts that constitute a Spanish bullfight—the lancing of the bull by the picador. Because the bull is still at full power in this first phase of the bullfight, the work of the picador is particularly dangerous, and a relief picador waits at the rail to finish the lancing should the first picador's horse be felled. Although each picador tried to protect his blindfolded horse from the bull's charge, before equine armor was adopted in the twentieth century it was not unusual for thousands of horses to be gored to death in a single season. In *Le picador*, Gérôme illustrates the aftermath of this combat, with the first picador limping to the sideline, his distinctive *castoreño* hat in hand, as his horse lies in a pool of blood not yet absorbed by the sand. In the foreground, the picador's partner turns away from the thundering crowd, steeling himself to finish the lancing of the bull. This attack would both enrage and injure the animal sufficiently to prepare it for the encounter with the matador, who waits at the edge of the ring.

Although the violence of the encounter is only implied in Gérôme's composition, and the horse standing in the foreground seems immune to the noise of the crowd and the imminent danger posed by the bull, a contemporary American art critic still classified it as "one of [Gérôme's] cynical and cruel pictures." Having encountered the finished version of *Le picador* in Philadelphia while it was in the Henry C. Gibson collection, the critic continued on to describe the image in sober terms as "one of [Gérôme's] most depressing examples of 'showing up' some distant country where we hoped there was some romance left and proving by a piece of literal transcription how vile and mean is the activity. It is a Spanish arena with excruciating, almost perpendicular seats, a prosaic audience, a villainous picador without a shade of gallantry, an ugly gray horse lame in his foreleg... a sorrel lies dead on the sand decorated with obscure reddish blots. This [is a] revolting portrayal of the ugliness and prose of the bull fight."[5] Scholar Eric Zafran has argued along similar lines that in addition to the likely instigation provided by Manet's bullfighting scenes, the subject matter also allowed Gérôme to transpose into a modern-day setting his interest in the blood sports of the ancient world—seen in such famous paintings as his *Police Verso* (1872, Phoenix Art Museum) and *The Christian Martyrs—Last Prayer* (The Walters Art Museum, Baltimore), a painting on which Gérôme labored from 1863 to 1883.[6] —*SJS*

1 See, for instance, Manet's 1865 canvas entitled simply *Bullfight* (Art Institute of Chicago).

2 Gerald M. Ackerman, "Gérôme and Manet," *Gazette des beaux-arts* (September 1967): 171–72.

3 Fanny Field Hering, "Gérôme," *The Century Magazine* 37, no. 4 (February 1889): 493.

4 Albert Keim, *Gérôme* (New York: Frederick A. Stokes, 1912), 73. Cited in Gerald M. Ackerman, *The Life and Work of Jean-Léon Gérôme: With a Catalogue Raisonné* (New York: Sotheby's Publications, 1986), 128.

5 E. S., "Mr. Henry C. Gibson's Gallery," *Private Art Collections of Philadelphia* (May 1872): 575. Cited in Eric M. Zafran, *Cavaliers and Cardinals: Nineteenth-Century French Anecdotal Paintings* (Cincinnati: Taft Museum, 1992), 46.

6 Zafran, *Cavaliers and Cardinals*, 46.

Henri Gervex, 1852–1929

The Communicants, study for the painting
Première Communion à la Trinité, ca. 1877
oil on canvas
17.75 x 14.50 inches (45.10 x 36.80 cm)
Signed lower right: *H. Gervex*
Inscribed lower right, above signature:
à mon ami / L. Hennique
Snite Museum of Art
Gift of Mr. and Mrs. Noah L. Butkin
2009.045.039

45

Provenance
Galerie Rossini, Paris; Mr. and Mrs. Noah L. Butkin, 1978; placed on loan with the Snite Museum of Art, University of Notre Dame, 1978; converted to a gift of the estate of Muriel Butkin, 2009.

Selected Bibliography
Gourvennec, Jean-Christophe. "I – Apprentissage et succès: Les années 1870." In *Henri Gervex, 1852–1929*. Paris: Paris-Musées, 1992, pp. 28–29, 103–7.

One of the primary portrait painters of the Third Republic, Henri Gervex began his career by exhibiting subjects drawn from the daily lives of ordinary people. Such paintings suggested that he was an advocate of the Naturalist movement then evolving in both the visual arts and literature. In fact, the present sketch is dedicated to L. Hennique (Léon Hennique), a Naturalist writer close to Émile Zola and the group of Médan.[1] It is a study for *The First Communion at the Church of the Trinité (Première Communion à la Trinité)* (fig. 1), a huge painting that Gervex noted he had great difficulty painting in his Parisian studio, because he could not step far enough away from it to see the overall effect.[2]

Struggling to attract attention early in his career, Gervex wanted to create a canvas that would have a memorable impact on the 1877 Salon audience. (One year later, he would show his controversial painting *Rolla* [1878, Musée des Beaux-Arts, Bordeaux], which was rejected by the Salon jury.) He developed *The First Communion* in the traditional academic manner, carefully plotting his composition in studies. First, he produced a series of drawings that sketched almost all of the primary figures in the painting, from the well-dressed woman leaning over the balustrade at the altar to young members in the procession.[3] Gervex experimented with alternate movements for the communicants and painted a set of oil studies, some highly finished, for the young girls processing around and down the altar steps. The study in the Snite Museum collection shows a first communicant moving toward the audience, wearing the typical white dress appropriate to the ceremony and folding her hands in prayer. The name of the principal model for this sketch is not known; she might have been someone Gervex knew, or he may simply have witnessed an event in a church located close to his Parisian home. Whatever the case, the study provides a convincing depiction of a young girl swept up in the religious meaning of the moment.

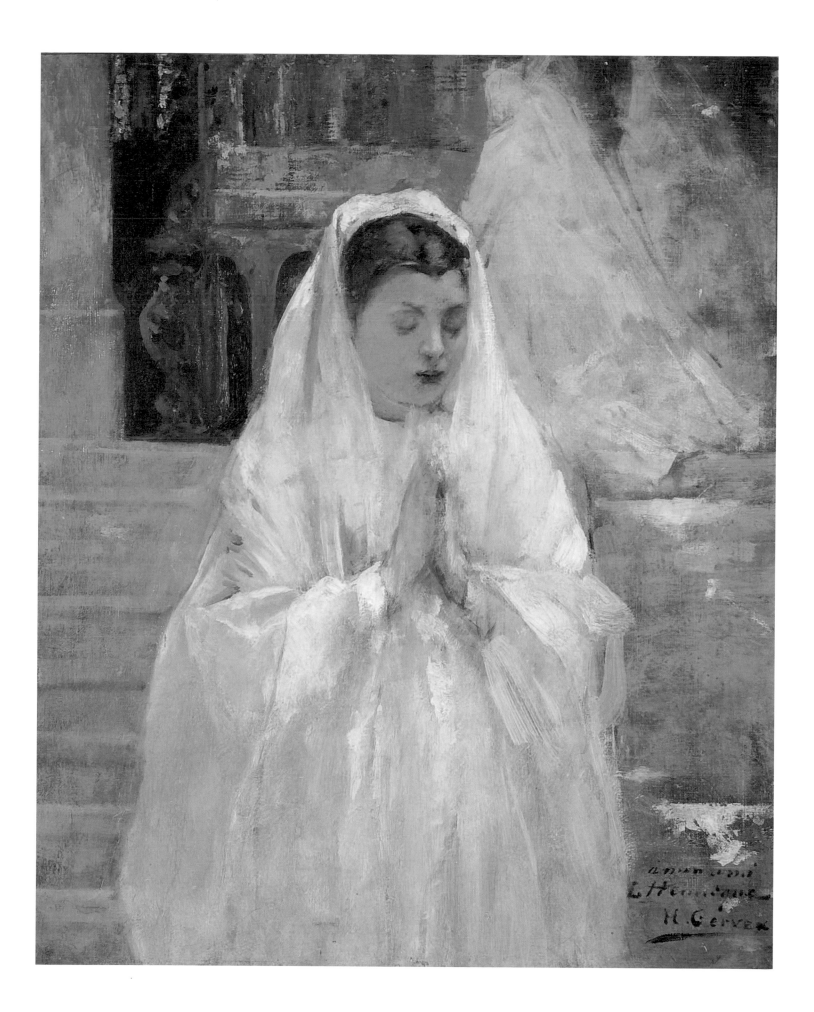

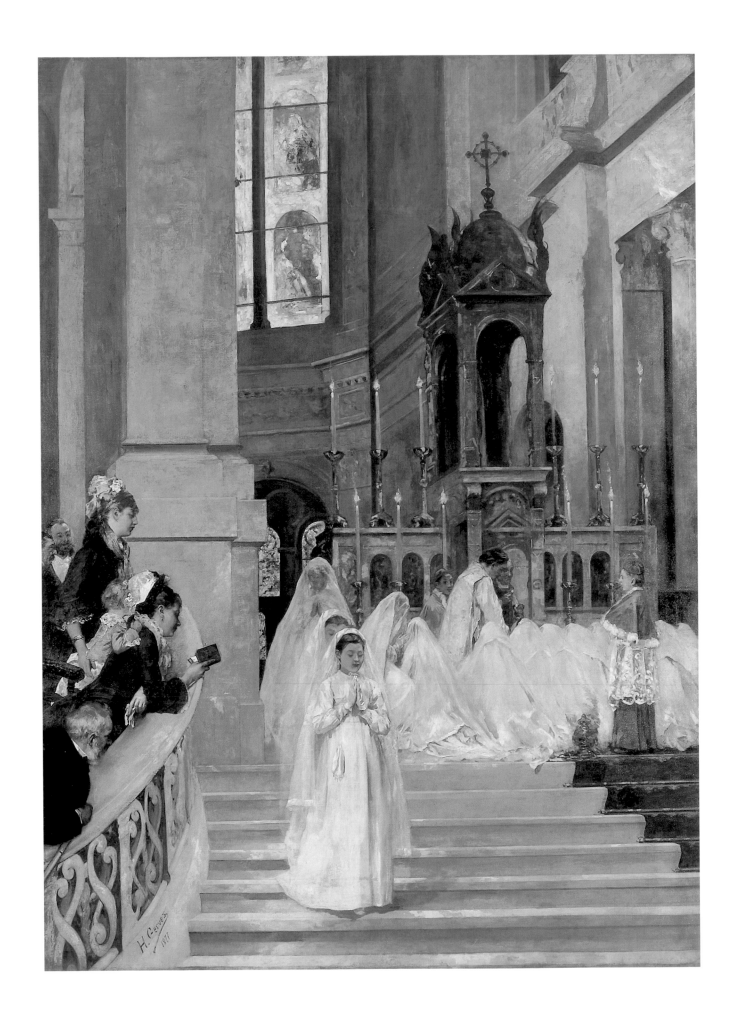

Fig. 1. (opposite page) Henri Gervex (1852–1929), *The First Communion at the Church of the Trinité (Première Communion à la Trinité)*, 1877, oil on canvas, 158.27 x 114.57 inches (402 X 291 cm), Musée des Beaux-Arts, Dijon.

Fig. 2. Interior of the altar area of the La Trinité, Paris.
Photo: Suzanne Nagy, courtesy of the Church of the Holy Trinity.

The numerous preliminary studies Gervex made reflect the difficulty he had in composing the final painting and organizing the procession of communicants. He even developed an alternative version, a painting now in the mayor's office in Oloron-Sainte-Marie. In that more complex composition, the communicants are arranged in two rows: ascending the stairs of the altar and kneeling before the priest, then descending the stairs as they move toward the congregation.[4] In the final version, a simpler and more direct treatment of the subject, the young girls move slowly down the steps in a pre-cinematic moment that will eventually embrace the visitors inside the church.[5] Some of the spectators, presumably members of the girls' families, lean over the balustrade at the left of the composition. This section of the church is in reality further away from the steps (fig. 2); Gervex brings it closer to the participants in order to accentuate the onlookers' energizing presence in the scene. One young child leans over her mother's back so that she, too, can see the procession, foreshadowing the time when she will participate in her own communion.

Although Gervex rarely again attempted a religious theme, *The First Communion* attracted the attention of the well-known critic Paul Mantz in his review for the newspaper *Le Temps*. Mantz commented that the "scene remained truthful," implying that Gervex had brought his eye for realistic detail to bear on a subject that was not always painted with such precision.[6] It is significant that Gervex chose the Église de la Sainte-Trinité (Church of the Holy Trinity, known as La Trinité) as the site for the first of many paintings of ceremonial scenes inside official buildings of the Third Republic.[7] Construction on La Trinité began in 1861 (during the Second Empire), and it was dedicated in 1867.[8] In the ensuing years, the church was transformed into a hospital to tend to the poor and sick during the severe winter of 1870–71, when Paris was under siege by the Germans. The grandeur of the interior was augmented by paintings and sculpture by some of the leading academic artists of the era.[9] This storied site lent an aura of history and importance to Gervex's painting, which is an evocation of the religious observance and duty demanded by the dogma of the Catholic Church. —*GPW*

1 On Naturalism in the visual arts and literature, see Gabriel P. Weisberg, *Illusions of Reality: Naturalist Painting, Photography, Theatre, and Cinema, 1875–1918* (Brussels: Mercatorfonds, 2010). Also see *Henri Gervex, 1852–1929* (Paris: Paris-Musées, 1992).

2 See Jean-François de Canchy, "Henri Gervex, 1852–1929: Biographie," in *Henri Gervex*, 23–83. This section of the essay lists Gervex's Salon contributions by year. The year 1877 is discussed on p. 28ff.

3 This series of drawings is reproduced as a photograph in "Henri Gervex, 1852–1929," 104.

4 Some consider this painting a reduced adaptation of the Dijon painting; more likely, it was another version of the composition that Gervex eventually cast aside to concentrate on what would become the finished canvas.

5 "Henri Gervex, 1852–1929," 104.

6 Paul Mantz, "Le Salon de 1877," *Le Temps*, May 27, 1877.

7 See *Le triomphe des mairies: Grands décors républicains à Paris, 1870–1914* (Paris: Musées de la ville de Paris, 1986), 114–18.

8 The church was designed by the architect Théodore Ballu (1817–1885) as part of the reconstruction of Paris under Baron Haussmann.

9 See *L'Église de la Sainte Trinité* (Paris: Diocèse de Paris, 1993), 22.

Henri Gervex, 1852–1929

Woman in a Historical Costume
black, red, and white chalk on paper
mounted to lightweight board
19.25 x 12.50 inches (48.90 x 31.80 cm)
Signed lower right in red chalk: *H. Gervex*
Inscribed upper right in black chalk:
jupe crème / galons or / crenès satin rose
Snite Museum of Art
Gift of Mr. and Mrs. Noah L. Butkin
2009.045.023

Provenance
Hôtel Rameau, Versailles, sale October 14,
1979; Shepherd Gallery, New York, 1980; Mr.
and Mrs. Noah L. Butkin; placed on loan with
the Snite Museum of Art, University of Notre
Dame, 1982; converted to a gift of the estate of
Muriel Butkin, 2009.

Gervex had a wide following among wealthy collectors, who often wanted their portraits painted. Their patronage gave the artist considerable leeway in what he could paint, leading him away from contemporary subjects such as that seen in *The Communicants* (cat. no. 45) toward reconstructions of the past, an appropriate theme for a well-recognized Salon artist.

This drawing might be related to the recording of popular balls, where guests dressed in costumes appropriate to a chosen theme. This woman's gown evokes the opulence of such an event and demonstrates Gervex's ability to capture a historical period. The woman seems to be entering the scene, holding her dress up at the hem as she strides forward. The fabric is carefully drawn, so that its heaviness reinforces the sheen of the taffeta. The notations of color in the upper right indicate that the drawing had a further use: it developed a figure to be included in a much larger oil painting, where the colors of the dress, only suggested here, would be elaborated in relation to the rest of the composition.
—*GPW*

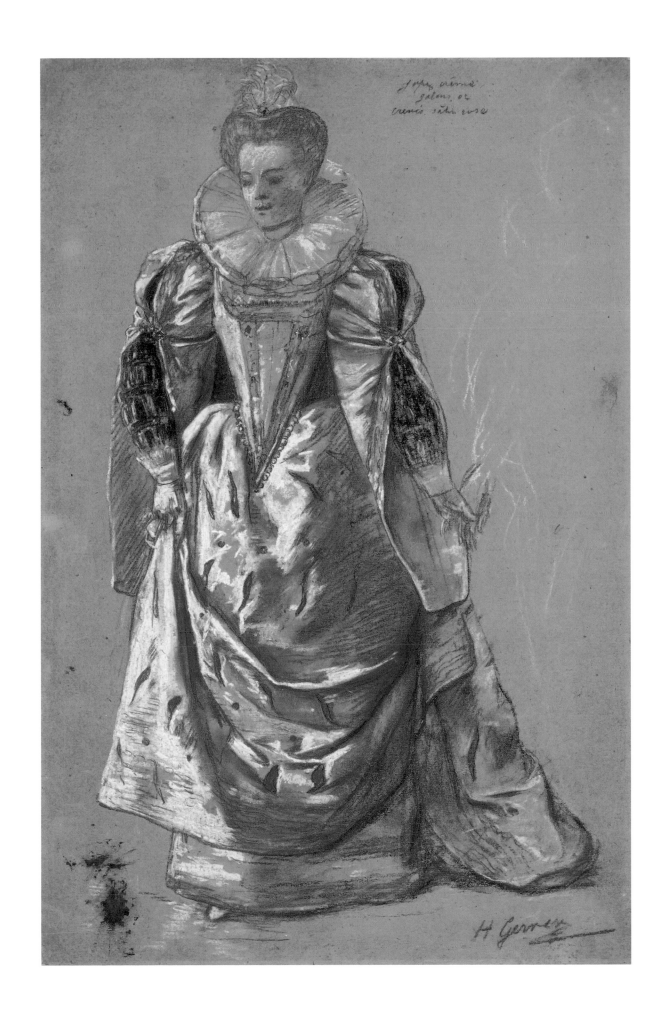

Pierre-Paul-Léon Glaize, 1842–1932

Study for "The Nights of Penelope," 1865
oil on canvas
10.25 x 15.5 inches (26.04 x 39.37 cm)
Signed and dated lower right: *PP Leon Glaize 1865*
Snite Museum of Art
Gift of Mr. and Mrs. Noah L. Butkin
2009.045.104

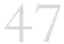

Provenance
Herbert Roman, Inc.; Mr. and Mrs. Noah L. Butkin, 1979; placed on loan with the Snite Museum of Art, University of Notre Dame, 1980; converted to a gift of the estate of Muriel Butkin, 2009.

The story of Penelope from Homer's *Odyssey* is a subject that painters have illustrated for at least eight centuries. Typically, ancient Greek vase painters showed Odysseus's wife Penelope working at her loom while she waited for her wandering husband to return from the Trojan War.[1] As the years passed and Odysseus did not return, Penelope increasingly had to fend off marriage proposals from a crowd of eager men. In order to postpone a decision—and thereby accept the fact that her husband was dead—she promised the eager suitors that she would consider remarrying only when she finished weaving her father-in-law's funeral shroud. Naturally, she had devised a strategy of undoing each day's weaving at night, thus preventing the shroud from ever being completed.

Images of Penelope at her loom fascinated a number of nineteenth-century painters, including John William Waterhouse, Max Klinger, John Roddam Spencer Stanhope, and Gustave Boulanger. In France, such classical Greek subjects were a routine part of the curriculum at Paris's École des Beaux-Arts, and young painters were instilled not only with images from antique stories, but also with a thorough education in the literature of ancient authors. Léon Glaize was no exception. After initially training with his father, the painter Auguste Glaize (1807–1893), he was sent to the École where he studied with Jean-Léon Gérôme, a proponent of the classical tradition. In 1859, Glaize made his Salon debut, and he subsequently exhibited side by side with his father for many years.[2]

In his *Study for "The Nights of Penelope,"* Glaize demonstrated the difference between a Neoclassical rendition of this theme and a late nineteenth-century interpretation. Rather than depicting Penelope in a traditional Greek chiton robe, which would have preserved her modesty as a Greek matron, Glaize clothed her in a diaphanous, sleeveless gown more likely to be seen at the Paris Opéra than in ancient Ithaca. Likewise, the sculpture of Athena, who presides over Penelope's nightly deception, is clad in an equally skimpy cloak, despite the fact that she carries both her spear and shield. The tone of the painting is thus more light-hearted than earlier versions of the theme. By updating his subject to fit the tastes of his own era, Glaize created a historical genre painting, a specialty that was well received by bourgeois patrons. The finished canvas, for which this is the oil sketch, was shown in the 1866 Paris Salon. —*JLW*

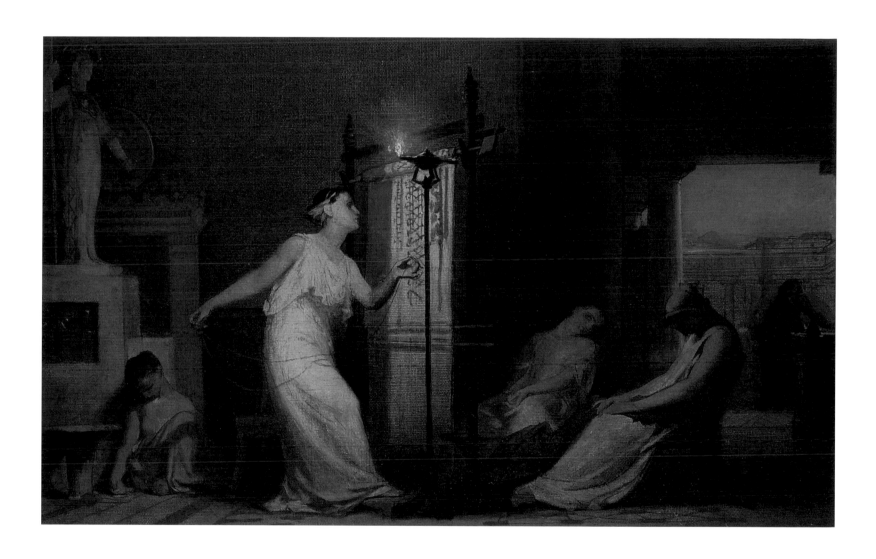

1 For the full epic poem of the aftermath of the Trojan War, see Homer, *The Odyssey of Homer*, trans. Richard Lattimore (New York: Harper Perennial Modern Classics, 1991). One early example of Penelope at her loom is the fifth-century-BCE red-figured *skyphos* by the Penelope Vase Painter. The vase, which shows Penelope at the loom and Telemachos, is currently in the collection of the Museo Nazionale in Chiusi, Italy.

2 C. H. Stranahan notes that Léon Glaize received medals at the Salon in 1864, 1866, and 1868; in 1877, he received the Légion d'honneur award, and in 1878, a first-class medal. See C. H. Stranahan, *A History of French Painting from Its Earliest to Its Latest Practice* (New York: Charles Scribner's Sons, 1888), 437.

François-Marius Granet, 1775–1849

The Ruins, 1832
oil on canvas
11.38 x 12 inches (28.90 x 30.50 cm)
Signed and dated lower left: *Granet / 1832*
Snite Museum of Art
Gift of Mr. and Mrs. Noah L. Butkin
2009.045.069

48

Provenance
Galerie Jonas, Brussels; Mr. and Mrs. Noah L. Butkin, 1977; placed on loan with the Snite Museum of Art, University of Notre Dame, 1980; converted to a gift of the estate of Muriel Butkin, 2009.

Selected Bibliography
Coutagne, Denis. *François Marius Granet, 1775–1849: Une vie pour la peinture.* Paris: Somogy editions d'art, 2008.

————. *Granet: Paysages de Provence.* Aix-en-Provence: Musée Granet, 1988.

Munhall, Edgar. *François-Marius Granet: Watercolors from the Musée Granet at Aix-en-Provence.* New York: The Frick Collection, 1988.

Throughout his adult life, François-Marius Granet moved back and forth between Rome and Paris, relishing the warmth and geniality of life in Italy, but also the cultural opportunities that awaited an artist in France. Born in Aix-en-Provence in December 1775, he left in 1796 to study art in Paris, only to return almost immediately to the south after the unexpected deaths of both of his parents. Two years later, he was back in Paris and studying art under the tutelage of Jacques-Louis David. His early work showed great promise, and he made his Salon debut in 1799 with *Interior of a Cloister*, after only a year's study in David's studio. The young Granet's skill at developing sophisticated images of architectural interiors would become a mainstay of his work throughout his career.[1]

Although Granet continued to exhibit at the Paris Salon regularly in the following decades, he lived primarily in Rome from 1802 to 1824. In 1808, he won a gold medal for *Santa Maria in Via Lata*, and in 1819, he received the cross of the Légion d'honneur from Louis XVIII for his painting *The Choir of the Capuchin Church on the Piazza Barberini, Rome.* The following year, he traveled to Paris to paint his first major state commission, the newly refurbished Galerie de Diane at the Château de Fontainebleau, but he returned to Rome as soon as possible.[2]

His years in Rome came to an end in late 1824 when Granet's childhood friend Comte Auguste de Forbin, who was the Director of Royal Museums, appointed him Associate Curator of Painting of the Royal Museums, and then Curator of Paintings in 1826. What would appear to be extreme good fortune to many artists came at a price for Granet; he had to choose between his love of Rome and his desire for a serious career in the arts. During his tenure in Paris as Curator of Painting of the Royal Museums, however, he seems to have been absent more often than not. As Edgar Munhall commented in a 1988 exhibition catalogue, "most of the documents concerning Granet in the archives of the Louvre are his requests for leaves of absence."[3]

Naturally, those leaves of absence were spent either in Rome or in southern France, where he had purchased some land near Aix-en-Provence—which would become the subject of many paintings in the years to come. By 1830 however, with his election to the Académie des Beaux-Arts in May, Granet realized that he would be required to reside in Paris permanently. He found living quarters at 56, rue Saint-Lazare and installed his Roman mistress there in 1831. For the next seven years, he worked as the first curator of the Musée Historique de Versailles, managing the development of this new museum established by King Louis Philippe to showcase the glories of French history.

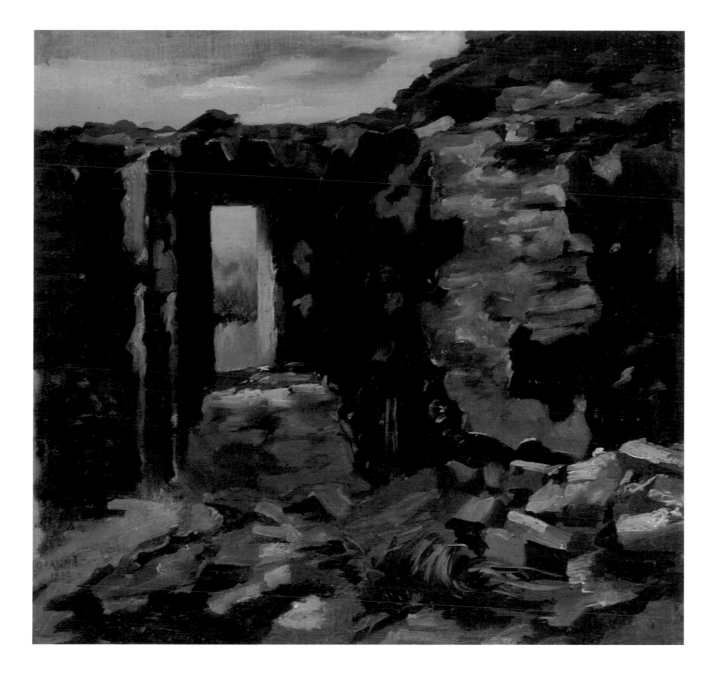

Although Granet seems to have taken his curatorial work quite seriously this time, he still occasionally left Paris for the south of France, where he could tend to his own property and enjoy the summer sun. This was the case between April and October of 1832, when *The Ruins* was probably painted. Like many of his earlier paintings, this one portrays the ruins of the built environment rather than an exclusively natural ruin. The viewer's eye is guided from the enclosure of a dilapidated structure to a clearly framed stone doorway that opens onto a distant and cloudy landscape. In this small oil sketch, Granet almost seems to offer his personal perspective on his own situation in life: standing in a tumbled-down shell of a building and looking at a gray sky ahead.[4]

—JLW

1 During these years, Granet lived in a deconsecrated Capuchin convent on the Place Vendôme, along with other students of Jacques-Louis David, as well as Jean-Auguste-Dominique Ingres and the Italian sculptor Lorenzo Bartolini (1777–1850). This building may have been the inspiration for Granet's *Interior of a Cloister*.

2 See the entry in this catalogue on *Diane de Poitiers Receiving a Message from Francis I* (cat. no. 60), by Édouard Pingret, for a discussion of the significance of "Diane" in relation to Francis I during this early nineteenth-century period.

3 Edgar Munhall, *François-Marius Granet: Watercolors from the Musée Granet at Aix-en-Provence* (New York: The Frick Collection, 1988), 63.

4 For an English translation of Granet's memoirs, which provide insight into his state of mind, see Munhall, *François-Marius Granet*, 3–59.

Jean-Paul Laurens, 1838–1921

The Corpse of King Clother on His Bier, ca. 1878–80
oil on canvas
11.25 x 16.75 inches (28.58 x 42.55 cm)
Signed lower left: *Jn-Paul Laurens*; and lower right: *PL*
Snite Museum of Art
Gift of Mr. and Mrs. Noah L. Butkin
2009.045.093

49

Provenance

Shepherd Gallery, New York; Mr. and Mrs. Noah L. Butkin, 1976; placed on loan with the Snite Museum of Art, University of Notre Dame, 1980; converted to a gift of the estate of Muriel Butkin, 2009.

Exhibitions

Exposition maîtres et petit maîtres du XIXᵉ siècle, October 1942, Galerie René Drouin, Paris.

Jean-Paul Laurens, 1838–1921: Peintre d'histoire, October 6, 1997–January 4, 1998, Musée d'Orsay, Paris; February 2–May 4, 1998, Musée des Augustins, Toulouse.

Selected Bibliography

Jean-Paul Laurens, 1838–1921: Peintre d'histoire. Paris: Réunion des musées nationaux, 1997.

Valmy-Baysse, Jean. *Peintres d'aujourd'hui: Jean-Paul Laurens; Sa vie, son oeuvre*. Paris: Librarie Félix Juven, 1910, cat. no. 2.

The history paintings of Jean-Paul Laurens embody many of the conflicting values of French culture in the decade immediately following the Franco-Prussian War of 1870–71. At the Salon of 1872, the first exhibition following France's defeat by the Prussians, Laurens received considerable attention—and a medal—for his painting *Le Pape Formose et Etienne VII*. This gruesome image depicts a bizarre event from January 897, in which the exhumed corpse of Pope Formosus was put on trial by his successor, Pope Stephen VII.[1] Despite the macabre subject matter, Laurens's painting of the skeletal Pope Formosus, clothed and crowned in his papal regalia, not only won a medal but also received positive critical commentary from Théophile Gautier, who recognized that the horror was, in fact, part of the attraction that drew audiences to the painting.[2]

This unusual combination of historical fact and gothic imagination established Laurens as a painter whose sensibility indirectly reflected the devastating experience of the Franco-Prussian War and the even more harrowing trauma of the Paris Commune, which estranged French citizens from one another. By creating historical distance through the choice of a medieval subject, Laurens encouraged viewers to make analogies with contemporary events, and hinted at his own interpretation of the terror that had engulfed France in the early 1870s.

By the end of the 1870s, the vogue for Merovingian subjects was increasingly popular, in part because this early medieval period was viewed as revealing the barbarism of the Germanic tribes who invaded the lands that would eventually become France.[3] In addition, these thematic paintings provided a means of expressing support for the principles of republican government—and those of the Third Republic of France, in particular. Albert Maignan's *Hommage à Clovis* (1885, Musée des Beaux-Arts, Rouen), for example, shows the child Clovis II sitting on a throne that is obviously much too large for him, while sycophant retainers bow before him. Clearly, the young Clovis II is in no way qualified to take over his father's position, much less to rule over a vast territory. Hereditary monarchy is thus shown to be a sham perpetuated for the consolidation of power by the ruling families.

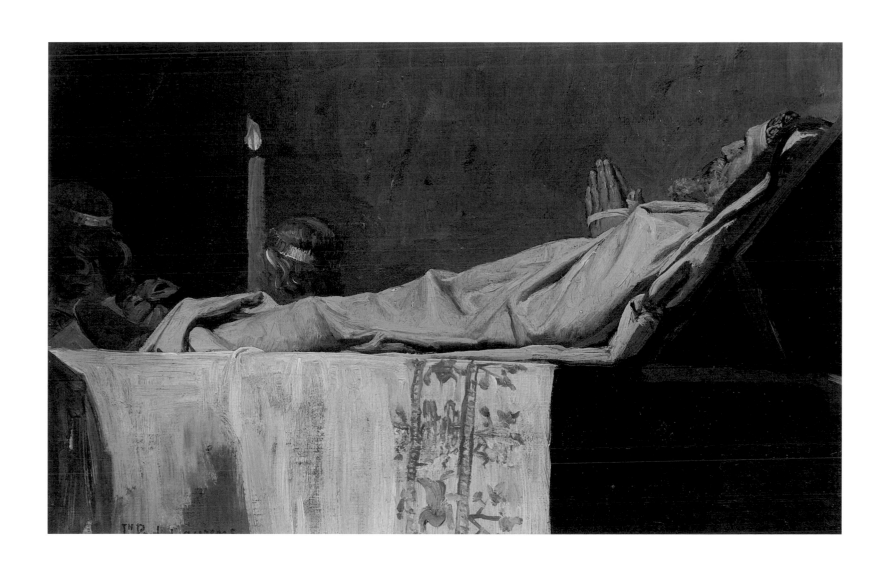

Laurens found this subject matter especially well suited to his own aesthetic and political positions. As a steadfast republican with deep suspicions about the church's role in national affairs, he embraced the Merovingian themes as one avenue for exploring more contemporary issues. The opportunity to develop an in-depth presentation of these themes seems to have been initially proposed to Laurens by his former instructor, Alexandre Bida (1813–1891).[4] Bida recommended that he contact the publisher Louis Hachette in regard to a "grand luxe" edition of Augustin Thierry's *Récits des temps mérovingiens*. Thierry's original publication had first appeared in the late 1830s, and was an early attempt at writing a "scientific" history of France based on empirical research, albeit within the context of a vivid Romantic literary sensibility.[5] This combination of a "scientific" approach to historical analysis with an evocative, even theatrical, presentation of factual information appealed to Laurens, and made him the ideal candidate for creating a series of etchings for Thierry's book.[6]

Laurens's second illustration for *Récits des temps mérovingiens* is entitled *Les funérailles de Clother* (Musée Antoine Vivenel, Compiègne) and is directly related to the painting *The Corpse of King Clother on His Bier*. In fact, the painting is a detailed study of the figure of the dead King Clother, with two attendants at the foot of his bier. The etching that appeared in the publication repeats this motif exactly, but within a larger composition that includes mourners and clergy, as well as an early medieval architectural background. The small oil painting in the Snite Museum was clearly a preliminary sketch made in conjunction with the publication of the etchings for Thierry's book.

The subject of the painting again advocates the perspective that the historical Germanic invaders of French lands were violent, irrational, and uncivilized. This image depicts the funeral of the ambitious King Clother (ca. 497–561), the fourth son of Clovis I, who became king of the Franks in 558 after having murdered his brother's children and annexed his great-nephew's territory. Next, he murdered his own son, Cham, for disagreeing with him; Cham, his wife, and his children were confined to their cottage, which was then set on fire. According to legend, Clother eventually repented of this action and sought forgiveness at the tomb of Saint Martin in Tours. He died not long afterward at his royal palace in Compiègne, which is presumably the setting for Laurens's painting. Although the repentant Clother is being buried in a Christian rite in the final version of the etching, the horror of his actions in life was part of Thierry's narrative. In the oil sketch, Laurens focused only on the dead body of the king, who wears blood-red footwear and rests his head on a red-striped cloth. The silent figures at the foot of the bier are seen only from the back, as if turning their faces away from the false piety of a barbaric and illegitimate ruler. —JLW

1 For a discussion of the legal context of this trial, see Donald E. Wilkes, Jr., "The Cadaver Synod: Strangest Trial in History," *Flagpole Magazine*, October 31, 2001, 8–9.

2 Théophile Gautier, "Salon de 1872, Peinture IV," in *Le Bien Public*, June 17, 1872, 2; cited in *Jean-Paul Laurens*, 1838–1921: *Peintre d'histoire* (Paris: Réunion des musées nationaux, 1997), 23. In describing Laurens's work, Gautier says that he produced "peintures énergiques et sombres devant lequelles il est impossible de ne pas s'arrêter longtemps, malgré l'horreur du sujet, peut-être même un peu à cause de cela." Gautier died in October 1872, making this his last Salon review.

3 It must be noted that nation states were just beginning to emerge during the Merovingian period, as warring tribes vied for control of territory following the end of the Roman Empire in 476.

4 Alexandre Bida specialized in Orientalist painting, but he also received considerable acclaim for his illustrations of the Bible—in particular, twenty-eight etchings of the Gospels, *Les saints évangiles*, published in 1873. See also *Jean Paul Laurens*, 1838–1921, 165. It should be noted that Muriel Butkin bequeathed a drawing by Bida, *Café in Constantinople* (1847), to the Cleveland Museum of Art.

5 Thierry's *Récits des temps mérovingiens* originally appeared as a series of articles in the liberal monthly magazine *Revue des deux mondes* in the late 1830s, and was published as a book in 1840. See Augustin Thierry, *Récits des temps mérovingiens: Précédés de considérations sur l'histoire de France* (Paris: J. Tessier, 1840).

6 Laurens's illustrations were published in Augustin Thierry's *Récits des temps mérovingiens* (Paris: Librairie Hachette, 1881 and 1887). The second plate, *Les funérailles de Clother,* is developed from the painting in the Snite Museum.

Victor Lecomte, 1856–1920

Man Reading under a Lamp, 1887
oil on panel
12 x 8.75 inches (30.48 x 22.23 cm)
Signed lower right: *V. Lecomte 1887*
Snite Museum of Art
Gift of Mr. and Mrs. Noah L. Butkin
2009.045.048

50

Provenance

Shepherd Gallery, New York; Mr. and Mrs. Noah L. Butkin, 1975; placed on loan with the Snite Museum of Art, University of Notre Dame, 1979; converted to a gift of the estate of Muriel Butkin, 2009.

When Victor Lecomte exhibited his *La lampe baisse* and *L'Étudiant*, paintings linked to the Snite Museum composition, at the 1887 Salon, he was already established as a regular contributor to the Paris Salons, often showing paintings that demonstrated his obsession with internal lighting effects.[1] His canvases frequently depicted members of a family either reading, sewing, or working on artistic compositions by lamplight. Lecomte may have been developing these themes as a deliberate continuation of seventeenth-century interests, evident particularly in the work of the Dutch Caravaggisti painters. Or he may have been documenting a contemporary fascination with oil lamps, which had replaced candles as one of the primary ways of illuminating a space. He was certainly not alone in addressing this subject during the nineteenth century.

Many of Lecomte's compatriots, both conservative and progressive in their inclinations, used an internal light source to illuminate their scenes. But Lecomte seemingly produced more paintings of this type than most of his colleagues, as was recently established in an exhibition held just outside of Paris.[2] In the Snite Museum panel, the space surrounding the figure is darkened, masking the details of the room and the hangings on the walls, so that all attention is focused on the activity of the figure during the evening hours. This spotlighting effect, sometimes even brighter in scenes using different lighting equipment, centers the interest on people and their lives.

Lecomte received several official awards for his *sous la lampe* scenes, including an honorable mention at the 1892 Salon and a third-class medal in 1897. The artist achieved even greater visibility at the Exposition Universelle, where he received a bronze medal in 1900 and a second-class medal in 1905. These prizes attest to his fame at the turn of the century, which led to official purchases by the French government. In 1903, the state secured an *Après dîner, effet de lampe* for 1500 francs, sending the painting to a provincial museum in Cahors, where it can be found today, although not in very good condition. In 1906, *Intérieur, effet de lampe* was acquired by the government for 250 francs and sent to the town hall in Montmorency, not far from Paris; the location of that piece is currently unknown. Finally, in 1908, Lecomte sold another work, *La cigarette*, to the French state; that painting was sent to the French embassy and then to Madrid.[3]

Thus, for a period of time, Lecomte's works were admired and selected for purchase by government officials. They believed that his images, which emphasized the importance of family life, represented the vision of the "good life" that the Third Republic espoused for French citizens. The official philosophy of the republic was that a good life was attainable for all Frenchmen when family members believed in education and cared for one another. —*GPW*

1 *Salon des artistes français* (Paris: Société des artistes français, 1887), cat. nos. 1447–48.

2 See *Sous la lampe: Peintures de 1830 à 1930* (Paris: Musée de Saint-Maur-des-Fossés, Villa Medicis, 2011).

3 Information on these sales was supplied to the author by the staff at the Musée de Saint-Maur-des-Fossés and further documented in archives on Lecomte in the Documentation department at the Musée d'Orsay, Paris.

Alphonse Legros, 1837–1911

Portrait of a Cardinal with His Patron Saint, ca. 1865
oil on canvas
22.13 x 28 inches (56.20 x 71.10 cm)
Signed lower right: *A. Legros*
Snite Museum of Art
Gift of Mr. and Mrs. Noah L. Butkin
1978.025.001

51

Provenance
Shepherd Gallery, New York; Mr. and Mrs. L. Butkin, 1975; Gift of Mr. and Mrs. Noah L. Butkin to the Snite Museum of Art, 1978.

Well established by the mid-1860s as a painter and printmaker, Alphonse Legros worked on a number of religious compositions. He moved between London and Paris, establishing contacts on both sides of the English Channel. As a close friend of James McNeill Whistler, an American painter linked to the Realist tradition, Legros was welcomed into the progressive Realist camp in London; in Paris, he associated with Henri Fantin-Latour and with François Bonvin, who painted small-scale Realist compositions that recalled the Dutch masters of the seventeenth century. His interest in religious imagery began as early as 1861, when his painting *Ex voto* (Musée de Beaux-Arts, Dijon) drew acclaim at the Paris Salon. Unfortunately, it remained unsold until Legros himself arranged for the painting to be accepted by the museum in Dijon, the city where he received his first artistic training at the École des Beaux-Arts.[1]

The *Ex voto* heralded a series of religious genre compositions that Legros worked on in the 1860s. Among these was his *Vocation of Saint Francis*, a canvas that entered the collection of the Musée des Beaux-Arts et de la Dentelle in Alençon in 1862. In that work, the unidealized figures and the quality of objectivity convey an understanding of the paintings of Gustave Courbet, then the reigning master of Realism. Legros placed the praying monks close to the viewer, across the frontal plane of the canvas, giving them a sense of grandeur. Their humble commitment to a life of prayer and self-denial is elevated to a position of importance and sincerity.[2]

In the Snite Museum painting, the haloed saint holds a prayer book in one hand but looks off into the distance, while the cardinal stares at the book as if seeking to learn what the saint already understands; Legros thus suggests that only the cardinal can be privy to the exposed prayer. The painting presents the humility of devotion as a crucial message for a public audience to follow. Legros intended to make his religious figures approachable

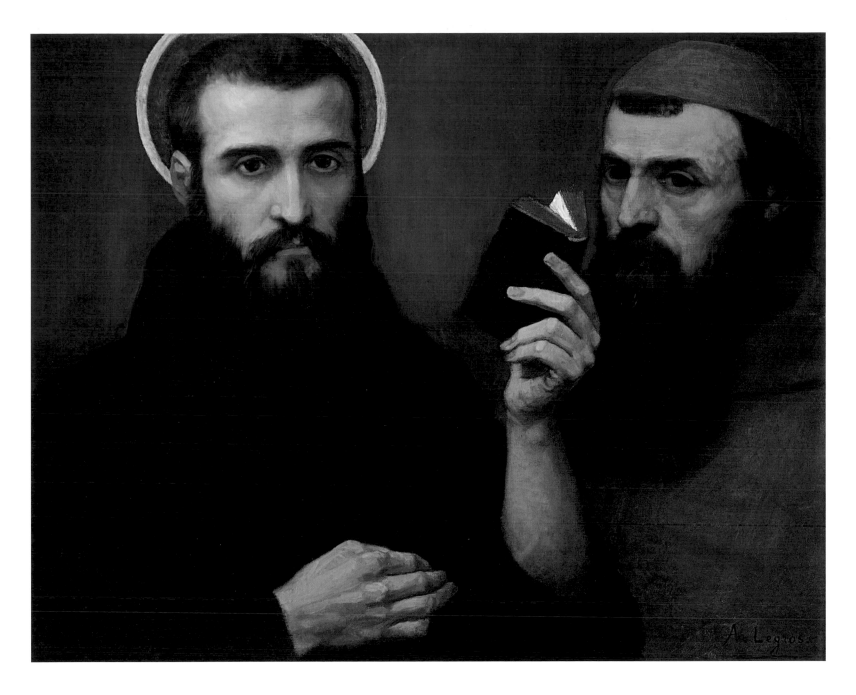

for the masses: here, he emphasizes the humanity of both the saint and the cardinal by depicting them as if they were portraits of living people. The nineteenth-century art critic Philippe Burty, an astute observer of new art, noted that Legros often visited a monastery in Paris. Reliance on real models was thereby part of his artistic training. He incorporated the authentic dress and practices of monks into his Realist paintings, which were suggestive of Spanish and Flemish works of earlier periods.[3]
—GPW

1 Gabriel P. Weisberg, *The Realist Tradition: French Painting and Drawing, 1830–1900* (Cleveland: The Cleveland Museum of Art and Indiana University Press, 1980), 116.

2 Timothy Wilcox, *Alphonse Legros, 1837–1911* (Dijon: Musée des Beaux-Arts, 1988). See also Alexandre Seltzer, "Alphonse Legros: The Development of An Archaic Visual Vocabulary in Nineteenth-Century Art" (PhD diss., State University of New York at Binghamton, 1980).

3 For further information on Legros, see "Curriculum Vitae de Legros," Papiers Clément-Janin, carton 74, dossier 3 bis, manuscript, Bibliothèque Nationale de France, Paris.

Fig. 1. Wax stamp on verso of canvas.

Lepoittevin (Eugène Poidevin), 1806–1870

Still Life with Eel and Fish (Sting-Ray)
oil on panel
13 x 9.75 inches (33.02 x 24.77 cm)
Inscribed on verso at upper left, in black ink and enclosed in a
horizontal rectangle: *LePoittevin* (red wax estate stamp) (fig. 1)
Snite Museum of Art
Gift of Mr. and Mrs. Noah L. Butkin
2009.045.122

52

Provenance
Shepherd Gallery, New York, 1976; Mr. and
Mrs. Noah L. Butkin, 1976; placed on loan
with the Snite Museum of Art, University of
Notre Dame, 1988; converted to a gift of the
estate of Muriel Butkin, 2009.

Exhibitions
*Chardin and the Still-Life Tradition in
France*, 1979, The Cleveland Museum of
Art, cat. no. 21.

Selected Bibliography
Weisberg, Gabriel P., with William S. Talbot.
Chardin and the Still-Life Tradition in France.
Cleveland: The Cleveland Museum of Art,
1979, p. 57, cat. no. 21.

Raised by a family interested in the arts, Lepoittevin was trained
by Xavier Leprince (1799–1826) and Louis Hersent (1777–
1861). After failing to win the Prix de Rome, he denounced the
academic tradition and devoted himself to painting after nature—
one of the principal goals of progressive painters in the 1830s. He
exhibited at the Paris Salon, beginning in 1831, but also showed
his work in England and Germany, where he was especially
appreciated for his genre scenes and seascapes. His anecdotal
narratives were strongly influenced by the Dutch and Flemish
painters of the seventeenth century.

In 1831, the coastal town of Etretat, in Normandy, became
Lepoittevin's preferred location for his genre scenes; he
constructed a villa there with an expansive view of the bay.[1]
Lepoittevin was in the forefront of painters, including Gustave
Courbet and Claude Monet, who visited Etretat to paint outdoors.
His numerous canvases reflecting the activities of fishermen
and bathers employ unusual viewpoints and demonstrate a firm
handling of extensive views of nature.

It is not known exactly when Lepoittevin painted this small panel
of fish, but he was certainly aware of the tradition of painters
hanging fish on a wall, as if they were trophies from the sea. As
an early contributor to the still-life revival, along with artists
such as François Bonvin and Antoine Vollon, Lepoittevin created
vibrantly colored paintings that proved popular with consumers
eager to elevate still-life painting to a position of significance.
—*GPW*

1 See *Le XIXè Siècle* (Paris: Talabardon and Gautier, 2011), cat. no. 21.

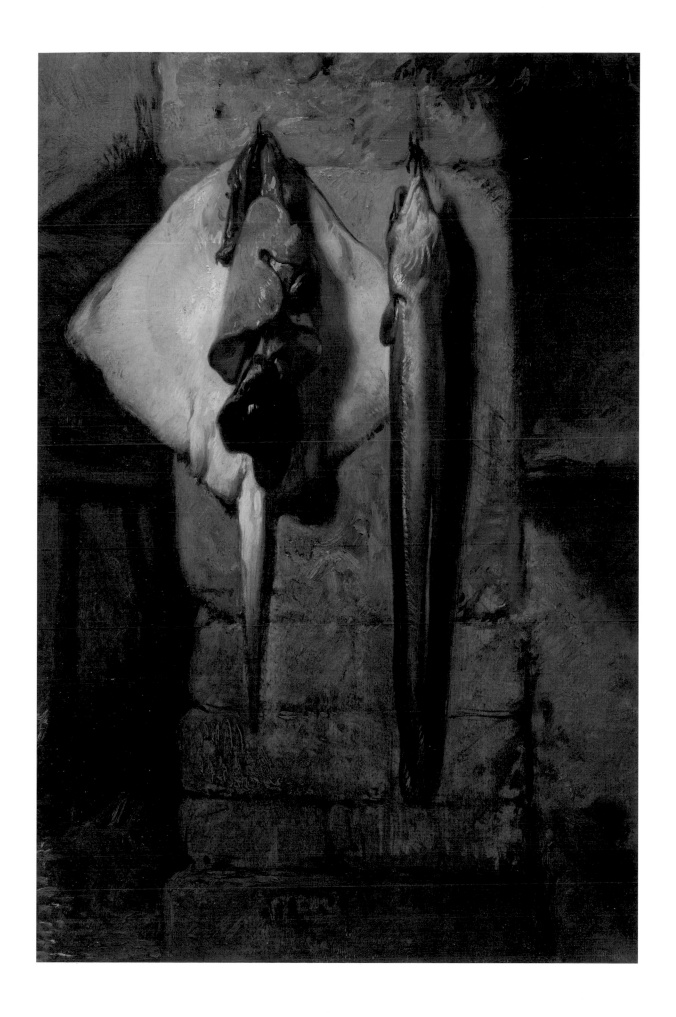

Léon-Augustin Lhermitte, 1844–1925

A Funeral (Dernière cérémonie ou les funérailles)
charcoal
12.88 x 10.38 inches (32.70 x 26.40 cm)
Signed lower right in charcoal: *L. Lhermitte*
Snite Museum of Art
Gift of Mr. and Mrs. Noah L. Butkin
1977.047.006

53

Provenance

Sold by the artist to M. Oules, artiste-peintre, London, 1869; Sotheby's, London, sale June 24, 1966, cat. no. 49; Sotheby's, New York, October 25, 1977, sale 673, cat. no. 52; Shepherd Gallery, New York, 1977; Mr. and Mrs. Noah L. Butkin, 1977; gift of Mr. and Mrs. Noah L. Butkin to the Snite Museum of Art, 1977.

Exhibitions

Christian Imagery in French Nineteenth-Century Art, 1789–1906, May 20–July 26, 1980, Shepherd Gallery, New York, cat. no. 156.

Selected Bibliography

Le Pelley Fonteny, Monique. *Léon Augustin Lhermitte (1844–1925): Catalogue raisonné.* Paris: Cercle d'art, 1991, cat. no. 55.

Early in his career, Léon-Augustin Lhermitte dedicated himself to working in charcoal, believing, as many of his contemporaries did, that drawing was just as significant as painting. His *fusains* (as they were called at the time) were highly finished. Lhermitte focused on scenes and individuals drawn from daily life, thinking that such representations could be made as significant as those visualizing the heroic past.

Among these early drawings was *Le tourneur* (Victoria and Albert Museum, London), in which Lhermitte observes a workman at his lathe in scrupulous detail. Originally purchased by the British collector Constantin Ionides in 1869, that drawing was part of a large collection of Realist paintings and works on paper that Ionides amassed by young artists of Lhermitte's generation. Although *A Funeral* was not part of the Ionides collection, it was purchased by an English artist in the same year as *Le tourneur*, suggesting a broadening interest in Lhermitte's charcoal compositions outside of France. As Ionides's collection became known in the 1870s, other collectors probably hoped to locate works by artists that he was introducing to the English art community.

Even though the figures in Lhermitte's sketch move rather stiffly, they convey the sense that the artist was working from observed reality. He captures the anguish on the faces of the mourners as they pass through a rural church to view a closed coffin. Lhermitte would later develop a series of drawings for a book on rural life. He also began using the medium as preparation for commissioned compositions. With this early sketch, Lhermitte establishes himself as a master of black-and-white in a work that transcends anecdotal genre to become a moving representation of French daily life. —*GPW*

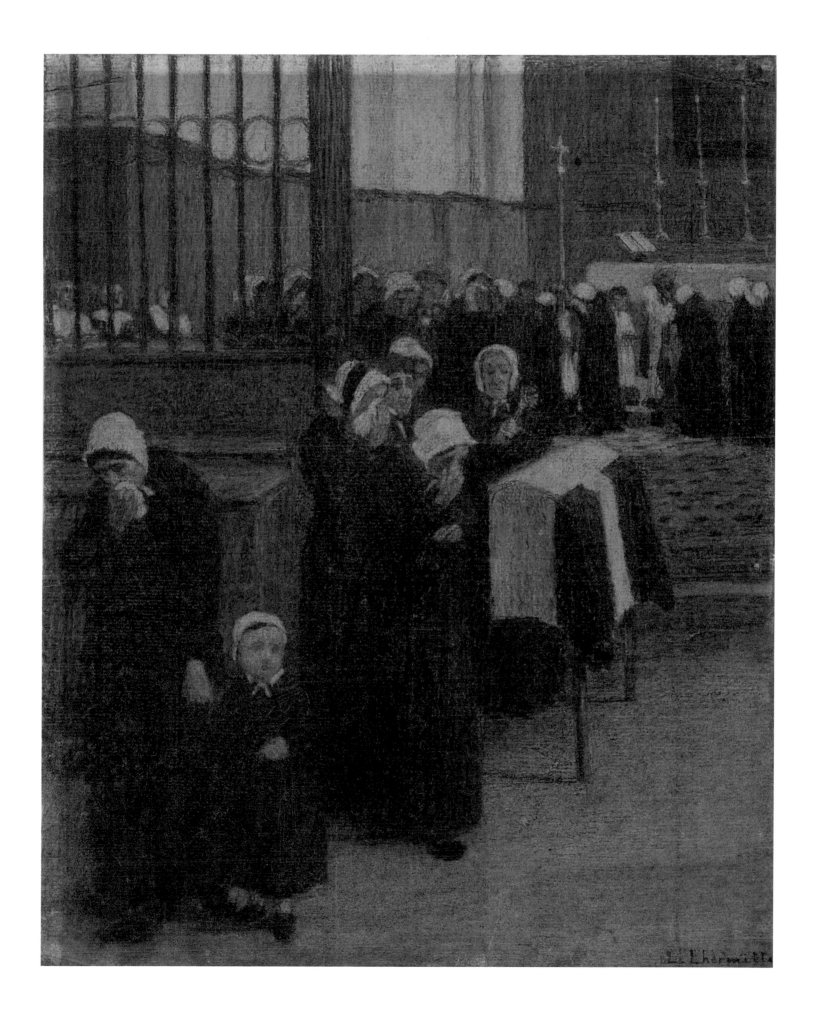

Léon-Augustin Lhermitte, 1844–1925

Harvesting, Late Afternoon, ca. 1893–1903
oil on canvas
17.88 x 12.75 inches (45.40 x 32.40 cm)
Signed lower left: *L. Lhermitte*
Snite Museum of Art
Gift of Mr. and Mrs. Noah L. Butkin
2009.045.076

54

Provenance
Sotheby Parke-Bernet, sale no. 3939, Jan. 14, 1977, lot no. 159; Shepherd Gallery, New York, 1977; Mr. and Mrs. Noah L. Butkin, 1977; placed on loan with the Snite Museum of Art, University of Notre Dame, 1980; converted to a gift of the estate of Muriel Butkin, 2009.

Selected Bibliography

Le Pelley Fonteny, Monique. *Léon Augustin Lhermitte (1844–1925): Catalogue raisonné.* Paris: Cercle d'art, 1991.

———. *Léon Augustin Lhermitte et la paye des moissonneurs.* Les dossiers du Musée d'Orsay 44. Paris: Réunion des musées nationaux, 1991.

Images of rural life in France are at the heart of Lhermitte's artistic production. Throughout his long career, he returned again and again to the theme of haymakers, gleaners, and the life of farmworkers at the end of the nineteenth century. Like many of his colleagues, Lhermitte strove to capture the agricultural traditions of the French countryside before they disappeared in the rush of industrialization and urban development.

The oil sketch *Harvesting, Late Afternoon* is one of many images related to the subject of gleaners. The custom of gleaning, or gathering up any usable pieces of grain that remain after harvesting, was traditionally reserved for the poorest rural workers in France. Lhermitte's canvas owes a debt to Jean-François Millet's famous painting *The Gleaners* (1857, Musée d'Orsay, Paris) in its idealization of the figures, but the immediacy of the Naturalist painter's image also reflects the influence of the Impressionists' interest in light, as well as a concern for depicting the tangible textures of the landscape best exemplified by the work of Jules Bastien-Lepage. Equally significant, Lhermitte's gleaners no longer carry the political message of Millet's earlier work; what had been a sharp reminder of the political volatility among the poor in 1857 was transformed into a more objective image of the conditions of agricultural laborers in the Third Republic.

In the process of creating a painting, Lhermitte typically drew and sketched prolifically, often reworking an image in a variety of different media, including charcoal drawings, etchings, pastels, and oil sketches.[1] Other versions of *Harvesting, Late Afternoon* can be seen in two pastels that contain nearly identical compositions. One is a pastel on paper mounted on canvas and titled *Haymakers* (private collection) that is very close in size to the Snite Museum painting—17.76 x 13.78 inches (45.11 x 35 cm).[2] The only significant difference between the two works, aside from the medium, is that the pastel contains a red farm building in the upper right background and a clearly defined wagon under the grain shed. The other pastel, *Glaneuses près des meules* (1903, private collection), is a more-nearly square composition featuring

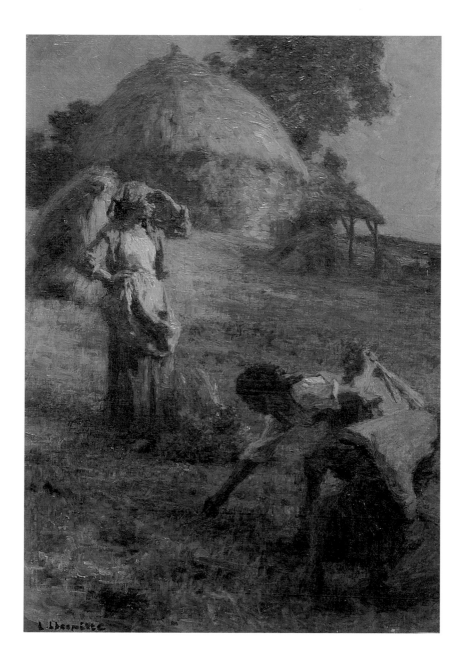

the same three women in the foreground, with the grain stack and shed in the distance, but with an additional fourth figure carrying a bundle of grain that she has already gleaned.[3]

All of these works appear to be related to two canvases, both entitled *The Gleaners*, one from 1893 and one from 1922, which helps to provide a reasonable range of dates for the Snite Museum painting.[4] Most likely, *Harvesting, Late Afternoon* was created in the 1890s, since the square-format pastel *Glaneuses près des meules* provides an end date of 1903. Although the 1922 painting does include a reverse image of the women gathering the stray stalks of grain, the composition also illustrates men loading the grain wagons and clambering onto the top of the grain stacks—elements that are absent in the earlier images. —*JLW*

1 Monique Le Pelley Fonteny, *Léon Augustin Lhermitte et la paye des moissonneurs*, Les dossiers du Musée d'Orsay 44 (Paris: Réunion des musées nationaux, 1991), 5–6.

2 The title *Haymakers* is misleading, as the figures are harvesting not hay but grain. For a fuller discussion of this topic, and to view an image, see the Hay in Art Database at www.hayinart.org.

3 See Monique Le Pelley Fonteny, *Léon Augustin Lhermitte (1844–1925): Catalogue raisonné* (Paris: Cercle d'art, 1991), cat. no. 704.

4 Ibid., cat. no. 296 is from 1893 and is vertical in format like the Snite Museum painting and the undated pastel. The entry for cat. no. 253, which is dated 1922, states that another version of the same work, titled *Glaneuses près des meules*, was done in pastel that same year. This would suggest that there are two pastels with the same title, one from 1903 and one from 1922.

Prosper Marilhat, 1811–1847

Outside Cairo
oil on canvas
25 x 32 inches (63.50 x 81.30 cm)
Signed lower left: *Marilhat*
Snite Museum of Art
Gift of Mr. and Mrs. Noah L. Butkin
2009.045.045

55

Provenance
Julius H. Weitzner, New York; Probasco
Collection, Christie's, London, *Fine Continental
Pictures, 19th/20th Centuries*, June 16, 1978,
cat. no. 101; Shepherd Gallery, New York,
1978; Mr. and Mrs. Noah L. Butkin, 1978;
placed on loan with the Snite Museum of Art,
University of Notre Dame, 1978; converted to a
gift of the estate of Muriel Butkin, 2009.

Exhibitions
Wadsworth Atheneum, Hartford, Connecticut.

When Prosper Marilhat arrived in Paris in 1828, he had already established a reputation as a portrait and landscape painter. He was soon engaged by Baron Karl von Hugel to go on an expedition to the Near East, in 1831–33. From this trip, Marilhat brought back a number of studies, which he used to develop finished paintings for the Paris Salon. He visited Greece, Syria, Lebanon, and Palestine, but it was Egypt (specifically Cairo) that held his interest; he stayed there for a considerable period of time. The villages of the Nile Delta and Upper Egypt especially attracted Marilhat's attention, providing him with a wealth of sketches that he used later. Despite trips to Italy and elsewhere, the Near East remained his passion, and he always retained his freshest impressions of what he had seen in Cairo.

One of the first recorders of sites in the Near East, Marilhat gained fame as an early Orientalist who did not rely on his imagination to construct his compositions. He accurately recorded what he saw, capturing the region's brilliant light to make his scenes memorable for individuals who had never been to the Near East but who wanted to secure paintings of this contemporary theme. Although the exact site that is depicted here remains unknown, Marilhat's study of a gateway provides an early instance of a French artist using his fascination with the Near East to further his career. —*GPW*

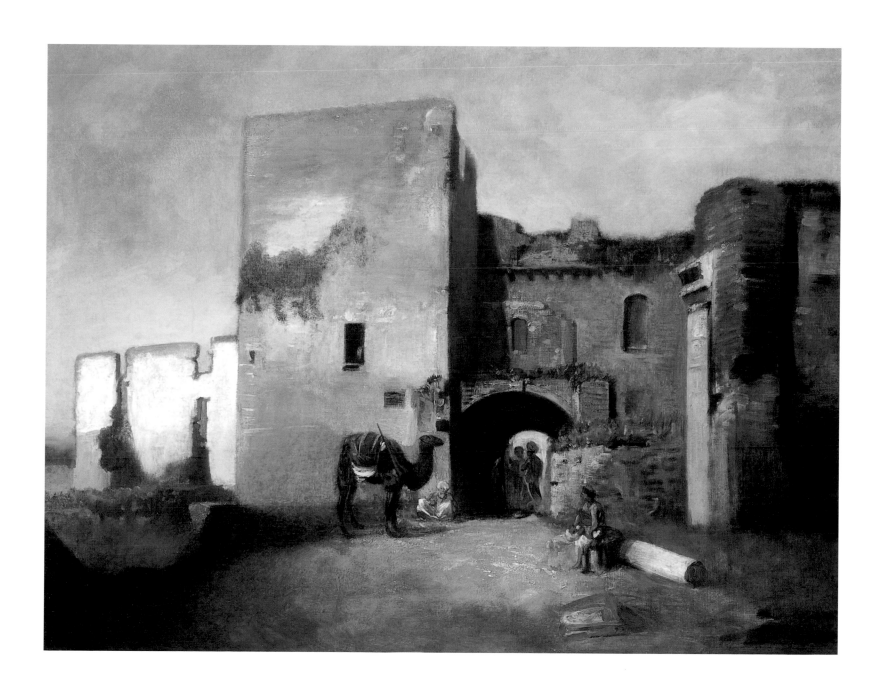

Jean-Louis-Ernest Meissonier, 1815–1891

Study for "1807, Friedland," ca. 1875

graphite on ivory wove paper

11.50 x 7.50 inches (29.30 x 19.10 cm)

Inscribed lower left in graphite: EM

The Cleveland Museum of Art

Bequest of Muriel Butkin

2009.130

56

Provenance

The Norton Galleries, New York, 1973; Mr. and Mrs. Noah L. Butkin, Shaker Heights, Ohio; bequest of Muriel Butkin to the Cleveland Museum of Art, 2009.

Making his Salon debut in 1834 with *The Flemish Burghers*, Ernest Meissonier built a reputation in the 1840s and '50s exhibiting small-scale genre subjects inspired by seventeenth-century Dutch and Flemish masters. The exquisite rendering of meticulous detail that characterized his youth proved consistent in his mature work. Meissonier embarked upon the military subjects for which he is now best known in 1859, when he was commissioned by Napoleon III to record the emperor's campaign in Italy. The artist ultimately submitted two canvases, *The Emperor Napoleon III at the Battle of Solferino* (1863, Musée National du Château, Compiègne) and *Napoleon III Surrounded by His General Staff* (1864, Musée National du Château, Compiègne), but the works did not lead to further commissions or secure his standing as a military artist.

Undaunted, Meissonier pursued his ambition to be a history painter by turning his attention to re-creating France's recent past, particularly the revolutionary and empire periods. His most ambitious project was a series of three paintings commemorating Napoleon I's military career. At the Salon of 1864, he exhibited the monumental *1814, The Campaign of France* (Musée d'Orsay, Paris), in which Napoleon retreats through a desolate, frozen landscape. The solemn work was intended to emblematize Napoleon's military and psychological setbacks and to show the emperor poised on the precipice of defeat. As a foil to *1814*, Meissonier envisioned the epic *1807, Friedland* (The Metropolitan Museum of Art, New York) as an exhilarating spectacle of Napoleon's troops on the verge of one of their greatest victories. His goal was to paint the soldier's adoration for their leader, and their willingness to sacrifice their lives for his cause.[1] Although Napoleon on his white horse is central to the unfolding drama, the ferocious energy of the anonymous cuirassiers of the 12th regiment and their horses overwhelms the image. It has been suggested that Meissonier's composition was based on Auguste Raffet's *La revue nocturne* (1836), a lithograph depicting an eerie vision in which ghostly cuirassiers, risen from their tombs, encircle the specter of Napoleon.[2] In the spirit of Raffet's lithograph, Meissonier implied undying allegiance with the fierce expressions of the cuirassiers.

Obsessed with detail, Meissonier immersed himself in his subject for many years, interviewing eyewitnesses to the battle, reading military memoirs, collecting uniforms and accessories, and studying the movement of horses in his sizable stable. He made dozens of oil on panel studies, as well as studies in graphite or pen; but while he was willing to show a group of his oil sketches in an 1884 retrospective, he chose not to exhibit the drawings.

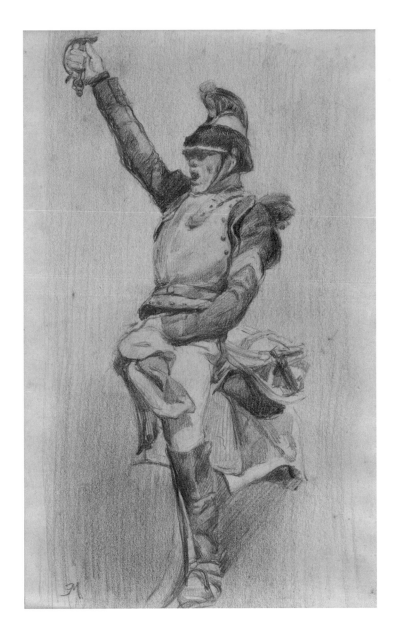

Such works were personal investigations of form, color, and movement, not intended for public consumption. Meissonier later described his drawings to Jean-Léon Gérôme as "made on whatever with whatever, always by the accident of present need and certainly never in view of pleasing the public."[3] The Cleveland Museum of Art's graphite study focuses on a soldier at the right of the painting. Mounted on horseback and brandishing a sword, the figure rides with his chin tucked and his mouth wide open in a battle cry. His eyes are shaded by his helmet, rendering him an anonymous allegory of fanatical devotion. Meissonier's own military experience was extensive. A member of the National Guard, he served as a lieutenant colonel in the Franco-Prussian War and opposed partisans of the Paris Commune. Such a subject would have had profound resonance for an artist whose goal was to re-create the past. —HL

1 *Catalogue of the A. T. Stewart Collection of Paintings, Sculptures, and Other Objects of Art* (New York: American Art Association, 1887), cat. no. 210. Cited in Constance Cain Hungerford, *Ernest Meissonier: Master in His Genre* (Cambridge: Cambridge University Press, 1999), 157.

2 Michel Convin, "Séries et Individus," *Le Musée Critique de la Sorbonne (Mucri)*, http://mucri.univ-paris1.fr/mucri11/article.php3?id_article=36. Convin discusses Raffet's and Meissonier's treatment of cuirassiers as undifferentiated types in *La revue nocturne* and *1807, Friedland*.

3 Letter dated January 20, 1884, conserved in the Collection Frits Lugt, Institut Néerlandais, Paris, i9516(2)/70; quoted and translated in Hungerford, *Ernest Meissonier*, 170.

Jean-Louis-Ernest Meissonier, 1815–1891

The Charging Cuirassier (Study for "1807, Friedland"), ca. 1867–72
oil on paper mounted on panel
16 x 13 inches (40.60 x 33 cm)
Snite Museum of Art
Gift of Mr. and Mrs. Noah L. Butkin
2009.045.068

57

Provenance

J-P Chapelle–P. Perrier–D. Fromentin,
Versailles; André Chenue, Paris; François
Flameng, Paris; Galerie Georges Petit, May
26–27, 1919; Sotheby Parke-Bernet, New York,
April 19, 1974, cat. no. 181; Mr. and Mrs. Noah
L. Butkin, 1974; placed on loan with the Snite
Museum of Art, University of Notre Dame,
1980; converted to a gift of the estate of Muriel
Butkin, 2009.

Exhibitions

*French Nineteenth-Century Oil Sketches: David to
Degas*, March 5–April 16, 1978, The William
Hayes Ackland Memorial Art Center, The
University of North Carolina at Chapel Hill.

Selected Bibliography

Burty, Philippe. *Jean Louis Ernest Meissonier
(La vie de Meissonier).* Translated by Clara Bell.
London: Chapman & Hall, 1884.

Fisher, Jay McKean, William R. Johnston,
Kimberly Schenck, and Cheryl K. Snay. *The
Essence of Line: French Drawings from Ingres to
Degas.* Baltimore, MA, and University Park,
PA: Baltimore Museum of Art, Walters Art
Museum, and Pennsylvania State University
Press, 2005.

Gottlieb, Marc. *The Plight of Emulation: Ernest
Meissonier and French Salon Painting.* Princeton,
NJ: Princeton University Press, 1996.

Hungerford, Constance Cain. *Ernest Meissonier:
Master in His Genre.* Cambridge: Cambridge
University Press, 1999.

Selected Works from the Snite Museum of Art.
Notre Dame, IN: Snite Museum of Art,
University of Notre Dame, 1987, p. 159 (illus.).

Sterling, Charles, and Margetta M. Salinger.
*French Paintings: A Catalogue of the Metropolitan
Museum of Art,* vol. 2, *XIX Century.* New York:
The Metropolitan Museum of Art, 1966, pp.
152–53 (illus. p. 153).

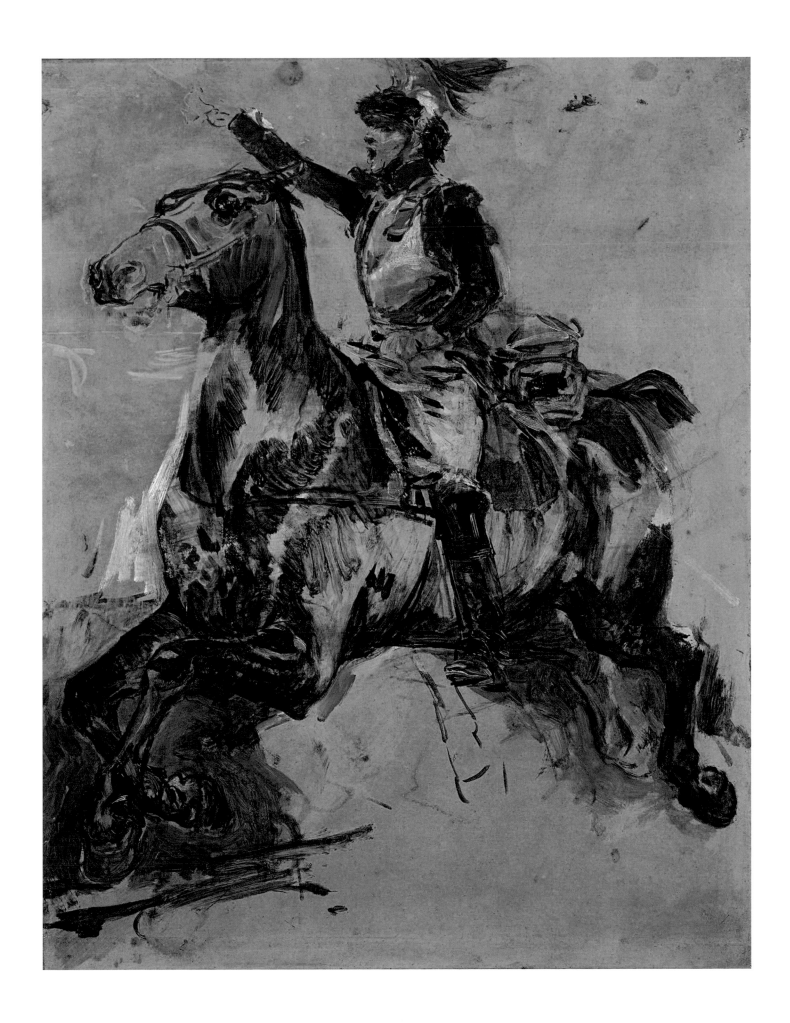

This small oil sketch of a Napoleonic cuirassier, or cavalry soldier, charging into battle was one of many studies for Meissonier's large painting of Napoleon's victory over the Russians at Friedland, Germany, on June 14, 1807. Meissonier's intention for the completed painting, entitled *1807, Friedland* (1861–75, The Metropolitan Museum of Art, New York), was to illustrate "the love, the adoration of the soldiers for the great Captain in whom they had faith, and for whom they were ready to die."[1] It is not so much a victory celebration as a tribute to the relationship between the French Army and its commander.

The process of creating *1807, Friedland* took nearly fifteen years, largely because Meissonier was intensely concerned with both historical and scientific accuracy in his depiction of men, horses, costumes, weapons, and military accoutrements. In fact, this painting took longer to complete than any other work that the artist produced.[2] In the mid-1860s, he focused on historical research into military uniforms, helmets, swords, and the harnesses, saddles, and trappings for horses, as well as technical studies of the human body in motion. As always with Meissonier, the careful and accurate depiction of reality was paramount; nature was truth, and anything less than absolute veracity was unacceptable. When he showed *1807, Friedland* at the Universal Exposition in Vienna in 1873, he found some of the details lacking, and so continued to work on it for another two years.

The *Charging Cuirassier* sketch probably dates from 1867–72, when Meissonier developed a series of studies of riders and horses on small oil panels.[3] During this time, he made exhaustive oil sketches of horses in motion, always striving for the most realistic image possible. In addition to closely observing his own stable of horses, Meissonier most likely studied the work of Jules-Etienne Marey (1830–1904), whose scientific research into animal movement was well underway by the 1860s. Marey's focus was on the muscular responses to changes in pressure, speed, and distance as the horses moved at various gaits. For Meissonier, this type of information was extraordinarily valuable, especially once it had been translated into drawings by Emile Duhousset (born 1823), a drawing instructor at the École des Beaux-Arts, for Marey's preliminary publication, *La machine animale*, in 1873.[4]

As an example of Meissonier's creative process, *The Charging Cuirassier* illustrates both the intensely focused study of a cavalry soldier and the emotional energy associated with the theme of French soldiers' relationship to Napoleon. Even in this small sketch, the figure seems entirely engaged in the moment, as he charges forward in celebration not only of victory but also of the French Army itself. —*JLW*

1 Letter from Meissonier to Alexander T. Stewart, 1876. Cited in Constance Cain Hungerford, *Ernest Meissonier: Master in His Genre* (Cambridge: Cambridge University Press, 1999), 157.

2 Hungerford, *Ernest Meissonier*, 166.

3 A similar oil sketch, *Study of Cuirassiers for "1807, Friedland" and "1805, The Curassiers before the Charge,"* is now at the Musée d'Orsay, Paris. The figure on the right in this sketch is very close to *The Charging Cuirassier* in the Snite Museum. See Hungerford, *Ernest Meissonier*, 169 (fig. 72).

4 It should be noted that Duhousset eventually became a technical consultant to Meissonier, in 1887. See Hungerford, *Ernest Meissonier*, 167–68.

Fig. 1. Wax seal on verso of canvas.

Isidore Pils, 1813–1875

Oil sketch of two figures in "The Death of a Sister of Charity," ca. 1850

oil on canvas

17 x 10.50 inches (43.18 x 26.67 cm)

Stamped lower left: *I. PILS*

Stamped on verso in wax: Pils estate seal (fig. 1)

Snite Museum of Art

Gift of Mr. and Mrs. Noah L. Butkin

2009.045.118

58

Provenance

Hôtel Drouot, Paris, *Vente tableaux, études, esquisses, aquarelles, dessins par I. Pils,* March 1876, p. 43, cat. no. 419; Galerie André Watteau, Paris; Mr. and Mrs. Noah L. Butkin; placed on loan with the Snite Museum of Art, University of Notre Dame, 1982; converted to a gift of the estate of Muriel Butkin, 2009.

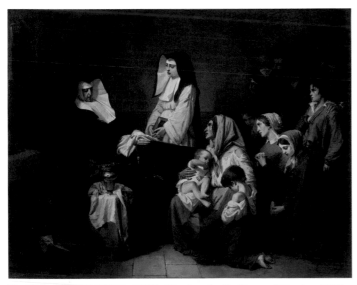

Fig. 2. Isidore Pils (1813–1875), *The Death of a Sister of Charity*, 1850, oil on canvas, 95.50 x 120.88 inches (242.57 x 307.03 cm), Musée des Augustins, Toulouse.

The academically trained Isidore Pils was exceptionally well represented at the Salon of 1850–51 as a member of the emerging Realist group. Already an established painter who had shown religious and historical subjects at the Paris Salons, Pils was now moving in another direction, focusing on the condition of the indigent and outcasts of society with his exhibition of *The Death of a Sister of Charity* (fig. 2). It was a theme that he was personally committed to: the composition derived from his own traumatic experiences of childhood illness, coupled with his growing compassion for the poor. In constructing the image, he made several drawings of single figures and groups of figures, followed by a series of preliminary oil studies, including the one in the Snite collection.[1]

The selection of this subject arose from Pils's intense familiarity with the Hôpital Saint-Louis, an infirmary in the center of Paris where sick children were cared for by nuns under the direction of the Mother Superior Saint Prosper. Pils had been treated there on three separate occasions during the 1840s for bouts of tuberculosis, so he was intimately aware of the work done by the hospital staff to assist those in need. When the Mother Superior passed away, the artist was motivated to create a testimonial to her importance. The resulting painting was a visual memorial to a dedicated, compassionate sister, as well as a personal statement by Pils on how he had been tended to by the hospital staff. It effectively conveys the grief of the mourners entering the death chamber to pay their last respects, so that the image becomes a reminder of their gratitude for what Saint Prosper had done for them. Following the Revolution of 1848, the painting's message also coincided with the government's increasing concern for improving the conditions of the disenfranchised. It affirmed the government's munificence toward the poor and its efforts to eliminate pauperism during the Second Empire.[2]

After constructing the entire scene, Pils began focusing on individual sections. The Snite Museum's oil study was used to define the relationship between a young boy, who stands at the far right, and a crippled beggar, who is walking with the aid of a wooden crutch while leaning on the boy's shoulder. Pils may have used real models to help him achieve a sense of realism. While the man is dressed in tattered garments, the young boy wears a blue worker's smock and striking red trousers. The colors of his clothing symbolize that he is the future of the

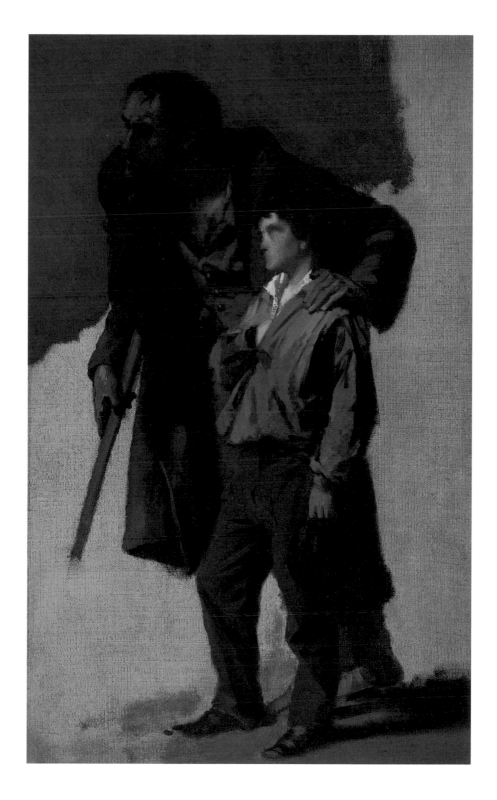

French nation. By showing the older man leaning on this youth for support, Pils heightens the bond between old and young, stressing the cyclical nature of life. Oil studies were important in the evolution of Pils's compositions, and sketches like this one reveal the artist's working method. They also demonstrate how he used the academic tradition to develop a Salon painting with a contemporary message for the nation. —*GPW*

1 For more information on the drawings that Pils made in the development of this composition, see Gabriel P. Weisberg, "Early Realist Drawings of Isidore Pils," *Master Drawings* 28, no. 4 (1990): 387–408.

2 For further discussion of these issues, see *The Realist Tradition: French Painting and Drawing, 1830–1900* (Cleveland: The Cleveland Museum of Art and Indiana University Press, 1980), 107–8. On Louis Napoleon's theories on the elimination of pauperism, which were expressed in the 1840s, see A. de Magnitot, *De l'assistance et de l'extinction de la mendicité* (Paris: Firmin-Didot Frères, 1850), 322ff.

Isidore Pils, 1813–1875

Young Woman in a Prison Cell
oil on canvas
47 x 33.63 inches (119.38 x 85.42 cm)
Inscribed at right: illegible text
Snite Museum of Art
Gift of Mr. and Mrs. Noah L. Butkin
2009.045.112

59

Provenance

Shepherd Gallery, New York; Mr. and Mrs. Noah L. Butkin, 1976; placed on loan with the Snite Museum of Art, University of Notre Dame, 1980; converted to a gift of the estate of Muriel Butkin, 2009.

There is no record of this haunting representation in the Pils repertoire, and it remains unknown to the primary scholar who has studied the artist in France.[1] In a constricted space suggestive of a prison cell, a young woman dressed in black looks upward in a manner typical of the Romantic tradition. A sense of claustrophobia surrounds the carefully observed figure. At the upper left, a small window allows a little light into the gloomy room, illuminating the wall directly to her right. The woman seems lost in contemplation, as if awaiting some news or divine intervention, but the exact nature of the narrative is unknown.

As an academic figure study, the image reveals the care that Pils took in depicting his models. It may be linked to either a historical subject or a religious painting of a penitent saint. It is a highly finished composition similar to the type that Pils completed at the beginning of his career, when he was just emerging from his training with François-Edouard Picot (1786–1868). —*GPW*

1 Mrs. Gaëlle-Pichon-Meunier, e-mail message to author, April 27, 2010.

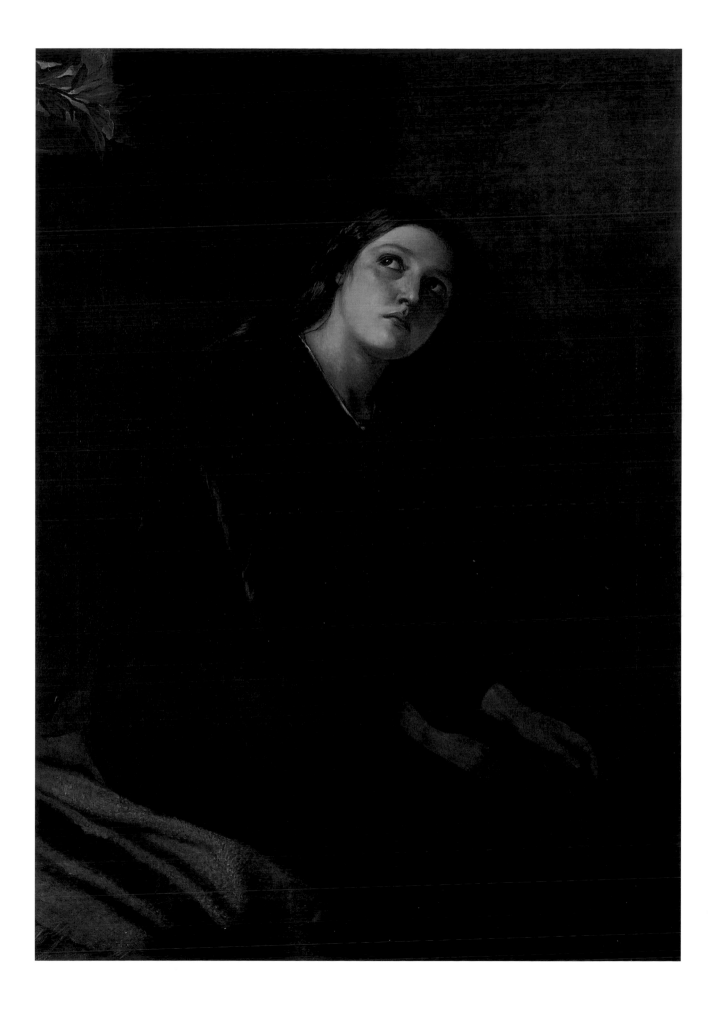

Édouard Pingret, 1788–1875

Diane de Poitiers Receiving a Message from Francis I, 1846
oil on canvas
31.25 x 25.38 inches (79.40 x 64.50 cm)
Signed and dated lower right: *Théop. Pingret, 1846*
Snite Museum of Art
Gift of Mr. and Mrs. Noah L. Butkin
2009.045.047

Provenance

Sotheby Parke-Bernet, London, February 15, 1978, cat. no. 143; Mr. and Mrs. Noah L. Butkin, 1978; placed on loan with the Snite Museum of Art, University of Notre Dame, 1978; converted to a gift of the estate of Muriel Butkin, 2009.

Exhibitions

Salon of 1824, Paris, lists a painting of this title (cat. no. 1361) belonging to M. le Chevalier Marcotte. The painting in the Snite Museum collection is an 1846 replica of this 1824 original.

Selected Bibliography

Explication des ouvrages de peinture, sculpture, gravure, lithographie et architecture des artistes vivans exposés au musée royal des arts, le 25 août 1824. Paris: C. Ballard, Imprimeur du roi, 1824.

Born just before the outbreak of the French Revolution in 1789, Édouard Pingret studied art during one of the most tumultuous periods of modern history. As a young painter, he received instruction in the studios of Jacques-Louis David and Jean-Baptiste Regnault—both very influential leaders of French Neoclassicism. In 1810, Pingret began exhibiting at the annual Salon in Paris, establishing a career that would garner him several honors over the next few decades. In both 1824 and 1831, he received silver medals at the Salon, and in 1839, he was made a chevalier of the Légion d'honneur after having painted nine major history paintings for King Louis Philippe's Galerie des Batailles (Gallery of Battle Scenes) at Versailles.

The painting in the Snite Museum represents an anecdotal approach to depicting French historical figures that was especially popular in the early decades of the nineteenth century. This canvas of *Diane de Poitiers Receiving a Message from Francis I* captures an intimate moment in the life of the famous Renaissance beauty, an influential woman at the court of Francis I in the early 1500s, as she reads a message from the king. In the background, a man's portrait hanging above the fireplace may in fact be based on Titian's *Portrait of Francis I*, which was first displayed at the Musée du Louvre in 1804 and would have been well known to Pingret.[1]

Pingret's decision to portray significant historical figures in the style of genre paintings reflects the changing aesthetic attitudes of the 1820s. Like many other paintings by the artist, this one is related to the popular "troubadour style," which romanticized the French medieval period, but it also reflects the creation of a French national aesthetic narrative that placed Francis I at the center of the European Renaissance. The concept of the "Renaissance" first emerged in the early nineteenth century, and it was French painters of the time who most clearly identified the period as a time of significant change in Western culture—and who proclaimed a leading role for Francis I as a patron of the arts.[2]

Pingret's painting was one of many that referenced Francis I. François Fleury-Richard (1777–1852), also a student of David, depicted a similar domestic setting in an earlier painting titled *François I and Marguerite of Navarre* (1804, Napoleonmuseum, Arenenberg, Switzerland). Fleury-Richard illustrated the king and his sister, Marguerite, in a late medieval interior with a window design very similar to that in Pingret's painting. Despite the medieval architecture, however, the figures in both paintings wear fashionable Italian Renaissance–style clothing. Pingret depicts Diane de Poitiers (1499–1566) in Italian Renaissance costume rather than referencing actual portraits of her available at the time. Not only is she painted in the strict profile view

60

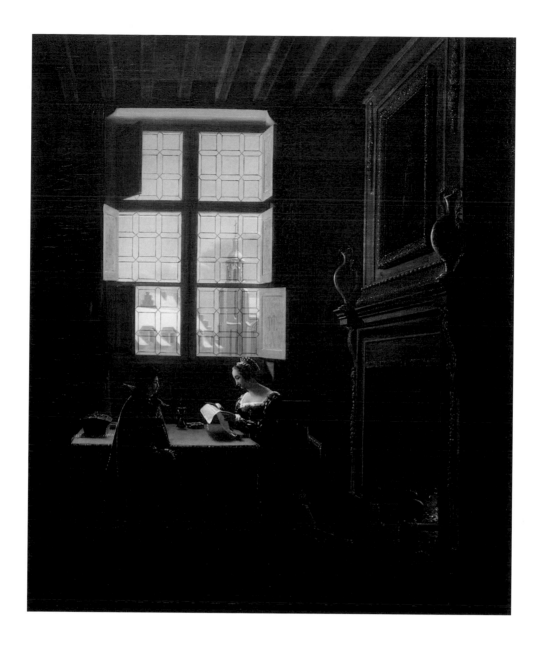

typical of Italian Renaissance painters, she is also shown wearing a gown that echoes the style of dress in Leonardo da Vinci's *Portrait of a Lady from the Court of Milan* (ca. 1490, known as *La belle ferronnière*, Musée du Louvre, Paris), with its square neckline and ruched sleeves.[3]

The subject matter of Pingret's work remains open-ended. Although a narrative is clearly suggested by the intensity with which Diane de Poitiers reads the letter, and by the presence of the messenger who waits for her reply to the king, there is no easily identifiable event that might have served as the source for this image. As an evocation of a romanticized moment in French history, however imaginary, it reflects the concerns of a generation of painters striving to create an art historical narrative that encompassed both French national identity and a more humanistic approach to the presentation of the past. —*JLW*

1 Janet Cox-Rearick, "Imagining the Renaissance: The Nineteenth-Century Cult of François I as Patron of Art," *Renaissance Quarterly* 50, no. 1 (Spring 1997): 209.

2 Ibid., 207–50.

3 Although it is not historically possible, Leonardo's painting was presumed to be a portrait of Francis I's mistress, known as *La belle ferronière* in the early nineteenth century. The theme of Francis I, his mistress, and the painting by Leonardo became a popular subject among artists wishing to underscore the importance of the relationship between the royal art patron and the equally prestigious Renaissance artist. Paintings featuring this subject were exhibited at the Salons of 1810, 1814, and 1833. For a full discussion of the theme and its popularity in early nineteenth-century painting, see Cox-Rearick, "Imagining the Renaissance," 228–29.

Pierre Puvis de Chavannes, 1824–1898
Inspiration or *The Violinist*, 1852–55
oil on canvas
23.5 x 19.88 inches (59.70 x 50.50 cm)
Signed lower right: *Puvis de Chavannes*
Snite Museum of Art
Gift of Mr. and Mrs. Noah L. Butkin
2009.045.049

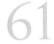

Provenance

P. A. Chéramy, Paris; Hôtel Drouot, Paris,
P. A. Chéramy Collection sale, April 14–16,
1913, cat. no. 58; Collection Guérin, Paris;
Herbert Mayer, New York, 1956; Mr. Walter P.
Chrysler, Jr., New York; Daniel B. Grossman,
New York; Sotheby's, London, July 5, 1978,
cat. no. 240; Christie's, New York, May 2,
1979, cat. no. 15; Mr. and Mrs. Noah L.
Butkin, 1979; placed on loan with the Snite
Museum of Art, University of Notre Dame,
1979; converted to a gift of the estate of Muriel
Butkin, 2009.

Exhibitions

Puvis de Chavannes, November 26, 1976–
February 14, 1977, Grand Palais, Paris; March
18–May 1, 1977, Galerie Nationale du Canada,
Ottawa.

Selected Bibliography

Brown, Aimée Price. *Pierre Puvis de Chavannes:
A Catalogue Raisonné of the Painted Work*. New
Haven, CT: Yale University Press, 2010, vol. 2,
cat. no. 23.

Meier-Graefe, Julius. *Collection Chéramy*.
Munich: R. Piper, 1908, p. 108, cat. no. 241.

Inspiration, or *The Violinist*, is an early work by Pierre Puvis de
Chavannes from his first full decade as a painter in Paris. The
influence of his training with Eugène Delacroix in the mid-1840s
is evident in the similarity of the painting to his teacher's 1831
portrait of Nicolò Paganini (The Philips Collection, Washington,
DC), the virtuoso violinist whose technical skill astounded
audiences throughout Europe. Although *Inspiration* depicts a
bust-length image, rather than a standing figure as in Delacroix's
painting, the pose is nearly identical, the angle of the head and
position of the arms almost indistinguishable.

The theme of music and musicians is one that recurs in Puvis's
work throughout his career. During the 1850s, he may have
been inspired by his friend Achille Dien, who was a professional
violinist and composer of numerous chamber music pieces.[1]
Another friend, and an occasional visitor to the informal
"academy" in Puvis's studio at 11, place Pigalle, was François
Pollet (1811–1883), who was engraving images of violins during
this same period.[2] Although the model for this painting is
unknown, it is not impossible that a friend or colleague may
have posed for Puvis in these early years of his career.

The 1850s were a decade of transition and experimentation in
French painting, evolving from the Romanticism of the 1820s
and '30s into the new Realism of the 1850s. Puvis's work
embodies the Romantic paradigm of the emotional power of art
in any form. Like Delacroix, Puvis has depicted a violinist who
is completely enthralled in his passion for music. As the title
suggests, the subject of this painting is inspiration: the musician
attending to his muse as he stares blankly into space, his hands
idle and his violin without strings. This is not a violinist getting
ready to play, but a musician listening to an inner voice that
guides him in the creation of his art. With his ghostly pallor and
dark-circled eyes, Puvis's violinist is the epitome of the bohemian
soul—a Romantic vision of emotional engagement in art that
transcends all practical realities of life. —*JLW*

1 The piano trio, consisting of a piano, violin, and violoncello, was the dominant
 form of chamber music in mid-nineteenth-century France. Puvis's friend Achille
 Dien and Camille Saint-Saëns were leading proponents of chamber music during this
 time, often composing and performing together in the musical circles of Paris. For a
 further discussion, see Stephen E. Hefling, *Nineteenth-Century Chamber Music* (New
 York: Routledge Press, 2004), 289.

2 Aimée Price Brown, *Pierre Puvis de Chavannes: A Catalogue Raisonné of the Painted
 Work* (New Haven, CT: Yale University Press, 2010), 2:19. Price Brown describes
 the "academy" held at Puvis's studio with his friends Gustave Ricard, Alexandre
 Bida, and François Pollet. The young artists apparently hired a live model to pose
 after eight o'clock at night, and then critiqued each other's work.

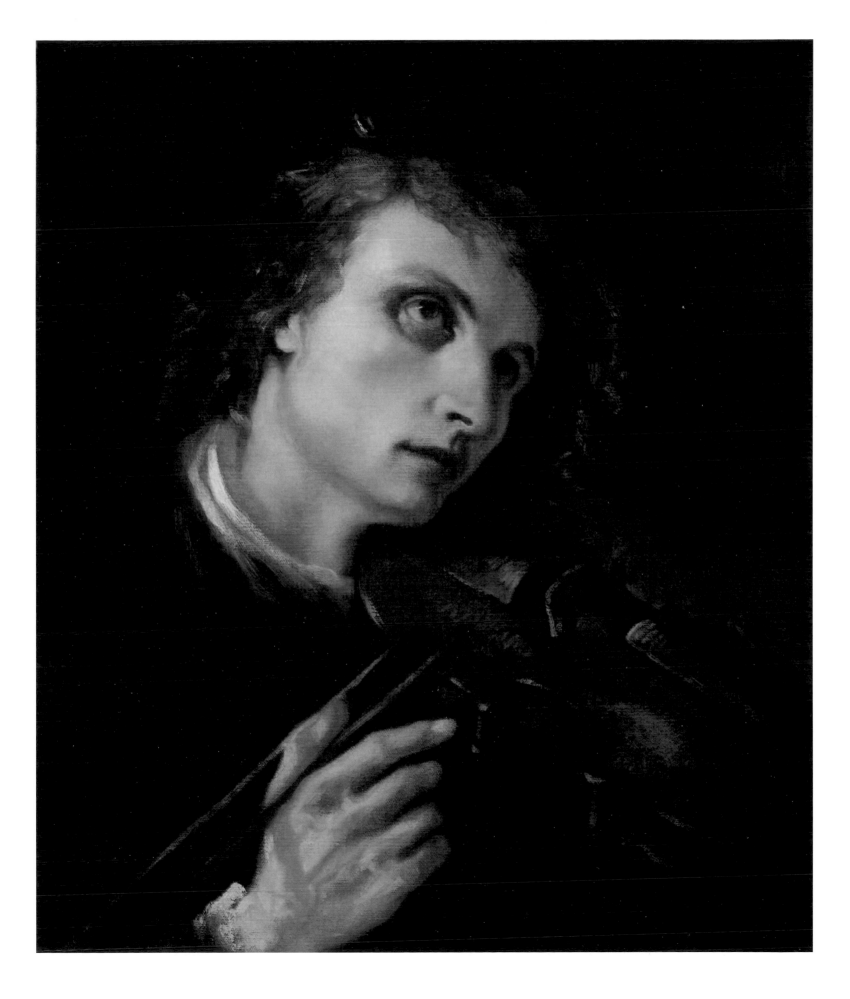

Germain Ribot, 1845–1893

Still Life with Dead Birds and a Basket of Oysters
oil on canvas
18.06 x 21.75 inches (45.88 x 55.25 cm)
Signed lower left: *Germain Ribot*
Cleveland Museum of Art
Bequest of Noah L. Butkin
1980.281

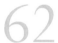

62

Provenance
Christie's, London, K. Wyndham sale, April 1, 1977, cat. no. 105 (illus.); Shepherd Gallery, New York; Mr. and Mrs. Noah L. Butkin; bequest of Noah L. Butkin to the Cleveland Museum of Art, 1980.

Exhibitions
Chardin and the Still-Life Tradition in France, 1979, The Cleveland Museum of Art, pp. 56, 86, 90, and cat. no. 24.

The Realist Tradition: French Painting and Drawing, 1830–1900, 1980–81, The Cleveland Museum of Art, cat. no. 211 (illus.).

Selected Bibliography
d'Argencourt, Louise, and Roger Diederen. *European Paintings of the 19th Century*. Cleveland: The Cleveland Museum of Art, 1999, pp. 540–51.

In addition to his portraits, genre scenes, and religious paintings, Théodule Ribot (cat. nos. 63–67) was well known for his still lifes. He completed a number of compositions featuring humble earthenware ceramics, suggestive of the Spanish tradition of the seventeenth century.[1] His children—Théodule-Clement, known as Germain (1845–1893), and Louise (1857–1916)—learned the still-life tradition from him and maintained it even after his death in 1891, especially during periods when the family was in dire financial straits. Germain and Louise became extremely accomplished still-life painters in their own right. Together with their father, they formed a kind of workshop, making it now quite difficult to discern each individual's contributions. They seemingly worked in interchangeable styles, further complicating the issue of which still lifes can be credited to which artist.[2]

While little is known of Louise Ribot's public career, as early as 1870 Germain was exhibiting paintings under his own name at the Paris Salon.[3] The Salon catalogue that year listed him as his father's pupil and indicated that he was doing still lifes with a symbolic emphasis. Throughout the 1870s, Germain continually contributed works to the annual Salons. His paintings were noted as being influenced by Antoine Vollon (a close friend of his father's), and by 1880 Germain recorded Vollon as his teacher.

The type of still life that Germain specialized in—flower and fruit arrangements on a spare tabletop—became a very saleable commodity. These canvases appealed to a wealthy middle-class clientele in search of works to decorate their apartment interiors. Paintings by Germain that have appeared on the art market in recent years feature a delicate color palette that is far removed from his father's more somber still lifes.

This grouping of dead birds (magpie, partridge, jay, and sparrow) appears to be placed in a kitchen interior, where the game will be prepared for consumption.[4] In painting the various birds, Germain demonstrated that he was a master of plumage. The dark tonality is quite different from most of his other still lifes, making the image seem closer to the goals of Realism rather than a pleasing arrangement aimed at middle-class tastes. —*GPW*

1 See Gabriel P. Weisberg, "Théodule Ribot's Still Life with Eggs and the Practice of Still-Life Painting in the Late 19th Century," *Van Gogh Museum Journal* (1997–98): 76–87.

2 Ibid., 80. This is especially the case with Louise, who even signed her paintings in a way similar to her father.

3 See *Explication des ouvrages de peinture, sculpture, architecture, gravure...exposés au Palais des Champs Elysées, le 1er Mai, 1870* (Paris, 1870), cat. nos. 2419–20.

4 Entry by Roger Diederen, *European Paintings of the Nineteenth Century* (Cleveland: The Cleveland Museum of Art, 1999), 540–51.

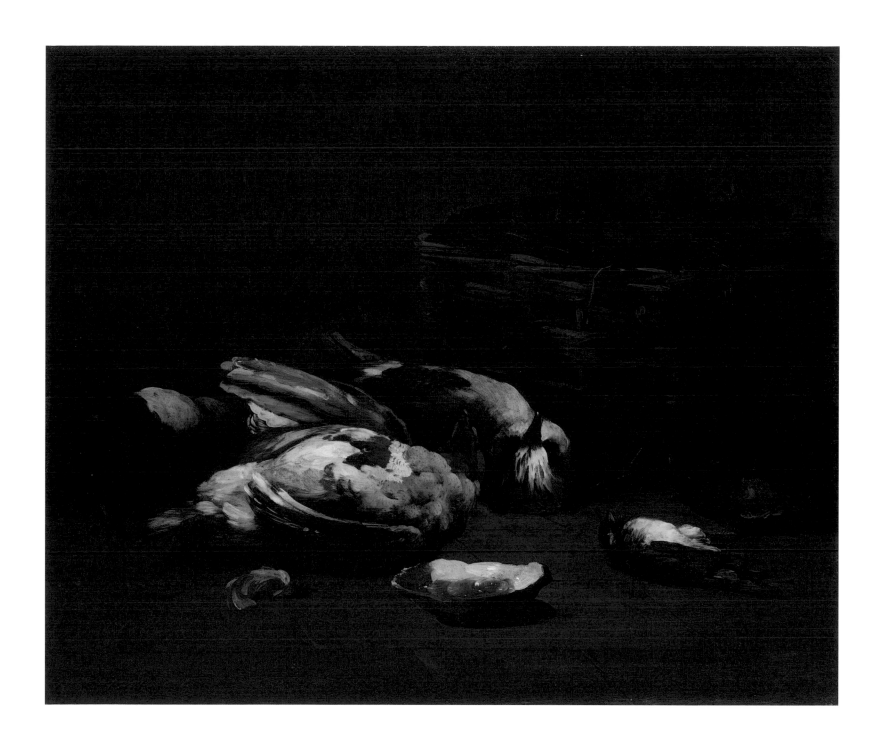

Théodule Ribot, 1823–1891

Four Girls Studying a Drawing, 1876
ink wash and watercolor on cream wove paper
11.34 x 16.18 inches (28.80 x 41.10 cm)
Signed and dated lower right in watercolor: *t. Ribot. 1876*
The Cleveland Museum of Art
Bequest of Muriel Butkin
2010.289

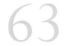

Provenance

Galerie Arnoldi-Livie, Munich, Germany, 1977; Shepherd Gallery, New York, 1978; Mrs. Muriel Butkin, Shaker Heights, Ohio; bequest of Muriel Butkin to the Cleveland Museum of Art, 2009.

Exhibitions

Gemalde und Seichnungen Neuerbungen, summer 1977, Galerie Arnoldi-Livie, Munich, Germany, cat. no. 32 (illus.).

This quiet scene of four young women in a domestic setting embodies the Realist tenet of chronicling the daily lives of humble people. Subjects that were close to home figured prominently in Théodule Ribot's art, and his friends and family members often served as models. From the time his works were first accepted into the Salon of 1861, he exhibited genre and still-life paintings alongside religious subjects. In the 1870s, in addition to portraits of identified sitters, he increasingly showed genre pictures such as *Reading (La lecture)* and *Young Girl (Jeune fille)*. Ribot's Salon submissions were not limited to oil paintings; in 1874, he exhibited three watercolors: *An Old Woman (Une vieille femme)*, *The Knitting Lesson (La leçon de tricot)*, and *Conversation*. Four etchings—a portrait, a kitchen scene, a head of a young girl, and a young girl reading—were among the works he showed in 1877.

Such subjects imply that children often feature in Ribot's oeuvre. The artist's own children have been identified in several of his paintings and drawings. Gabriel Weisberg identified Ribot's daughter Mignonne as the subject of *The Little Milkmaid (La petite laitière)*, of about 1865 (The Cleveland Museum of Art).[1] Weisberg has also proposed that Ribot's daughter Louise was the sitter for his wash drawing *Woman Looking Down* (1872, private collection). The foreground figure at the right in *Four Girls Studying a Drawing* bears a striking resemblance to the subject of *Woman Looking Down*, and thus may be identifiable as Louise. Similarly, an older Mignonne may be among the four figures. *Four Girls Studying a Drawing* was drawn eleven years after *The Little Milkmaid*, when Mignonne would have been about seventeen years old. The closeness of the figures clustered together at the right side of the drawing suggests the intimacy of family, or at the very least, a close community entirely at ease in the domestic setting.

Perhaps most remarkable about the drawing is its deep chiaroscuro. Light emanates from an unknown source, bathing the face and hands of the young woman who holds the object of the group's scrutiny. The rest of the setting is primarily shrouded in darkness. The tension created between the illuminated and tangible versus the hidden and intangible was likely influenced by seventeenth-century Spanish painting. King Louis Philippe's inauguration of the Galerie Espagnole, a collection of 455 paintings by 80 artists, at the Louvre in 1838 fed the French taste for Spanish painting. Later, in 1869, the Louvre was bequeathed the collection of Dr. Louis La Caze, which included works by

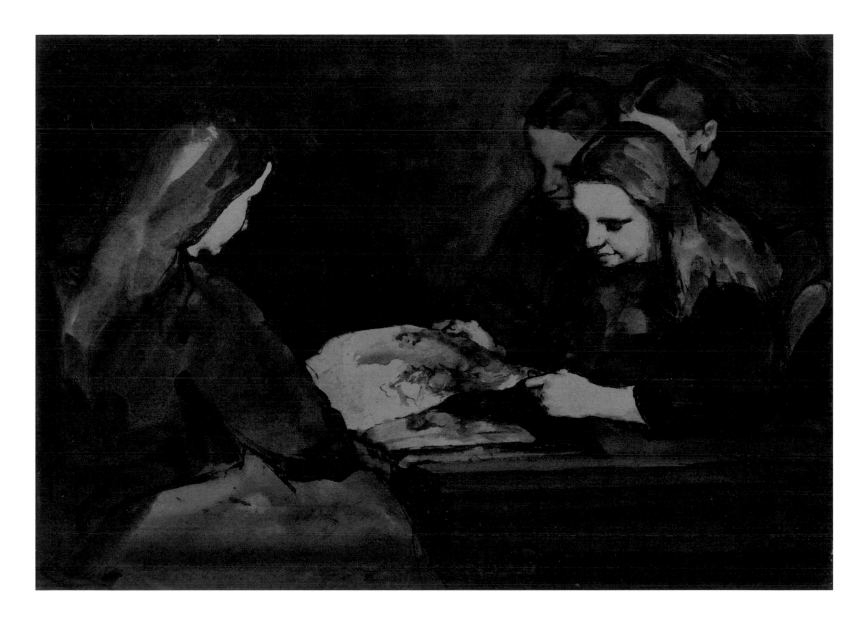

Jusepe de Ribera (1591–1652) and Diego Velázquez (1599–1660).[2] This collection had been appreciated by many artists, including La Caze's friend François Bonvin (cat. nos. 10–13), thanks to the doctor's Sunday salons. Ribot's penchant for Spanish Baroque painting was noted by the young Romain Rolland, a dramatist, novelist, art historian, and essayist who would be awarded the Nobel Prize for literature in 1915. Upon seeing an exhibition devoted to Ribot at the Galerie Bernheim-Jeune in 1887, Rolland wrote: "Not for an instant can I imagine these paintings before me are French. One thinks of the Spanish—Ribera, Zurbaran, the masters of black."[3] The dark interior, predominantly brown palette, and dramatic highlights on the figures' faces in this drawing evoke Spanish genre paintings that are similarly focused on the quiet and the quotidian. —HL

1 Gabriel P. Weisberg, "Théodule Ribot: Popular Imagery and the Little Milkmaid," *The Bulletin of the Cleveland Museum of Art* 63 (1976): 253–62.

2 Gary Tinterow and Geneviève Lacambre, *Manet/Velázquez: The French Taste for Spanish Painting* (New York: The Metropolitan Museum of Art, 2003), 395–96.

3 Romain Rolland, *Le cloister de la rue l'Ulm: Journal de Romain Rolland à l'Ecole Normale, 1886–1889* (Paris, 1952). Quoted in Tinterow and Lacambre, *Manet/Velázquez*, 518.

Théodule Ribot, 1823–1891

Old Woman with Glasses
crayon on bistre paper
7.63 x 6.19 inches (19.38 x 15.72 cm)
Signed lower right in crayon: *t. Ribot*
Snite Museum of Art
Gift of Mr. and Mrs. Noah L. Butkin
2009.045.021

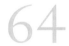

Provenance
Shepherd Gallery, New York; Mr. and Mrs. Noah L. Butkin; placed on loan with the Snite Museum of Art, University of Notre Dame, 1982; converted to a gift of the estate of Muriel Butkin, 2009.

Ribot had little money for studio models, but he found many opportunities to observe the members of his family in intimate moments: reading, singing, working in an interior, or conversing with one another. A number of the charcoal and pen and ink drawings he made of his wife, children, and mother were small in size, reflecting the intimacy of the relationships between Ribot and his subjects. In the studies of his mother, he expressed his awareness of the paintings and drawings of Rembrandt van Rijn (1606–1669), whose works were being revived in the mid-nineteenth century as part of a rediscovery of the seventeenth-century Dutch School.[1] Rembrandt's interest in conveying the age of his sitters, and examining their facial features in microscopic detail, led to the creation of psychological portraits that influenced Ribot.

Ribot's old woman has tilted her head to one side, perhaps in order to read a book held in her unseen hands, or perhaps to catch as much light as possible in the dim interior for some other activity. Although her pursuit remains unclear, Ribot's sensitivity to his mother's facial expression, and to the way light illuminates her face and garments, suggests that he saw drawing as much more than a preliminary step to painting. For Ribot, as for other Realists such as François Bonvin, a drawing was a finished work in itself. While this particular study can be linked with a painting (location unknown), Ribot made sure that it also functioned as an independent work.[2] —*GPW*

1 On this phenomenon, see Alison McQueen, *The Rise of the Cult of Rembrandt: Reinventing an Old Master in Nineteenth-Century France* (Amsterdam: The University of Amsterdam Press, 2004).

2 The painting was noted in two auction sales: *19th Century European Paintings*, Sotheby's, London, February 15, 1978, cat. no. 158, where it was called *Portrait of the Artist's Mother*; and Christie's, April 9, 1978, cat. no. 134, where it was listed as *Portrait de la mère de l'artiste*.

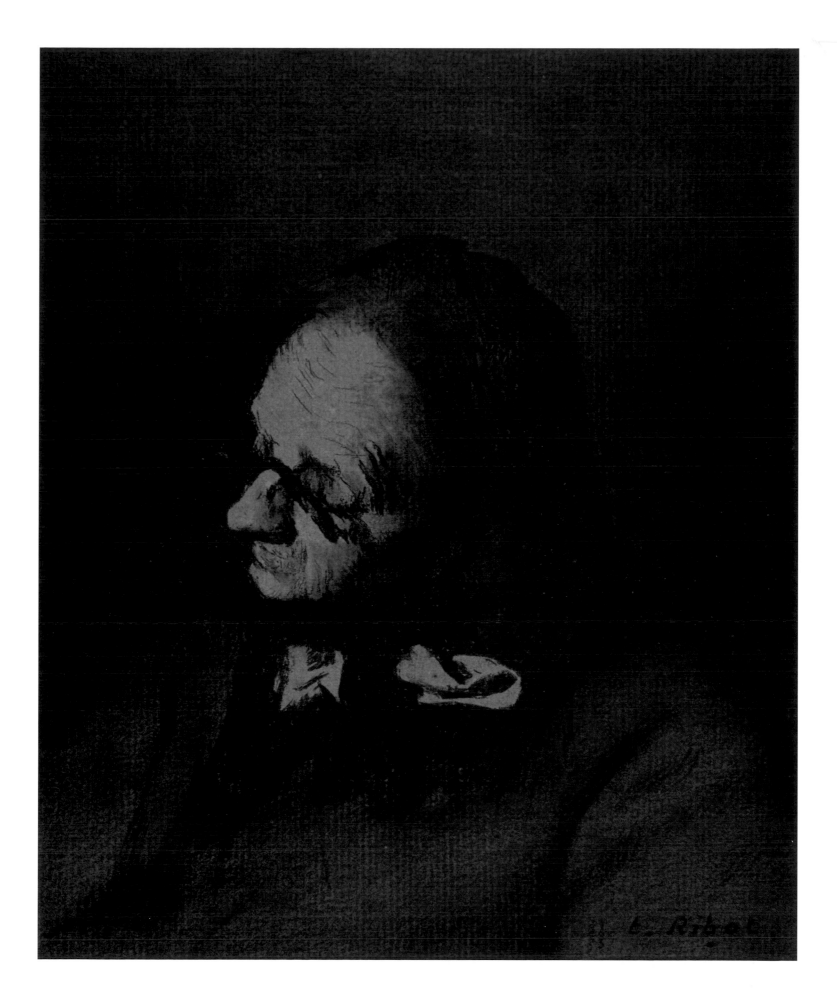

Théodule Ribot, 1823–1891

Portrait of Léon Charly, 1880
oil on canvas
29 x 23.5 inches (73.70 x 59.70 cm)
Signed lower left: *à mon ami / T. Ribot*
Inscribed on back of stretcher: *Léon Charly, poète français / 1880*
Snite Museum of Art
Acquired with funds provided by the Butkin Foundation and Mr.
and Mrs. Charles K. Driscoll '63
2011.010

65

Provenance
Collection Léon Charly, France; private
collection, Bordeaux, France; Jane Roberts,
Fine Arts, Paris; acquired by the Snite Museum
of Art with funds provided by the Butkin
Foundation and Mr. and Mrs. Charles K.
Driscoll '63, 2011.

Exhibitions
1880, Galerie de l'Art, Paris, cat. no. 33,
Portrait de M. C. (appartient à M. Charly).

Although best known for his genre scenes and still lifes, Ribot
was also committed to making portraits of his family and close
friends. In these canvases, the artist was remarkably adept at
conveying his subjects' individuality and temperament. The
aesthetic philosopher Eugène Veron, writing about Ribot's
portraits in a review of the 1880 retrospective exhibition of
his work at the Galerie de l'Art, noted that they captured
psychological depth through a directness of pose that allowed
the "true character of a sitter to appear naturally."[1] Among
the portraits shown at that retrospective was this depiction
of the poet Léon Charly. The work is inscribed "1880" on the
stretcher—a rarity, since Ribot's works are seldom dated.

Despite Ribot's dedication to portraiture, the number of
portrayals he completed is not extensive. Several were self-
portraits and portraits of family members, including one of his
son Germain, who was himself a painter; another of Mme. Ribot;
a study of his sister; and one large composition of his daughter
Louise, who also had an active career as a painter.[2] In addition,
he made portraits of individuals who helped his career, such as
Jules Luquet—of the publishing firm A. Cadart et Luquet—and
his son, who had contributed to the diffusion of Ribot's etchings
under the aegis of the Société des Aquafortistes, a group that
Luquet and Alfred Cadart had first sponsored during the 1860s.[3]
The few other known portraits in Ribot's oeuvre are of men who
at one time crossed his path, including Charly.

It is unclear how well Ribot knew the poet, but they must have
been acquainted because Charly dedicated one of his poems
to the painter. In an article on Ribot, the art critic Gonzague-
Privat gives the impression that the two men knew each other
rather well, yet he provides no specific information on how or
when they met.[4] Ribot's portrait conveys Charly's elegance: his
mustache and beard are carefully brushed, his cravat neatly tied.
He looks intelligent and alert, and his attire and demeanor
imply a financially comfortable background. By spotlighting
the figure and giving the head primary importance, Ribot
demonstrates that he understood the portrait traditions of

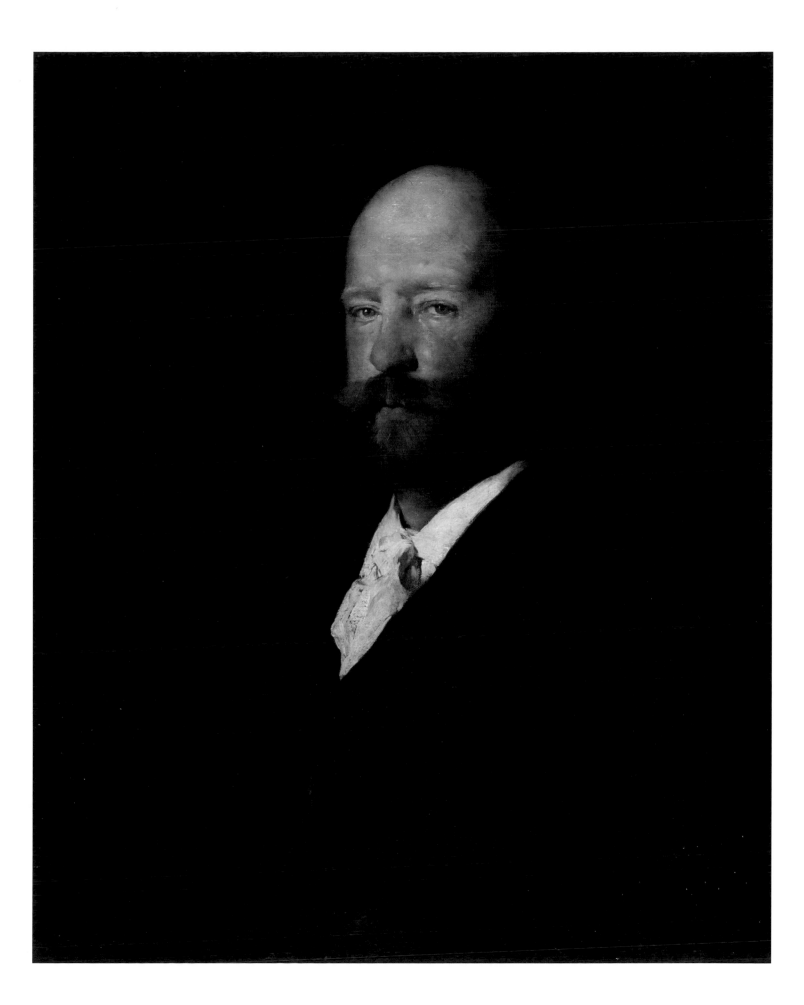

seventeenth-century Holland. For Gonzague-Privat, the Charly portrait was "luminous," conveying an inner light that the critic found present in certain portraits by Eugène Delacroix.[5]

Few details are known about Charly's life and career. From the scanty available evidence, it seems he was a person of considerable financial means who was able to collect works of art in the Romantic and academic traditions. He is said to have owned several works by Thomas Couture (1815–1879) that were exhibited in the 1880 retrospective of that painter held in Paris.[6] In 1885, an oil sketch by Eugène Delacroix for the *Massacre of Chios* was included in a major exhibition in Paris and noted as having come from the collection of Léon Charly.[7] These references indicate that Charly was a collector of taste who was interested in well-established painters. His attention to Ribot reveals that he was also attracted to a contemporary artist who was still active.

Ribot's own interest in literary works in the Romantic vein has been noted, and may have led the two men to become friends. The few random poems by Charly that have been located suggest that he was a peripheral member of the Parnassians, a group founded in the 1860s that was dedicated to an independent point of view.[8] In 1866, Charly published three poems in *Le nain jaune*, a magazine edited by the art critic Jules Castagnary. *Le nain jaune* was one of the more adventuresome publications of the time: in 1864, for example, Lecomte de Lisle was placed in charge of a series of critical articles that became a declaration of the new principles of writing, in opposition to traditional attitudes.[9] The first of Charly's sonnets published in this progressive magazine, "Le poète," combines the topics of creativity and the love of a woman, a suitable theme for a young writer.[10] Another sonnet, entitled "La réalité," is dedicated to the trials and tribulations of a poet trying to write verse.[11] Since Castagnary believed that France was looking for a new poet to be a spokesman for the era, perhaps Charly was hoping to place himself in the running.[12] A slightly later sonnet called "Poésie. Éveil," in which the poet

melancholically compares existence to the growth of a tree, reflects his interest in conveying his psychological moods, as an outgrowth of Romantic poetry.[13] In these early poems, Charly stresses a sense of mystery, almost mysticism, as if he desired to be a painter in verse.

In March 1871, Charly's poetry moved in a more political direction when he published "La fuite triomphale des Prussiens" in *Le monitor parisien*. This widely available broadsheet publication was filled with republican sentiment and hatred of the Germans, who had overwhelmed France in the Franco-Prussian War. Charly portrayed the Germans as comical (for instance, he makes fun of the humorous way the Germans tried to speak French) and incapable of frightening the people of France, even young children. His sophisticated writing contains vitriolic references that demonstrate just how much the German presence was despised by the French. The poem goes on to point out that "the French flag does not carry the eagle of Bonaparte, even red they are glorious; after Waterloo, Metz and Sedan, push it aside from the proud flag of our ancestors." With this statement, Charly echoed the widespread socialist sentiment that would allow the establishment of the Paris Commune just two weeks after publication of his poem.

Charly went on to contribute poems to a wide variety of sources. By July 1873, "Le lévrier" was published in *La renaissance littéraire et artistique*, a journal that was a haven for young writers such as Stéphane Mallarmé, Arthur Rimbaud, and Emile Zola who were moving literature toward Symbolism and Naturalism.[14] "Le lévrier" examines the impending death of a dog that senses what is going to happen to him. The tug of war between the animal and a young child who torments it alludes to both a realist view of the world and a deeper, more allegorical meaning—the poem was completed just a few short years after the Paris Commune. A later piece called "Poésie," dedicated to the poet Théodore de Banville, appeared in a more traditional publication, *L'Artiste*.[15] However, in 1888, Charly contributed an unusual verse, "Le Dimanche au

bois de Clamart," to *Le Pierrot*, whose primary editor was the radical artist and satirist Adolphe Willette. In this stream-of-consciousness poem, Charly questions the middle class's ability to enjoy an outing in the Bois de Clamart. Although the specific targets of the verse are unclear, it indicates another dimension to Charly's poetry, one that appealed to younger generations.[16]

While there is little trace of Charly's contributions to poetry or art collecting today, he was certainly known to a select group during the period. His artistic independence and the varied dimensions of his poetry, along with his dedication to Ribot's work, would have endeared him to the painter—who himself was regarded as a supreme independent, working out his own issues in paintings that belonged to no specific school. Charly seems to have held a similar belief in individuality, making him a prime subject for Ribot's portraiture. —*GPW*

1 Eugène Veron, "Th. Ribot, exposition générale de ses oeuvres dans les Galeries de l'Art," *L'Art* 2 (1880): 127–31, 156–60.

2 For further information on Ribot's portraits, see *Exposition Th. Ribot, au Palais National de l'École des Beaux-Arts* (Paris: Imprimerie de l'Art, 1892).

3 See Janine Bailly Herzberg, *L'Eau-forte de peintre au dix-neuvième siècle: La Société des Aquafortistes, 1862–1867* (Paris: Léonce Laget, 1972).

4 See Gonzague-Privat, "Th. Ribot," *L'Événnement*, May 26, 1880, 2–3. Whether the verses dedicated to Ribot were published or not, they were noted by Privat in his article.

5 Gonzague-Privat, "Th. Ribot," 3.

6 For information on these works, I am indebted to discussions with Ms. Pradie-Ottinger, director of the Musée d'Art et d'Archéologie, Senlis, and with Jane Roberts in Paris. An examination of the Couture retrospective catalogue of 1880, however, provides no evidence that certain works by Couture were actually in Charly's personal collection at the time of the exhibition.

7 *Exposition Eugène Delacroix au profit de la souscription destinée à élever à Paris un monument à sa mémoire*, March 6–April 15,1885, École Nationale des Beaux-Arts, cat. no. 555, *Étude pour le massacre de Scio*. The author is indebted to Jane Roberts for pointing out this detail.

8 See Maurice Souriau, *Histoire du Parnasse* (1929; Geneva: Slatkine Reprints, 1977), 246, for this general comment on the Parnassians.

9 See Souriau, *Histoire du Parnasse*, 228.

10 Léon Charly, "Le poète," *Le nain jaune*, August 22, 1866, 2.

11 Léon Charly, "La réalité," *Le nain jaune*, August 22, 1866, 2.

12 Jules Castagnary, *Le nain jaune*, October 20, 1866, 2.

13 Léon Charly, "Poésie. Éveil," *Le nain jaune*, November 7, 1866, 3.

14 Léon Charly, "Le lévrier," *La renaissance littéraire et artistique*, July 20, 1873, 189. For information on *La renaissance*, see Jean-Michel Place and André Vasseur, *Bibliographie des revues et journaux littéraires des XIXè et XXè siècles* (Paris: Éditions de la Chronique des Lettres Françaises, 1973), 1:64–66.

15 Léon Charly, "Poésie," *L'Artiste*, July 1885, 640.

16 Léon Charly, "Le Dimanche au bois de Clamart," *Le Pierrot*, November 30, 1888, 4.

Théodule Ribot, 1823–1891

Singers
oil on canvas
29.25 x 23.75 inches (74.30 x 60.33 cm)
Signed lower left: *t. Ribot*
The Cleveland Museum of Art
Bequest of Noah L. Butkin
1977.127

Provenance
Cadart and Luquet, Paris, ca. 1865; by 1890, Galerie Bernheim-Jeune, Paris; Frederick R. Sears, Boston, Massachusetts; Norton Gallery, New York; Mr. and Mrs. Noah L. Butkin; bequest of Noah L. Butkin to the Cleveland Museum of Art, 1977.

Exhibitions
1865, La Société des Amis des Arts de Bordeaux, cat. no. 450.

Exposition T. Ribot, 1890, Galerie Bernheim-Jeune, Paris, cat. no. 226, *Le Concert.*

Exposition Th. Ribot, 1892, probably Palais National de l'École des Beaux-Arts, Paris, cat. no. 26, *Une répétition.*

Exposition Ribot, 1911, possibly Galerie Bernheim-Jeune, Paris, cat. no. 19, *Les chanteurs.*

The Realist Tradition: French Painting and Drawing, 1830–1900, 1980–81, The Cleveland Museum of Art, cat. no. 50.

Selected Bibliography
d'Argencourt, Louise, and Douglas Druick. *The Other Nineteenth Century: Paintings and Sculpture in the Collection of Mr. and Mrs. Joseph Tanenbaum.* Ottawa: National Gallery of Canada, 1978, pp. 164, 166 (similar works).

Sertat, Raoul. "Théodule Ribot." *Revue encyclopédique,* August 1, 1892, pp. 1010–13 (illus.).

Weisberg, Gabriel P. *The Realist Tradition: French Painting and Drawing, 1830–1900.* Cleveland: The Cleveland Museum of Art and Indiana University Press, 1980, pp. 50–51, cat. no. 12.

———. "Théodule Ribot: Popular Imagery and the Little Milkmaid." *The Bulletin of the Cleveland Museum of Art* 63 (1976): cat. no. 7, fig. 13.

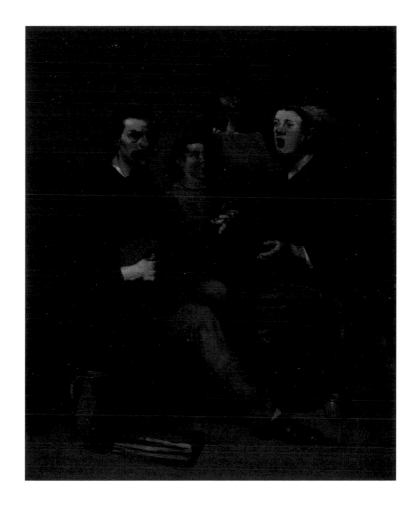

One of the better-known paintings by Ribot, this canvas was exhibited by some of the leading art dealers in the nineteenth century, including Alfred Cadart (during the 1860s) and, later, the Galerie Bernheim-Jeune; the latter gallery maintained a stock of Ribot's paintings well into the twentieth century. Through this base of supportive dealers, Ribot was able to find many clients who appreciated his canvases, which often featured themes drawn from the daily life of ordinary people.

The Singers portrays a group of the itinerant performers who could be found practicing in the streets of Paris and entertaining in grime-laden cabarets, until they disappeared from the city by the end of the century. Ribot's composition emphasizes their proletarian roots, recording the figures' ruddy, well-worn complexions and the earnest, straightforward way in which they participate in their activity. The discarded songbook, the pitcher, and the metal drinking cup reinforce the simplicity of their manner. The singers stand or sit on rough benches around an overturned wooden barrel, singing from memory (or, in one man's case, from sheet music). One member accompanies the group on a cittern, a cousin of the lute that had been especially popular in the sixteenth and seventeenth centuries. The theatrical lighting effects, albeit within a monochromatic range of color, enhance the sense of a performance.

Whether the sitters were actually real musicians—perhaps even a single family group, as in many of Pablo Picasso's versions of street musicians—or whether Ribot constructed a generic group of performers from models in his studio remains unknown. Comparisons with Édouard Manet's paintings of the 1860s, such as *The Old Musician*, can also be advanced; but Ribot's decision to include a young girl among the performers distinguishes his troupe from the exclusively male groups in Manet's work.[1] The fact that this painting was well received in the nineteenth century, and that it was reproduced and written about in the press, reveals that there was an eager audience for readily understood depictions of everyday life. —*GPW*

1 In the entry for cat. no. 191 in Louise d'Argencourt and Roger Diederen, *European Paintings of the 19th Century* (Cleveland: The Cleveland Museum of Art, 1999), Alisa Luxembourg incorrectly notes that this was an "all male band." In fact, a young girl is part of the group.

Théodule Ribot, 1823–1891

Two Children Praying—Two Acolytes Kneeling, 1861
oil on canvas
18 x 14.38 inches (45.70 x 36.50 cm)
Signed and dated lower right: *T Ribot 1861*
Inscribed lower left on a painted scroll: *Mon Dieu je vous donne mon Coeur*
Snite Museum of Art
Gift of Mr. and Mrs. Noah L. Butkin
2009.045.087

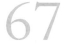

Provenance
Shepherd Gallery, New York; Mr. and Mrs. Noah L. Butkin, 1975; placed on loan with the Snite Museum of Art, University of Notre Dame, 1980; converted to a gift of the estate of Muriel Butkin, 2009.

This oil on canvas is a study for Ribot's Salon painting *Young Girls Praying (La prière des petites filles)*, which is signed and dated 1862. When Ribot exhibited the finished version at the Paris Salon of 1863, he was recognized as a young Realist painter whose works often suggested strong ties with Spanish seventeenth-century artists.[1] Because of this relationship, critics dubbed him a new Jusepe de Ribera, thereby granting the artist a pedigree that would further promote his burgeoning career. Continuing to exhibit well into the later decades of the nineteenth century, Ribot found his paintings sought after by private collectors; he was also sponsored by some top gallery dealers, who recognized his sense of independence and his ability to maintain his career even though he was not associated with any larger group of contemporary painters. In 1887, the Galerie Bernheim-Jeune in Paris held a retrospective exhibition for the artist, publishing a version of a catalogue raisonné.[2] By 1892, shortly after Ribot's death, a large-scale exhibition of his work was held at the École des Beaux-Arts; the finished Salon version of *Young Girls Praying* was listed as belonging to the Galerie Bernheim-Jeune, evidencing that these dealers were not only promoting Ribot but also collecting his best works for themselves.[3]

The interest in this particular Salon painting led Ribot to produce an etching of the same subject for the Société des Aquafortistes, a group of progressive artists working with the entrepreneur Alfred Cadart to promote the etching medium. With this goal in mind, Cadart published yearly portfolios of prints. Ribot's etching of *Young Girls Praying* was included in the group's annual publication for 1862–63, thereby assuring the work a broader following through the growing attention being paid to this reproductive medium.[4]

Although Ribot's exact working methods in constructing a finished composition, especially one destined for the Paris Salon, are largely unknown, it is likely that he developed his compositions gradually, as was typical of academically trained artists. He would, therefore, have created studies by positioning models in his studio in the poses he was considering using on his canvas, dressing them in the appropriate costumes. In this case, Ribot completed a composition of two young girls wearing religious robes and kneeling in a pose of supplication, similar to how the two lead children are positioned in the finished composition. The Snite Museum study has one child looking in the direction of the viewer, as she establishes eye contact with the imagined audience; the other figure, situated slightly behind her, looks off into the distance. One girl holds a cross, the other a rosary—attributes that suggest, along with their clothes, that

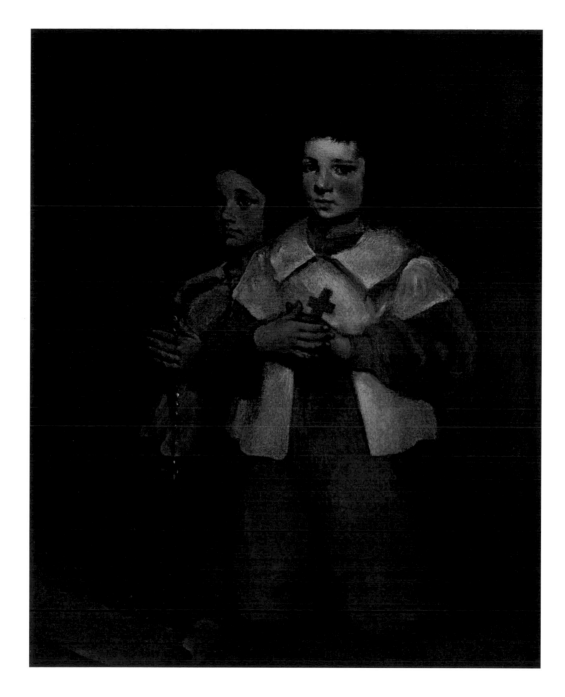

they are novices in training to become nuns. Ribot often used his young daughter as a model during the 1860s; this seems to be the case with the acolyte who looks out at us with a sense of innocence.[5]

Ribot's ability to convey a message of religious commitment was paramount both within the preliminary work and, even more so, in the finished canvas. The fact that this preliminary oil sketch also sheds light on how Ribot worked lends the painting additional importance, especially since the artist's working methods have remained so elusive. This early study may open the way to a more detailed examination of Ribot's oeuvre and contribute to a richer understanding of nineteenth-century painting as a whole. —GPW

1 On Ribot's ties with Realism and Spanish seventeenth-century masters, see Gabriel P. Weisberg, "Théodule Ribot's Still Life with Eggs and the Practice of Still-Life Painting in the Late 19th Century," *Van Gogh Museum Journal* (1997–98): 76–87.

2 See *Exposition T. Ribot, catalogue raisonné des oeuvres exposées*, with a preface by Louis de Fourcaud, May–June 1867 (Paris: Galerie Bernheim-Jeune, 1887). Bernheim held subsequent exhibitions of Ribot's work in 1890 and 1911.

3 See *Exposition Th. Ribot, au Palais National de l'École des Beaux-Arts* (Paris: Imprimerie de l'Art, 1892), 33, cat. no. 25.

4 See Janine Bailly Herzberg, *L'Eau-forte de peintre au dix-neuvième siècle: La Société des Aquafortistes, 1862–1867* (Paris: Léonce Laget, 1972), 1:72.

5 On Ribot's use of his daughters as models, see Gabriel P. Weisberg, "Théodule Ribot: Popular Imagery and the Little Milkmaid," *The Bulletin of the Cleveland Museum of Art* 63 (1976): 253–62.

Tony Robert-Fleury, 1837–1912

Two Chimney Sweeps
oil on panel
8.75 x 6.63 inches (22.20 x 16.80 cm)
Signed lower right: *Robt. Fleury,* with indecipherable date
Snite Museum of Art
Gift of Mr. and Mrs. Noah L. Butkin
2009.045.117

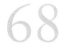

Provenance

Monsieur Tajan, February 5, 1979; Galerie Jacques Fischer–Chantal Kiener, Paris, February 13, 1979; Mr. and Mrs. Noah L. Butkin, 1979; placed on loan with the Snite Museum of Art, University of Notre Dame, 1981; converted to a gift of the estate of Muriel Butkin, 2009.

Selected Bibliography

Weisberg, Gabriel P., and Jane R. Becker, eds. *Overcoming All Obstacles: The Women of the Académie Julian.* New Brunswick, NJ: Rutgers University Press and The Dahesh Museum, New York, 1999.

Tony Robert-Fleury enjoyed a career filled with official honors and a steady clientele, including the government of France and the City of Paris.[1] In addition, he taught for many years at the Académie Julian, a private art school that was one of the first to offer women a professional education in painting.[2] Robert-Fleury himself learned his art initially from his father, Joseph-Nicolas Robert-Fleury (1797–1890), and then from Paul Delaroche and Léon Cogniet, each of whom educated the young artist in the academic tradition of the École des Beaux-Arts. Somewhat surprisingly, he did not make his Salon debut until 1864, when he was twenty-seven years old. However, he won medals in both 1866 and 1867, as well as a medal of honor in 1870. From that point forward, Robert-Fleury was a significant figure in the Paris art world, exhibiting regularly at the Salon and at the Exposition Universelle in 1878, 1889, and 1900.

Over the decades, his work evolved from academic history paintings such as *The Last Days of Corinth* (1870, Musée d'Orsay, Paris) to more loosely painted portraits of young women such as *Lesbia and the Sparrow* (Bowes Museum, Barnard Castle, County Durham, England). Although these portraits are often undated, the influence of Impressionism is evident in the bright, unmixed colors, an emphasis on natural light, and a much freer brushwork than in the painter's previous works. Similarly, the small oil sketch *Two Chimney Sweeps* suggests that perhaps Robert-Fleury had been looking at images of ragpickers and street children shown by artists such as Jean-François Rafaelli (1850–1924) at the independent exhibitions of the Impressionists in the 1870s and '80s.

As an instructor at the Académie Julian, Robert-Fleury could not be unaware of contemporary art exhibitions in Paris, especially if his students were talking about them, and that may explain the anomaly of *Two Chimney Sweeps* in his body of work. Its very modest size implies that it was perhaps just a passing idea, but it does raise the question of whether he experimented with a more Realist approach to painting. The one painting that may have some relation to *Two Chimney Sweeps* is an undated commission

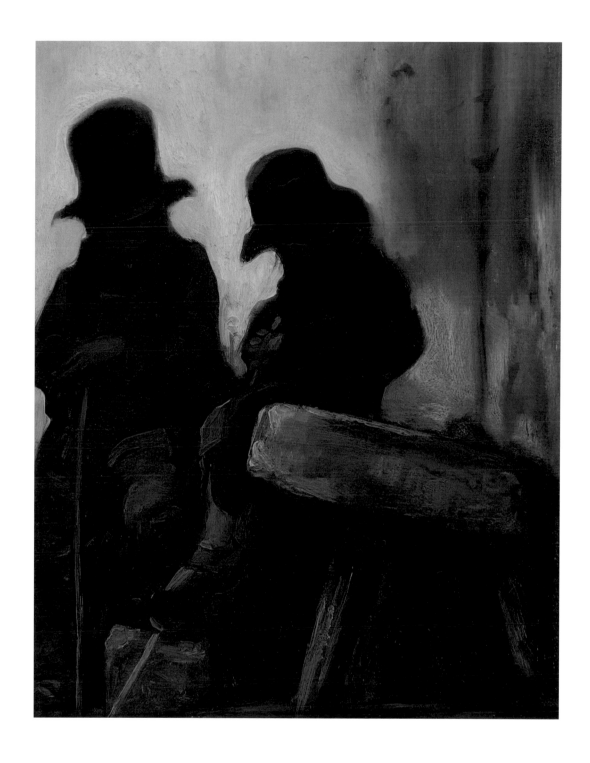

for the Hôpital de la Salpêtrière, an asylum for the mentally ill in Paris. The subject matter for this large work is made clear by its title, *Philippe Pinel Releasing Lunatics from Their Chains at the Salpêtrière Asylum in Paris in 1795.* Here, too, Robert-Fleury depicted people under duress, offering viewers a sober picture of life in the asylum. As in the portrayal of the young chimney sweeps, there is a degree of Naturalism in showing the life of the poor and the mentally ill, who were rarely considered fit subjects of official painting. Whether *Two Chimney Sweeps* was ever

intended to become part of a more substantial painting remains unknown, but it does suggest that Robert-Fleury was willing to experiment outside of his characteristic style on occasion. —*JLW*

1 Robert-Fleury painted decorative murals for both the Palais du Luxembourg and the Hôtel de Ville (city hall) in Paris.

2 See Gabriel P. Weisberg and Jane R. Becker, eds., *Overcoming All Obstacles: The Women of the Académie Julian* (New Brunswick, NJ: Rutgers University Press and The Dahesh Museum, New York, 1999), 13–41.

Ferdinand Roybet, 1840–1920

Head of John the Baptist
oil on panel
21 x 25.25 inches (53.34 x 64.14 cm)
Signed upper right in black oil: *F. Roybet*
Inscribed on verso at upper right: *Ferdinand Roybet né à Uzes 1840–1920*
Snite Museum of Art
Gift of Mr. and Mrs. Noah L. Butkin
1978.025.002

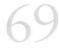

Provenance
Shepherd Gallery, New York; Mr. and Mrs. Noah L. Butkin, 1975; gift of Mr. and Mrs. Noah L. Butkin to the Snite Museum of Art, 1978.

Exhibitions
A Decade of Collecting: 1970 to 1980, September 23–December 31, 1979, Snite Museum of Art, p. 48 (illus.).

Selected Bibliography
Shepherd Gallery. *Christian Imagery in French Nineteenth-Century Art, 1789–1906*. New York: Shepherd Gallery, 1980, pp. 374–75 (dedicated to the memory of Noah L. Butkin).

Ferdinand Roybet dedicated his painting career to reinterpreting the Dutch masters of the seventeenth century, using a fluid and grandiose style suggestive of Frans Hals (ca. 1581–1666). His indefatigable work ethic, fueled by the interest his works generated among rich patrons around the world, led to an extremely large production. From 1865 onward, he regularly exhibited at the Paris Salons, providing him with considerable visibility in France. Some of his paintings were purchased in the United States by wealthy individuals such as Cornelius Vanderbilt, who were eager to collect examples of the French modern tradition. Roybet was also supported by a number of the leading American gallery dealers, who promoted his flamboyant painting style because they recognized an active market for his canvases.

Another side to Roybet's work was his interest in religious subjects, works that were not immediately marketable. The *Head of John the Baptist* falls into this category. In this oil panel, the saint's ethereal qualities are heightened by a subtle halo over his head and the suggestion that he is asleep rather than brutally decapitated. However, Roybet based his study, in part, on a real model: the hint of a smile, the frozen teeth, and the waxy skin suggest a figure just beginning to become a death mask. Clearly there was a Naturalistic side to Roybet's creativity that the artist normally kept hidden, so as not to ruin his mass appeal. Although there is no documentation of just how many religious works Roybet created, he was deeply interested in Christ's Passion, completing a series of twenty paintings that were exhibited after his death, at the 1926 Salon. Perhaps other pieces depicting the lives of saints still await rediscovery.

This undated panel reflects the nineteenth-century fascination with death, a theme that was frequently visualized by members of the earlier Romantic generation. That interest gives the painting a far deeper resonance than is usually associated with Roybet's oeuvre. The majority of his compositions were designed for easy, popular consumption—depictions of cavaliers and musketeers drawn from a much earlier era and reflected in popular contemporary novels by authors such as Alexandre Dumas.

Roybert was widely admired in his time, and was awarded the Légion d'honneur in 1893. But his compositions declined in value after his death, as few thought that he had followed a progressive course. This panel, with its profound sense of spirituality, will perhaps encourage a renewed appreciation of his work. —GPW

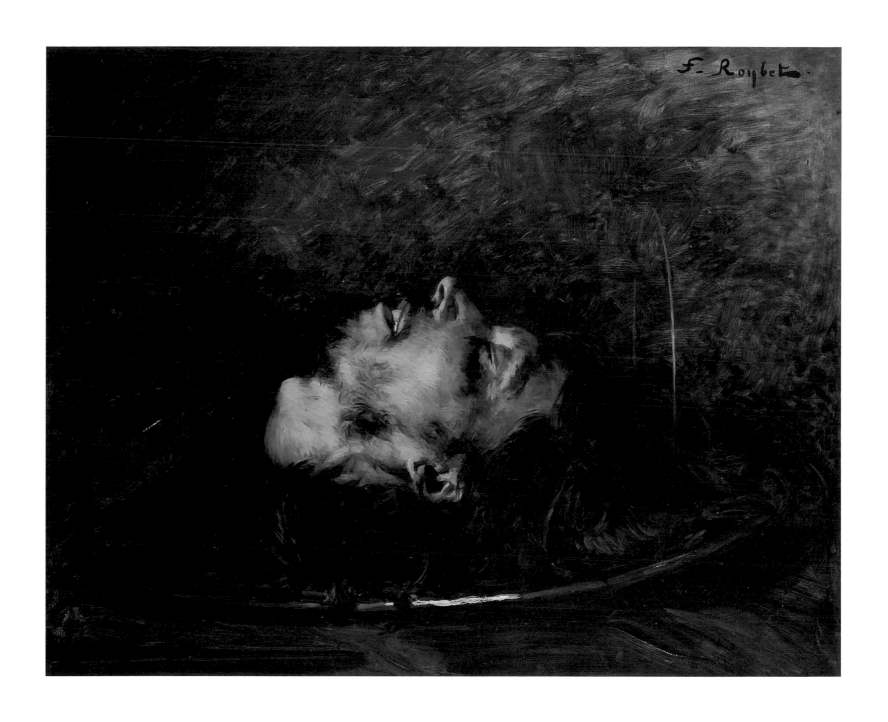

Ary Scheffer, 1795–1858

Princesse Marie de Sayn-Wittgenstein, 1855
oil on canvas
32.75 x 23.13 inches (83.20 x 58.70 cm)
Signed and dated lower left: *Ary Scheffer / 1855*
Snite Museum of Art
Gift of Mr. and Mrs. Noah L. Butkin
2009.045.100

70

Provenance

By descent to Prince Philip Hohenlohe
(Princess Marie de Sayn-Wittgenstein married
into the Hohenlohe family); Shepherd Gallery,
New York; Mr. and Mrs. Noah L. Butkin, 1976;
placed on loan with the Snite Museum of Art,
University of Notre Dame, 1980; converted to
a gift of the estate of Muriel Butkin, 2009.

Exhibitions

Exposition of 1859, Paris.

Ary Scheffer, 1795–1858, April 10–July 28,
1996, Musée de la Vie Romantique, Paris.

Selected Bibliography

Brody, Elaine. "All in the Family: Liszt, Daniel
and Ary Scheffer." *Nineteenth Century French
Studies* 13, no. 4 (Summer 1985): 238–43.

*Catalogue des oeuvres de Ary Scheffer exposées
au profit de la caisse de secours de l'association
des artistes peintres, sculpteurs, architectes et
dessinateurs.* Paris: Imprimerie de J. Claye,
1859.

Ewals, Leo. *Ary Scheffer, 1795–1858.* Paris:
Paris Musées, 1996.

*Gazette des Beaux-arts: Courrier Européen de
l'art et de la curiosité*, no. 4.3 (July–September
1859): 48.

*Museum Ary Scheffer Dordrecht: Catalogus der
Kunstwerken en Andere Voorwerpen, betrekking
hebbende op Ary Scheffer en Toebehoorende
aan Dordrechts Museum.* Dordrecht: De
Dordrechtsche Drukkerij en Uitgevers
Maatschappij, 1934.

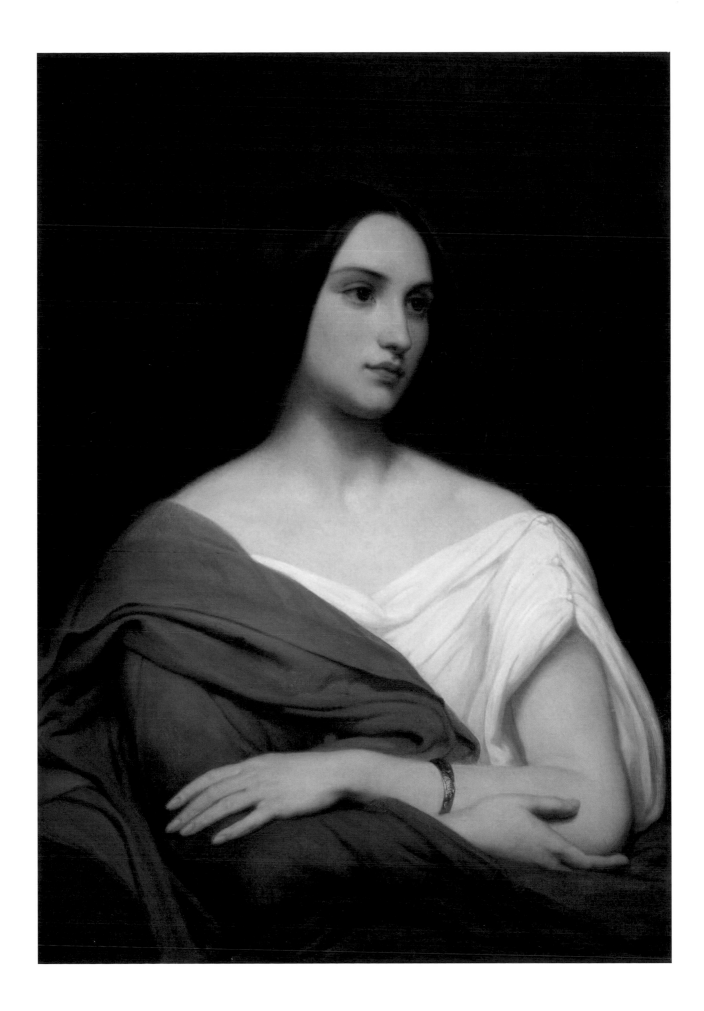

This striking portrait of Princess Marie de Sayn-Wittgenstein, painted in the last few years of Ary Scheffer's life, embodies the theatrical sensibility that characterized much of the artist's career. Scheffer had arrived in Paris in 1810 at age fifteen, hoping to build on his education from the Drawing Academy of Amsterdam by entering the studio of the Neoclassical painter Pierre-Narcisse Guérin (1774–1833). Although Scheffer remained true to the classical aesthetic of his training, his preference for dramatic lighting and sharp contrasts of light and dark also hint at a more Romantic sensibility that was intended to evoke an emotional reaction from viewers.

In fact, Scheffer's circle of friends included many leading Romantic musicians and composers, including Frédéric Chopin, Charles Gounod, Gioachino Antonio Rossini, and Franz Liszt, all of whom he painted during his career. It was his relationship with Liszt that sparked the creation of this portrait. The two men met in 1825 at a concert in the salon of Louis Philippe; by all accounts, they immediately became friends, despite the fact that Liszt was only fourteen years old at the time.[1] Scheffer painted a portrait of Liszt in 1837 (*Portrait of Franz Liszt*, 1837, Goethe Nationalmuseum, Weimer), and Liszt returned the favor by dedicating several compositions to his friend.[2] Throughout the following decades of success and failure, love affairs won and lost, and both personal and political upheavals, the friendship remained constant.

It is not surprising then, that Liszt would visit his old friend Scheffer in the summer of 1854, nor that he would be accompanied by Marie de Sayn-Wittgenstein, the daughter of his mistress, Princess Carolyn zu Sayn-Wittgenstein. At the time, Scheffer was staying in the Dutch seaside town of Scheveningen,

home to a substantial artists' colony. Liszt was visiting nearby Rotterdam when he wrote to Marie: "Tomorrow morning we're going to Scheveningen… to call on Ary Scheffer."[3] Undoubtedly, this was Marie's introduction to Scheffer, and perhaps the moment when the idea of a portrait was first proposed. Although Liszt and Carolyn zu Sayn-Wittgenstein had no children together, they both had offspring from previous relationships, and Liszt seems to have been particularly fatherly toward his mistress's children.[4]

The portrait depicts an elegant young woman dressed in a loose white gown beneath a blue overgarment, with only a single plain gold bracelet on her left arm. Although not the latest fashion of the 1850s, the simplicity of the costume highlights the youthful freshness of Marie's skin and face. She is positioned against a solid brown background that underscores the mood of quiet reverie and emphasizes Marie's grace and dignity, as she emerges as a young woman. —*JLW*

1 Elaine Brody, "All in the Family: Liszt, Daniel and Ary Scheffer," *Nineteenth Century French Studies* 13, no. 4 (Summer 1985): 238–43.

2 Leo Ewals, *Ary Scheffer, 1795–1858* (Paris: Paris Musées, 1996), 67. The compositions dedicated to Scheffer included three songs from *William Tell* and Clara's song from *Egmont*.

3 See Brody, "All in the Family," 239. Quoted from *The Letters of Franz Liszt to Marie zu Sayn-Wittgenstein*, trans. and ed. Howard E. Hugo (Cambridge: Cambridge University Press, 1953), 60–61.

4 A year later, Liszt would again contact Scheffer, asking him to introduce his son, Daniel, to Parisian society. Unfortunately, both Daniel and Scheffer died before any contact was actually established. See Brody, "All in the Family," 238–43.

Octave Tassaert, 1800–1874

Deathbed Scene, ca. 1840–60
oil on panel
9.75 x 8 inches (24.80 x 20.30 cm)
Signed lower left: *O.T*
Snite Museum of Art
Gift of Mr. and Mrs. Noah L. Butkin
2009.045.061

71

Provenance

Albert Benamou, Paris; purchased by Shepherd Gallery, 1974; Mr. and Mrs. Noah L. Butkin, 1974; placed on loan with the Snite Museum of Art, University of Notre Dame, 1980; converted to a gift of the estate of Muriel Butkin, 2009.

Selected Bibliography

Le Guen, Murielle. "Un nouveau regard sur les dessins d'Octave Tassaert (1800–1874) du Musée Léon Bonnat à Bayonne." *Revue du Louvre* 50, no. 2 (April 2000): 77–84.

————. "Une acquisition du Musée de la Vie Romantique de Paris: La porte fermée (1855) par Octave Tassaert." *Revue du Louvre* 47 (February 1997): 59–63.

Prost, Bernard. *O. Tassaert: Notice sur sa vie et catalogue de ses oeuvres*. Paris, 1886.

Sheon, Aaron. "Octave Tassaert's *Le suicide*: Early Realism and the Plight of Women." *Arts Magazine* 55 (May 1981): 142–51.

Weisberg, Gabriel P. *The Realist Tradition: French Painting and Drawing, 1830–1900*. Cleveland: The Cleveland Museum of Art and Indiana University Press, 1980.

Octave Tassaert's oil painting *Deathbed Scene* clearly states one of the artist's recurring themes: the desperation of the poor in the middle decades of the nineteenth century. Whether under the rule of Louis Philippe in the 1830s and '40s or the Second Empire of Napoleon III in the 1850s and '60s, Tassaert returned repeatedly to scenes of death, disaster, and poverty. Such images echo his own experience as a child sent out to make his living at age twelve, but they are also an accurate reflection of the bleak conditions in which many French citizens lived during these decades.

Tassaert was born into a family of artists whose precarious finances dictated that all of the children begin earning their living as soon as possible.[1] The young artist initially studied printmaking—a viable, if meagerly rewarded vocation—before deciding to pursue a painting career at the École des Beaux-Arts. Like most art students in the 1820s, Tassaert absorbed both the Neoclassicism of the academy and the Romanticism of painters such as Théodore Géricault and Eugène Delacroix, who had begun to gain recognition at the annual Salon exhibitions. After nearly a decade of struggle, Tassaert received positive acclaim for his submission of a history painting to the Salon of 1827.[2]

The creation of history paintings had long been a staple for French painters working in the classical tradition taught at the École des Beaux-Arts, but the revolution of 1830 modified that approach by shifting the subject matter from historical events to contemporary political imagery. Under the rule of the "citizen king" Louis Philippe, artists were asked to develop large-scale public paintings illustrating the values of the *juste milieu*, a phrase that described the middle-of-the-road position taken by a monarch who had superficially agreed to accept the rule of the people.[3] Tassaert participated in the 1831 competition for commissions destined for the Chamber of Deputies, submitting a fully developed sketch on a predetermined subject about the dangers of extremism on the royalist right.[4] Tassaert's submission did not win, but it marks his entry into dealing with contemporary social issues in his painting. From this point forward, his work would increasingly reflect the actual living conditions of the people.

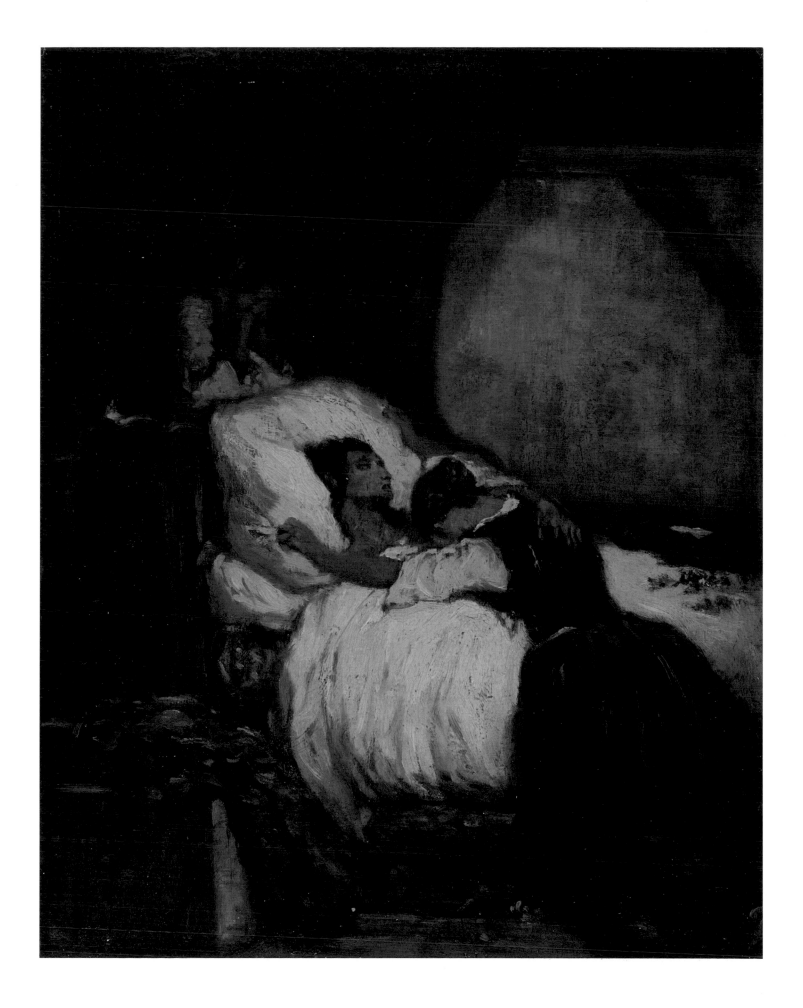

A painting such as *Deathbed Scene* is characteristic of this change. Familiar with hardship from his own experience, Tassaert compellingly depicted the plight of poverty-stricken families in urban Paris. His images ranged from ragged children huddled against a closed door in the winter (*La porte fermée*, 1855, Musée de la Vie Romantique, Paris) to a depiction of his own barren and frigid studio (*A Corner of His Atelier*, 1845, Musée du Louvre, Paris). Most famous, however, is Tassaert's 1852 painting of a suicidal mother and daughter, *An Unfortunate Family (The Suicide)* (Musée Fabre, Montpelier). Although the literary source for that image was *Les paroles d'un croyant* (1834), by Félicité de Lamennais, Tassaert's scene requires little external narrative to explain the circumstances: a mother and daughter escape the profound desolation of their lives through carbon monoxide poisoning from the undersized heater in their wintry room. A print of the Madonna and Child on the wall offers hope for a better life in the next world.

The composition of *Deathbed Scene* is very similar to *An Unfortunate Family (The Suicide).* Although the narrative here is more ambiguous, the figure lying in the bed is already turning gray in death, as his loved ones despair at his passing. As in many of Tassaert's paintings, the setting is a garret apartment with only bare-bones furnishings: a rustic, narrow bed and table in a half-timbered room without windows. On the coverlet lie unidentifiable sprigs of green—a symbol of the new life of spring, or a plant such as hemlock that ends life completely.

Stylistically, this oil sketch is reminiscent of Géricault's grim and sometimes grisly images of body parts, or of the dead and dying figures in Delacroix's paintings from the 1820s. The impasto technique and the sharp contrast between light and dark also echo a Romantic sensibility. However, the subject matter dates the work to a midcentury period consistent with Tassaert's images of suicide, death, and the life-destroying exigencies of poverty in urban Paris. —*JLW*

1 Gabriel P. Weisberg, *The Realist Tradition: French Painting and Drawing, 1830–1900* (Cleveland: The Cleveland Museum of Art and Indiana University Press, 1980), 310–11.

2 Ibid., 310. The painting is now lost, but it reportedly depicted a scene from the life of Louis XI.

3 See Albert Boime, "The Quasi-Open Competitions of the Quasi-Legitimate July Monarchy," *Arts Magazine* 59 (April 1985): 94–105.

4 The subject was the famous confrontation between Honoré Gabriel Riqueti, comte de Mirabeau (1749–1791), and Henri Evrard, marquis de Dreux-Brézé (1762–1829), during the French Revolution. Dreux-Brézé, who was Louis XVI's master of ceremonies, repeated the king's order that the members of the Third Estate disburse. Mirabeau defied the order, thus proclaiming that the king's authority no longer deserved immediate acquiescence. See Boime, "The Quasi-Open Competitions," 96–97.

Octave Tassaert, 1800–1874

The Road to Calvary, before 1850
oil on canvas
13 x 16 inches (33.02 x 40.64 cm)
Inscribed on verso at upper center in black ink: *Esquisse par Tassaert / C.M.*
Stenciled on verso at center, vertically, in black: canvas maker's mark, illegible; partially erased white chalk at left: *37*
Labeled on verso: *Christian Imagery in 19th-Century Art 1789–1906 / Shepherd Gallery / May 20–July 26, 1980 / cat. no. 58, ill'd.*
Snite Museum of Art
Gift of Mr. and Mrs. Noah L. Butkin
2009.045.038

72

Provenance

Goerges Martin du Nord, Parks; Shepherd Gallery, New York; Mr. and Mrs. Noah L. Butkin, 1977; placed on loan with the Snite Museum of Art, University of Notre Dame, 1978; converted to a gift of the estate of Muriel Butkin, 2009.

Selected Bibliography

d'Argencourt, Louise, and Roger Diederen. *European Paintings of the 19th Century*, vol. 2. Cleveland: The Cleveland Museum of Art, 1999.

Le Guen, Murielle. "Un nouveau regard sur les dessins d'Octave Tassaert (1800–1874) du Musée Léon Bonnat à Bayonne." *Revue du Louvre* 50, no. 2 (April 2000): 77–84.

Prost, Bernard. *O. Tassaert: Notice sur sa vie et catalogue de ses oeuvres.* Paris, 1886.

Weisberg, Gabriel P. *The Realist Tradition: French Painting and Drawing, 1830–1900.* Cleveland: The Cleveland Museum of Art and Indiana University Press, 1980.

In the wake of the French Revolution of 1789, the design and construction of new churches was a rarity in Paris. The evolution of the Panthéon, completed just as the Revolution began, offered a cautionary tale as it alternated between being a church devoted to Saint Geneviève and a temple dedicated to the great men of France.[1] Even the Cathedral of Notre Dame was "rededicated" to Reason in 1793, and the figure of Liberty replaced the Virgin Mary on some of its altars. For the most part, church design came to a standstill for the next three decades, as anticlericalism became identified with the goals of the revolutionary ideals. It is somewhat surprising, then, that the renovation of existing churches—and the construction of new ones—began to emerge as an important element in Parisian culture beginning in the 1820s.[2]

With the advent of new church building, as well as the renovation of earlier worship spaces that had been damaged by the Revolution, there was a growing need for religious imagery to decorate the interiors. Tassaert's *Road to Calvary* appears to have been prepared for just such a project. The rounded arch form at the top of the painting suggests strongly that the completed work would have been installed, either as a mural or a fresco, in a chapel with a similar structure. This would indicate that the destination for the final version of this image was probably a Neoclassical church, rather than a Gothic or Gothic Revival building where pointed arches would have been typical.

The subject of the painting is the traditional story of Christ falling as he carries the cross on his way to Golgotha. Simone of Cyrene helps to share the load of the wooden cross, while Mary Magdalene stumbles to the ground, kissing Christ's feet. In the background, to the left are the Virgin Mary and Saint John the Evangelist; and on the right, a soldier carrying a lance approaches the fallen figures. In the darkening sky overhead, a trio of angels laments the scene below. The composition respects the customary iconography of Christ's Passion, but Tassaert's angels generate a dynamic energy, with their outstretched arms reaching past the architectural frame of the arch, beyond the picture plane and into the space of the viewer.

A related painting, *Heaven and Hell* (ca. 1850, The Cleveland Museum of Art), was also part of the original Butkin collection.[3] This work is considerably more finished than the sketch of *The Road to Calvary*, but it contains an identical rounded arch form at the top of the painting, raising the possibility that both compositions were originally developed for the same location. The subject of a Last Judgment, in this case the battle for a young

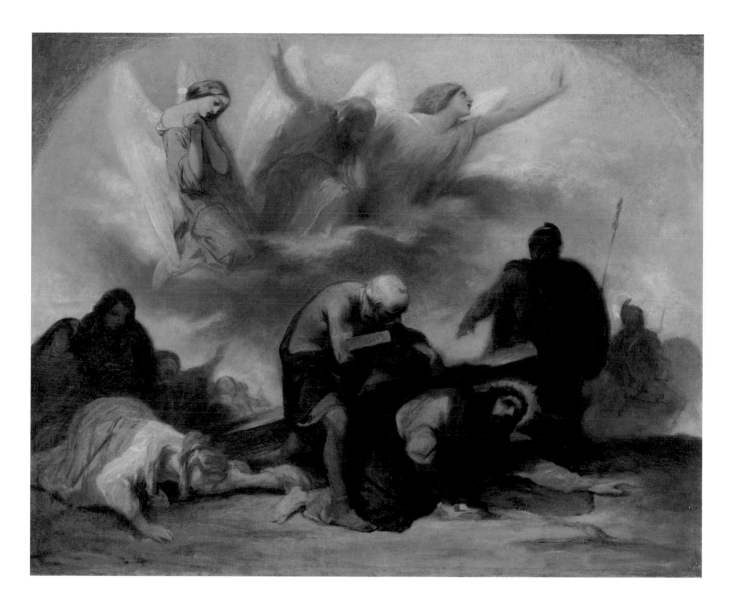

woman's soul, is consistent with a cycle of paintings related to the life and Passion of Christ. What distinguishes *Heaven and Hell*, however, is the potential political interpretation related to the revolution of 1848 and the Second Republic (1848–52). If the dead woman represents an allegorical figure of France, as the Cleveland Museum of Art proposes, then the republican Tassaert is proclaiming the fragility of the French national soul, caught between the evils of royalist despotism and the ideals of liberty, equality, and brotherhood.

As Tassaert knew only too well, the principles of the Revolution had too often been derailed by the economic and political interests of powerful groups. By aligning the fate of France's allegorical soul with the Last Judgment, and underscoring Christ's sacrifice for the soul of humanity, Tassaert linked republican ideals to Christian morality, implying that moral integrity was a requirement for the future of the nation. —*JLW*

1 The Panthéon was originally commissioned in 1744 by Louis XV, who had made a vow that he would build a new church dedicated to Saint Geneviève, patron saint of Paris, if he recovered from an illness. The architect, Jacques-Germain Soufflot (1713–1780), began construction in 1758, but the building was not completed until 1789, at which time the revolutionary government decided it should be a mausoleum for important men from the Age of Reason, rather than a church.

2 New church construction in the Neoclassical style during this period includes the Church of La Madeleine, begun in 1806 as a temple to Napoleon's soldiers, but completed in 1842 as a church dedicated to Mary Magdalene. For a discussion of a possible connection between Tassaert and this church, see Murielle Le Guen, "Un nouveau regard sur les dessins d'Octave Tassaert (1800–1874) du Musée Léon Bonnat à Bayonne," *Revue du Louvre* 50, no. 2 (April 2000): 77–84. Le Guen suggests that Tassaert may have assisted François Bouchot in some work at La Madeleine, but there is as yet no further corroboration of this possibility.

3 For an image of *Heaven and Hell*, see Louise d'Argencourt and Roger Diederen, *European Paintings of the 19th Century*, vol. 2 (Cleveland: The Cleveland Museum of Art, 1999).

Horace Vernet, 1789–1863

Sketch for Portrait of the Duc de Chartres, 1829

oil on canvas

9.50 x 7 inches (24.10 x 17.80 cm)

Inscribed upper left in gold: *411*

Stamped with collector's seal on verso: *painted in 1829*; verso at lower right: red vente stamp; old labels: *Horace Vernet; B3316; ID 813;* in old hand: *Le Duc de Chartres / Lieutenant General 1792 / illegible-Louis Phillippe / illegible*

Snite Museum of Art

Gift of Mr. and Mrs. Noah L. Butkin

2009.045.059

73

Provenance

Sotheby's, London, *European Paintings*, May 9, 1979, cat. no. 317; Mr. and Mrs. Noah L. Butkin, 1979; placed on loan with the Snite Museum of Art, University of Notre Dame, 1980; converted to a gift of the estate of Muriel Butkin, 2009.

Selected Bibliography

Horace Vernet (1789–1863). Rome: De Luca Editore, 1980.

Renaudeau, Claudine. "Horace Vernet (1789–1863): Chronologie et catalogue raisonné de l'oeuvre peint." PhD diss., Université de Lille II, 1999, p. 254.

This 1829 sketch for a portrait of the Duc de Chartres depicts Ferdinand-Philippe, the eldest son of Louis Philippe, who was the Duc d'Orléans at the time of the painting. Young Ferdinand-Philippe was born on September 3, 1810, in Palermo, Sicily, where his parents lived in exile at his mother's family home. In fact, he was named Ferdinand in honor of his maternal grandfather, King Ferdinand I of the Two Sicilies.

The title of Duc de Chartres traditionally belongs to the oldest son of the Duc d'Orléans, who was typically the younger brother of a king. In the years following the French Revolution of 1789, the lineage of the Bourbon kings of France was complicated by the decapitation of Louis XVI and the subsequent royalist restoration under Louis XVIII in the wake of Napoleon's exile. This placed Louis Philippe, the father of the Duc de Chartres, in line for the French throne, because he was descended from a sixteenth-century Duc d'Orléans who was the brother of Louis XIV.

The Duc de Chartres in Horace Vernet's portrait did not set foot in France until he was four years old, in 1814. The family did not stay long, however, but was forced into exile again in 1815; this time, they moved to Twickenham, near London, where they remained until 1817. Back in France in 1819, the Duc de Chartres was schooled initially by tutors and then at the Lycée Henri IV, which is where Vernet first painted the young duke in 1821. That earlier portrait shows a rather sober eleven-year-old boy with a hoop and stick in his hands (*The Duc de Chartres with a Hoop*, 1821, private collection, Paris). In the background are the buildings of the Lycée and the convent associated with the church of Saint-Étienne-du-Mont, both of which are located in the heart of Paris's medieval Latin Quarter. After completing his studies at the Lycée Henri IV, the duke studied at the École Polytechnique and then joined the First Regiment of Hussars in the French Army.

The 1829 sketch at the Snite Museum shows the now nineteen-year-old colonel in the military uniform of his regiment. Vernet must have prepared this small oil sketch as a study for the slightly larger *Portrait of the Duc de Chartres* (location unknown) that

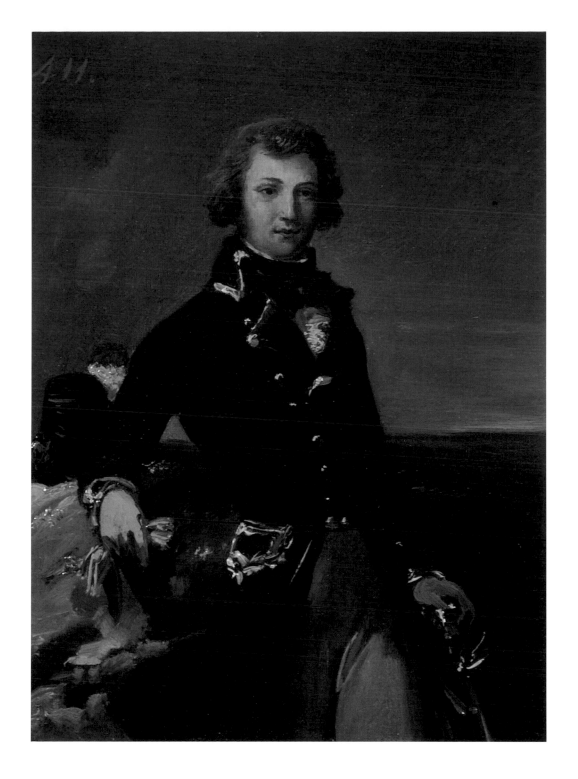

was exhibited at the International Arts and Antiques Fair in Maastricht, Netherlands, in 1995.[1] The somber landscape suggests that storms are thundering around the duke, but the rising sun on the horizon might be understood as a sign of better times to come. Vernet's savvy sense of politics, and perhaps his hope for a republican France under the more liberal control of the soon-to-be king Louis Philippe, may well have encouraged him to include such symbolism in this very small oil sketch. —*JLW*

1 Claudine Renaudeau, "Horace Vernet (1789–1863): Chronologie et catalogue raisonné de l'oeuvre peint" (PhD diss., Université de Lille II, 1999), 254. Renaudeau's catalogue raisonné notes that the finished portrait of the Duc de Chartres was sold at the Hôtel Drouot, Paris, on March 18, 1994, and exhibited in 1995 at the International Arts and Antiques Fair in Maastricht. However, there is no information about the current location of the painting. The author would like to thank Katie Hornstein for her assistance in locating Claudine Renaudeau's catalogue raisonné in Paris.

Jules-Jacques Veyrassat, 1828–1893

Horse Cart with Three Figures under a Tree
oil on panel
12.13 x 16.38 inches (30.81 x 41.61 cm)
Signed lower right: *J. Veyrassat*
Snite Museum of Art
Gift of Mr. and Mrs. Noah L. Butkin
2009.045.078

74

Provenance
Shepherd Gallery, New York; Mr. and Mrs. Noah L. Butkin, 1977; placed on loan with the Snite Museum of Art, University of Notre Dame, 1980; converted to a gift of the estate of Muriel Butkin, 2009.

After studying in Paris with Henri Lehmann (1814–1882), Jules-Jacques Veyrassat made his first appearance at the Paris Salon in 1848. During the 1860s, due to his extraordinary ability as an etcher, he attracted the attention of the British print connoisseur Philip Gilbert Hamerton. He continued his work as a painter as well, receiving a Salon medal in 1872; he also was awarded the Légion d'honneur in 1878, for paintings based on views he had observed outdoors.

Veyrassat is generally associated with the painters who worked in the village of Barbizon and the surrounding fields. He is often compared with Charles Jacque (1813–1894) and Jean-François Millet (1814–1875), who also were both painters and printmakers. Veyrassat's main emphasis as a painter was on scenes of rural activity, especially linked to work in the fields such as hay gathering or, as in the present example, taking a rest at noontime. He was a prolific draftsman, making numerous outdoor sketches in preparation for larger paintings.[1] This small, intimate depiction of peasants eating their midday meal under a tree, beside a stream, would have appealed to a private collector for both its subject matter and its size. —*GPW*

1 The Cabinet des Dessins at the Musée du Louvre owns a remarkable series of the artist's small sketches, which he might have used for his painted compositions or simply as records of what he saw in the countryside.

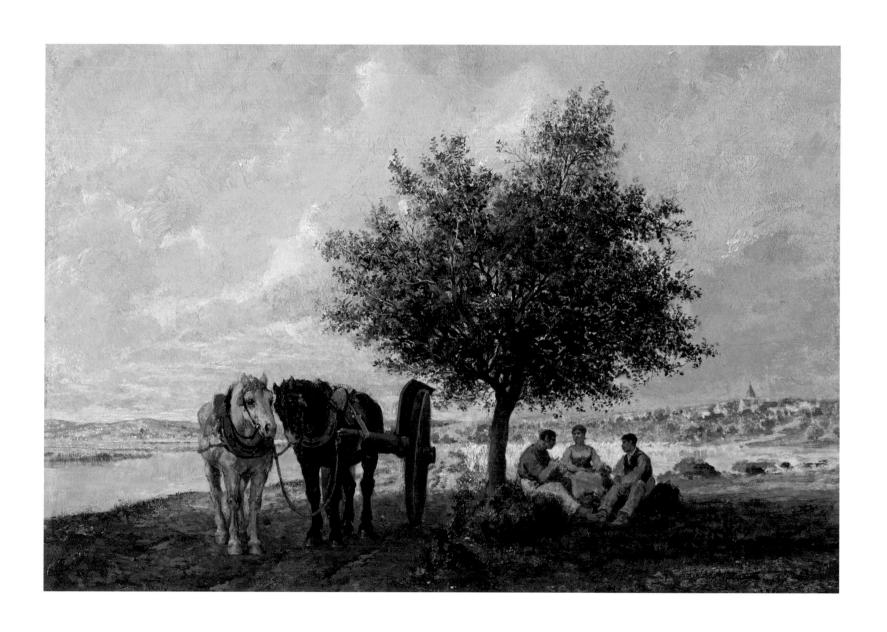

Jehan-Georges Vibert, 1840–1902

Figures on Rocks at the Edge of the Sea, or *The Coast at Etretat*, 1867
oil on canvas
23.25 x 36.75 inches (59.10 x 93.30 cm)
Signed and dated lower right: *J G Vibert 67*
Snite Museum of Art
Gift of Mr. and Mrs. Noah L. Butkin
2009.045.110

75

Provenance

Collection Mr. Anthony J. Antelo, Philadelphia;
Heseltine Galleries, Philadelphia; Shepherd
Gallery, New York; Mr. and Mrs. Noah L. Butkin,
1977; placed on loan with the Snite Museum of
Art, University of Notre Dame, 1980; converted
to a gift of the estate of Muriel Butkin, 2009.

Selected Bibliography

Jehan-Georges Vibert: La comédie en peinture. New York:
Arthur Tooth and Sons, 1902, vol. 2, p. 30 (illus.).

Selected Works from the Snite Museum of Art.
Notre Dame, IN: Snite Museum of Art,
University of Notre Dame, 1987, p. 185 (illus.).

Strahan, Edward, ed. *Art Treasures of America
Being the Choicest Works of Art in the Public and
Private Collections of North America*. Philadelphia:
George Barrie, 1879, pp. 24 (illus.), 26
(mentioned as *Coast Scene with Figures*).

Weisberg, Gabriel P., with an essay by Petra ten-
Doesschate Chu. *Redefining Genre: French and
American Painting, 1850–1900*. Washington, DC:
The Trust for Museum Exhibitions, 1995, pp. 96
(illus.), 107, cat. no. 74.

Zafran, Eric M. *Cavaliers and Cardinals:
Nineteenth-Century French Anecdotal Paintings*.
Cincinnati: Taft Museum, 1992, p. 22 (illus.).

Well known during the nineteenth century for his innumerable images of cardinals and priests, Jehan-Georges Vibert enjoyed a lively following among collectors intrigued by anecdotal genre scenes with a satirical edge.[1] The small scale of these paintings indicates they were produced for intimate interiors, probably for a bourgeois audience that enjoyed the humor of the anecdotes.

Occasionally, Vibert painted scenes with different themes related to his own life, including this semi-autobiographical view of the coastline at Etretat. On a rocky outcropping jutting out toward the English Channel, a group of onlookers is mesmerized by the power and dominance of nature. The figures at the tip of the ledge peer over to survey the waves crashing below. Above them, to the right, another cluster of observers watch more cautiously, some huddling under umbrellas for protection from the sea foam; one male figure in this party stands particularly upright, as if entranced by the action of the waves. To the far right are two more figures, one of them a frightened young woman who looks as if she wants to escape from the turbulence below. Vibert included himself and the Spanish painter Eduardo Zamacois y Zabala (ca. 1841–1871) in the composition, apparently leading a group of friends on an excursion at Etretat: the man seated at the promontory edge wears an informal cap like the one Vibert often wore.[2]

It is known that Vibert often visited the village of Etretat in Normandy, which had become a popular resort for travelers and an artists' colony. The striking beauty and uniqueness of Etretat's coastline attracted numerous tourists, fascinated by the strange rock formations that had been battered by the sea for centuries. Other artists who painted the site included Gustave Courbet, Eugène Boudin, James McNeill Whistler, and Claude Monet; the pictures they made were usually dramatic landscapes devoid of figures.

After Vibert died in 1902, a sale of his most intimate personal effects was held.[3] Among the works sold was *Surpris par la marée (Surprised by the Tide)*, a painting that brought 5500 francs.[4] Since the review of the sale does not provide the dimensions or a photographic record of the work, we cannot be sure that the painting is a version of *The Coast at Etretat*. But the title in the sales catalogue implies a similar scene, and the price paid for it, along with the fact that it was still in Vibert's possession, demonstrates the importance of the work. By 1902, the Snite Museum painting was already in America; so could there be another version of this theme in existence?

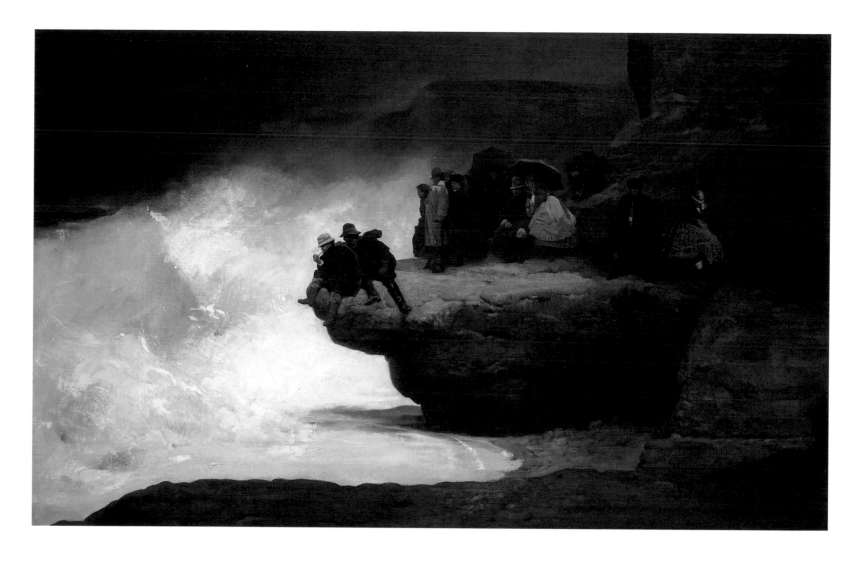

The Coast at Etretat was well known during the late nineteenth and early twentieth centuries. Close to the time of the sale of Vibert's paintings from his studio, the American gallery Arthur Tooth and Sons published a two-volume book on the artist, *La comédie en peinture*, which reproduced the painting and identified the site as Etretat in the text.[5] The picture is also found in Edward Strahan's *Art Treasures of America* (1879), albeit in an engraving, with the title *Coast Scene with Figures*. Then in the collection of Anthony J. Antelo, in Philadelphia, the painting was regarded as a significant work in one of the better collections in the United States.[6] Its listing in the Strahan publication assured that the image was widely recognized as an example of anecdotal genre painting.
—*GPW*

1 See Eric M. Zafran, *Cavaliers and Cardinals: Nineteenth-Century French Anecdotal Paintings* (Cincinnati: Taft Museum, 1992), 22 (illus.).

2 For a similar type of dress in another painting, see Zafran, *Cavaliers and Cardinals*, 14, fig. 14, where Zafran notes that the figure is certainly a "youthful self-portrait." He also identifies Vibert in *The Coast at Etretat* on p. 22.

3 See "Revue des ventes: Atelier J. G. Vibert," *Journal des arts, November 29, 1902, 3. Also see Vente après décès: Catalogue des tableaux, esquisses, aquarelles, dessins, objets d'art et d'ameublement européens et de l'Extrême Orient; Tapisseries composant l'atelier de Jehan-Georges Vibert dont la vente aura lieu en son hôtel, 18, rue Ballu les Mardi 25 et Mercredi 26 Novembre, 1902* (Paris: Lib.-impr. réunies, 1902).

4 "Revue des ventes," 8.

5 *Jehan-Georges Vibert: La comédie en peinture* (New York: Arthur Tooth and Sons, 1902), 2:30.

6 See Edward Strahan, *Art Treasures of America Being the Choicest Works of Art in the Public and Private Collections of North America* (Philadelphia: George Barrie, 1879), 26.

Jehan-Georges Vibert, 1840–1902
A Night Class
oil on wood panel
24 x 18 inches (60.96 x 45.72 cm)
Signed lower left: *J.G. Vibert*
Cleveland Museum of Art
Bequest of Noah L. Butkin
1980.292

76

Provenance
Alonzo J. Tinsley, New York; Sotheby Parke-Bernet, New York, sale 84, May 18, 1977; Shepherd Gallery, New York; Mr. and Mrs. Noah L. Butkin; bequest of Noah L. Butkin to the Cleveland Museum of Art, 1980.

Exhibitions
Paris Salon, 1881, cat. no. 2346, *Un atelier le soir.*

Exposition Nationale, 1883, Palais des Champs Elysées, Paris, cat. no. 688, *L'Atelier du soir.*

The Artist and the Studio in the Eighteenth and Nineteenth Centuries, 1978, The Cleveland Museum of Art, cat. no. 20.

Selected Bibliography
Buisson, J. "Le Salon de 1881." *Gazette des beaux-arts* 24 (July 1881): 70.

Du Seigneur, Maurice. *L'Art et les Artistes au Salon de 1881.* Paris: P. Ollendorff, 1881, p. 216.

McKeever, Kathleen. "A Night Class." In Louise d'Argencourt and Roger Diederen, *European Paintings of the 19th Century.* Cleveland: The Cleveland Museum of Art, 1999, pp. 622–25.

Vibert, J-G. "The Night School." *Century Magazine* 51 (November 1895–April 1896): 554, 556 (illus.).

Zakon, Ronnie L. *The Artist and the Studio in the Eighteenth and Nineteenth Centuries.* Cleveland: The Cleveland Museum of Art, 1978, p. 37.

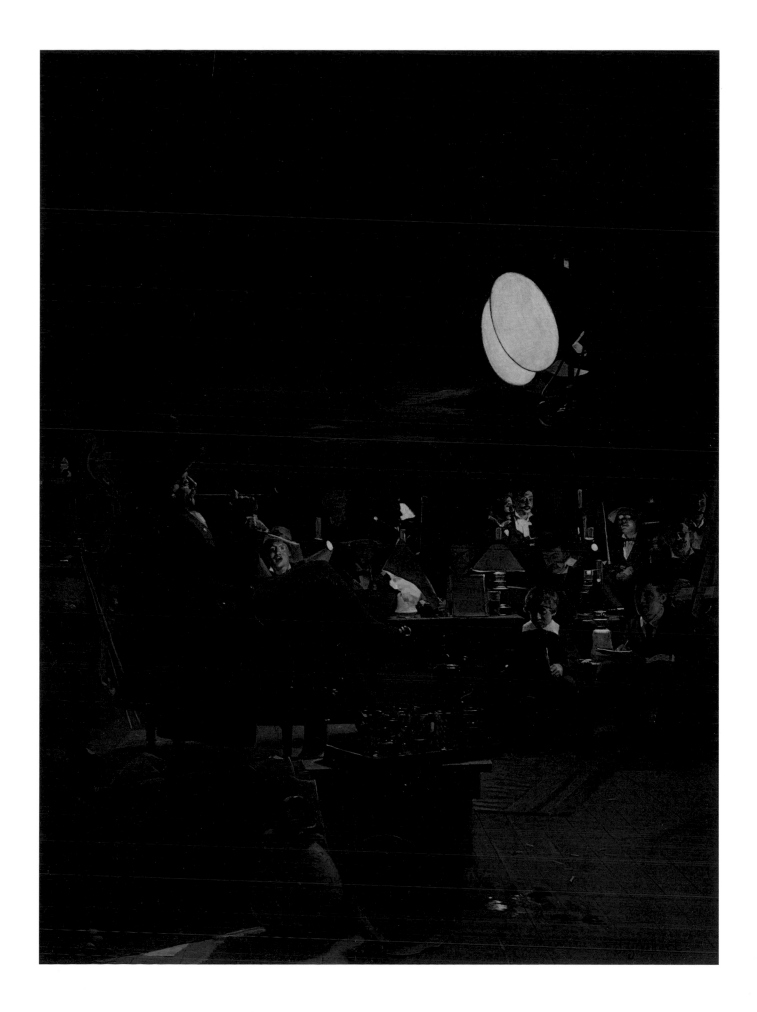

An atypical example of Vibert's work (who was better known for his satirical depictions of clergymen), the *Night Class* was commented upon by critics when it was shown at the 1881 Paris Salon. It was also highly regarded by Vibert himself, who sent it to the Exposition Nationale in 1883. Significantly, the work gained further support in the United States when it was mentioned and reproduced in *Century Magazine* in 1895. The small panel illustrates how painters worked from the model in their ateliers and, more importantly, reflects how studio practices were being modified by new technological innovations.

Anecdotal genre paintings were widely produced in the nineteenth century, and artists spent considerable effort finding vintage clothes and uniforms for their models to wear. Vibert's depiction of a model dressed in seventeenth-century garb, sitting on a dais in front of a roomful of students, documents this tradition. The students are positioned close together, with little room between one another as they try to establish the best vantage point from which to draw the figure. Clustered in three compact rows, many using small lamps to light their sketchbooks, the budding professionals eagerly study the model. Because the scene takes place at night, which was unusual at that time, the model is illuminated by two arc lamps. These lamps reveal the brilliant colors of the dress and nuances of the facial features, details that would not be so apparent without direct spotlighting. They also cast light on the smoke from a student's pipe swirling above the others' heads, and they highlight the concentration of the bohemian-hatted students as they sketch intently.

The use of electric light, which was introduced at the 1878 Exposition Universelle in Paris, would have appeared modern to an audience in 1881.[1] Because of this invention, the night class could now become a staple in the academic curriculum, expanding opportunities for those who did not have time to draw during the day. Many painting students had other day jobs; it was only at night, under the tutelage of a mentor, that they could develop their own works. By documenting this modernization in studio practice, Vibert linked himself, by inference, to progressive practices in artistic training. —*GPW*

1 Kathleen McKeever, "A Night Class," in Louise d'Argencourt and Roger Diederen, *European Paintings of the 19th Century* (Cleveland: The Cleveland Museum of Art, 1999), 622–25.

Antoine Vollon, 1833–1900

Portrait of a Young Man, 1877
oil on canvas
18 x 15 inches (45.72 x 38.10 cm)
Signed lower left: *A. Vollon / 77--*
Snite Museum of Art
Gift of Mr. and Mrs. Noah L. Butkin
2009.045.080

77

Provenance

Sotheby's, London, sale May 4, 1977, cat. no. 28 (illus.); Shepherd Gallery, New York; Mr. and Mrs. Noah L. Butkin, 1977; placed on loan with the Snite Museum of Art, University of Notre Dame, 1980; converted to a gift of the estate of Muriel Butkin, 2009.

Selected Bibliography

Selected Works from the Snite Museum of Art. Notre Dame, IN: Snite Museum of Art, University of Notre Dame, 1987, p. 178 (illus.).

Although the sitter in this portrait remains unknown, the painting is definitely by Antoine Vollon.[1] It is unknown how many portraits Vollon completed; he was primarily a still-life painter. The two recorded examples, from 1860 and 1889, are a self-portrait and a depiction of an intimate friend.[2] This portrayal conveys a liveliness of expression and intensity of character that imply a painter well versed in doing portraits, revealing that Vollon could have had a substantial career working in this genre if he had chosen to do so. The work is dated 1877, and the young sitter might have been an assistant in Vollon's atelier. During this period, Vollon's still-life paintings were extremely popular, and he may have had associates working in his studio in order to meet the high demand. If that is the case, the name of the individual may reappear as more research is done into Vollon's studio practices. —*GPW*

1 Carol Forman Tabler, e-mail to author, April 8, 2010.

2 *Antoine Vollon, 1833–1900: A Painter's Painter* (New York: Wildenstein, 2004), 11 and cat. no. 30 (frontispiece).

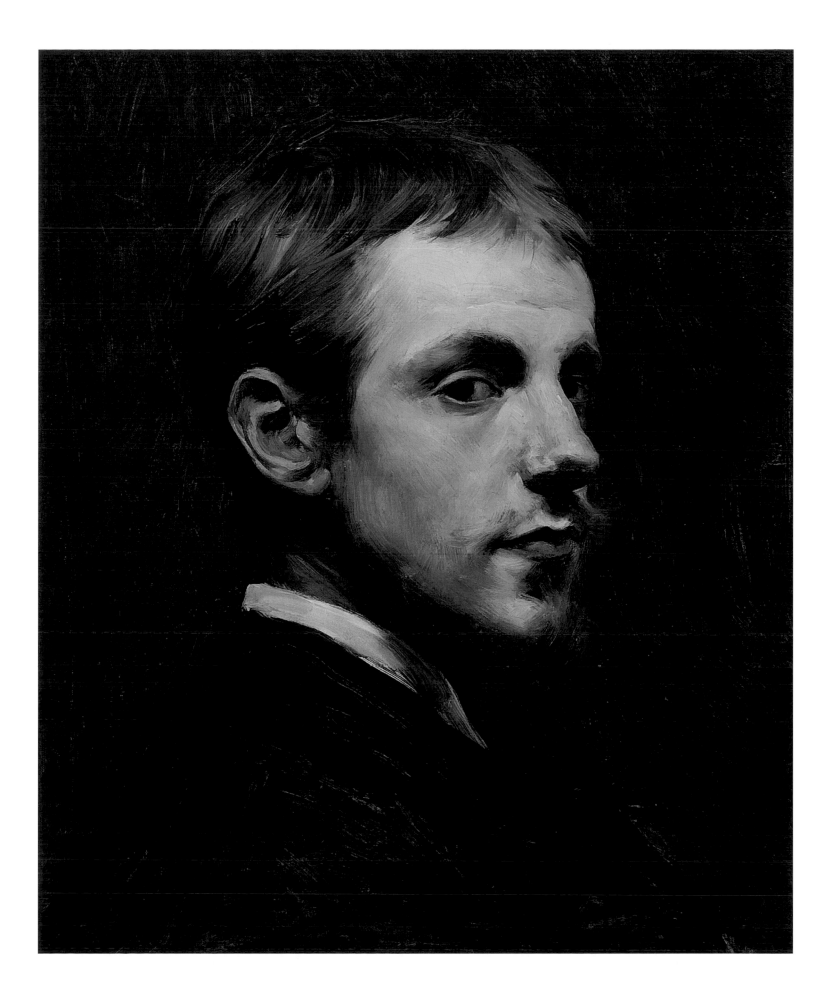

Antoine Vollon, 1833–1900

Still Life with Fish and Shrimps
oil on canvas
28.25 x 36.13 inches (71.80 x 91.80 cm)
Signed lower right: *A. Vollon*
Snite Museum of Art
Gift of Mr. and Mrs. Noah L. Butkin
2009.045.114

78

Provenance
Brame et Lorenceau, Paris; Couper Gallery, London; Arcade Gallery, London; Mr. and Mrs. Noah L. Butkin, 1973; placed on loan with the Snite Museum of Art, University of Notre Dame, 1980; converted to a gift of the estate of Muriel Butkin, 2009.

Exhibitions
Summer Exhibition, June 12–July 15, 1967, Couper Gallery, London, cat. no. 28 (illus.).

Chardin and the Still-Life Tradition in France, 1979, The Cleveland Museum of Art, cat. no. 28.

Selected Bibliography
Weisberg, Gabriel P., with William S. Talbot. *Chardin and the Still-Life Tradition in France.* Cleveland: The Cleveland Museum of Art, 1979, p. 58, cat. no. 28 (illus.).

As one of the preeminent still-life painters of the mid-nineteenth century, Vollon had a broad following. His paintings were widely praised and collected, and in 1900 (close to end of his life), he was elected to the prestigious Institut de France. This was a rare honor for a painter whose oeuvre consisted mainly of genre scenes and still lifes, painting categories that had long been considered unworthy of a great artist.[1] Vollon's approach to his subjects reflected the freedom and bravado of some of the major still-life innovators of the time, such as Édouard Manet, while remaining linked to the well-established traditions of the sixteenth and seventeenth centuries in the Low Countries and Spain.

During the 1860s and '70s, when still-life painters were becoming increasingly numerous, Vollon frequently favored the depiction of fish in studies of dead wild animals. In some of his images, the fish were offered for sale amid a rich profusion of many other foodstuffs. Here, he randomly placed several kinds of fish and some shrimps in baskets on a spare tabletop recalling seventeenth-century Dutch or Flemish market stalls. Vollon presents the fish as if they were still alive, squirming and tumbling across the wooden plank. The only other form in the composition is a rustic ceramic container, at the left, suggesting that these creatures are going to be prepared and served to a humble French family.

The freely painted style of this canvas indicates that Vollon was adopting some of the technical innovations of earlier Romantic artists and the Impressionists, even though the tone of the still life remains gray and monochromatic. Despite the humble theme, a sense of abundance emanates from the scene. In other compositions, Vollon created still lifes of lavish objects suggestive of an upper-class home. This range meant that his works appealed to diverse members of the public interested in collecting paintings in this category. His success proved that still-life painting was a significant category of expression that allowed an original creator to display his or her talent at depicting otherwise modest subjects.
—*GPW*

1 Gabriel P. Weisberg, with William S. Talbot, *Chardin and the Still-Life Tradition in France* (Cleveland: The Cleveland Museum of Art, 1979), 58, cat. no. 28. Still life was revived in the midcentury under the stimulus of Chardin, and the category was raised from the lowest level of appreciation.

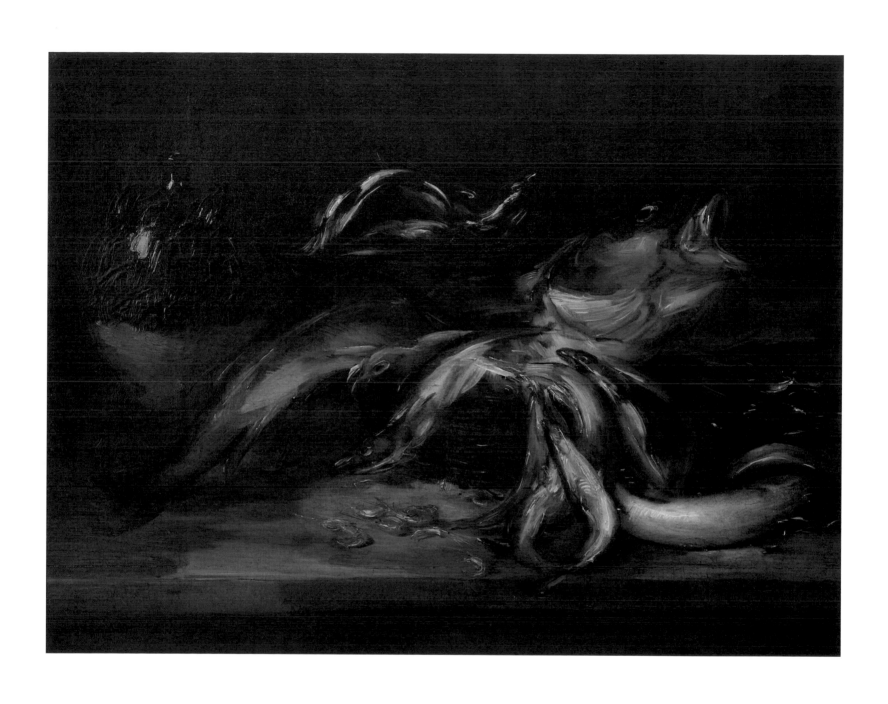

Antoine Vollon, 1833–1900

View of the Seine, or *The Seine and the Pont des Saints-Pères*, about 1888–89

oil on canvas

25.63 x 31.88 inches (65.10 x 80.98 cm)

Signed lower right: *A. Vollon*

Snite Museum of Art

Gift of Mr. and Mrs. Noah L. Butkin

2009.045.115

79

Provenance

Possibly atelier sale (Hôtel Drouot, Paris, May 20–23, 1901, cat. no. 35, as *Pont de Paris*, 65 x 76 cm); Georges Pent, Paris, 1924; Knoedler Gallery, New York, 1924; Mrs. Gilbert P. Schaefer, Mentor, Ohio; Parke-Bernet, sale October 30, 1969, cat. no. 119a (illus.); Sotheby's, New York, sale June 3–4, 1971, cat. no. 16, as *Pont des Arts*; the Norton Galleries?; Mr. and Mrs. Noah L. Butkin, 1971; placed on loan with the Snite Museum of Art, University of Notre Dame, 1980; converted to a gift of the estate of Muriel Butkin, 2009.

Exhibitions

View of Paris, 1939, Knoedler Gallery, New York, cat. no. 19, lent by Mrs. Gilbert P. Schaefer.

Selected Bibliography

Tabler, Carol Forman. "The Landscape Paintings of Antoine Vollon (1833–1900): A Catalogue and Analysis." PhD diss., Institute of Fine Arts, New York University, 1995, cat. no. 148.

Weisberg, Gabriel P. "Realism and Impressionism in Nineteenth-Century French Art." *Antiques* 120, no. 2 (August 1981): 334, fig. 1.

As a painter dedicated to Paris, Vollon made a series of canvases that convey the variety of the city. Many of them picture the well-known bridges spanning the river Seine, showing these locations from afar and frequently from a high vantage point that suggests a topographic or panoramic reading of the city. These wide-angled landscapes record river traffic and barges moored to the banks, demonstrating Vollon's ability to capture the misty atmosphere at a specific moment in time. They also call attention to architectural details, documenting well-known buildings in the distance that act as staffage for the compositions and that could be identified with ease by contemporary viewers.

Vollon often produced several views of the same location, as was the case with the Pont des Saints-Pères. Whether this was because he wanted to develop a series of paintings on a single thematic motif (as some Impressionists did) or simply because he was asked to reproduce the same site by multiple clients remains unknown. He typically worked on several versions of a site at once and sometimes did not complete them, as in this instance—either tiring of the theme or feeling unsatisfied with the emerging results. In *View of the Seine*, certain sections of the painting are inconsistently worked, as noted by Vollon scholar Carol Forman Tabler.[1] Tabler points out that this rendering of the site seems to have been made around 1888–89—a particularly significant moment, since Paris was readying itself for the massive international exhibition of 1889, when millions of visitors were to come to the city. Scenes such as this would have been especially desirable and appropriate, adding another reason why Vollon worked on them at this moment in his career.[2]

The bridge in the background has been identified as the Pont des Saint-Pères, although it no longer exists in the form that Vollon recorded. In the 1930s, the present Pont du Carrousel was constructed, replacing the much older bridge.[3] Because of the changes brought about by urban modernization, Vollon's views of Paris often reveal an older city, documenting monuments that were eventually replaced. This aligns his paintings, finished or not, with another nineteenth-century tendency: recording the

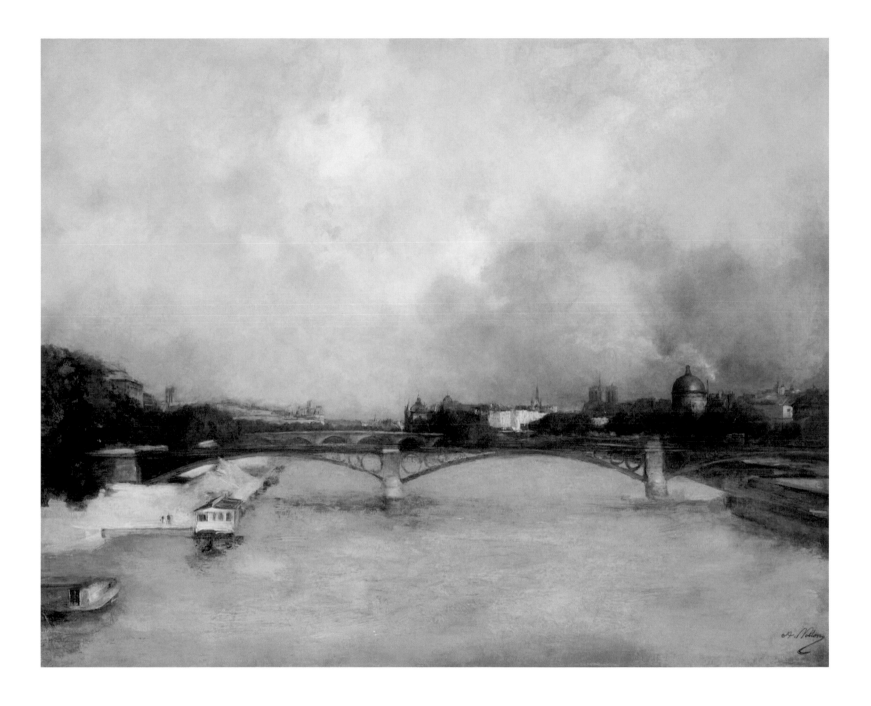

city before it disappeared forever under the banner of progressive revitalization. This quality can be seen in many of the images by midcentury etchers such as Charles Meryon (1821–1868) and A. P. Martial (1828–1882), printmakers who contrasted old and new Paris in their compositions. Vollon was interested in the graphic arts and was aware of the innovations of members of the Société des Aquafortistes during the 1860s and beyond. He shared their desire to document the changing locations and viewpoints of the city. Placing the sites he selected against this contextualized history adds another dimension to the interpretation of Vollon's paintings.[4] —GPW

1 Tabler notes that the left-hand side of the foreground seems "curiously tentative," while the sky is "fully rendered." See Carol Forman Tabler, "The Landscape Paintings of Antoine Vollon (1833–1900): A Catalogue and Analysis" (PhD diss., Institute of Fine Arts, New York University, 1995), cat. no. 148.

2 Tabler, e-mail to author, April 8, 2010.

3 Tabler, "The Landscape Paintings of Antoine Vollon," cat. no. 147.

4 See Janine Bailly Herzberg, L'Eau-forte de peintre au dix-neuvième siècle: La Société des Aquafortistes, 1862–1867, 2 vols. (Paris: Léonce Laget, 1972), with appropriate references to Vollon, Méryon, and Adolphe-Martial Potemont (called Martial).

Antoine Vollon, 1833–1900
View of Versailles
black and white chalk on sturdy-weight wove paper
12.38 x 19.25 inches (31.50 x 48.90 cm)
Inscribed lower right in graphite: *A. Vollon / Versailles*
The Cleveland Museum of Art
Bequest of Muriel Butkin
2010.287

80

Provenance
Hazlitt, Gooden, and Fox, London; Shepherd Gallery, New York, 1975; Mr. and Mrs. Noah L. Butkin, Shaker Heights, Ohio; bequest of Muriel Butkin to the Cleveland Museum of Art, 2009.

Although Vollon was best known for his Realist still lifes, recording picturesque views of Paris comprised a significant portion of his artistic output. According to Etienne Martin, the artist's first biographer, "Vollon adored landscape; all his life he dreamed of becoming exclusively a landscapist. 'It is the first of my métiers,' he said."[1] Vollon's first Salon acceptance in 1864 was a still life, and he consistently exhibited that genre throughout the 1860s and '70s. Not until 1886 did he submit a landscape painting. This is remarkable, given that Barbizon School artists had been exhibiting pure landscape at the Salon since the 1850s, albeit enduring scathing criticism at times. Landscape painting played a major role in the first exhibition of the Société Anonyme, which opened in 1874 and became known as the first Impressionist exhibition. Carol Forman Tabler suggests that Vollon's reason for withholding his landscapes from the Salon was his perception that landscape painting offered less potential for academic success than still-life painting.[2] Apparently, Vollon was loathe to associate himself with the avant-garde and pure landscape painting.

Nevertheless, Tabler proposes that given Vollon's significant number of landscapes, he played an important role in the development of Naturalism.[3] Numerous paintings of the coast of Normandy made in the 1870s demonstrate the artist's awareness, and presumably admiration, of Gustave Courbet's and Claude Monet's paintings of that region's dramatic, rocky coastline. That Edmond Renoir, the brother of the artist Pierre-Auguste Renoir, was one of Vollon's most outspoken champions underscores Vollon's link with the Impressionists. In 1879, Renoir organized a solo exhibition of Vollon's works at the offices of *La vie moderne* that featured a range of his subjects, including landscapes. In a review of the exhibition published in the journal, Edmond Renoir lauded these works in particular, calling the artist "the greatest landscapist of the French School" since the Barbizon painters[4]—a remarkable pronouncement, given that the fourth Impressionist exhibition had been on view from April 10 to May 11, 1879, featuring landscapes by Monet and Camille Pissarro (1830–1903).

In addition to painting en plein air, Vollon explored landscape motifs in graphite, watercolor, and chalk. His strongest drawings were rendered in black and white chalk, with which he created a range of tones, from the shadowy black of densely planted trees to pale, cloud-filled skies. The Cleveland drawing depicts Versailles

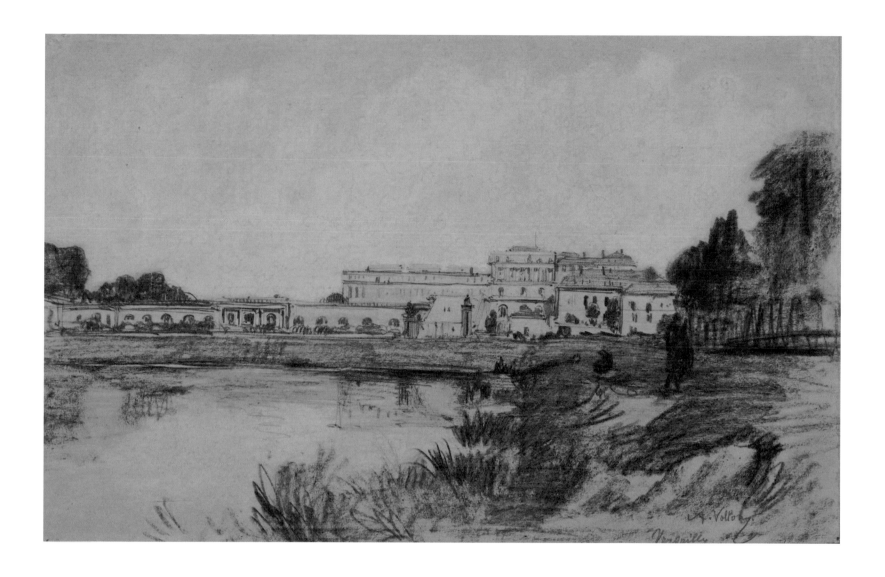

from the south, one of the most picturesque views of the château that had attracted artists since the seventeenth century.[5] Vollon positioned himself at the edge of the Pièce d'eau des Suisses, a large pond dug out by soldiers from the Régiment des Gardes Suisses. From the left, we see the Orangerie, followed by one of Versailles's two grand flights of stairs known as Les Cent Marches that lead to the upper terrace of the palace. Above the steps, we glimpse a corner of the central part of the château, as well as windows of the Salon de la Paix and the Apartement de la Reine. The drawing provides a clear view of the south façade of the south wing, the Aile du Midi. This precise rendering of the château's details is juxtaposed with the artist's bold, expressive description of the landscape at the edge of the Pièce d'eau des Suisses, creating a contrast between the cultivated and the wild. —*HL*

1 Etienne Martin, *Antoine Vollon: Peintre (1833–1900)* (Marseille: Académie des Lettres, Sciences et Beaux-Arts, 1923), 26–27: "Vollon adorait le paysage; tout sa vie il rêva de devenir exclusivement paysagiste: C'est le premier des métiers, disait-il." Quoted in Carol Forman Tabler, "Antoine Vollon: Master Painter," in *Antoine Vollon, 1833–1900: A Painter's Painter* (New York: Wildenstein, 2004), 22n47.

2 Tabler, "Antoine Vollon," 16.

3 Ibid., 16.

4 Edmond Renoir, "Notre exposition: Antoine Vollon," *La vie moderne* 1, no. 9 (June 5, 1879): 143. Quoted in Tabler, "Antoine Vollon," 19.

5 I am grateful to Emanuel Ducamp, independent art historian and Président de l'Association Paris-Saint-Pétersbourg, and Bertrand Mondot, Curator at the Château Versailles, for helping to identify this view.

Author Biographies

Gabriel P. Weisberg

Gabriel P. Weisberg is Guest Curator and Editor of *Breaking the Mold*. As Curator of Art History and Education at The Cleveland Museum of Art (1973–1981) he worked closely with Noah and Muriel Butkin in developing their collection of French paintings. He also organized two significant exhibitions with catalogues that are directly linked with the Butkins' paintings. The first, *The Realist Tradition, French Painting and Drawing, 1830–1910* appeared in 1980; the second, *Illusions of Reality: Naturalist Painting, Photography, Theatre and Cinema, 1875–1918* was organized in 2010 for the Van Gogh Museum, Amsterdam. He is currently Professor of Art History at the University of Minnesota, Minneapolis.

Kirsten Appleyard

A native of Ottawa, Ontario (Canada), Kirsten Appleyard graduated from the University of Notre Dame in 2011 with a Master of Arts in Art History. Her primary research interests lie in the areas of fifteenth-century Italian art (specifically, the work of Fra Angelico), and sacred art of the twentieth and twenty-first centuries (by artists such as Georges Rouault, Marc Chagall, and a contemporary French Catholic painter named Arcabas). In 2010, Kirsten curated a Rouault and Chagall exhibition at Baylor University (her undergraduate alma mater) entitled *Sacred Texts, Holy Images: Rouault's* Miserere *and Chagall's* Bible *Series*; she was also privileged to be a part of the *Breaking the Mold* exhibition while working as the Higgins Graduate Intern at the Snite Museum of Art during her years at Notre Dame. She is currently serving as a curatorial consultant for the Snite Museum for a Rouault exhibition to take place in 2013.

Heather Lemonedes

Heather Lemonedes, Curator of Drawings at the Cleveland Museum of Art and adjunct professor in the Department of Art History at Case Western Reserve University, specializes in 19th century works on paper and paintings. She has participated in the organization of numerous exhibitions accompanied by scholarly catalogues including *Paul Gauguin: Paris, 1889* (2009) and *Monet in Normandy* (2007). Dr. Lemonedes is currently organizing the exhibition, *British Drawings from the Cleveland Museum of Art* and is writing the accompanying collection catalogue. She has previously been employed in the Prints and Drawings Department at The Metropolitan Museum of Art and in the Print Department at Christie's, New York. She received a B.A. from Vassar College; an M.A. from the Courtauld Institute of Art, University of London; and a Ph.D. from the Graduate Center, City University of New York.

Sarah Sik

Sarah Sik (Ph.D., University of Minnesota) is a historian of 19th- and 20th century art, design and intercultural exchange at the University of South Dakota. Previously, she taught at Penn State University and Bucknell University. Recent publications include "Those Naughty Little Geishas: The Gendering of Japonisme" in *The Orient Expressed: Japan's Influence on Western Art, 1854–1918* (Mississippi Museum of Art and Washington University Press, 2011). In addition, her research has focused on the designer John S. Bradstreet, the introduction of Jugendstil interiors to the United States, the print piracy of the graphic artist Maurice Biais, and the emergence of celebrity culture in the 19th century. Current research projects include the deco-sculptural furnishings of François-Rupert Carabin, the figure of Pierrot in the art of Adolphe-Léon Willette, and the exhibition group Les Arts Incoherents.

Janet L. Whitmore

Janet L. Whitmore (Ph.D., University of Minnesota) teaches graduate and undergraduate courses in the history of art, design and architecture at Harrington College of Design in Chicago. She is the author of "Transatlantic Collecting: Paris to Minneapolis" in *Twenty-First-Century Perspectives on Nineteenth-Century Art: Essays in Honor of Gabriel P. Weisberg* (University of Delaware Press, 2008); "Landscape Dreams," *Barbizon to Brittany: Landscapes of France in Bluegrass Collections* (University of Kentucky, 2006); and "A Panorama of Unequaled Yet Ever-Varying Beauty," *Currents of Change: Art and Culture in the Mississippi River Valley during the 1850s* (University of Minnesota Press, 2004).

Colophon

Printed on Utopia Premium Silk
End sheets: Neenah Classic Laid
The typefaces used are Perpetua and Gill Sans
Design by Sedlack Design Associates, South Bend, Indiana
Printing by Mossberg & Company Inc., South Bend, Indiana
Published by the Snite Museum of Art, University of Notre Dame, Notre Dame, Indiana

This publication was made possible by generous gifts from
Mr. and Mrs. Thomas J. Lee '59 and Mr. Ralph M. Hass.

Printed July 2012